Gendered Epidemic

Gendered Epidemic

*Representations
of Women in
the Age of AIDS*

**edited by
NANCY L. ROTH AND KATIE HOGAN**

Routledge
New York and London

Published in 1998 by
Routledge
29 West 35th Street
New York, NY 10001

Published in Great Britain by
Routledge
11 New Fetter Lane
London EC4P 4EE

Library of Congress Cataloging-in-Publication Data

Gendered epidemic: representations of women in the age of AIDS /
 Nancy L. Roth and Katie Hogan, editors.
 p. cm.
 Includes bibliographical references and index.
 ISBN 0-415-91784-0 (hbk.: alk. paper).—ISBN 0-415-91785-9 (pbk.: alk. paper)
 1. AIDS (Disease) in women. I. Roth, Nancy L., 1957– . II. Hogan, Katie, 1960– .
RA644.A25G468 1998
362.1'969792'0082—dc21 97-32081
 CIP

In memory of
Mary Hogan Anderson and
Amanda Anderson

CONTENTS

Women, Write, AIDS

Cindy Patton

In the 1970s, second-wave feminists rallied under the phrase "the personal is political." Earlier 19th- and 20th-century feminisms had emphasized women's concrete lack of political forums, economic opportunity, and protection in public spaces. These new feminists wanted to center the loosely Marxian macro-analyses of 1960s student left and anti-war politics squarely on women's daily lives. Although interpreted by some as the first step toward voluntaristic "me-ism," the phrase was intended to emphasize the connection between politics of public engagement and the more private, especially sexual, politics experienced outside formal political processes. The idea seemed clear: macro-political forces are inflected in our private lives, and our daily experiences provide the basis for framing analyses of the larger, "public" world.

By the 1980s, however, the complexities of moving between levels of analysis and the tendency to rank claims to personal experience (i.e., the "crisis of identity politics") began to strain the coalitions forged in the 1970s. In principle, the Rainbow Coalition groups supported a broad program of social justice. But in practice, local engagements pitted slightly differing interests against each other. The right seized this opportunity in order to question the legitimacy and "rights" of, especially, gays and lesbians, radical or nationalist blacks, and feminists. They used the affirmative action debates, anti-pornography ordinances, and gay rights initiatives to deepen the conflicts among left-leaning political groups whose politics had cohered through a fragile effort to identify across "identities" with compassion.

Emerging at the same moment that the Rainbow Coalition

was eclipsed by the Christian Coalition, AIDS organizing inherited the commitment to personal politics and the contradictions it embedded. Like its gay lib precursor, itself influenced by feminism, AIDS organizing specially valued the knowledge obtained from chaffing under the oppressive labeling of the medical system. Also influenced by 1970s poststructural theorists like Michel Foucault (who was at least partially touched by the feminism of his place and time), AIDS activists inherited the tendency to complex analysis of social and political processes: work on the social responses to and representation of the epidemic stand as some of the most politically invested and dazzling examples of cultural criticism. Sometimes these two tendencies pushed AIDS organizing forward at lightning speed. But sometimes conflicts between what we know as situated, medicalized bodies and how we analyze as post-Marxist critics collided, stalling AIDS politics in relation to particular issues.

Ironically, the very pairing of personal and political that feminists had contributed to post-1960s politics returned in a new version that actually made it more difficult to voice and conceptualize the problems faced by women in the epidemic. Women living with HIV, but also those at risk of contracting it and those whose job category, history of volunteering, or family connections produced the disproportionate number among those providing the care for people living with AIDS worldwide, seemed impossible to marshall under a single, politically effective category: Woman?

Since about 1993, efforts by women to get the issues of women better addressed have resulted in unproductive and often ugly battles between gay men and women. We are not each other's enemy: complex national systems create a situation in which we are asked to choose among ourselves who has the greatest and most authentic need. This obscures real material differences between men and women in this epidemic. I want to try to open up some space to reconsider how to bring the voices and analysis represented in this volume to the center of debate and strategizing, with the hope of altering what now seems like a zero sum game.

It has taken great courage and effort for gay men to produce the modicum of political leverage they have achieved in relation to AIDS research and policy. The degree to which policy and education in the U.S. have remained largely Victorian is a testament to the intransigence of homophobic attitudes, not the fault of gay men and their political labor. Women are greatly indebted to this work. However problematic have been the responses to women's needs by gay community-based AIDS service organizations, the women's movement as a loose entity was much slower to recognize women's needs. The main reason underlying the ill fit between gay men's organizing models and seropositive women's needs, as well as the women's movement's slow response is the complex class dimension of women's position in the epidemic.

This is difficult to explain clearly; the problem is class structuration, and not the specific positioning of particular gay men, to whom, again, I want to express a great debt. Instead of hurling accusations of privilege, we have to come to grips with the extent to which spokespersons and those most actively engaged as researchers and theorists, come from the most educated stratum of the groups they represent. This has probably generally been true in American activism, with the possible exception of some periods of labor organizing. Especially with "invisible" groups, and even more intensely in a medical-political crisis like HIV, gaining an audience requires specialized knowledge that is not easily obtained informally, or without the help of people with some level of formal training. Even we AIDS-medicine autodidacts had the advantage of extensive specialized knowledge and knowledge acquisition skills in other areas.

One of the great triumphs of middle-class gay people has been our ability, in the last two decades, to gain some legitimacy as a political constituency, and to succeed in many professions "despite" our publicly acknowledged sexuality. Gay men living with HIV, to their credit, leveraged their skills and their tenuous legitimacy, along with a very powerful claim to the experience of oppression at the hands of the medical system, to exercise some control over how they are collectively represented in relation to HIV. Perhaps even more significant, and especially in the social sciences and humanities, gay men and gay men living with HIV as researchers bring their particular knowledge as people living with HIV to their professional activities. This, I believe, has begun to create a new kind of research ethic that embraces compassion and to some degree breaches the barrier between researched and researcher. This may even have some effect on AIDS policy.

As personally wrenching as it has been for gay men to take up the position of persons living with HIV in their professional research domains, it is critical to recognize that class operates doubly to limit the possibilities of a woman with HIV being similarly situated, and therefore able to represent the particularities of her interests within professional circles. The enfranchisement of the affected, emerging in some areas of AIDS research and policy, means that being openly seropositive brings with it at least a small degree of moral and political force, however constrained each individual might finally be.

This new window is not open to women. First, because HIV has, apparently, occurred more often in women in minority groups or class segments with less access to formal education, proportionately and absolutely few women living with HIV have acquired the capital necessary to be part of the research and policy professions. I'm not suggesting that more than a tiny minority of the gay men affected by HIV are members of the professional managerial class. However, because of the sheer numbers of gay men affected, it has been those men who have been able to seize this particular opportunity to affect

AIDS research and policy. While the "consumer" movement among seroposi-
tive people has created a mechanism for self-education that has been taken up
by both men and women, this position is outside the research enterprise—an
important force for agitation, but not one with any real hope of stable power
or institutional leverage. But second, seropositive women who do occupy these
class and professional positions are treated as exceptions. Whereas middle-
class gay men are perceived as legitimate representatives of other gay men,
middle-class women are viewed as speaking on behalf of another class of
women, not speaking directly in their own interests.

This problem of "speaking for" rather than "speaking as" has troubled
the women's movement for a century and a half. To the extent that our sex is
accepted (among ourselves and by sources of power) as a real line of affinity,
we can "speak together" as different kinds of women, even if some of our
voices are allowed to be more articulate or credible. The early stereotyping of
HIV as a disease of immorality and deviance challenged women's assertion of
ourselves as a sex-class. Middle-class seropositive women are considered par-
ticular victims, and seropositive women from other classes are viewed as sex
criminals who indirectly endanger "nice" women and children by infecting
otherwise blameless men. In the mainstream media, and to a great extent fem-
inist media and books, the only space for the voice of the seropositive woman
has been as a highly personal, naive, pathetic voice—a speech that doesn't
stand equal to the highly articulate and politically sophisticated voices we now
expect from gay men. If they are sophisticated and political, victim-women are
suspected of having been coopted by feminist organizers, or of simply being
unrepresentative of the women who have contracted HIV. (This is also a well-
worn reading—women who put themselves through college or feed their chil-
dren doing sex work are not considered "real" prostitutes.)

The fact is, class, ethnicity, and gender structuration conspire to place
some women at extraordinary risk of having unprotected sex or unsterilized
needle sharing with men who are very likely to have HIV. This same structura-
tion prevents the women at greatest risk from acting within our political sys-
tem on their own behalf. Without a closer consideration of the relationship
between educational advantage, organized community structure, and class,
our politics of authenticity leads us to expect women with HIV to be pathetic
and resourceless.

We are each a scarred body, twisted and marked from criss-crossing both
institutional definitions and our own categories. Some bodies become hyper-
visible in the grid of research, politics, and policy because their multiple desig-
nations align, cohere, and create a sense of a continous body across
institutional and community spaces. "Gay men" now seems to be such a solid-
ity, however little the most public image fits their many private lives. But

others' bodies disappear precisely because there is no way to link up their fragmentary definitions into something that can hold a place in political representation. The recently touted numbers suggesting that "AIDS deaths" are declining do not make much of the finding that in most places in the U.S. death among women is increasing, and AIDS, as a cause of death, has moved nearer the top of the list for women, especially women of color. "Woman" is too many things in the epidemic: epidemiology's "partners of," communities' "other half," the "general public's" most vulnerable part, the dangerous sexual outlaws that prey on wayward men. They are either a demographic exception (not gay men) or the idealized case where we can see the unbiased (by sexuality) "truth" of the pathos of the epidemic. Simultaneously passive, innocent victim and monstrous, infectious sex organ, women do not yet have a voice that gives them purchase on the representational and medical systems that engulf them.

The present volume, then, arrives at an extremely tenuous moment in our efforts to develop strategies for improving the situation of women with HIV. These essays fall into a range of registers, from explicitly practical to explicitly theoretical. They engage the problems of identity politics, strategies of self-representation, and the concrete processes of moving knowledge across the invisible walls that divide the knowing from the known.

Gendered Epidemic

Nancy L. Roth and Katie Hogan

An explosion of what theorist Cindy Patton calls a "new visibility of 'woman'" in discussions of HIV infection has occurred in the last five years. Images of women and HIV/AIDS now appear in activist writings; in women's health books and testimony; in novels, poetry, and nonfiction; on television, in magazines, and in commercial films. Gender issues are receiving increased visibility in the development of public policy, testing of treatment protocols, and promulgation of prevention programs. New York City's Gay Men's Health Crisis has a Lesbian AIDS Project that is only three years old. But this new visibility of "woman," no matter how crucial, hard won, and necessary, cannot explain the deeply entrenched historical silences and gendered distortions that characterized the first decade of the HIV pandemic, and that often continue to structure HIV/AIDS prevention efforts targeted toward women and representations of women and HIV/AIDS.

This collection weaves together theoretical, critical, and practical perspectives to question the idea that simply taking AIDS and adding "women" will provide the insights necessary to stem the spread of HIV. We claim that this ineffectual tokenism seriously overlooks the intricate processes and conceptualizations of gender that have kept women repressed within the discourse and treatment of HIV. Scholars have shown repeatedly that perceptions of HIV infection coded as "male" are directly linked to the distorted representations of women in medical research, outreach, and treatment. This book adds to the critical literature on women and HIV infection by providing an investigation of the ways in which HIV is a gendered epidemic—and *why it is*.

The conjunction of HIV infection and women provides information for gender theory and practice on how women are perceived, represented, and most importantly, treated in our culture at large. Despite the achievements of the women's movement, the success of feminism in the academy, and the steady gains women have made in terms of education and economic autonomy, the multiple issues of women and HIV infection disturb accepted ideas and pose challenges to theory and activism. By joining the critical and activist perspectives, we provide a more textured analysis that makes clear the relationship between existing racially and gender-inflected societal structures and the meanings that have been made of AIDS.

We call for a rethinking of the pandemic that includes changes in feminist theory, public health policy, and practice to accommodate the identities, experiences, and knowledges that have been heretofore excluded. We offer the perspectives of HIV-positive women, theorists, teachers, artists, policy makers, and activists, some of whom occupy all, one or more of these subject positions, in an effort to describe conflicts and contradictions, and to pose new theories and new practices. In so doing, we move both feminist and health communication theory forward, while highlighting the intersections where theory and practice can inform each other. As Gayatri Chakravorty Spivak succinctly explains, "The real task here is to displace and undo that killing opposition between the text narrowly conceived as the verbal text and activism narrowly conceived as some sort of mindless engagement" (1990, 120–121).

Unfortunately, for many feminists, HIV and women is still perceived as a "single-issue," a "materialist" serious example of oppression, yet an "issue" that seems unrelated to the questions and concerns of feminist theory. In 1988, the feminist cultural theorist Paula Treichler wrote: "Given the intense concern with the human body that any conceptualization of AIDS entails, how can we account for the striking silence, until very recently, on the topic of women in AIDS discourse?" (193). Yet feminists, with a few remarkable exceptions, have been slow to recognize both the impact of AIDS on women and the implications of HIV for feminist theory. Lesbians, unless they identify as feminist or as "political," are often indifferent and ignorant.

We maintain that the gendered epidemic offers profound practical as well as epistemological challenges. The basic tension arises from the distinction between the activity of philosophical inquiry and the activity of feminism as building a political movement—in Spivak's parlance, the perceived gap is rooted in that "killing opposition" between theory and practice. With this collection, we begin to fill this gap; we theorize women's bodies, experiences, and deaths with respect to HIV by exploring the relationship between experience, in all its variety and complexity, and theories.

To this end, the book is presented in three sections (Gendered Habits:

Gender, Sexuality, and HIV/AIDS; Gendered Abjection: Prevention—Policy and Practice; and Gendered Silence: Representation—Exclusions and Inclusions. The first presents an essay by John Erni which explores the relationship between sexuality and gender in the context of the United States experience of the HIV/AIDS epidemic. Erni argues that we might begin to rethink gender, sexuality, race, class, and nationality as intertwining, singularizing habits. They are not something we are, but something we do. In this framework identities are habitual actions. As habits, both individual identities and social identities have the possibility of reconfiguration.

The remainder of the book builds on this theoretical foundation as it explores two key arenas in the gendered epidemic: HIV/AIDS prevention programs targeted toward women in general, and lesbians specifically, and representations of women and HIV/AIDS in the press, popular literature, the AIDS quilt, and alternative film. Each of the sections is introduced by a theoretical piece that is consistent with Erni's theoretical framework and expands it to address its specific focus. The first pieces that follow critique current practice by drawing on both theoretical and experiential evidence. The final works in each section present alternatives that address some of the issues raised in the critiques and that make use of portions of the theoretical positions that introduce the sections. The juxtaposition of theory and practice in each section highlights ways in which they might inform each other in seeking to understand identity and policy in the age of HIV/AIDS.

In the second section, Karen Zivi's critique of Julia Kristeva's theory of the abject forms a framework for several perspectives on HIV/AIDS prevention efforts targeted toward women. Recent feminist writings have called into question binary conceptions of gender and have posited instead a multiplicity of genders and an uncoupling of gender and sexual orientation. In so doing, some of the gendered positions have been labeled as abject.

Expanding the notion of the abject to HIV/AIDS, Karen Zivi's "Constituting the 'Clean and Proper' Body: Convergences between Abjection and AIDS," uses Kristeva's theory of abjection to argue that AIDS has become, in some sense, a metaphor of the abject. Zivi uncovers the ideological underpinnings in moral rhetoric, research agendas, media narratives, representations, and public policy of the abjectification of HIV/AIDS. She also explores the *limits* of Kristeva's theory in this context by suggesting that it cannot account for relations of power and history and thereby excludes important particularities of race, class, gender, nation, and sexuality. Zivi discusses those she calls subjects who are multiply abjected, individuals who cannot move away from the symbolic position of abject. In contrast stand those, such as Ryan White and Kimberly Bergalis, who move from abjection to occupy the position of symbol and national hero. Kristeva's more limited view of abjection is unable

to account for such representational shifts.

The remaining essays in the section focus on HIV/AIDS prevention in the context of abject identity/ies. Consistent with Erni's theoretical structure, the essays in this section struggle with postmodern conceptions of multiplicity. A variety of subject positions available to at least some women are examined and critiqued through the lens of HIV/AIDS prevention policy and practice.

Amber Hollibaugh's essay , "Transmission, Transmission, Where's the Transmission?," first appeared as a response to Judith McDaniel and Kathy Mazzo's article on lesbians and safer sex which appeared in the May 1994 issue of the feminist journal, *Sojourner.* McDaniel and Mazzo claim that not only is there a great deal of confused information on HIV transmission and lesbians, but that there is a growing anxiety about lesbian transmission, an anxiety created, in part, by lesbian safer-sex activists. This anxiety, they assert, is thwarting lesbians' already fragile claim to erotic freedom and experimentation. Hollibaugh's response, which we have reprinted here, argues that McDaniel and Mazzo's fundamental thesis rests on an oversimplified understanding not only of HIV infection, which Hollibaugh sees as a complex global issue of concern to all queers, but also the unstable category of lesbian. Hollibaugh's essay, informed by her work with primarily working-class women of color who partner with women at the Lesbian AIDS Project in New York City, challenges many of the gendered (as well as middle-class and white) assumptions that have limited discussions of HIV, especially within and among lesbian communities.

Carmen Vazquez continues this critique by suggesting that within the lesbian communities the casual assumptions concerning what constitutes lesbianism and more importantly "good" and "bad" lesbian practices blind women to the needs of working-class women of color who have sex with women. Prevention programs reflect white, middle-class assumptions and practices and do not speak to the experiences of women who comprise one of the fastest growing segments of HIV-positive people. She exhorts community activists, HIV/AIDS care organizations, and the government to recognize the multiplicity of experience and to reach out to all who are affected by the virus.

Cynthia Madansky recalls her experiences in attempting to create a safer sex handbook for lesbians which was strongly censored. Portions of the handbook, which was designed to be sex-positive and lesbian-affirming, are reproduced in the chapter along with a chronology of events and a critical response. Madansky questions how lesbians will protect themselves in this epidemic if they cannot say who they are or describe what they do.

Marion Banzhaf and Chyrell Bellamy bring the voices and experiences of HIV-positive women into the forefront. These two HIV-negative health care workers conduct a "conversation about sex" with HIV-positive women. They

show that the social location of HIV-positive women offers the richest contestation of tabloid stereotypes of women and AIDS. Their essay claims a subject position for HIV-positive women to claim their own identities, rather than to reify the identities imposed by those who would label them as "other."

The book's final section uses feminist lenses to explore public communication and the absence of public communication about women and HIV/AIDS. The essays expose media (including feminist media) silences about women and HIV/AIDS and explore the reasons behind the silence, examine how women are constructed when they are the object of mainstream media attention, explore how the AIDS quilt reifies gendered experiences, address how gender, race, and class intersect with HIV/AIDS in recent novels, and discuss how video images produced by HIV-positive women for and about themselves differ from other representations of women and HIV/AIDS. In each case, the authors call into question established theories of public communication and provide alternatives informed by practice in the age of sexual epidemic.

Paula Treichler and Catherine Warren's chapter, "Maybe Next Year: Feminist Silence and the AIDS Epidemic," provides a theoretical framework for examining not only the presence and absence of public discourse about women and HIV/AIDS, but also offers methods for reading representations against the text when they do appear. Their content analysis of mainstream women's and feminist publications, from *MS.* to *New Woman*, to *Vogue*, and lesbian and gay publications, including *The Advocate*, *Gay Community News*, and *Sparerib*, demonstrates the woeful silence of feminists in the epidemic. It highlights HIV/AIDS as one of the premier symbolic battlegrounds of our time and suggests that the absence of feminist voices in the struggle cedes the framing of key feminist issues brought to the fore by the epidemic to those who marginalize women in general and women with HIV/AIDS in particular.

Carra Leah Hood's essay, "Scarlett Begat Kim: A Counter-Biography" comprises a presentation of biographical "facts" about Kimberly Bergalis, drawn from medical and legal texts which have not been discussed in public discourse: i.e., the media. This critical biography explores the ways in which the narrative about Bergalis in the press was constructed against a racialized narrative of AIDS and produced a female figure in the tradition of the "pure white southern woman" often associated with Scarlett O'Hara.

Flavia Rando suggests that the NAMES Project AIDS quilt reifies women's roles in the epidemic as passive, sentimental caregivers. The quilt, she asserts, provides for the reconstruction of a mythic community that was denied to those with HIV/AIDS during their lifetimes. The quilt serves as a metaphor for the body/politic constructed by the AIDS crisis which denies the body and denies community to those most affected.

Gender, HIV/AIDS, and race come together in two recent novels, *touch*

and *Push*. While Katie Hogan celebrates the authors for addressing these of-ten-avoided topics, she critiques their reproduction of raced and gendered subjects. She notes that the epidemic brings into view the ways in which these prevailing narratives are integral to cultural meanings and structures.

In response, Alexandra Juhasz provides a description of how HIV-positive women seize the tools of technology, in this case, camcorders, and produce videos on women and AIDS for their communities. In this case, the public communication is produced by community members themselves, thus obliter-ating the silence and allowing representations of women with AIDS as subjects rather than as the "abject other." This report provides a remarkable contrast with the essays that precede it and serves as a beacon lighting the path toward embracing new habits, rejecting abjection, and pursuing self-representation.

WORKS CITED

McDaniel, Judith, and Judith Mazza. "Safer Sex for Lesbians, What's It All About?" *Sojourner: The Women's Forum* 19.9 (May 1994): 4p.

Spivak, Gayatri Chakravorty. "The *Intervention* Interview." *The Post-Colonial Critic: Interviews, Strategies, Dialogues.* Ed. Sarah Harasym. New York: Routledge, 1990. 113–132.

Treichler, Paula. "AIDS, Gender, and Biomedical Discourse: Current Contests for Meaning." *AIDS: The Burdens of History.* Ed. Elizabeth Fee and Daniel M. Fox. Berkeley: University of California Press, 1988: 190–226.

Gendered Habits

Gender, Sexuality, and HIV/AIDS

Ambiguous Elements
Rethinking the Gender/Sexuality Matrix in an Epidemic

John Nguyet Erni

This essay focuses on the relationship between gender and sexuality and how they are understood and contested within the dominant constructions of the HIV/AIDS epidemic in the United States. It also endeavors to explore how they can serve as a resource for changing those constructions. It insists on theorizing sexuality and gender together, even as it attends, and I think it must, to the specificities of each axis. As the epidemic approaches its third decade, how sexuality and gender can be reconceptualized, and more importantly how their interimplications can be theorized, may have the potential to reframe how the epidemic is defined. The need for such a reframing is clear: over the past sixteen years in the U.S., frustrations have been escalating in the care-giving, social service, and activist communities over the serious incongruence between people's concrete and varied experiences in the epidemic and the dominant social and scientific practices operating on narrow and deadly cultural assumptions about sexual and gendered realities. Of late, the social acceptance of the common knowledge and definition about the epidemic, most notably in the areas of epidemiology and safe sex education, masks the continuing and escalating instability exactly in those same areas. For instance, how do we make sense of the discouraging news about "new" infection in populations not easily identified along taken-for-granted sexual, gender, racial, or class lines (such as the growing cases of infection

among white middle-class heterosexual teenagers)? How should we begin to acknowledge the risk of infection among bisexual men and women (and to acknowledge their existence as bisexuals)? How do we grapple with the reality and consequences of those sexual choices (gay and non-gay alike) that seem to defy the canonical approach to safe sex? The theoretical inquiry by feminism and queer theory about the complexity of gendered and sexual formations, identities, and practices—an inquiry *preceding* the epidemic—takes on a charged significance in the face of continued failure to apprehend gender and sexual differences in this ever-changing epidemic.

I am not suggesting that feminist and queer theorists and activists have the answer to the puzzled realities posed by those complexities. However, I am arguing that their efforts to examine dominant assumptions about the body and sociality in gender and sexual terms, to challenge the norms that regulate those assumptions, and attempt to open up dialogue among scientists, humanists, and activists have furnished an important political context in which we can continue to wrestle with this terrible crisis and the power relations that mold it.

In my view, some of the most vital ensembles of scholarship within cultural theory today (in all of its creative, multiplying forms) are those that seek to grapple with the perplexing lines of connection that comprise agency and identity, lines that criss-cross the material, psychical, corporeal, representational, and spatial/temporal domains.[1] In these works, the usual markers of difference—race, gender, sexuality, class, nationality—are seen as sites or effects of articulation and distribution along those discursive lines. I use the term "ensemble" in order to signal a certain thickening of critical reflections actively being offered by scholars today (e.g., most notably in the unusually abundant proliferation of "special issues" in journals, and in highly specialized symposiums and conferences). To be sure, the congealment I am thinking about here is the result of the rapid institutionalization of "area studies." These interdisciplinary studies represent a series of critical calls to examine what Ernesto Laclau and Chantal Mouffe (1985) call "the 'surplus' of the social vis-à-vis the rational and organized structures of society" (1). Postcolonial studies, ethnic studies, gay and lesbian studies, science studies, to name only a few, reflect and intervene in the contemporary social order in a way that defies totalizing disciplinary narratives and reductionist explanatory paradigms. As area studies grow, one of the consequences is that the questions of race, gender, sexuality, class, and nationality are approached by way of interdisciplinary dialogue, of course, but also by way of displacement and competition, even with the best intentions in mind. Paradoxically, the important task of thinking these differences *together* appears to be carrying out through different forms and degrees of antagonism. This tendency is also reflected outside of academic settings, for instance, in the AIDS activist communities struggling

to form coalitions across an increasing, and sometimes divisive, multitude of constituents.[2] I have no illusion that the attempt to think through the manifestly complex relations among race, gender, sexuality, class, and nationality is a formidable task, with no guarantee of a clear and stable "state of affair." But it matters how we come to terms with the specific conditions of possibility—theoretically, politically, contextually—that frame our understanding of race, gender, sexuality, class, and nationality *individually and across each other.*

In this essay, by focusing on one of the debates within the kind of scholarship I have mentioned above—the debate over the gender/sexuality matrix—I undertake the task of examining carefully how the debate is carried out and what kind of critical reflections it can offer for and between feminism and queer theory. I will contextualize this debate in relation to some of the recurrent ambiguities in the dominant constructions of HIV/AIDS, ambiguities that foreground the questions of gender and sexuality. Finally, I will propose a different framework for thinking about the gender/sexuality matrix within the epidemic, one that is closely connected to Deleuzian philosophy. I hope to attempt to imagine how a Deleuzian perspective can reframe feminists and queer theorists' efforts to work through the interimplication of gender and queerness. More specifically, I want to suggest rethinking gender and queerness in terms of a theory of "habits" in relation to the performativity of identity. Such a theory, I will argue, can provide a useful vehicle for talking about those ambiguous configurations of gender and sexuality that confound monological ways of thinking within the dominant constructions of the HIV/AIDS epidemic.

WE?

How do we approach the question of whether and how it is possible to think gender and sexuality in anti-separatist and anti-assimilationist terms simultaneously? Can this inquiry be covered by neatly demarcated boundaries known as feminism on the one hand and queer theory on the other? Assuming that we can, then how may "we" articulate the terms of this inquiry based on the historical and temporal relations between feminism and queer theory, assumed commonly and paradoxically as separate (feminism first and later, queer theory) and overlapping at the same time? If a cultural and political inquiry is radically contextual (in Lawrence Grossberg's term [1993]), in other words, if it is historically situated and produces the objects or "events" of its own inquiry simultaneously, the problem of "we" underscores two important characteristics of the gender/sexuality debate: the history and conditions of possibility for the articulation of the feminist and queer theoretical projects, and the mutability of the terms that operate in, and are operationalized, by

those projects. To take this a step further, the problem of "we" *within the crisis of AIDS* impels an occasion to (a) rearticulate the histories of feminism and queer theory (such as their temporal relations, their epistemological convergences as well as gaps, and their very status as histories *vis-à-vis* the distinct history of AIDS), and (b) remap the mutating terms used by them (such as "sexual difference," "the body," "public sphere," "psychic reality," "resistance"). Here, I do not want to rehash the tired discussion about the trials and triumphs of "communities" (even as we find it useful in certain contexts to use the term politically). My interest lies more in exploring how intellectual projects such as feminism and queer theory were motivated, negotiated, legitimized, institutionalized, canonized, and contested, and how this investigation can be used to rethink the HIV/AIDS epidemic in the late 1990s. My discussion will be broad; its limitation lies in assumed abstractibility of gender and sexuality as operating terms in the feminism and queer theory on the one hand and in the social construction of the epidemic on the other. Moreover, the process by which they become the operating terms must be considered in interior and exterior terms at the same time, that is, as thickening tendencies *into* the epistemological centers of the anti-sexist and anti-homophobic projects and *against* the social, political, and philosophical grains that oppress or impede the expression of such projects.

The attempt to invoke feminism and queer theory together often means recalling the ambivalence of solidarity that underlies much of the historical and social experiences of lesbians and gay men. Standing together against the tides of oppression, lesbians and gay men have learned how to stand apart, so that the pressures of community consensus-building would never gloss over the difference and specificity of lesbian and gay male cultures. Since the 1970s, as a result of a theoretical and political divestiture within feminism toward a more radical theory of sex and sexuality, there have been at least three broad transformations within feminist theory. First, the definitions of "gender" and "sexual difference" have shifted along an anti-foundationalist line of thought to include a wide range of minoritarian sexed identities and practices not reducible to the binaristic male/female framework. At one historical moment, this shift helped to consolidate the movement within feminism from the anti-pornography stance to the anti-anti-pornography position. I mention this in order to highlight the fact that the process by which feminist theory was challenged and reinvigorated occurred as a response to concrete historical struggles. So it is critically important to see this first transformation as a *conjunctural* event. Second, the work of seriously theorizing "lesbianism" began to take on a charged significance. The articulation of a "lesbian criticism" within feminism meant taking feminist theory into the heart of the gender/sex-

uality matrix by making visible the specificity of female-to-female erotic bonds and identifications. Over the years, lesbian criticism itself has progressed from the attempt to assert "authentic" lesbian existence to exploring the mutability of lesbian practices in multierotic and multiracial frameworks.[3] Third, as a result of the two transformations noted above, the centrality of an identitarian model of politics was called into question. Increasingly it was realized that as the feminist movement intersected with the civil rights, sexual liberation, and postcolonial movements, the centrality of the rallying frame of "identity politics" obscured the particularities of oppressions based on gender, race, and sexuality in ways that were *not* manifestly gender-specific, race-specific, or sex-specific. The problems of capital, technology, nationalism, citizenship, to name only a few, apprehend gender, race, and sexuality in complex ways, deepening the ambivalence of a political theory that over-invests in an identity-based perspective. Needless to say, the same problems render any model that fails to think *across* identities at multiple discursive planes theoretically and politically limiting.

One may say that it is against the context of those transformations—of a divestiture in feminist theory, of the visibility of lesbian criticism, and of a problematization of identity politics—that queer theory articulated itself *with and alongside* feminism. Not a feminism as a static ground, but a feminism that exceeds itself in a series of continuous transformations. If queer theory represents a useful set of ideas that has the potential to rearticulate the gender/sexuality matrix, it is not because it likens feminism (the analogical argument), transcends feminism (the universalizing claim), or competes with feminism (the vanguard position). Such logics would be downright naive because they presuppose a relationship between two unchanging modes of thought. The recent history of the transformation of feminist theory briefly sketched above suggests that through the processes of self-reflexive inquiry and the conjunctural intersections with other practices of difference, feminism flows and intensifies with those practices. In a sense, feminism and queer theory interanimate one another in a kind of continuing and productive excess. The commitment to specificities and singularities within each domain must therefore be seen as something borne out of mutual articulations. Most importantly, we must realize that such articulations do not multiply aimlessly in a kind of uncontrolled excess; rather they always take place around concrete historical and political needs.

In this way, I find it crucial to consider the relationship between queer theory and feminist theory as something shaped and transformed by concrete conjunctural political struggles. The repudiation of men and women under the names of pornography, nationalism, family values, and AIDS, for instance, is

the critical ground upon which queers, feminists, queer feminists, and feminist queers have attempted to work out our individual *and* coalitional interventions. And we have done so through various strategic moments of cooperation, temporary retreat, cross-identification, appropriation, compromise, and even refusal. Of late, in the attempt to gain institutional visibility and legitimacy on the one hand and to fight the multiple social disasters connected to AIDS on the other hand, queer theory has located itself in a strategic alliance with feminist thought. In the process, queer theory has found it necessary to reproduce both the narratives of feminist authority and feminist divestiture, borrowing from feminism a theory of sociality centering on gender and sexual difference while attempting to articulate a uniquely queer epistemological framework sufficiently different from feminism. In the still emerging moment of visibility and identity, but more importantly in the moment of trying to intervene into a conjunctural crisis that threatens both the gendered and queer bodies, what is possibly more important for queer theory than learning how to practice strategic cooperation, temporary retreat, cross-identification, appropriation, compromise, and refusal?

QUEER RISING AND THE QUESTION OF HISTORICITY

In the following, I would like to focus a bit on the recent flurry of debate about just how to negotiate the politics of affinity between feminism and queer theory, in order to reconsider the debate's epistemological and political ties with the AIDS crisis. Far from being a historical accident, the AIDS crisis in fact produces anew the dialectics of awkwardness between sex and sexuality, feminism and queer theory.

It is by now common to point to and appropriate Eve Sedgwick's *Epistemology of the Closet* (1990) as one of the central texts with which to construct queer theory and gay and lesbian studies together as a unique and coherent intellectual and political project. There is no reason to believe that only gay and lesbian studies and queer theory can benefit from Sedgwick's work, even as the locus of her inquiry turns on those specific questions that generate and regulate the gay, lesbian, and queer subjects. Never before has the articulation of an anti-homophobic theory and practice been so elegant, yet so contentious. Sedgwick's sweeping polemical claim in the book—that "many of the major nodes of thought and knowledge in twentieth-century Western culture as a whole are structured—indeed, fractured—by a chronic, now endemic crisis of homo/heterosexual definition, *indicatively male*, dating from the end of the nineteenth century" (1; emphasis added)—has moved the locus of her inquiry of knowledge toward gay male sexuality, and marked her antihomophobic project with that indicative maleness. As such, the appropriation (over-

appropriation?) of *Epistemology of the Closet* by gay, lesbian, and queer schol-
ars requires us to recognize and wrestle with the effects of an emerging queer
theory framed by "gay male sexuality." Leaving aside for the moment the de-
gree of political efficacy achievable by a feminist woman devoting her energy
to exploring gay male subjectivity, Sedgwick's call for a serious attention to
gay male sexuality marks a new opening for a dialogue about how we could
talk about the possibility of meshing gender and sexuality. This is also a dia-
logue about the limits of thinking them together. All the while, this opening,
this book, was profoundly precipitated by the disquieting effects of loss and
political unrest produced by a demonized disease syndrome.

In the opening of *Epistemology*, Sedgwick makes her intentions known:

> *Epistemology of the Closet* is a feminist book.... At the many inter-
> sections where a distinctively feminist (i.e., gender-centered) and a
> distinctively antihomophobic (i.e., sexuality-centered) inquiry have
> seemed to diverge, however, this book has tried consistently to press
> on in the latter direction. I have made this choice largely because I
> see feminist analysis as being considerably more developed than gay
> male or antihomophobic analysis at present—theoretically, politi-
> cally, institutionally.... [T]hat flowering [of gay and lesbian stud-
> ies] is young, fragile, under extreme threat from both within and
> outside academic institutions, and still necessarily dependent on a
> limited pool of paradigms and readings. The viability, by now
> solidly established, of a persuasive feminist project of interpreting
> gender arrangements, oppressions, and resistances in Euro-Ameri-
> can modernism and modernity from the turn of the century has
> been a condition of the possibility of this book *but has also been
> taken as a permission or imperative to pursue a very different path
> in it.* And, indeed, when another kind of intersection has loomed—
> the choice between risking a premature and therefore foreclosing
> reintegration between feminist and gay (male) terms of analysis, on
> the one hand, and on the other hand keeping their relation open a
> little longer by deferring yet again the moment of their accountabil-
> ity to one another—I have followed the latter path. (15–16; empha-
> sis added)

I reproduce this rather long passage in order to point out that for Sedgwick the
anti-homophobic project she imagines has never left feminism behind. Her
strategic choices—to defend a vulnerable enterprise at present, to set the prior-
ity or imperative to mobilize a queer perspective from within feminist theory,
and to resist simple assimilationism—suggest that "gay male sexuality" is

being used here as a distiller through which the gender/sexuality matrix can be rethought *inside feminism,* and not as a new, totalizing center of inquiry outside of it. Never is there a suggestion of a supercession or displacement of gender by sexuality as the rising and exclusive term of analysis. Moreover, the emphatic tone with which Sedgwick expresses her authorial position hints at a certain crisis that encircles, if not defines, her focus on gay male sexuality, for it is *that* which is the very site of the crisis that beckons her project now. Working with the framework set out by Sedgwick, Michael Warner has provocatively argued that "we do not know yet what it would be like to make sexuality a primary category for social analysis—if indeed 'sexuality' is an adequate grounding concept for queer theory" (1993: xiv–xv). In other words, we cannot proceed with queer theory as if it knew what its proper object of analysis is. To pin down queer theory to a limited notion of queerness (such as sexuality outside gender) would be an obvious mistake. But the more serious error emerges from the inability to see the links between the practice of queer theory and the crisis of gay male sexuality as a historical experience. Regardless, in general terms, sexuality—whether it is grafted onto the gay male body or some other queer sites—has its potential to reframe gender through its anti-reductionism to collapse one to the other, even as the definitional thrust in queer theory endeavors to legitimize itself through rhetorical and strategic self-positioning *in* and *vis-à-vis* feminism at the same time.

We must not lose sight of the discursive and institutional forces that stigmatize gay and lesbian studies and queer theory today. At present, it appears that there have been fewer women's studies programs that embrace and integrate queer theory than gay and lesbian studies programs that are both discursively and institutionally positioned inside women's studies. Here, the question of disciplinary positionality should itself be suggestive enough to point to ideological pressures outside of both women's studies and gay and lesbian studies that mold their relative positions in the academy. The need for gay and lesbian studies programs to invent such admittedly hegemonic ideals as distinctiveness, coherence, disciplinarity, etc. in order to have a space in the academy perhaps all the more underscores the imperative to construct sexuality through and with gender, and never without it. Moreover, the historical experience of AIDS suggests that the contour of a queer theory that links itself to feminism now is perhaps most traceable around the figure of the gay male (*because* of the crisis of gay male sexuality), more so than other discursive figures. Once again, any attempt to understand the struggle over the gender/sexuality matrix, such as the one provided by Sedgwick, must take into consideration the particular social, political, and historical conjuncture to which it responds. Put in a different way, a neglect of attention to institutional hegemony and to the impact of AIDS on the particularities of gender and sexual theories today is

what propagates a dehistoricized view regarding the relationship between feminism and queer theory.

In sum, queer theory is, by definition, a mutating discourse since (a) it resists a reductionism toward sexuality as its stable center of inquiry (even as it does invest in sexuality as a guiding term of analysis) and (b) it continues to change according to historical transformations, reterritorializations, and crises. Feminism, too, has always been a mutating enterprise for largely the same reasons. Its continuous enactment and reenactment of a gender-based political discourse, as we may recall, arose as a series of conjunctural responses to different historical and political needs. (Note: The feminist interventions into Marxism in the 1960s and postmodernism in the 1980s, to take only two such moments, signaled that gender was never theorized exclusively outside the analysis of class or the simulacra.) We may recall that one of the most profound transformations in feminism took place in the early 1980s as it heeded the call by radical sexual theorists (most notably, of course, Gayle Rubin) to rewrite the discourse of "sexual difference" to include its multiple but suppressed connections to a wide range of sexual minorities, without falling into the trap of treating sexuality as a mere derivation of gender. (The various anti-racist positions developed within feminist frameworks, which occurred around the same time, further reconfigured gender, again avoiding the trap of treating race and postcoloniality as a diversion from gender.) When Rubin urged feminists at that time to incorporate its critique of gender into "a radical theory of sex" and to develop "an autonomous theory and politics specific to sexuality" (1993: 34), she did so by marking the historical moment into which her critique intervened:

> Feminism has always been vitally interested in sex. But there have been two strains of feminist thought on the subject. One tendency has criticized the restrictions on women's sexual behavior and denounced the high costs imposed on women for being sexually active. This tradition of feminist sexual thought has called for a sexual liberation that would work for women as well as for men. The second tendency has considered sexual liberalization to be inherently a mere extension of male privilege. This tradition resonates with conservative, anti-sexual discourse. With the advent of the anti-pornography movement, it achieved temporary hegemony over feminist analysis. (28)

At that time, the reframing of feminist analysis was taken up by Rubin as she saw the need to develop a distinct theory of sexuality, a theory that could then be used to mount an opposition to the anti-pornography hegemony. This

exercise highlighted clearly the need to explore the interanimation of sex and sexuality, at a historical moment prior to the visibility and institutionalization of gay and lesbian studies and queer theory.

QUEERING FEMINISM?

In "Sexualities without Genders and Other Queer Utopias" and "Against Proper Objects," Biddy Martin (1994) and Judith Butler (1994) respectively attack a certain "wrong turn" that gay and lesbian studies and queer theory have seemed to take. They are troubled by how the current effort to develop an autonomous queer theory can obscure feminism and even make invisible a certain form of female queer identity. Martin states her objections:

> I am worried about the occasions when antifoundationalist celebra-
> tions of queerness rely on their own projections of fixity, constraint,
> or subjection onto a fixed ground, often onto feminism or the female
> body, in relation to which queer sexualities become figural, per-
> formative, playful, and fun. In the process, the female body appears
> to become its own trap, and the operations of misogyny disappear
> from view.... [L]esbian and gay work fails at times to realize its po-
> tential for reconceptualizing the complexities of identity and social
> relations, at moments when, almost in spite of itself, it at least im-
> plicitly conceives gender in negative terms, in the terms of fixity,
> miring, or subjection to the indicatively female body, with the con-
> sequence that escape from gender, usually in the form of disembodi-
> ment and always in the form of gender crossings, becomes the goal
> and the putative achievement. (1994, 104–105)

Martin's argument rightly exposes a tendency in queer theory to use analogy as a rhetorical framework for establishing its uniqueness by harnessing gender as a stable term from which to pursue its "liberation" (from stuffy feminism). Echoing and extending from Martin, Butler points out that the problem of the analogical framework employed by queer theory lies in what she calls "the chiasmic confusion [over] the constitutive ambiguity of 'sex'" (1994: 6). Butler argues that queer theory tends to arbitrarily bracket out a certain preferred sense of the concept of sex and ignore its other valences. She points out that through downplaying the theoretical ties between sex and sexual difference (which feminism has fought hard to keep) and championing those between sex and sexual excesses, parodies, and performances, queer theory forces a distinction that would help to compel an autonomous definition of itself by way of a desexualization of feminism: "the ambiguity of sex as act and identity will be

split into univocal dimensions in order to make the claim that the kind of sex that one is and the kind of sex that one *does* belong to two separate kinds of analysis: feminist and lesbian/gay, respectively" (4).

The critiques by Martin and Butler must be taken seriously. By performing its own reductionism, queer theory sometimes tends to project too easy a conception of politics that confuses queer energies with resistance, performativity with political efficacy. Yet I'd like to footnote the critiques by Martin and Butler by issuing three caveats.

First, a note about the use of metaphors. Butler hints that queer theory's compulsion to distinguish itself from feminism approximates a repudiation of feminism. In pointing out queer theory's projection of feminism as the "ground" upon which it asserts its own identity, Butler goes so far as to insinuate queer theory's uncanny act of "burying," and by implication, its unspoken wish for the death of, feminism:

> The institution of the "proper objects" [in gay and lesbian studies] takes place, as usual, through a mundane sort of violence. Indeed, we might read moments of methodological founding as pervasively anti-historical acts, beginnings which fabricate their legitimating histories through a retroactive narrative, burying complicity and division in and through the funereal figure of the "ground." (6)

Given so much discursive weight that has burdened queer theory whose recent new "beginnings" were profoundly chiselled by the AIDS epidemic and massive deaths, the charge of it inflicting a burial or funereal act in its moment of identity-formation seems rather disturbing, and the attribution of its anti-historicity rather mistaken. Here, the figure of death registers ironically a different kind of "mundane violence" on queerness, the one that the homophobic society has consistently wielded around AIDS, the one where queers are the recipients of the violence.

Second, a note on reductionism. Martin also objects to the tendency in queer theory to privilege forms of demonstrably visible cross-gender identification that would reify the practices of queerness. In thinking about queer theory's propensity to theatricalize the body and the social through visible forms of drag, indicatively performed by the gay male body, Martin detects the discursive pressures in such a performance: the pressure to set the cross-dressing or cross-identifying gay male body as the emblem of discursive (if not actual) mobility (110); the pressure to cast the woman's body (and by implication, gender and feminism in general) as undramatic or uninteresting (107); and the pressure to render lesbians invisible, particularly lesbians who "pass" by way of the practices of femme, that is, lesbians who do not display outward

visible signs of cross-gender identification (107). As a recourse to these pres-
sures, Martin suggests, "One of the goals of our analyses must be to imagine
both possibilities, one that relies on what might have been visibly, tangibly
surprising or different and one that apprehends what may not stand out"
(111). While I think Martin is right, I can't help but to find in her argument
something rather ironic: the charges rely on a manifestly reductionist frame
that fixes queer theory at the site of visible performativity: identity-in-drag. It
is true enough that a certain branch of queer theory foregrounds (gay male)
drag as a model of queer positivity and thus ignores unspectacular forms of
queer identities and "invisible" modes of cross-gender identifications. But this
argument zooms in too quickly on a single plane. Nor does this argument suc-
ceed in escaping the same projectionary logic that it claims to detect on that
specific plane of queer theory. For instance, Martin writes about the femme
lesbian who bears little or no visible marks of crossing:

> The very fact that the femme may pass implies the possibility of de-
> naturalizing heterosexuality by emphasizing the permeabilities of
> gay/straight boundaries. In a sense, the lesbian femme who can sup-
> posedly pass could be said most successfully to displace the opposi-
> tion between imitation (of straight roles) and lesbian specificity,
> since she is neither the same nor different, but both. (112)

The success of passing, according to Martin, thus rests on the ability of the les-
bian femme to be different from the other differences, namely heterosexuality,
gender mimicry, and lesbian specificity. Here, it seems that passing is recast as
a mode of practice that neither straight-imitating lesbians nor lesbian-acting
lesbians can *sufficiently* perform. If we follow Martin's logic, we will find that
her own claim that the femme lesbian is both crossing and not crossing gender
and sexual boundaries in fact troubles her celebration of femme passing as ap-
parently a more complex—and by implication, more interesting and performa-
tive—form of lesbianism. This goes to show not an analytical fault *par
excellence*, but more of a built-in analytical doublesidedness through which a
certain rhetorical fixity is bound to take place in an analytical moment point-
ing toward something and against something at the same time.

 Third, as to Martin's other charge that the privilege of queer drag recen-
ters the gay male body and gay male sexuality in queer theory, a move fraught
with the potential to once again restrict or ignore the transgressive potential of
the female body and of gender theory, I agree with her judgment but nonethe-
less feel compelled to point out that the association of gay male sexuality and
theatricality has carried a distinct discursive weight and power especially in
the history of AIDS. In various degrees and intensities, drag as a theatrical

political tool, as we have witnessed in AIDS protests, has taken the appearance of Wall Street business people, mock medical researchers, pretending power mongers, and false journalists, etc. Theatricality in AIDS activism, as Judith Butler (1993) has pointed out, also takes the form of dramatic display of queer defiance. Butler writes,

> To oppose the theatrical to the political within contemporary queer politics is, I would argue, an impossibility: the hyperbolic "performance" of death in the practice of "die-ins" and the theatrical "outness" by which queer activism disrupted the closeting distinction between public and private space have proliferated sites of politicization and AIDS awareness throughout the public realm. (232–233)

Drag is not merely a form of cross-identification across zones of gender and sexuality. It is an explicit political tool that, *because of* its theatricality, brings to light the dire need to refashion the body in crisis, biologically and sociopolitically. If queer theory seems to gravitate toward drag, then this must be understood as a moment of struggle over the crisis of gay male sexuality, not an unreflexive celebration of it.

Since queer theory was recently written in part from within a weighty atmosphere of despair over, and coping with, the crisis and (medical) demise of so many gay men, its current propensity to affirm, make visible, and even fabricate, the marks of gay maleness must itself be considered an explicitly political and historical act (which at some level is about explicitness and visibility). Insofar as gay male sexuality has reemerged as an historical point of crisis and hence a point of critical examination, and insofar as this examination must always recognize the messy multiplicity internal to the category of the gay male sexuality, then the strategic focus on gay maleness—for now—lends support for a complex cross-identification of historically driven differences, for feminism and queer theory alike.

As a whole, the debate over the gender/sexuality matrix confirms what Gayatri Spivak calls the inevitable errors of identity (and, I would add, by implication, the inevitable errors of identity politics). The slippery nature of gender and sexuality, as reflected in the slippery formations and reformations of feminism and queer theory, should not lead us to conclude that oppressions based on one's gender and sexuality liquidate in the midst of unspecifiable ambiguities. Meanwhile, my instinct is that the success of our effort to bring the inquiries of gender and sexuality together ultimately depends on our ability, at this particular institutional and discursive atmosphere, to arrive at understandings of queer theory that will address the processes of its institutional

maturation and the affordability of its institutional, territorial security within a turbulent time marked by various strands of assaults on queerness sustained by rampant homophobia and by AIDS.

Moreover, as AIDS has violently thrust the questions of gender and sexuality to their epistemological and political limits by threatening to undo desires, bodies, psyches, and socialities—a condition that in turn undoes gender and sexuality as self-standing, whole, autonomous, generalizable entities—the theories we have to describe such a condition must be able to address this atomizing process. We can take the debate raised by Martin and Butler as a point of departure for a rethinking of the epidemic that has, by corporeal damage and by discourse, dissolved universalizing conceptions of gender and sexuality. Epidemiological knowledge, for instance, is notoriously universalizing in its production of gender and sexual groupings defining risks. But by the same token, epidemiology is notoriously fragile in the face of the shifting particularities of yet unnamed gender and sexual formations. Rather than continuing to conceptualize gender and sexuality according to behavioral models being utilized in mainstream AIDS research, we may want to consider the moments, elements, traces, sites, and zones of gendered and sexual effects. We may want to consider inscriptions, distributions, flows, proliferations, interruptions, and surprises as the operations of gender and sexuality reshaped by the epidemic. In short, we may want to talk about gender, sexuality, and their interanimation as what Deleuze calls singularizing effects.

PRACTICES OF BECOMING

In the remaining part of this essay, I would like to briefly propose a Deleuzian framework for rethinking the gender/sexuality matrix in AIDS. Increasingly, the theoretical debate surrounding the intersections between social and discursive categories (gender, sexuality, race, class, nationality, etc.) has somewhat exhausted those terms of analysis. I am particularly concerned with how those terms can survive the assault of historical crises such as AIDS, breast cancer, new forms of genocide, the automation of capital, the violence of migration, and so on. Once again, I am advocating a conjunctural analysis with which the mutation and interimplication of identities can be discerned. Ultimately, the continuous debate over the multiple intersections among various domains of difference turns on our ability to think in terms that are no longer universalizing or predestined, but are mobile, temporary, organic. The increasingly normalized discourse about AIDS in the late 1990s has precipitated universalizing and predestined conceptual categories that are in turn employed to inform epidemiological research and behavioral research about the classification and formation of sexual risks. It's time we took those social discourses of

epidemiology and sexual risks down a different path.

A question immediately arises: how can we reassemble a vision of gendered and sexual networks after we articulate the collapse of universalizing, predestined paradigms of knowledge and the inefficacy of the imperative to categorize, to set essentializing boundaries? Deleuzian feminists, such as Rosi Braidotti, Elizabeth Grosz, Camilla Griggers, Moira Gatens, Elspeth Probyn, Donna Haraway, and others, have argued that subjectivity is a matter of "becoming." Before I discuss the potential for the concept of "becoming" to readdress the crisis of AIDS, I should like to recall Michel Foucault's notion of the technology of the self.

Foucault conceptualizes the technology of the self as the validation—making true—of power through its production and reproduction of the governing knowledge about the body and subjectivity. As I have argued elsewhere, for Foucault, knowledge is, in the deepest sense, practice (Erni, 1994: 116). Drawing on Foucault's "Questions of Method," I define discourse as "an aggregate of the technologies of practices (how things operate) and the rise of rationality (what cultural and historical effects of dominance the practices engender)" (117). The technology of the self—assembled through the practices of, for instance, biomedical or legal discourses—thus reinforces governmentalist rationality that, in turn, validates those practices as true, normal, commonsensical, good. As Teresa de Lauretis (1987) and scores of other feminists have argued, gender and queerness can be conceived as technologies of the self. In this context, the effort of biomedicine and behavioral research to define AIDS—from epidemiology to safe sex advice—must be seen as the effort to reproduce conceptions of gender and sexuality that can then be validated as truth. Within this totalizing technology, the practices of "deviant" gender and sexuality—such as lesbians who have sex with men, men who have sex with each other but do not consider themselves gay, men and women who have sex with the other gender but do not unequivocally define themselves as heterosexual or gay or bisexual, individuals who have differing HIV serostatus having sex with each other, queers who become biological parents either through sexual intercourse, surrogacy, or fertilization through technologies, to name only a few[4]—fall outside of medical "truth" and are relegated as incomprehensible, exceptional, or phantom phenomena. Once placed outside of normalizing "truth," these deviant practices refracted through the lenses of gender and sexuality disappear from epidemiological surveillance and safe sex materials. By now, readers may be quite familiar with these problematic, if not deadly, definitions of "true" gender and sexuality in the epidemic. Within the context of this epidemic, the normalizing technologies of gender and queerness promote social and intellectual practices that ironically fail to apprehend real zones of risk.

Take, for instance, safe sex as a set of knowledge that is impacted by conceptions of gender and sexuality (and other non-gender-specific and non-sex-specific practices). Activists have long argued that the canonical approach to safe sex promoted by behavioral and clinical researchers depends on conceptions of risk that bond types of risky behavior and classes of "risky identities" into imagined correspondences. But even the activists' effort to disarticulate the two never moves away from the canonical zone, whether in the conception of the loci of risk (i.e., bodily fluids, certain modes of sexual practices) or in the conception of prevention (i.e., the use of condom, dental dam, and gloves). Yet, exerting pressure on the system called "safe sex," we see that it includes the following components, many of which are distinctly marked by gender and sexual differences:

a. generational differences and their implied sociopsychological states (e.g., recklessness, "wish for immortality," maturity, responsibility);

b. individual and social definitions of what constitutes eroticism in sex;

c. the degree of safe sex across relational zones (e.g., one-night stands, open relationships, committed relationships);

d. the shifts of degree of safe sex over time in those forms of relationships;

e. impact of alcoholic and narcotic influences (and the gender implications in the moment of sexual negotiation under those influences);

f. locations of sex (and their implied seduction of dare offered by the locales);

g. impact of new treatment options to prolong lives on various populations (e.g., how do lesbians and gay men differ in their respective negotiation between the benefits provided by the new protease inhibitor combination therapy and the meaning about the consequences of safe sex practices?);

h. all of the human indignities of low self-motivation, confusion, impatience, and various psychological tendencies couched in the name of love, or in the name of jealousy, spite, disappointment;

i. differences in all of the above across cultures, races, and classes (each imbued by their pressures of gender and sexual conformities).

I hope the enumeration above does more than complicating the picture of safe sex, more than pointing out the imperfections brought by human frailties. In

any event, at whichever level of understanding—socially, psychologically, privately, ideologically—the practices of safe sex must be continued, including what I have called the canonical approach. Yet, precisely for *that* reason, the imploding disjunction between promoted understanding of safe sex and the striking forms of differences surrounding it, and the fact that the disjunction is consistently glossed over, are dimensions that must be incorporated into safe sex education.

Furthermore, one of the ways of understanding the intricacies of the self is to consider the process by which the discursive technologies of the self replicate for the continuous maintenance of truth-making. The repetition of those technologies and the norm that governs the repetition has led Judith Butler to propose a theory of "performativity." Drawing on Foucault and speech-act theories, Butler reinforces Foucault's notion of the materiality of bodies and subjectivities by adding to it an emphasis on the processual and enunciative nature of materialization. She proposes "a return to the notion of matter, not as site or surface, but as a process of materialization that stabilizes over time to produce the effect of boundary, fixity, and surface we call matter. . . . Construction not only takes place *in* time, but is itself a temporal process which operates through the reiteration of norms" (1993, 9–10). She argues that one acquires subjectivity through reiteration and the temporal logic that governs it. But through the same process, one's subjectivity can be challenged, even destabilized. The difference depends on the citability of norms and conventions (10). In other words, the conceit to repeatedly cite existing orders, laws, conventions, and norms in order to sustain authority may in fact reveal their constructedness and open up gaps and fissures of identity precisely during the reiteration process. Butler describes those gaps and fissures as "the constitutive instabilities in [the] constructions, as that which escapes or exceeds the norm, as that which cannot be wholly defined or fixed by the repetitive labor of that norm" (10). Accordingly, every identity is constituted by discursive formation as much as by deformation (229).

An important point in Butler's framework is that the key to subjecthood lies in the sedimenting effects of discursive repetition. Butler elaborates:

> If a performance provisionally succeeds (and I will suggest that "success" is always and only provisional), then it is not because an intention successfully governs the action of speech, but only because that action echoes prior actions, and *accumulates the force of authority through the repetition or citation of a prior, authoritative set of practices.* What this means, then, is that a performance "works" to the extent that *it draws on and covers over* the constitutive conventions by which it is mobilized. In this sense, no term or statement

can function performatively without the accumulating and dissimu-
lating historicity of force. (1993, 227)

In this way, "I" (as gendered, sexed, racial, national, etc.) acquire my identity
through the dialectical interplay of additive as well as subtracting effects in my
citations of norms.

Curiously, this is a remarkably cogent description of the knowledge
known as "serostatus" in AIDS (and other similar immunity-related diseases).
The "I" in the determination of HIV serostatus—as in "I am positive"; "I am
negative"—appears to be a continuous act of enunciation through citing test
results generated from medically authoritative knowledge. Yet before another
test, this "I" acquires (or wishes to acquire) certainty through the accumula-
tive enunciation of that originary citation of authority, so much so that odd
proclamations can be imagined about one's identity regarding serostatus, such
as "I *am* negative three months ago." As the months go by, that certainty
achieved through accumulative citations begins to wear down, subtracting
from it the authority that once constituted the "I." Even then, a revised enun-
ciation such as "I used to be negative three months ago" continues the act of
citational repetition, even as the force of it has weakened. By contrast, the
enunciations "I don't know," "May be," or "Not quite" represent the escape
from, if not the end of, citationality; under these terms, the serostatus ceases
its performativity.

I belabor to delineate these possible enunciations in order to present the
case that the assumption of accumulation/dissimulation in Butler's theory of
performativity suggests rather linear lines through which identity is consti-
tuted and governed. I want to suggest that the theory of performativity is lim-
iting its own radical politics by prescribing its key operation—that is,
citationality—only as a process along the figurative lines of up and down, and
never multidirectional (as perhaps suggested in the enunciation of "I don't
know," "May be," and "Not quite"). At every interval between tests, one's def-
inition and proclamation of one's serostatus move and intensify across spaces
that may go against the grain of accumulative or dissimulative repetitions.

I suggest that the instances of "may be" and "not quite" can be treated
more broadly as a path of identity formation that can take the theory of per-
formativity further. It can do so by addressing those moments of performance
of the self that are intense but not necessarily accumulative, energetic but not
always constitutive, encountering but not formative, connecting but not con-
gealing. But always consequential.

Deleuze's concept of "becoming," especially as it is adopted by feminists,
including queer feminists, provides a supplementary model to that of per-

formativity. In *A Thousand Plateaus*, Deleuze and Guattari speak about "becoming" in this way:

> For us. . . . there are as many sexes as there are terms in symbiosis, as many differences as elements contributing to a process of contagion. We know that many beings pass between a man and a woman; they come from different worlds, are born on the wind, form rhizomes around roots; they cannot be understood in terms of production, only in terms of becoming. (cited in Braidotti, 1994, 111)

This figurative language provides not only the vehicle with which to describe the notion of becoming and its radical potential for reconfiguring the self. Calling it "a materialist, high-tech brand of vitalism," Rosi Braidotti stresses that "becoming" represents a radical theory of difference, in which difference is imbued with a generative positivity capable of social transformation. Gender, as seen in the passage above, does not refer to empirical man or woman. Rather, gender refers to a network of symbolic and material planes that precipitates around and produces gendered forms of self and sociality. Already, this way of conceptualizing gender blends its contours with other social axes of difference, such as gay, lesbian, queer, subaltern, dark skin, fair skin, postcolonial, and so forth. Each form of difference is always capable of refiguring difference, because each difference is an emerging figure, becoming different.

For Braidotti, the connection between refiguration and becoming within the Deleuzian framework is particularly useful for feminism. As she points out, "Deleuze shares with feminism a concern for the urgency, the necessity to redefine, re-figure and re-invent theoretical practice, and philosophy with it, in a reactive/sedentary mode" (100). Feminist refigurations of "woman" have taken many forms, with varying degrees of theoretical abstractions, such as Teresa de Lauretis's (1990) figure of the "eccentric subject," Donna Haraway's (1985) "cyborg," Luce Irigaray's (1985) "two lips," Alice Jardine's (1985) "gynesis," Camilla Griggers's (1996) figuration of the "becoming-woman" in technological spaces, Rosi Braidotti's (1994) "nomadic subject," Elspeth Probyn's (1996) "outside belongings," and Elizabeth Grosz's (1994) lesbian volatility as a figure of intensities and flows. All of these feminist figurations represent defiant feminist plenitude. Not all of them draw on the Deleuzian framework, but they share the desire to re-invent gender and sexuality. Far from advocating a complete dissolution of all identities into a meaningless flux, they in fact rewrite gender and sexuality by tracing their multiple specificities in material contexts, such as in scientific technologies, at the scene of writing, in cityscapes, or in the transnational sphere.

In the context of AIDS, this radical theoretical practice to refigure gender and sexuality can open up a path of understanding that has been consistently, if not fatally, ignored. "Queer," for instance, is itself a figuration expressing constantly transforming, slippery modes of being. Taken as a mode of analysis (rather than a reference to empirical queers), queer delineates lines of becoming with varying affects, surprises, and breaks. In a theoretical sense, the varying modes of "becoming-queer"—as opposed to "being queer"—have been an important resource for coping with the material realities of the epidemic. In fact, we have learned a few things about becoming-queer throughout the course of this epidemic. For instance, has queer professionalism not been a perverted form of cameleonic existence inside the halls of bureaucracies and professional institutions that often plot against queers? (Witness, once again, the infiltration of queers into Wall Street, medical labs, and newspaper offices in order to create change from within.) Is queer humor not an attempt to resignify the tragedy and trauma felt by the sexual persecution of gays and lesbians? Is silence not a highly motivated and intense form of mourning, even as we simultaneously chant "silence = death"?[5] Was not queer "promiscuity," something demonized by everyone as the locus of queer death, not a resource for inventing the very discourse of safe sex in the early 1980s?[6]

Becoming queer is thus the process of perverse refiguration of lives, texts, desires, institutions, behaviors, and various ways of being in the world, so that the transformation is continuous, specific, provisional, something not easily made stable. Rosi Braidotti approximates this kind of refiguration with the phrase "as if." The practice of "as if" registers those "untidy" surpluses of experiences. Like the enunciation of "may be" and "not quite," the practice of "as if" activates a stream of mobile bodies, affects, and signifiers, setting them into the orbit that surrounds closely connected zones of differences. It is "as if" gender, sexuality, race, postcoloniality, and class were evocative of one another, allowing us to flow from one zone of specificity to another in varying intensities. Braidotti refers to this kind of fluidity within the imaginary of "nomadic" refiguration as "emphatic proximity, intensive interconnectedness" (1994, 5).

The Deleuzian theory of becoming refined by feminists and queer theorists thus enables a perspective regarding the practice of performativity as something that "adds to" without "adding up" (Probyn 1994, 4–6). The mode of becoming shatters the desire for depth and authenticity that even social constructionism clings to. Instead, it proposes that what identity you have depends not on the sedimenting effects of forming roots in a given sociality, but on how, where, and when the intensities and flows of performativity (through repetition and citationality) are spread out, distributed, routed, and rerouted. In AIDS, could it be that the supposedly incomprehensible routes of viral

transmission that cannot be explained under the existing epidemiological taxonomy, or the reemergence of "high risk" sexual behavior[7] are moments of "discontinuous becoming" (Braidotti's term)?

What are the consequences for thinking in this way? If altering the discourse can lead to doing things differently, what difference will it make when we include unnamed and unstable forms of desire and identity in epidemiological surveillance practices? How do we develop new ways of talking and doing safe sex by acknowledging and accounting for the various forms of being sexual? The notions of "as if" and "becoming" may be too evocative, too abstract, and too risky in our effort to find a way to reconceptualize the reality of AIDS. But avoiding thinking in a different way about how uncharted desires and unclassifiable identities are linked to the possibility of infection is more risky, because it leaves the dominant pedagogy of safe sex uncontested. Avoidance also signals a detrimental notion that the reimagination of gender and sexual networks—a task long recognized by scholars and activists to be important for surviving the AIDS crisis—is frivolous or unreal to people who live their lives not yet signifiable in epidemiological knowledge or safe sex guidelines. The need to grapple with these alternative forms of desires, identities, and behaviors, and to mobilize a different discourse to address them, should begin with a more complex, more radical political understanding of what Cindy Patton (1996) calls the "ob-scenity" of gender and sexuality:

> As a contemporary political idea. . . . ob-scenity is the abjected, the meaningless, the thing that does not try to recover meaning but tries to secure the space *prior to visibility*, prior to information. . . . Ob-scenity is a kind of palpable presence that is not so much invisible as it is detectable only on a different, potentially more disturbing, more *radical* level as a more deeply embodied volume. (141; emphasis hers)

Thus, whereas it is important to continue developing effective epidemiological and pedagogical practices for those already describable clinical-behavioral matrices in identifiable populations—identified, that is, in existing, visible information—it is equally important to recognize gender and sexual networks that exist most *realistically* in their particularities of context, style, and pleasure. To echo Eve Sedgwick (1993), we need to pay close attention to those spaces and times where things may be relentlessly "untidy," simply because their rules of emergence exceed social norms. Instead of dismissing those things as irrelevant, exceptional, or crazy, we—as educators, medical professionals, and activists—ought to see them as a fertile ground for reconstructing

the definitions of AIDS within the dominant discourses. At a time when those definitions are dangerously being normalized, the practice of "as if," of paying attention to discontinuous becoming, of nurturing emphatic proximity between interconnecting zones of identities, may just help us generate a different strategy of knowing each other. And surviving.

CONCLUSION

Increasingly, it is conceptually necessary for us to think about the gender/sexuality matrix and other axes of difference not in terms of model, framework, or even theory, but in terms of operations/operationality. Ideas and identities are actual and actualizing entities; their existence depends on how, where, and when they operationalize (walk, move, poach, make do, rebel) along existing vectors of power and thus generate certain social and discursive effects. These effects may appear at the ideological, cognitive, bodily, affective, or a combination of some or all of these levels. These effects may not be permanent, root-taking, authentic, grounded, or deep. But nor are they without consequences. Most importantly, no identities or ensemble of identities operate in a vacuum; they always register and are registered by context, conjuncture, history.

This leads me to think of habits. I wonder whether habits operationalize identity. Habits are unconsciously enacted performances that take place at the level of the everyday (Wise, 1996). They are tendencies or lines of doing or undoing things through repetition. Habits are embodied practices: they may reside in the emotional domain (e.g., the habits of love), the physiological or motor domain (e.g., the habits of driving), the psychological domain (e.g., the habits of identification), or the ideological domain (e.g., the habits related to voting). But they cannot be predetermined by any of these domains. They are best understood in terms of what they perform, the linkages they make (between and across other habits and other non-habitual performances), the changes they undergo, the capacity with which they replicate over space and time. Such operations do not so much accumulate into a structure of everyday life; rather, they specify the movements of everyday experience. In Deleuzian terms, habits are singularizing operations.

Through spatial and temporal repetitions, habitual practices take on an important dimension in our everyday life. In fact, some habits become an integral part of life at specific personal and social junctions, such as in the context of AIDS, the habits of safe sex, of taking medication according to specific schedules, of reading the science page in the newspaper, of reading the obituary page in the newspaper, of attending fund-raising events, of attending funerals, of mourning.

But anyone can realize that habits are formed, and can be changed. They

are not binding operations. Rather, they move on the surface of the everyday. They may even fade over time. In other words, the intensity with which habits are enacted may change, and the desire they generate may break, thus altering the specific shape and mood of the everyday, but without reconstituting it. The untotalizing character of habits signals a kind of regulated fluidity, a kind of becoming. In Deleuzian parlance, habits are a desiring machine, or a connection of desiring machines. They flow through the body and the social world in a continuum of unceasing production. Put differently, the performativity of habits gives everyday life a certain provisional routine and shape through linking our bodies (i.e., the enunciator of habits) and the world (what Pierre Bourdieu [1972] calls the "habitus") and back. The term "rehab" thus typically refers to the attempt to re-perform habits after the habitual connection between the body and the world is disrupted or severed. This in part explains the positivity of habits as an affirmative force.

I wonder whether we may begin to rethink gender, sexuality, race, class, and nationality as intertwining, singularizing habits. I want to suggest the possibility of thinking those zones as operations of (dis)continuous becoming akin to the matter of habits, of talking about gender, sexuality, etc. as not something we are, *but something we do concretely, relationally, provisionally.* Is it not possible to discern the enactment of the self through the habitual performativity of actions, texts, lines of movement, intensities of belongingness? Thinking of identities in terms of habits avoids the disillusionment of a completely knowable, always consistent, contradiction-free self. More importantly, it opens up new possibilities of refiguring the self and forging a redefinition of sociality. It is this energetic possibility toward refiguration that we must strive for, at a time when an expansive pandemic has erupted the world over and forced a powerful search of new ways of becoming.

NOTES

1. The burgeoning work that examines the crossings between gender, sexuality, race, class, nationality, and so on are too numerous to be enumerated here. Some of the work that explores the connections between sexuality and other domains of identity, however, immediately comes to mind. See, for instance, Andrew Parker, Mary Russo, and Patricia Yaeger, eds., *Nationalisms and Sexualities* (New York: Routledge, 1992); Henry Abelove, Michèle Aina Barale, and David M. Halperin, eds., *The Lesbian and Gay Studies Reader* (New York: Routledge, 1993); Bad Object Choice, *How Do I Look?* (Seattle: Bay Press, 1991); Judith Butler and Biddy Martin, eds., *Diacritics* (a special issue on "Critical Crossings"), vol. 24, no. 2–3 (Summer-Fall 1994).

2. See Douglas Crimp, "Right on, girlfriend!," in *Fear of a Queer Planet: Queer Politics and Social Theory,* ed. Michael Warner, 300–320.

3. For the works that reconceptualize lesbian criticism, see Julia Creet, "Daughter of the Movement: The Psychodynamics of Lesbian S/M Fantasy," *Differences*, vol. 3, no. 2 (Summer 1991): 135–159; Lisa Henderson, "Lesbian Pornography: Cultural Transgression and Sexual Demystification," in *New Lesbian Criticism: Literary and Cultural Readings*, ed. Sally Munt, 173–191; Bonnie Zimmerman, "Lesbians like This and That: Some Notes on Lesbian Criticism for the Nineties," in *New Lesbian Criticism: Literary and Cultural Readings*, ed. Munt, 1–16.

4. The discussions about multiple, non-conforming, or simply surprising sexual practices linked to sexual identities not easily classified under the dominant sexual taxonomy (homosexual, heterosexual) or discourses of family have emerged in recent years. For example, Cindy Patton's *Last Served?* (London: Taylor & Francis, 1994) has a strong critique of the conception of risk applied to women. Various forms of lesbian and straight women's sexuality, particularly lesbian motherhood, that have consistently been ignored by policy-makers and researchers are also discussed in ACT UP/NY Women & AIDS Book Group, *Women, AIDS & Activism* (Boston: South End Press, 1990). The question about the non-correspondence in male sexuality between their sexual practices, sexual object-choices, and sexual identification is explored by anthropologists Ana Maria Alonso and Maria Teresa Koreck, "Silences: 'Hispanics,' AIDS, and sexual practices," in *The Lesbian and Gay Studies Reader*, ed. Abelove, Barale, and Halperin, 110–126. See also Tomas Almaguer, "Chicano Men: A Cartography of Homosexual Identity and Behavior," *Differences*, vol. 3, no. 2 (Summer 1991): 75–100. Finally, for a discussion of the psychological realities of individuals who have sexual relations across HIV serostatuses, see Walt Odets, *In the Shadow of the Epidemic* (Durham, North Carolina: Duke University Press, 1995).

5. See Douglas Crimp, "Mourning and Militancy," *October*, vol. 51 (1989): 3–18.

6. See Cindy Patton, *Sex and Germ: The Politics of AIDS* (Boston: South End Press, 1985).

7. For a coverage of the story of "relapse" of unsafe sexual practices among young gay and bisexual men in San Francisco reported in the early 1990s, see Victoria A. Brownworth, "Teen Sex: America's Worst-Kept Secret," *The Advocate*, issue 599 (March 1992), and Adam Pertman, "Unsafe Sex Resurging among Young Gay Males," *Boston Globe* (April 18, 1994): 23+. For general discussions about young adults and safe sex issues, see Dominic Abrams, et al., "AIDS Invulnerability: Relationships, Sexual Behavior and Attitudes among 16–19 Year Olds," in *AIDS: Individual, Cultural and Policy Dimensions*, ed. Peter Aggelton, et al.

WORKS CITED

Abelove, Henry, Michèle Aina Barale, and David M. Halperin, eds. *The Lesbian and Gay Studies Reader.* New York: Routledge, 1993.

ACT UP/NY Women & AIDS Book Group. *Women, AIDS & Activism.* Boston: South End Press, 1990.

Abrams, Dominic, Charles Abraham, Russell Spears, and Deborah Marks. "AIDS Invulnerability: Relationships, Sexual Behavior and Attitudes among 16–19 Year Olds." In *AIDS: Individual, Cultural and Policy Dimensions,* ed. Peter Aggelton, Peter Davies, and Graham Hart. Bristol, Penn.: Falmer Press, 1990.

Almaguer, Tomás. "Chicano Men: A Cartography of Homosexual Identity and Behavior," *Differences,* vol. 3, no. 2 (Summer 1991): 75–100.

Alonso, Ana Maria and Maria Teresa Koreck. "Silences: 'Hispanics,' AIDS, and Sexual Practices." In *The Lesbian and Gay Studies Reader,* ed. Henry Abelove, Michèle Aina Barale, and David M. Halperin, 110–126. New York: Routledge, 1993.

Bad Object-Choices, ed. *How Do I Look? Queer Film and Video.* Seattle: Bay Press, 1991.

Bourdieu, Pierre. *Outline for a Theory of Practice.* Cambridge: Cambridge University Press, 1972.

Braidotti, Rosi. *Nomadic Subjects: Embodiment and Sexual Difference in Contemporary Feminist Theory.* New York: Columbia University Press, 1994.

Brownworth, Victoria A. "Teen Sex: America's Worst-Kept Secret," *The Advocate,* issue 599 (March 1992).

Butler, Judith. *Bodies That Matter: On the Discursive Limits of "Sex".* New York: Routledge, 1993.

———. "Against Proper Objects," *Differences* (Special Issue: More Gender Trouble: Feminism meets Queer Theory), vol. 6, no. 2–3 (Summer-Fall 1994): 1–26.

Butler, Judith and Biddy Martin, eds. A special issue on "Critical Crossings," *Diacritics,* vol. 24, no. 2–3 (Summer-Fall 1994).

Creet, Julia. "Daughter of the movement: The Psychodynamics of Lesbian S/M Fantasy," *Differences,* vol. 3, no. 2 (Summer 1991): 135–159.

Crimp, Douglas. "Mourning and Militancy," *October,* no. 51(1989): 3–18.

———. "Right on, girlfriend!" In *Fear of a Queer Planet: Queer Politics and Social Theory,* ed. Michael Warner, 300–320. Minneapolis: University of Minnesota Press, 1993.

de Lauretis, Teresa. *Technologies of Gender.* Bloomington: Indiana University Press, 1987.

———. "Eccentric Subjects: Feminist Theory and Historical Consciousness," *Feminist Studies,* vol. 16, no. 1 (Spring 1990): 115–150.

Deleuze, Gilles and Felix Guattari. *A Thousand Plateaus: Capitalism and Schizophrenia.* Translated by Brian Massumi. Minneapolis: University of Minnesota Press, 1987.

Erni, John Nguyet. *Unstable Frontiers: Technomedicine and the Cultural Politics of "Curing" AIDS.* Minneapolis: University of Minnesota Press, 1994.

Griggers, Camilla. *Becoming-Woman*. Minneapolis: University of Minnesota Press, 1996.

Grossberg, Lawrence. "Cultural Studies in/of New Worlds," *Critical Studies in Mass Communication*, no. 10 (1993): 1–22.

Grosz, Elizabeth. *Volatile Bodies: Toward a Corporeal Feminism*. Australia: Allen & Unwin, 1994.

Haraway, Donna. "A Manifesto for Cyborgs," *Socialist Review*, no. 80 (1985): 65–107.

Henderson, Lisa. "Lesbian Pornography: Cultural Transgression and Sexual Demystification." In *New Lesbian Criticism: Literary and Cultural Readings*, ed. Sally Munt, 173–191. New York: Columbia University Press, 1992.

Irigaray, Luce. *This Sex Which is Not One*. Translated by Catherine Porter with Carolyn Burke. Ithaca, NY: Cornell University Press, 1985.

Jardine, Alice. *Gynesis: Configurations of Woman and Modernity*. Ithaca, NY: Cornell University Press, 1985.

Laclau, Ernesto and Chantal Mouffe. *Hegemony and Socialist Strategy*. London: Verso, 1985.

Martin, Biddy. "Sexualities without Genders and Other Queer Utopias," *Diacritics*, vol. 24, no. 2–3 (Summer-Fall 1994): 104–121.

Odets, Walt. *In the Shadow of the Epidemic: Being HIV-negative in the Age of AIDS*. Durham, North Carolina: Duke University Press, 1995.

Parker, Andrew, Mary Russo, Doris Sommer, and Patricia Yaeger, eds. *Nationalisms and Sexualities*. New York: Routledge, 1992.

Patton, Cindy. *Sex and Germ: The Politics of AIDS*. Boston: South End Press, 1985.

———. *Last Served? Gendering the HIV Pandemic*. London: Taylor & Francis, 1994.

———. *Fatal Advice: How Safe-sex Education Went Wrong*. Durham, North Carolina: Duke University Press, 1996.

Pertman, Adam . "Unsafe Sex Resurging among Young Gay Males," *Boston Globe* (April 18, 1994): p. 23+.

Probyn, Elspeth. *"Love in a Cold Climate"*: *Queer Belongings in Quebec*. Montreal: GRECC, 1994.

———. *Outside Belongings*. New York: Routledge, 1996.

Rubin, Gayle. "Thinking Sex: Notes for a Radical Theory of the Politics of Sexuality." In *The Lesbian and Gay Studies Reader*, edited by Henry Abelove, Michèle Aina Barale, and David M. Halperin, 3–44. New York: Routledge, 1993.

Sedgwick, Eve Kosofsky. *Epistemology of the Closet*. Berkeley: University of California Press, 1990.

———. *Tendencies*. Durham, North Carolina: Duke University Press, 1993.

Warner, Michael. "Introduction." In *Fear of a Queer Planet: Queer Politics and Social Theory*, ed. Michael Warner, vii–xxxi. Minneapolis: University of Minnesota Press, 1993.

Wise, J. Macgregor. "Technology: Habit, Memory, Space." Paper presented at the International Communication Association Annual Conference, Chicago, May 1996.

Zimmerman, Bonnie. "Lesbians like This and That: Some Notes on Lesbian Criticism for the Nineties." In *New Lesbian Criticism: Literary and Cultural Readings*, ed. Sally Munt, 1–16. New York: Columbia University Press,

Gendered Abjection

Prevention—
Policy and Practice

Constituting the "Clean and Proper" Body
Convergences between Abjection and AIDS

Karen Zivi

INTRODUCTION

On December 1, 1995, President Clinton gave a World AIDS Day address entitled "Shared Rights, Shared Responsibilities." In this speech he called on United States citizens to stand together in the struggle to end the ignorance and prejudice surrounding HIV/AIDS, to end the persecution and discrimination of those living with HIV. His words echoed the sentiments expressed by the National Commission on AIDS in their final report of 1993. There the Commission, like President Clinton, identified fear, ignorance, and prejudice as having marked and marred America's response to the AIDS epidemic. According to the Commission, our society's "unreasoning fear and cruel indifference" had made the AIDS epidemic an "expanding tragedy" characterized by unheeded recommendations, inadequate funding, and avoidable and unnecessary deaths.[1]

Though the ideas of the President and the National Commission are not new, they continue to have great significance and import as we move further into the second decade of the epidemic. Despite highly praised advances in AIDS drug therapies, both cure and vaccine continue to elude us—making AIDS the second-leading cause of death among individuals in the United States between the

ages of 25 and 44.[2] And despite progress in some areas of AIDS policy and treatment of individuals living with HIV/AIDS, the trends identified by the National Commission—fear, prejudice, ignorance, and inappropriate policies—continue to be with us today in our public policies, media representations, and public discourse.[3] That is, concerns about what is moral or immoral, natural or not natural continue to inform a variety of policies responses, often stigmatizing HIV-infected individuals. In 1995, homophobic Senator Jesse Helms threatened the reauthorization of the Ryan White Comprehensive AIDS Resources Emergency (CARE) Act by urging Congress to reduce the amount of Federal money spent on AIDS, a "gay man's" disease spread through "deliberate, disgusting, and revolting conduct." [4] Though this particular campaign was unsuccessful, Senator Helms was instrumental in drafting an amendment prohibiting the distribution of Federal funds to AIDS programs which are found to "promote or encourage" drug use or sexual activity.[5]

Around the same time, arguing that HIV-positive individuals were compromising combat readiness and taking jobs and money away from "healthy" individuals, Congress attempted to amend the military funding bill to require that all HIV-positive military personnel be discharged. This was proposed despite opposition from the Defense Department and evidence that HIV infection neither compromises combat readiness nor proves to be a burdensome medical expense.[6] Concerned about the impropriety of promoting illegal drug use, the Federal Government continues to prohibit the use of Federal funds to support needle exchange programs. This despite the National Academy of Sciences' research findings which recommend the implementation of such programs to reduce HIV transmission among injection drug users.[7] And despite the U.S. Public Health Services guidelines, supported by the American Academy of Pediatrics and the American College of Obstetrics and Gynecology, recommending that HIV testing of pregnant women and newborns be voluntary, not mandatory, their concern about "neglected" and "innocent" babies has led Congress to amend the Ryan White CARE Act. The new "Provisions Concerning Pregnancy and Perinatal Transmission of HIV" uses language which some public health officials and women's health advocates believe encourages and may even compel states to impose mandatory testing on pregnant women and newborns.[8]

While these are not the only AIDS policies debated in recent years they are some of the most familiar and controversial. The discourse around the policies and the policies themselves suggest that it is important to continue questioning the motivations behind and implications of such practices. But how are we to understand the continuance of fear, ignorance, stigma, and unheeded recommendations evident here? What logic underlies the epidemic and

our responses to it? What is at stake in these practices that make them so controversial? As Christine Overall has suggested, understanding the logic of the epidemic requires:

> an awareness of the social and political dimensions of HIV infection; the cultural construction of AIDS language, images, and representations; the pervasive effects of racism and homophobia; the scapegoating and marginalization of groups such as gays, prostitutes, and intravenous drug users; the oppression of women; the power and authority of the medical and scientific establishment.[9]

So to, I suggest here, does it require an awareness of the psychic dimensions of the epidemic; an awareness of the relationship between a sense of individual and collective identity and our response to the epidemic. Understanding the logic of the psyche, as Kelly Oliver argues, sheds light on the logic of the social relation and opens up the possibility of renegotiating these social relations.[10] Thus in order to understand what these policies and practices both provide and cost us as a nation, to unravel the "logic" of the AIDS epidemic, I turn to the work of psychoanalyst Julia Kristeva and, in particular, her theory of abjection. I use Kristeva's theory of abjection, a theory of the constitution of subjectivity and sociality, of identity and social order, to examine our society's response to the epidemic and to suggest that in our society today, AIDS is our abject, AIDS policy and discourse part of our rituals of abjection.

In her work, *Powers of Horror: An Essay on Abjection*, (written in French and first printed in English in 1982), Kristeva identifies abjection as a universal process in and through which subjectivity, identity, and social order are constituted. In other words, abjection is a process through which we create individual, social, and political order.[11] It is a process by which we demarcate self from other on a personal and collective level, a process which begins in the realm of the psyche, but, according to Kristeva, is most often known through its secondary manifestations—the exclusionary rituals (incest taboo, dietary laws, even writing) by which we bring order and stability to our society.[12] The process, she argues, involves at least three stages: 1) the identification or coding of that which is threatening to order (the abject); 2) mechanisms for separations and divisions that function to jettison the abject (abjection); and 3) the production of a realm of beings or "objects" which are abased (abjected).[13] It is in and through these kinds of exclusionary rituals, practices which jettison that which "disturbs identity, system, order" (often associated with filth, waste, decay, disease), that both social order and individual identity—the "clean and proper body"—are produced.

Despite its universality, abjection does, according to Kristeva, vary across time and space "assuming specific shapes and different codings according to . . . various 'symbolic systems.'"[14] I suggest, then, that AIDS represents the historical enactment of abjection in the late twentieth century. Kristeva's work on the structure and process of abjection thus anticipates the logic of the AIDS epidemic: its central fears, its mechanisms of separation and exclusion, its concerns with fixing identity (be it sexual, gender, race, or class identity). That is, the logic of the epidemic coincides or converges with the logic of abjection. My analysis of AIDS discourse (policies and cultural narratives) will reveal that which AIDS shares with other historical manifestations of abjection: central fears of contagion, pollution, and disorder; exclusionary rituals and practices, prohibitions and policies which simultaneously produce and jettison the abject, that "not-yet-object" which is threatening to order;[15] and the production of a "domain of abject being," those who are cast off or marginalized.[16] To investigate AIDS as the abject is then to explore the fragile grounds of identity and social order in the age of AIDS. It is also to suggest the ways in which the abject, never wholly eliminated, comes back to haunt and threaten these practices. I therefore use Kristeva's theory of abjection to reveal AIDS as the abject—as that which is simultaneously threatening to and constitutive of social order, of subjectivity and sociality. To begin this investigation, then, I start where Kristeva herself starts, with the theory of abjection itself.

A THEORY OF ABJECTION

As already mentioned abjection is a process of excluding that which threatens individual and social order. It is the process of separation from that which appears threatening—filth, waste, disease, decay, death, bodily fluids: all that is metaphorically or metonymically associated with what is impure and unclean. Though this occurs daily and routinely in individual and collective lives, in times of public health crises, abjection is even more pronounced and obvious; the logic of epidemic closely follows the logic of abjection. As historians and theorists of disease and public health have suggested, when faced with the threat of disease, it is not uncommon for societies to respond by enacting measures which seek to isolate and separate the infected from the healthy. The infected are further divided into those who are guilty parties and innocent victims. There are those who, by virtue of their actions or moral character "deserve" the illness; sickness is just punishment for immoral behavior. And there are those who have contracted an illness "by no fault of their own" and are thus worthy of the sympathy of society.[17] In efforts to protect the public health and aid the innocent individuals, those who are identified as sources of

contagion are not only stigmatized, but isolated or quarantined, sometimes jailed. Their rights are infringed upon in the name of public safety. This is the legacy of coercive state actions and quarantine noted by historians and scholars of disease and illness.[18] These regulatory practices, coupled with representations of individuals as guilty, immoral, and impure function to produce social order and identity. But it is an order and identity that is tenuous, as it is often undergirded by fear of both physical and moral contagion, ignorance, and prejudice.

The instability of order in the face of a public health epidemic is emblematic of the instability of order on the individual, psychic level. Though the impure (the abject) may be both identified and jettisoned (abjected), individual and collective order are momentary at best. According to Kristeva's work, both the orderliness of civilization and the stable ego boundaries of subjectivity are actually phantasmatic.[19] Building on her work with patients suffering from psychosis, Kristeva reveals the subject as one who is "in process" or "on trial." This is a subject whose constitution is never complete because the abject is wholly ineliminable. In other words, Kristeva finds that in order for a child to become a speaking subject (and for an adult to remain one), he or she must separate from, abject, the maternal. This expulsion thereby establishes the boundaries between self and other, subject and object. In and through this process the child is able "to claim the body as its own and through its 'clean and proper' body, gain access to symbolization."[20] However, the constitution of the speaking subject is not only founded upon the violent separation and exclusion that is abjection, but also upon the desire, the want, the void left in this process. The process of abjecting the maternal and producing the maternal as abject, of splitting from that which nourished and met all one's needs, leaves the child with feelings of loss and wanting. According to Kristeva, "all abjection is in fact recognition of the *want* on which any being, meaning, language, or desire is founded. . . . [T]he experience of *want* itself [is] logically preliminary to being and object."[21] It is this want that fascinates the child, "beseeches" the subject, it beckons as it threatens to "pulverize" the subject.

Continual abjections are thus necessary in order to keep the abject at bay, at the margins. Exclusionary rituals are necessary for the survival of the subject and the social: "abject and abjection are my safeguards."[22] Abjection is not purely an historic moment. Rather, abjection—the constitution of the subject through the erection and maintenance of borders—is a lifelong process, the state of Kristeva's subject-in-process. The fragility of these borders must be screened over and the borders shored up if the subject is to partake in the fantasy of coherence and unity necessary for functioning in the symbolic order. This existence as speaking subject is secured through the use of language and a

socio-symbolic system of rituals, prohibitions, and exclusions, the "actions" of abjection. These function to veil the void at the core of being and prevent the subject from falling back into the abyss prior to signification.

According to Kristeva, every society and individual has its "socio-symbolic system" of rituals and taboos which attempt to "keep out that which threatens the speaking subject, and correspondingly the social order."[23] In her essay, Kristeva discusses various historical manifestations of this universal structure of abjection such as the incest taboo, defilement rituals, biblical dietary laws, menstruation rites, exclusions of disease and decay, prohibitions regarding the corpse. Underneath the surface of all orderly civilizations Kristeva reveals:

> the nurturing horror that they attend to pushing aside by purifying, systematizing, and thinking: the horror they seize on in order to build themselves up and function.[24]

Social order, in other words, is achieved through the erection and maintenance of boundaries between the pure and impure, what is clean and what is filth. What is to be excluded or abjected is that which may pollute the body of the subject or the social, that which threatens fragile borders with dissolution. This demarcating imperative is deployed in rituals and prohibitions often associated with food, bodily fluids, waste, and other forms of "pollution." The ritual exclusions guard against the subject's return to the passive state, the union with the maternal, "where the subject, fluctuating between inside and outside, would find death . . . "[25] Purification rites, which function to divide groups, subject and object, subjects and subjects, "on the basis of *excluding filth*," thus found the "clean and proper" body of the subject and social group.[26]

Public health measures can be understood as manifestations of abjection, as part of the socio-symbolic system of rituals used to bring orderliness to civilizations. As Sander Gilman has argued, we use verbal and visual representations of illness to "manage our fear of disease," to control and domesticate contagious disease. As with art, we deploy public policy in our quest for wholeness and order, an illusory stability that is built on the abjection or scapegoating of the infected.[27] In the past and present, the policies and the discourse surrounding illness have served as repositories for our projected fears of contagion as well as our desires for stability and health. They offer us a "fantasy of wholeness" by displacing instability onto particular groups of people who are relegated to the social margins. At the margins, these abjected individuals form the boundary between pure and impure, health and disease, that is necessary to individual and social order.

AIDS AND ABJECTION

According to Kristeva, literature "represents the ultimate coding of our crises, of our most intimate and serious apocalypses."[28] In other words, writing is that which simultaneously produces and unveils the abject; it functions to keep the abject at bay, maintaining order and boundaries, yet bringing us to the edge of the abyss that is at the core of being. Literature, Kristeva suggests, has taken the place of those sacred rituals which veiled the fragility (the horror) of our being, founded subjectivity upon this veil ("the veil . . . on which love of self and other is set up, . . . on which rest the sleep of individuals and the breathing spells of societies"), and also unveiled the abject to reveal our incomplete subjectivity.[29] Perhaps if she had written her book in the late 1980s, she would have argued that the AIDS epidemic—the disease and the strategies with which we produce and respond to it, the policies and approaches we use to contain, control, and master HIV/AIDS—represents an important, perhaps the ultimate, coding of the horror of being.

For the duration of this paper I shall illustrate how AIDS has come to function as our abject. I will discuss how AIDS, understood here not only as a disease but as an identity or quality which attaches to persons infected or associated with the disease, has become coded as abject and how it is that the process of abjection has shaped the lives of those bodies coded as abject.[30] In this section, then, I take up AIDS as the abject and explore various aspects of the epidemic which make visible the structure and the fearfulness of abjection. I begin with a discussion of the ways in which AIDS has been coded as abject, as non-object/non-subject, that which is to be jettisoned, cast off, excluded from society. This is followed by an exploration of the prohibitions and rituals, the mechanisms, we employ to abject AIDS, to construct borders between AIDS and the "general, healthy public." Together, these discussions represent an interrogation of the ways in which AIDS functions as the abject, as both the grounds upon which we constitute identity and as that which always places identity and order in jeopardy.

Every society, according to Kristeva, is founded upon abjection: "one encounters it as soon as the symbolic and social dimension of man is constituted and this throughout the course of civilization."[31] However, Kristeva does suggest that abjection is manifest differently throughout history. Within our symbolic order, AIDS (and by association, the person living with AIDS and, oftentimes, the person identified as a member of a "high risk" group), often comes to be coded as the abject. While it is not the only form of abjection visible today, AIDS is one of its most apparent and pervasive manifestations.[32] It is our society's abject—constituting and threatening the unity and identity of the individual and social order, calling "into question the boundaries upon which they are constructed."[33]

CODING AIDS AS THE ABJECT

HIV/AIDS is our society's abject, that which threatens our sense of corporeal integrity and psychic respectablilty as no other current disease quite does. According to Kristeva, the abject is often associated with that which transgresses and challenges psychic, symbolic, and physical borders and boundaries, with that which "pollutes." It is represented by waste, blood, decay, bodily fluids, and infection. AIDS, our "newest" major and, to date, incurable, infectious disease, is spread through bodily fluids—blood, sperm, breast milk—which permeate bodily borders and threaten the physicality as well as the psyche of individuals with slow and terrible degeneration, and inevitable death. In its hugely disruptive capacity, AIDS (the disease as well as the actions which lead to transmission) becomes that which is feared, that which must be cast off.[34] It represents the border of being, marks the place where an individual is not so that she may continue to be.[35] AIDS, as the abject, disrupts system and identity, dissolves the boundaries of subjectivity, makes visible the grounds and fragility of life. Like the *"corporeal waste*, menstrual blood, and excrement, or everything that is assimilated to them, from nail-parings to decay," AIDS is representative of "the objective frailty of symbolic order."[36] An "equivalent," "assimilation," metaphor or metonymy for the abject, AIDS threatens the health of the individual, the order of his or her life, the social faith in the ability of medicine and science to control nature, the "tolerant" and "democratic" order of our society. Within our narrative about AIDS, our public policies, our reactions to the disease, our treatment of people living with AIDS, AIDS comes to "stand for the danger to identity that comes from without: the ego threatened by the non-ego, society threatened by its outside, life by death."[37]

According to Kristeva, coding something as abject or associating a representation of filth with the abject, often entails a visual component.[38] In other words, the production of the abject often involves the ability to see that which is impure, decaying, or deemed to be the source of pollution and contagion.[39] For example, Kristeva discusses the nausea one experiences from seeing a layer of skin appear on milk, the horror one feels upon seeing a corpse ("refuse and corpses *show me* what I permanently thrust aside in order to live."),[40] and the fear one senses upon encountering the leper. Kristeva discusses the case of the leper in the section of *Powers of Horror* entitled "Boundaries of the Self's Clean and Proper Body." There she argues that there are powerful connections between visual decay and impairment and the psycho-social processes of abjection. Her discussion of leprosy as the "skin tumor, impairment of the cover that guarantees corporeal integrity, sore on the visible, presentable surface," brings to mind one of the most pervasive images of the AIDS epidemic—the person living with AIDS who is covered with KS (Kaposi Sarcoma) blotches. KS is a manifestation of a rare skin cancer that afflicts individuals with the

HIV virus and leaves them marked with purple blotches all over their bodies. Like the spots of a leper, the KS patches mark the infected, the impure, the contagious, the polluting. These visual manifestations of AIDS make it a likely candidate for stigma, according to Gregory Herek, as they produce fear and loathing in others, fears which correspond to the association of AIDS with the loss of "biological and psychic individuation."[41] KS, along with other physical manifestations of AIDS, such as weight loss, vomiting, and seizures, represent the degeneration and the loss of control over one's body. As one account has suggested:

> AIDS is about . . . loss of control—control of one's bowels and blad-der, one's arms or legs, one's life . . . AIDS is the moment to mo-ment management of uncertainty. It's a roller coaster ride without a seat belt. Once this ride begins, there is never a moment when the rush of events that swirl around you stops long enough for you to get your bearings. AIDS is like motion sickness except you realize that you'll never stop moving; one way or another, you'll be dealing with AIDS for the rest of your life . . . [42]

Given individuals' reaction to the appearance of this loss, its threatening possi-bility (AIDS is a contagious, as-yet incurable disease that "does not discrimi-nate"), and its ramifications for psychic ordering, it is not surprising that the body of the AIDS victim, like the leper, gets coded as the defiled, decaying, ab-ject body. This is the body that, according to Kristeva, represents "the privi-leged place of mingling [of pure and impure], of the contamination of life by death, of begetting and ending."[43] The site of AIDS, the infected body, is thereby coded as abject, that which is to be excluded, relegated to the margins of the social order.

The abject status of AIDS cannot, however, be reduced to or explained only in relation to visual manifestations of illness. In fact, many individuals do not develop noticeable symptoms until later stages of illness, and some who are asymptomatic never show any signs of infection. Therefore the abject sta-tus of AIDS or bodies associated with AIDS must be explained with reference to social context as well. The fact that AIDS is an infectious disease which is transmitted through bodily fluids which do not respect bodily borders, an ill-ness which manifests itself in the degeneration, decay, and death of the in-fected makes it an easily assimilated "object" of abjection. However, as with any disease, it does not, as Douglas Crimp has argued, "exist apart from the practices that conceptualize it, represent it, and respond to it."[44] To under-stand how AIDS is produced and functions as the abject, it is important to locate this process in an already-existing social discourse. Indeed, coding AIDS

as abject is not a reflection of something which exists or is known prior to our narratives and discourse, but rather involves and "implies the active work of selecting and presenting, of structuring and shaping: not merely the transmitting of already-existing meaning, but the more active labor of *making things mean*."[45] Making bodies with AIDS mean impurity and contagion involves a relationship between the disease and the already-abject status of many of those who have been infected. On the body of the infected individuals converge a variety of abjections associated with sexuality, skin color, class, gender, and illegal activity. The already-abject status of homosexuals, injection drug users, prostitutes, persons of color, and poor women—groups early and perhaps hardest hit by the epidemic—informs how we understand and respond to the epidemic.

To explicate the complexities of abjection in the AIDS epidemic we must complicate or build upon Kristeva's theory of abjection. For Kristeva, social context and historical or cultural differences are secondary to the universal structure of abjection. However, Deborah Linderman, Judith Butler, and Simon Watney have each suggested, such differences do matter. Linderman, in her review of *Powers of Horror*, reminds us that:

> At base, whether it is articulated in the individual unconscious or in manifest collective practices, abjection is a procedure of expulsion or exclusion of something jettisoned from the body (waste, excrement, filth, carnage, menstrual blood) or . . . of a metonymic or metaphoric transformation of that bodily jettison.[46]

Here Linderman is suggesting that AIDS functions as the abject in more ways than one, that the abjection of bodily jettison can be transformed based upon a likeness as well as upon a nearness. Both AIDS the disease and the person with AIDS (or likely to be infected with HIV) become metaphor and metonymy for a variety of fears and repulsions—not just a fear of infected bodily fluids, but also of "polluting" behaviors, practices, and social locations. The fact that in the United States AIDS began and continues to be primarily a disease of the social other, the already abject, complicates a simple reading of coincidence between Kristeva's theory and AIDS discourse. It is important, then, to recognize that AIDS as the abject represents and is informed by a variety of subjects, including but not limited to homosexuality, poverty, injection drug use, racism, and sexism. AIDS and bodies marked by AIDS are abjected along already-existing, hegemonic axes of power and differentiation involving "the repudiation of bodies for their sex, sexuality, and/or color."[47] Thus representations of AIDS come to signify a range of issues involving questions of identity, boundaries, and transgressions or permeations of boundaries. But coding the

person living or associated with HIV or AIDS as abject is not always the same. As recent history has proven, not all people with HIV/AIDS are treated the same, not all are coded as abject in the same manner or to the same degree. Often it is the prior status of the HIV-positive individual—as abject *or* as "clean and proper"—that leads to differential treatment. Understanding the logic of AIDS as abjection, therefore necessitates delving into this difference .

In his book *Policing Desire*, Simon Watney argues that representations of homosexuality and homosexuals as marginal and transgressive have greatly influenced the production and coding of AIDS. Watney notes that a principal determining factor in the AIDS epidemic has been the connections made "between the disease and the social groups in which it has initially emerged, in particular, gay men."[48] Already-formed identities (as abjected beings, as individuals "with whom identification is forbidden"), according to Watney, impact upon the way in which AIDS is received, produced, and coded.[49] Judith Butler also explores the convergence of bodies with AIDS and already-formed sexual identities. In her essay, "Sexual Inversions," Butler reminds us that there can be no identity without sex.[50] Indeed, a fundamental aspect of the constitution of the "clean and proper body" is sexual differentiation; divisions made according to gender as well as sexual orientation. According to her discussion, heterosexuality is figured as "clean and proper," the position inhabited by the speaking subject, while homosexuality is produced as abject, as that which endangers subjectivity through a transgression of the boundaries between pure and impure. Homosexuality represents, in this context, the "unnatural" penetration of bodily boundaries, anal and oral sex are figured as unclean, impure, and subject to expulsion from the social order. It is coded as endangering ordered sexual differentiation and thus identity. AIDS, born into this context of naturalized, purified heterosexuality, a sexual order which is designed to secure life and reproduction, can only be understood in light of the prior status of people with AIDS as abjected beings.[51]

According to Butler and Watney, the already-abject status of the homosexual body has exacerbated the status of gay men with AIDS, as well as many individuals with AIDS. In the case of gay men, AIDS came to be understood as the "just reward" for the transgressions of moral, social, and bodily boundaries. AIDS marked the "deserved" punishment for "unnatural" sex, for voluntary "degeneracy."[52] It came to be and remains coded as part of the "telos" of male homosexuality; "the necessary compensation for homosexual desires, . . . the *telos* of male homosexuality, its genesis and its demise, the principle of intelligibility."[53] As Paula Treichler suggests, AIDS and death are coded as "the price one pays for anal intercourse," for a "violation of natural difference."[54] This coding enables a variety of actions, prohibitions, and exclusions which seek to secure life (the life of the healthy, the "innocent") by

demarcating those who should be left to die.[55]

These sentiments and representations were placed in the national spotlight in the late Spring of 1995. During Senate debates regarding the reauthorization of the CARE Act, which provides needed care and services to all individuals infected with HIV, Senator Jesse Helms argued that gay men were to be blamed for the spread of HIV and the attendant siphoning of Federal funds away from other ill individuals. Gay men, he argued, engage in "deliberate, disgusting, and revolting conduct," in "unnatural acts" which transmit the disease. Such behavior made them unworthy recipients of Federal dollars and thus it was Congress's duty to reduce the amount of money spent on the care and services for HIV-positive individuals. Senator Helms even blamed gay men for the infection of an "innocent" Ryan White, a young hemophiliac who became a national figure in the late 1980s. Senator Helms continued his attack on gay men by proposing that the Senate prohibit the distribution of Federal funds to AIDS programs which "encourage or promote" intravenous drug use and homosexuality, programs which he described as "thinly veiled attempts to restructure values of American families in favor of the homosexual lifestyle." Though he may have stood virtually alone in his desire to stall reauthorization (the Senate approved reauthorization 97–3), his education amendment, though defeated, received a good deal of support (54–45) and seems to have influenced a more "acceptable" amendment barring the use of funds for programs which encourage drug use or homosexual and heterosexual sex.[56]

RITUALS OF EXCLUSION: JETTISONING AIDS

The aforementioned narratives and policies are part of what Kristeva calls the demarcating imperative of abjection. That is, they function as exclusionary rituals which produce a scapegoat or abject while simultaneously determining those to be protected. In this way they perform the work of death in the name of securing life.[57] Indeed, AIDS-related public policies, laws, and cultural narratives, offered as ways to control and contain the disease, are mechanisms of abjection which seek to exclude that which threatens psychic, social, and symbolic order on both the individual and collective level. AIDS, figured as that which threatens moral, physical, and social order and existence, is abjected in and through these processes. Keeping AIDS outside—outside of healthy bodies, outside of the "general" public, outside of the United States, outside of white, middle-class society, outside of our schools and our workplace—has become the task of much public and social policy and rhetoric. Our obsession with controlling and containing the disease (hence the continuous proposing and enactment of legislation, policy, theory, and practice in the name of "preventing" the spread of HIV transmission), reveals the ways in which AIDS

functions, like the abject, as that which constantly threatens bodily boundaries. As the abject, AIDS is that which denies control and containment, that which cannot be wholly eliminated, that which "from its place of banishment . . . does not cease challenging its master."[58] Like the speaking subject who must jettison that which threatens its physical and psychic borders, many individuals in our society today seek to exclude, to cast off AIDS or persons who suffer from HIV/AIDS. The goal justifying these actions is the protection of the public health and order. In other words, these practices "follow the same logic, with no other goal than the survival of both group and subject."[59]

This is the logic that has enabled a variety of exclusionary rituals, rites, and prohibitions in the age of AIDS. Concerned with maintaining the borders and integrity of the "clean and proper" individual and social body, we have sought to quarantine, isolate, label, test, and discriminate against individuals with AIDS. We can see this trend in the politics of AIDS, in laws proposed and enacted under the authority of state police power, in the practices of medical professionals, in the moral panic of the "general public." At the Federal level, this panic has been expressed through provisions in the 1990 Ryan White CARE Act which encouraged the criminalization of HIV transmission.[60] Mandatory screening, names reporting, and contact tracing were and continue to be often proposed public health policies.[61] HIV-positive military personnel are at risk of being discharged, HIV-positive nurses and doctors have been.[62] A quick look at public policy proposals and decisions reveals our society's obsession with keeping out, symbolically and socially, that which threatens the individual and public order, that which poses a threat to our mortality. This threat, however, comes from a variety of contagions or pollutants associated with sexual orientation and practices, reproductive decisions, and other behaviors. With AIDS representing the convergence of a variety of abjections (sexuality, class, race, gender), our exclusionary practices are meant to do more than repel an infectious disease. Coercive public policies have been proposed and enacted to control, regulate, and abject the activities and subjectivities of gay men, intravenous drug users, and prostitutes, among others.

One group currently threatened by the rise in coercive or compulsory public health strategies is women—in particular those of childbearing age and/or engaged in prostitution. AIDS-related policies which code these women, especially those who are HIV positive, as abject perpetuate a long-held assumption of the medical and health care system. This is the notion that women spread disease, that they are vessels or vectors of contagion and not individuals in need of medical care and services. As Gena Corea has reported, studies in medical journals, papers at conferences, research projects, health care guidelines, and even legal cases view women "simply as . . . organisms, like insects that transmit a pathogen."[63] This perspective leads to representing

HIV-positive pregnant women and prostitutes as endangering the health of their fetuses or clients. This perspective persists despite research that shows that perinatal transmission occurs only in approximately 25% of cases and female-to-male transmission of HIV is ten times less likely to occur than is male-to-female transmission. In other words, most HIV-positive women do not transmit the virus to their newborns, and prostitutes are at a much greater risk of being infected by HIV-positive johns than of transmitting HIV to them. What the examples below illustrate is that this statistical information is ignored in policy decisions and that, as with the treatment of gay men, social context or the "already-abject" status of the person matters. Abjection in the AIDS crisis, is thus manifest in and through attempts to regulate and control physical and moral contagion, to domesticate both disease and bodies. The result is the curtailment of the "free movement within society of people with AIDS."[64]

We see attempts to control and regulate women's bodies in the various proposals responding to perinatal HIV transmission (transmission from mother to infant around the time of birth). In response to a rise in the number of pediatric AIDS cases (a number which is predicted to increase given statistics which suggest that eighty percent of women with HIV are of childbearing age) and treatment advances, policies have been proposed which mandate the HIV testing of all women of childbearing years, of women in "high risk" groups, and/or of newborns. These proposals grow out of the Centers for Disease Control's 1985 recommendations that HIV-positive women of childbearing age "postpone" or "forego" pregnancy. These recommendations became incorporated in state health department policy, as did a particular attitude toward women who choose to give birth.[65] James Curran, the CDC's director of AIDS activities, made a comment which stated that women who were "logical will not want to be pregnant."[66] Implicit in this argument is the representation of those women who choose childbirth, those who think that a 75% chance of having an uninfected baby are good odds, as illogical or unreasonable.[67] This recommendation led to proposals and practices of directive counseling, of counseling which told women their only option was to avoid or terminate pregnancy. When the result of AIDS Clinical Trial 076, which studied the effects of AZT on perinatal transmission of HIV, were released, women's options increased. Now, according to the Public Health Services' guidelines, pregnant HIV-positive women should be counseled about the benefits of AZT. According to the results of the study, AZT, when taken during pregnancy and when given to the newborn, can reduce perinatal transmission to approximately 8%. The study, however, has come under attack for using a small of group of women with a particular T-cell count, for its premature termination, and for the lack of longitudinal study of the effects of AZT. In addition to mandatory testing,

policies have been proposed, even acted upon, which suggest that HIV-positive women be sterilized or even criminalized should perinatal transmission of HIV occur.[68] While no one denies that the prevention of transmission to newborns is a legitimate and important public health goal, public health officials, women's health advocates, lawyers, and ethicists are concerned about the motivations and implications of these policies.[69] Whether arguing for women's right to privacy or their right to be treated as autonomous individuals, these groups face the formidable task of challenging the coding of HIV-positive women as abject, a coding which enables the social exclusion of HIV-positive women, the abjection or jettisoning of those who do not conform to testing and reproductive regulations.

This has already happened to Cassandra McLellan.[70] McLellan was charged and prosecuted in criminal court for having violated North Carolina's state health department regulations regarding the behavior of HIV-infected individuals. According to these regulations, HIV-positive individuals are forbidden to have sexual intercourse without the use of a condom and must inform their sexual partners of their HIV status. McLellan was jailed for transgressing the first part of this regulation, for becoming pregnant after having received a positive HIV test result. Her pregnancy was introduced as evidence of her failure to use a condom during intercourse. And these actions caused the court to deem McLellan a threat to public health and social order. Represented as a threat to future generations, McLellan was abjected, cast out, jailed. Within the context of her trial, McLellan was produced as the abject, as the source or vector of contagion and pollution, and for that she has been expelled from society. Through this expulsion the court aimed to protect collective order and subjectivity. Though McLellan has been jailed, placed in the margins, she has not been wholly eliminated. She remains a "threat" to the borders of our clean and healthy society as she may be paroled, may come to represent a new campaign for the rights of people living with AIDS, or may contribute to the statistics that report the rising number of cases of AIDS in prison. Whatever happens to McLellan as her story circulates, she remains alive within AIDS discourse and thus, like the abject, reveals the fragility and tenuousness of those exclusionary rituals through which we constitute sociality.

Perhaps it is the kind of threat posed by women like McLellan, women who "disobey" or "disregard" policies used to regulate their reproductive choices which have caused legislators to shift the emphasis of their campaigns from the women to the infants themselves. AIDS-related reproduction policy campaigns in recent years have focused on identifying which newborns are infected with HIV. Supporters of policies to mandate HIV testing of newborns or to unblind previously blinded test results of infants, to release supposedly anonymous and confidential test results, have couched their campaign in the

rhetoric of protecting innocent, neglected babies.[71] The goal of the "Baby AIDS Bill" introduced by Nettie Mayersohn in New York State or the Waxman/Coburn Amendment to the CARE Act (the preliminary model for the "Provision Concerning Pregnancy and Perinatal Transmission") is purportedly to identify infected babies and notify their mothers so that newborns can receive early treatment for illness and transmission of HIV through breast milk can be avoided.[72] The Baby AIDS Bill requires that mothers be told the results of their infant's HIV test while the Waxman/Coburn Amendment (now the "Provisions") makes states' receipt of Federal funds dependent upon the implementation of mandatory HIV testing. In other words, if, by 1998, states fail to meet criteria showing that they have reduced perinatal transmission of HIV by fifty percent since 1993, that they know the HIV status of 95% of women who receive prenatal care, and that they have implemented laws mandating the HIV testing of newborns, they face the loss of federal support.[73] Supporters of such policies argue that such legislation "give[s] the woman and child a chance to take care of themselves."[74] They argue that voluntary testing programs have had low levels of response and thus babies are not getting adequate care. As the Editorial Board of *The New York Times* wrote in June of 1995, mandatory testing of newborns is justified because "the health of the baby is more important than any privacy right to the mother."[75] Without either a mandatory or a "strong voluntary approach," these babies will continue to be neglected and will not receive necessary medical treatments, according to *The Times.* Imposing mandatory testing or requiring the release of already-existing test results are thought to be the only "ethical" action to take.

While no one denies that newborns "deserve" health care or that treating newborns is a legitimate and important goal, serious challenges have arisen to both policies. Emphasis on newborns' test results has been questioned not only by AIDS activists, but also by both the American Medical Association (AMA) and the Centers for Disease Control (CDC).[76] Both organizations argue that mandatory tests of newborns "often are inconclusive and waste resources that could be better used on the mothers."[77] Tests are inconclusive because all babies born to HIV-positive mothers test positive for the virus after birth. Accurate test results can only be determined some 15 to 18 months after birth when the baby has shed its mother's antibodies. These policies are, therefore, criticized for being an invasion of the woman's privacy (the only HIV status that they accurately report is the mother's) and for failing to discuss the tenuous connection between testing and treatment.[78]

Perhaps more insidious than the misappropriation of money for inconclusive test results is the implication of guilt and blame in the rhetoric surrounding these policies. If these babies are innocent and neglected, someone must be guilty and neglectful. And if the need for the amendment is linked to low

turnout rates of pregnant women involved in voluntary testing programs, it must be the mothers who come to be represented as wholly responsible. According to opponents of these measures these proposals demonize pregnant women, scapegoating them for perinatal transmission of HIV, and coding them as irresponsible, irrational, uncaring mothers. In so doing, women are rendered invisible as sufferers of illness themselves. Within these policies and narratives, then, women are no longer represented as infected individuals who need care and services themselves, but rather are coded as "vessels or vectors" of contagion, as the neglectful source of disease itself.[79] Little mention is made of connecting positive-test results of newborns with women's receipt of necessary medical services.[80] As with policies and narratives which demonize (abject) gay men, these policies can also be read as seeking solace and order at the expense of the infected.

What this discourse reveals, then, are the stakes of "public order" and public safety. Identity and social health are constituted in and through the process of finding a demon, a source of contagion. With the identification of this abject being, this site of uncleanliness, comes the ritual of expulsion. For women such expulsions have placed their reproductive freedom in jeopardy and perpetuate the representation of women as vessels and vectors of contagion, as contaminants to an orderly society rather than as individuals in need and deserving of care themselves.

These were some of the problems Helen Cover faced as well. The story of Helen Cover, recounted by Gena Corea in her 1992 book *The Invisible Epidemic*, provides another example of the way in which multiple or prior abjections complicate and found the public, "legal" ritual of producing and excluding the abject. Though not involving her reproductive choice, Cover's story involves the correlation between drug use, sexuality, homelessness, poverty, and AIDS within the process of abjection. Cover, a young HIV-positive woman addicted to drugs and on probation following an assault charge, found herself out on the streets with no money or food. Hungry and in need of cash, Cover offered to perform fellatio on a man in exchange for twenty-five dollars. The man, an undercover police officer, arrested Cover. The district attorney charged her with prostitution and attempted murder for offering to fellate a man when she knew she was HIV-positive. Like the judge who sentenced McLellan, this judge viewed Cover as a threat to the public's health and safety. He fought to keep Cover in jail, to deny her bail and later her parole. Because Cover could be described by the district attorney as a drug-using, HIV-positive woman prostituting herself, it was easy to code her as abject. She was perceived to be a morally and physically impure individual who, in transgressing sexual, legal, and moral boundaries, threatened the health and well-being of others. What is troubling and telling about the judge's response to Cover's case

is that he denied her bail and did not place her in a drug treatment program.[81] As well, he ignored statistical information that reports female-to-male HIV transmission rates to be extremely low and shows no record of a man having ever been infected as a result of fellatio. Furthermore, knowing that her life expectancy was less than two years, the judge sentenced Cover to one and one third to four years; a term which amounted to a life sentence for offering to give a twenty-five dollar blow job.[82] He justified his action citing Cover's HIV status and her drug addiction which she had not been able to control. From his perspective he was protecting society from a deadly enemy; he "wasn't going to run the risk of her giving a death sentence to someone else."[83] The judge saw his task as excluding the filth and impurity represented by Cover, a body infected with AIDS, drug use, prostitution, poverty, and homelessness, an abject body. He was not going to allow the abject to threaten the survival and maintenance of the symbolic order.

REACHING THE LIMITS OF ABJECTION: THE CASE OF RYAN WHITE

Why is it that Helen Cover died in jail and that Cassandra McLellan remains there? Why is it that hundreds of individuals have been fired or displaced, that others have been abandoned and ridiculed, but yet some people with AIDS are our heroes? How is it that someone coded as abject can be recouped by speaking subjects, allowed back into the socio-symbolic order? Why is it that not all people living with HIV/AIDS occupy the position of the abject in our society? These are questions that emerge when one begins to examine the case of Ryan White, a case which may reveal some of the limits of Kristeva's theory of abjection.

Ryan White was a young boy, a hemophiliac, who became infected with HIV in the mid-1980s. When news first circulated about his HIV status, he was feared, avoided, coded as abject. For several years, Ryan was treated with hostility, disgust, and fear. He was teased, excluded from school, avoided, and harassed. People did not want to touch the doorknobs he had touched or eat off the same plates. However, by the time of his death in 1990, he was a national hero, signifying a high moral position in the symbolic order.[84] From ridicule to honor, from abject to what? What does it mean to occupy the position of abject at one moment and, at another, have a national law named after you? What does it mean for one regarded as dirty, polluting, fearful, and threatening to be honored by two presidents and a variety of superstars?[85] Is it because he was infected through a blood transfusion? Is it because he did not transgress other moral boundaries such as those transgressed by AIDS victims who are homosexual, poor, African-American, women and/or drug users? It would seem that by virtue of other facets of his identity and his "clean and

proper" behavior, Ryan White's HIV status was not enough cause for people to continue to code him as abject. Though White was clearly dying from a contagious disease, he did not pose the same kind of threat to individual subjectivity and social order as an HIV-positive pregnant woman or a sexually active gay man. He was a young white boy who did not threaten to transmit HIV through "unnatural acts," did not threaten the life of an infant, and did not engage in illegal activities such as prostitution and injection drug use. Like others who have achieved the status of "hero" or "innocent" Ryan White's disruptive quality came to be understood as minimal. Others whom society has recouped include Alie Gertz, an upper-middle-class woman in her early twenties who was infected through heterosexual contact with a man who, it is believed, was bisexual; Kimberly Bergalis, a young woman from Florida who claims she was infected by her dentist and spent her last years fighting for mandatory testing of health care workers and patients' right to know legislation; and Magic Johnson, superstar basketball player who claims to have been infected through heterosexual promiscuity.[86] Media representations of these individuals infected with HIV have revealed various "degrees" of abjection within the AIDS epidemic. According to Douglas Crimp, the "perfectly normal women" who become infected by a boyfriend or husband who used drugs or was bisexual are less ashamed than gay men, prostitutes, or those who use drugs. They are "innocent" in their own minds and the psyche of society. Even more innocent, notes Crimp, are "the white, middle-class hemophiliac children" like Ryan White.[87]

The particularities of the Ryan White case and the others raise concerns about the applicability and universality of Kristeva's theory. What, in Kristeva's totalizing project, can account for the different treatment received by individuals with AIDS? How do we talk about a body that is coded as abject numerous times or representations of bodily contagion that are complicated by concerns of moral pollution? As Iris Marion Young argues, Kristeva's theory does not account for these differences in social context. Since it "does not explain how some groups become culturally defined as ugly and despised bodies," we must look to social and historical variations in the "symbolic association" of individuals and groups with disease, death, and degeneracy. "Even if abjection is a result of any subject's construction, nothing in the subject's formation makes group loathing necessary."[88] If abjection is a process in and through which we all constitute our subjectivity, why are some peoples' subjectivity and figurations of the abject privileged over others?

Here the notion of multiply abjected may only be partly helpful. We never answer in universal terms the question of how or why, homosexuals, African-Americans, poor people, etc. come to be figured as the abject in the first place. Kristeva's theory leaves certian questions unanswered. It's not clear

why some groups are more loathsome than others. It's not clear why society chooses to embrace some ill people and fear others—or how it is that the feared become the embraced. Perhaps the Ryan White story or Magic Johnson's triumphant return to the NBA are examples of possibility, the possibility that once the fragility of subjectivity is revealed we will accept and welcome difference, rather than label it impure and expel it. But more likely these are examples of the importance of being singly, rather than multiply coded as abject, of posing only one kind of threat to identity and order rather than a variety of threats.

AIDS, converging, as it does in the majority of cases, at the site of bodies already coded as abject—gay men, intravenous drug users, poor women of color—represents that which can be only partially explained by Kristeva's theory. Though, to a large extent, AIDS partakes in the structure of abjection, its logic is socially and historically situated. Kristeva may help us understand the mechanisms in which "the repudiation of bodies for their sex, sexuality, and/or color," a repudiation which expels and repels, founds and consolidates "culturally hegemonic identities along sex/race/sexuality axes of differentiation."[89] Yet we never learn why this occurs along some axes at particular moments and not others.

Perhaps the stories of Ryan White and Magic Johnson can be read as offering hope that we are learning to respond to AIDS with compassion or that the recognition of the fragility of our own humanity leads us to appreciate others' humanity. In part, what these stories reveal is that the position of the abject is not a stable one. Abjections must be constantly reiterated and repeated, boundaries between pure and impure continuously shored up. If the abject is to be "kept in its place" it must be reproduced through the reiteration of media representations, cultural narratives, and public policies.[90] These stories also suggest that one's position as abject is determined by much more than one's HIV status. Infected babies, hemophiliacs, many who trace their illness to the deception or "immoral" behavior of another—these individuals are least likely to be abject.

What also goes unsaid or unaddressed here is what Judith Butler identifies as the resignification or politicization of abjection.[91] That is, publicly asserting one's abjectness, in particular one's queerness, such that it challenges and calls into question the "heterosexual matrix" that informs abjection, the framework of social order maintained in and through abjection. To politicize abjection is to "speak loudly" from the position of the socially marginal, the abject.[92] According to this position, one does not have to be a "clean and proper body," recognized as such by the symbolic order in order to be heard, recognized, and legitimated. Defying abjection is possible, as Richard Pérez-Feira, editor-in chief of *POZ* magazine has reminded us: "Every single day,

HIV-positive people are leading three-dimensional, *healthy* lives full of the same joys and pains, loves and hurts that everyone else goes through."[93] And as Pedro Zamora, AIDS activist and former cast member of MTV's *The Real World*, reminded people before his death, if they couldn't deal with all of him, he would deal with them. He was not going to separate his HIV status from his gayness or his choice of sexual activities.[94] Politicizing abjection may look like it did for the men and women interviewed on the PBS special *Living Positively*; men and women who were former drug users or prostitutes, for whom infection offered the opportunity to change their lives and gain self-esteem. For these and many others, recognizing and asserting their abjectness reveals the disruptive potential of abjection.

Whether we look to those who have been recouped by the symbolic order or to those who remain abject but are not silenced by it as models of hope for the future, we do need to recognize the stakes of our current public policies and cultural practices. Reading the epidemic through the logic of abjection reveals these stakes in stark relief. Social order, psychic boundaries, public health and safety, moral purity—these come to signify the result of and justification for controversial and deadly exclusionary rituals. The preservation and protection of some lives become the justification for others' deaths. And though, according to Kristeva, abjection is necessary for the survival of individuals and societies, nowhere is it written that we have to choose these particular socio-symbolic rituals along the way. We have some choice in what we code as abject, in determining what to expel in forming the margins of individuality and sociality. Perhaps if, as the National Commission suggested, the human face of AIDS is placed before the public alongside the fragility of our being, if this face is allowed to remain human, to resist abjection, then respect for human life will be the result.

NOTES

I wish to thank Linda Zerilli for her guidance and initial encouragement on this project and David Gutterman, Katie Hogan, Rick Poverny, and Nancy Roth for their thoughtful readings, helpful comments, and patience. I would also like to thank Michael Moody and Laurie Naranch for their hours of conversation, advice, and support.

1. National Commission on AIDS, *AIDS: An Expanding Tragedy: The Final Report of the National Commission on AIDS*, abridged version, 1993.

2. Sheryl Gay Stolberg, "Women & AIDS: The Better Half Got the Worse End," *The New York Times* (July 20, 1997): Sec. 4, p. 1 Week in Review.

3. On a more positive note, it's important to recognize that in 1993 the Centers for Disease Control changed their surveillance definition of AIDS to include gynecological

ons of the disease. The Americans with Disabilities Act (ADA) includes pro-
visions specifically to protect people with HIV/AIDS from being discriminated against.
In New Jersey, counseling of pregnant women is mandatory, but testing is voluntary.
Magic Johnson returned to the NBA after more than four years in hopes that the cli-
mate had changed favorably and many individuals living with HIV/AIDS have had
dramatically positive results using various AIDS drugs.

4. The Ryan White CARE Act, which became law in 1990 (Public Law
101–381), provides Federal dollars to states and cities hardest hit by the AIDS epi-
demic. The money is used to provide care and services for infected individuals and their
families. As well, the CARE Act provides guidelines for provision of care and services.
In 1995–96, the CARE Act came up for Congressional reauthorization. At that time,
Senators and Representatives proposed amendments in relation to both funding provi-
sions and institutional requirements. The accepted amendments are contained in the
Ryan White CARE Act Amendents of 1996 (Public Law 104–146).

5. Despite Senator Helms's attempts, the CARE Act has been reauthorized by
both Houses of Congress (Public Law 104–146). The final version of the AIDS pro-
gram funding amendment was written by Senator Kassebaum in an attempt to soften
Helms's original proposal which targeted only those organizations educating about ho-
mosexual sex. For more information see Katharine Seelye, "Helms Puts the Brakes to a
Bill Financing AIDS Treatment," The *New York Times* (July 5, 1995): A12; and Helen
Dewar, "Senate Votes to Continue AIDS Program; Helms Fails in Bid to Freeze Fund-
ing," *The Washington Post* (July 28, 1995): A10.

6. See David Dunlap, "Troops Infected with H.I.V. Facing Unexpected Fear of
Losing Their Jobs," The *New York Times* (May 29, 1995): A10; Eric Schmitt, "Presi-
dent Plans to Sign Bill to Cut Troops with H.I.V.," The *New York Times* (January 26,
1996): A6; and Alison Mitchell, "President Finds a Way to Fight Mandate to Oust
H.I.V. Troops," The *New York Times* (February 10, 1996): A1.

7. See Gina Kolata, "The AIDS Epidemic: Scientists Endorse Needle Exchanges,"
The *New York Times* (September 24, 1995): sec. 4 p.2 col.3 Week in Review; and David
Dunlap, "A Plea to Clinton to Lead U.S. Efforts Against AIDS," The *New York Times*
(December 7, 1995): B17.

8. Testing newborns is a controversial measure, for while it is the case that all
newborns born to HIV-infected mothers will test positive for the virus, only 25 to 30%
will actually seroconvert (become HIV-positive) after approximately fifteen months, at
which time the mothers' antibodies are replaced by the babies'. Rather than identifying
which children are actually HIV-positive, then, testing newborns reports on the
mother's HIV status instead. Mandatory testing of pregnant women has also been hotly
contested by women's health advocates, legal experts, public health officials, and ethni-
cists. For more on the controversy surrounding these proposals see the following: AIDS
Action Council, "Ryan White CARE Act Reauthorized," http://www.thebody.com/acc-
may396.html, accessed July 5, 1996; Lisa Bowledg, *Unjust Punishments: Mandatory*

HIV Testing of Women Sex Workers and Pregnant Women (Washington, DC: Center for Women Policy Studies, November 1992); Jim Dwyer, "State Stands By as Babies Die," *Newsday* (June 8, 1994): 2; Editorial Board, "AIDS Babies Deserve Help, Now," The *New York Times* (June 25, 1995): A14; Journal of the American Medical Women's Association, *Women and HIV/AIDS*, vol. 50, no. 3–4 (May–August 1995); Nettie Mayersohn, "Mothers Need to Know if They Have HIV," The *New York Times* (Aug. 5, 1995): A18; Anna Quindlen, "Mandatory HIV Tests for Newborns Break Trusts with Moms," *The New York Times* (June 8, 1994): 25; Kevin Sack, "House Panel to Draft Bill Requiring AIDS Tests of Newborns," The *New York Times* (July 14, 1995): A15; Letta Tyler, "New Rights For Moms in HIV Tests," The *New York Times* (October 11, 1995): A4; Women's AIDS Network, "Mandatory Language Included in Ryan White CARE Act," *WAN Newslette* (May 1996); and Sue Woodman, "The Push to Test Babies for HIV," *Ms.* (September/October 1994): 90–92.

9. Christine Overall, "Introduction," *Perspective on AIDS: Ethical and Social Issues,* edited by Christine Overall and William Zion (New York: Oxford University Press, 1991), vii.

10. Kelly Oliver, ed., *Ethics, Politics, and Difference in Julia Kristeva's Writing* (New York: Routledge, 1993).

11. Julia Kristeva, *Powers of Horror: An Essay on Abjection* (New York: Columbia University Press, 1982), translated by Leon S. Roudiez. Throughout this paper I will be using terms such as "subjectivity," "identity," the "speaking subject," and the "clean and proper" body/self interchangeably to represent the subject position constituted through abjection. In her work, Kristeva uses these terms metaphorically to represent the subject whose ego borders are being or have been erected through a series of separations and exclusions. Occupation of this subject position, though necessary for the production of meaning and signification, is actually phantasmatic; that is, the stability implied in the idea of the speaking subject is exactly what Kristeva is challenging. It is the notion that subjectivity or identity is constituted wholly and completely that is under interrogation and revealed as fragile in Kristeva's work.

12. For Kristeva, there exists an analogous relationship between the psyche and the social relation; the relation between self and other mirrors the relationship between the unconscious and the conscious. Abjection functions similarly on the psychic and on the social level. In both locations it follows the same logic which is to safeguard the survival of both group and subject. Thus the question of the exact relationship between the subjective and the social is placed aside; the question of whether or not the social can be reduced to the psychic is not dealt with in *Powers of Horror*, nor is it within the scope or focus of this essay to pursue that issue.

13. The abject is often identified with that which repels and nauseates. For example, Kristeva mentions food loathing, the skim on milk, corpses, menstrual blood, the leper as examples of what is coded as abject and jettisoned through the exclusionary practices of abjection. Kristeva, *Powers of Horror*, 68. For a good review of Kristeva's

work see Cynthia Chase, "Book Reviews," *Criticism*, vol. 26, no. 2 (1984): 193–201.

14. Kristeva, *Powers of Horror*, 68.

15. According to Kristeva what is abject is a "not-yet-object." It is not recognized as a thing or being, but rather as, in Cynthia Chase's words, "that which is cast off or rejected." "The abject is not an ob-ject facing me, which I name or imagine. Nor is it an ob-jest, an otherness ceaselessly fleeing in systematic quest of desire . . . The abject has only one quality of the object—that of being opposed to I." Kristeva, *Powers of Horror*, 1. Chase, "Book Reviews," 195.

16. Judith Butler, *Bodies That Matter: On the Discursive Limits of "Sex"* (New York: Routledge, 1993), 3.

17. Allan Brandt, "A Historical Perspective," *AIDS Law Today*, ed. Scott Burris, et al. (New Haven: Yale University Press, 1993), 47.

18. For good discussion of the history of disease and public health see any of the following: Ronald Bayer, *Private Acts, Social Consequences: AIDS and the Politics of Public Health* (New York: The Free Press, 1989); Sander Gilman, *Disease and Representation: Images of Illness from Madness to AIDS* (Ithaca, NY: Cornell University Press, 1994); Larry Gostin, "Traditional Public Health Strategies," *AIDS Law Today*, ed. Scott Burris, et al., 59–81; Gregory Herek, "Illness, Stigma, and AIDS," *Psychological Aspects of Serious Illness* (Washington, DC: American Psychological Association, 1990); Charles Rosenberg and Janet Golden, eds., *Framing Disease: Studies in Cultural History* (New Brunswick, NJ: Rutgers University Press, 1992); Susan Sontag, *Illness as Metaphor* and *AIDS as Metaphor* (New York: Doubleday Books, 1989); Meredeth Turshen, *The Politics of Public Health* (New Brunswick, NJ: Rutgers University Press, 1989).

19. Despite its phantasmatic quality, a belief in the wholeness and stability of subjectivity, in stable ego boundaries, is absolutely necessary for the speaking subject. In other words, according to Kristeva, a subject cannot signify or make meaning in the symbolic order unless he or she recognizes clear divisions between subject and object, self and other, pure and impure. Yet these boundaries are anything but stable.

20. Elizabeth Grosz, *Sexual Subversions: Three French Feminists* (Australia: Allen & Unwin Press, 1991), 71.

21. Kristeva, *Powers of Horror*, 5.

22. *Ibid.*, 2.

23. *Ibid.*, 68.

24. *Ibid.*, 210.

25. *Ibid.*, 63.

26. *Ibid.*, 65.

27. Gilman, *Disease and Representation*, 107.

28. Kristeva, *Powers of Horror*, 208.

29. *Ibid.*

30. Within the AIDS epidemic, I will argue later, AIDS the disease, the person

infected with AIDS, and individuals who are identified as members of "high risk" groups are also figured as abject. "High risk" groups are those categories that have been artificially constructed by the Centers for Disease Control in order to survey who is infected or is likely to be infected with HIV. Risk groups include gay/bisexual men, intravenous drug users, sexual partners of IV drug users, sexual partners of gay/bisexual men, hemophiliacs, those who received blood transfusions prior to 1985. These categories, based largely but not solely on behaviors, have been criticized for collapsing who one is with what one does. The use of "risk groups" has also been criticized for misleading individuals, for making some feel a false sense of security, and for rendering certain people, such as heterosexual women and lesbians, invisible within the epidemic. Thus there has been a move away from "risk groups" to "risk behaviors." See Gena Corea, *The Invisible Epidemic: The Story of Women and AIDS* (New York: Harper Collins Publishers, 1992) and Paula Treichler, "Beyond *Cosmo*: AIDS, Identity, and Inscriptions of Gender," in *Camera Obscura*, 28 (1993): 26.

31. Kristeva, *Powers of Horror*, 68.

32. Iris Marion Young has an interesting discussion of the function of abjection within racism, ageism, sexism, classism, and ableism in *Justice and the Politics of Difference* (Princeton, NJ: Princeton University Press, 1990). See also Noelle McAfee, "Abject Strangers: Toward an Ethics of Respect," and Norma Claire Moruzzi, "National Abjects: Julia Kristeva on the Process of Political Self-Identification," both in *Ethics, Politics, and Difference in Julia Kristeva's Writing*, ed. Kelly Oliver.

33. Kelly Oliver, *Reading Kristeva: Unraveling the Double-bind* (Bloomington, IN: Indiana University Press, 1993), 56.

34. The fear that AIDS is spread through spit has been vigorously denied. The often-repeated story is that someone would have to drink several gallons of saliva in order to be at risk of contracting HIV, and if they had been drinking that much saliva they may have problems of HIV infection.

35. Kristeva, *Powers of Horror*, 3.

36. *Ibid.*, 70.

37. *Ibid.*, 71. Here one can think of "without" as the outside of national borders—Haiti; the outside of heterosexual hegemonic culture—homosexuality; the outside of "moral" society—promiscuity, prostitution, homosexuality, drug use, etc.

38. In this way abjection is similar to stigma. According to Gregory Herek, stigma originally referred to visible markings on the body. Over time, however, stigma has come to be associated with socially undesirable or discredited characteristics which are produced and determined in social interactions. See Herek, "Illness, Stigma, and AIDS," 108.

39. For a good discussion of the relationship between visual images and AIDS see Douglas Crimp, "Portraits of People with AIDS," *Discourses of Sexuality From Aristotle to AIDS*, ed. Domna Stanton (Ann Arbor, MI: University of Michigan Press, 1992), 362–388.

40. Kristeva, *Powers of Horror*, 3.

41. *Ibid.*, 101.

42. Michael Callen, quoted in William Rubenstein's "Law and Empowerment: The Idea of Order in the Time of AIDS," 9(5) *The Yale Law Journal* vol. 9, no. 5 (1989):975.

43. Kristeva, *Powers of Horror*, 149.

44. Douglas Crimp, "AIDS: Cultural Analysis/Cultural Criticism," in *AIDS: Cultural Analysis/Cultural Criticism*, ed. Douglas Crimp (Cambridge, MA: The MIT Press, 1987), 3.

45. Stuart Hall, quoted in Simon Watney's *Policing Desire: Pornography, AIDS and the Media* (Minneapolis: University of Minnesota Press, 1989), 124.

46. Deborah Linderman, "Review of *Powers of Horror*," in *Sub-stance* vol. 13, no. 3–4 (1984): 140.

47. Judith Butler, *Gender Trouble: Feminism and the Subversion of Identity* (New York: Routledge, 1990), 133.

48. Though he does not use the language of abjection, that seems to me to be what Watney is implying. See Watney, *Policing Desire*, 23.

49. *Ibid.*, 12, 31.

50. "[S]ex is not a contingent or arbitrary feature of identity but, rather, . . . there can be no identity without sex and that it is precisely through being sexed that we become intelligible human beings" (Judith Butler, "Sexual Inversions," in *Discourses of Sexuality From Aristotle to AIDS*, ed. Domna Stanton, 344).

51. Sex, "naturalized as heterosexual . . . is designed to regulate and secure the reproduction of life. . . . Sex is not only constructed in the service of life or reproduction but, what might turn out to be a logical corollary, in the service of the regulation and apportionment of death" (Butler, "Sexual Inversions," 345).

52. Watney, *Policing Desire*, 21.

53. Butler, "Sexual Inversions," 359.

54. Treichler, "Beyond *Cosmo*," 26.

55. Butler, "Sexual Inversions," 361.

56. Seelye, "Helms Puts the Brakes to a Bill Financing AIDS Treatment"; Dewar, "Senate Votes to Continue AIDS Program; Helms Fails in Bid To Freeze Funding."

57. Butler, "Sexual Inversions."

58. Kristeva, *Powers of Horror*, 2.

59. *Ibid.*, 68.

60. For states to receive Federal funds they must be able to show that they have criminal laws which punish those who knowingly and willingly transmit HIV through blood, semen, and breast milk. "The Secretary may not make a grant . . . unless the chief executive officer determines that the criminal laws of the State are adequate to prosecute any HIV-infected individual . . . who [knowingly] makes a donation of [infected] blood, semen, or breast milk . . . "(Public Law 101–381, Sec. 2647, a, 1).

61. See Bayer, *Private Acts, Social Consequences: AIDS and the Politics of Public Health.*

62. See Gostin, "Traditional Public Health Strategies."

63. Corea, *The Invisible Epidemic: The Story of Women and AIDS,* 29–30.

64. Crimp, "Portraits of People with AIDS," 376.

65. Ronald Bayer reveals the implications and misleading nature of this position in "AIDS and the Future of Reproductive Freedom," in *A Disease of Sociey: Cultural and Institutional Responses to AIDS,* ed. Dorothy Nelkin, et al. (New York: Cambridge University Press, 1991), 191–215.

66. Bayer, "AIDS and the Future of Reproductive Freedom," 203.

67. Curran is not alone in this assumption. Nora Kizer Bell and John Arras have both argued that a 25% chance of transmission is too great a risk and that HIV-positive women who do choose to become pregnant are acting irresponsibly. See Nora Kizer Bell's "Women and AIDS: Too Little, Too Late?," *Feminist Perspectives in Medical Ethics,* eds. Helen Bequaert Holmes and Laura M. Purdy (Indianapolis, IN: Indiana University Press, 1992), 46–62. See also the exchange between John Arras and Carol Levine and Nancy Dubler on HIV and childbearing in *The Milbank Quarterly,* vol. 68, no. 3 (1990).

68. In 1985, the CDC released a policy statement advising HIV-positive women to postpone or forego pregnancy and urging all women planning families to be tested for HIV. This has been adopted by the American College of Obstetrics and Gynecology in a stronger form urging pregnant HIV-positive women to terminate pregnancy. Although not written into law, these advisories have been incorporated into the testing and counseling practices of many public health clinics, supported by medical professionals, and enabling the criminalization of HIV-positive women's pregnancy.

69. See the American Medical Women's Association Special Issue on "Women and HIV/AIDS" (May/August 1995).

70. Cited in Suzanne Sangree, "Control of Childbearing by HIV-Positive Women: Some Responses to Emerging Legal Policies," *Buffalo Law Review,* 309 (1993): 41. See *State v. McLellan,* No. 92 CR 05684 (Gen. Ct. Justice Cumberland County, NC, Mar 25, 1992), *aff'd,* No. 92 CR 05684 (NC Super. Ct., Mar. 17, 1993). See also Elizabeth Cooper, "When Being Ill is Illegal: Women and the Criminalization of HIV," *Health/PAC Bulletin* (Winter 1992): 10–14.

According to Sangree, McLellan is an HIV-positive woman who has been sentenced to two years in prison for violating the HIV-transmission regulations issued by the state health commission. The director of the county health department testified against McLellan, saying that she had failed to use a condom during intercourse—as stipulated in the regulations—thus resulting in pregnancy. "The State used McLellan's pregnancy as evidence that she had violated the regulations requiring her to use a condom." Charges against McLellan included failure to comply with quarantine and isolation orders as well as violation of health department codes. Her appeal was

unsuccessful and she cannot be paroled unless she is declared no longer to be a threat to public health. She may die in jail during her sentence because of her poor health. As of the writing of this essay no new information regarding McLellan's case was available (*Buffalo Law Review*, 351–353).

71. Blinded testing was initiated originally for statistical purposes only. Test results were anonymous and strictly confidential. No names were to have been reported.

72. In 1996, New York State passed the Baby AIDS Bill and began mandatory testing of all newborns with mandatory disclosure of results to parents in February of 1997. See Nettie Mayersohn, "Mothers Need to Know if They Have H.I.V.," and Deborah Sontag, "H.I.V. Testing for Newborns Debated Anew," The *New York Times* (February 10, 1997): A1.

73. Public Law 104–146.

74. Dwyer, "State Stands By As Babies Die," *Newsday*. See also Sack, "House Panel to Draft Bill Requiring AIDS Tests of Newborns."

75. *New York Times* Editorial Board, "AIDS Babies Deserve Help, Now."

76. The AMA, however, reversed their position on voluntary testing in June of 1996. They now favor mandatory testing of newborns and pregnant women with no option for refusal of testing. See Deborah Shelton, "Is it Time. . . , " *American Medical News* (September 2, 1996).

77. Editorial, "Showing Compassion, Sense in AIDS Funding," *The Seattle Times* (July 28, 1995): B4.

78. See the American Civil Liberties Union, "ACLU Position Statement on Prenatal and Newborn HIV Testing," http://www.aclu.com, accessed February 15, 1997.

79. V. Thandi James, "Is Ryan White Sacrificing Pregnant Women?," *New Jersey Women and AIDS Network News*, vol. 5, no. 3 (December 1995): 3.

80. See Cooper, "When Being Ill is Illegal."

81. The National Commission on AIDS's Final Report chastises the United States for lacking an adequate response to the connection between drug use and AIDS. They urged that national leadership be taken to reverse America's "failure to prevent substance abuse, to provide treatment for drug users, and to implement programs for safer injection." Such neglect, they argue, has "left a legacy with 'flash fire' potential for HIV transmission."

82. Corea, *The Invisible Epidemic*, 180.

83. *Ibid.*

84. For more information see Ryan White and Ann Marie Cunningham, *Ryan White: My Own Story* (New York: Dial Books, 1991).

85. President Bush planted a tree in Ryan's honor, President Reagan wrote a column honoring him after his death, and both Elton John and Michael Jackson befriended Ryan and wrote songs about him.

86. Greg Louganis represents an interesting case of mixed response to a superstar who reveals his HIV status. Louganis's public and media reception was mixed because

he not only revealed he was HIV-positive, but also that he was gay and that he knew he was infected in 1988 when he hit his head on a diving board at the Olympics. Because of his prior actions and his homosexualilty, some people were less than willing to make Louganis into a national symbol of courage in the face of AIDS.

87. Crimp, "Portraits of People with AIDS," 370.

88. Young, *Justice and the Politics of Difference*, 145.

89. Butler, *Gender Trouble*, 133.

90. Butler, *Bodies That Matter*, 10.

91. *Ibid.*, 21.

92. "Speaking loudly" is a term used by Rick Poverny in conversations from Fall 1995.

93. "David's Story," *POZ Magazine*, vol. 1, no. 3 (August–September 1994): 8.

94. Hal Rubenstein, "Pedro Zamora's Real World," *POZ Magazine*, vol. 1, no. 3 (August–September 1994).

Transmission, Transmission, Where's the Transmission?

Amber Hollibaugh

At a Health Forum about HIV+ Lesbian Healthcare needs, sponsored by The Lesbian AIDS Project—GMHC, of which I am the director, two women in a room of 150 people finally spoke out late in the program. Each unknown to the other until that night, first one stood, then the other and said

> I am here as an HIV+ lesbian infected through sex with my HIV+ female partner. I have been ridiculed and dismissed in talking about this, but I am here to say that I am not a liar or an exception. Before I was infected with HIV, I did not believe that lesbians could get AIDS. And like many of you in this room I didn't believe that women could pass this virus sexually to another woman. But I know differently now. The question for me is, how many more of us will have to stand up and testify about our own lives and our histories of sexual transmission with another woman before we are believed? Two of us know more now. And so should you.

Their eloquence silenced us all.

I am the director of the only, to date, lesbian-specific AIDS project in the world, but I work with a network of over a hundred frontline lesbian and bisexual healthcare women who confront, in similar ways, what I see daily. And each of us has been appalled at the growing numbers of lesbians with AIDS or HIV with whom we

work, while the consciousness about this in different segments of our communities remains so low. And though we often don't agree amongst ourselves on the exact or most probable female sexual routes of transmission, we all agree that we are seeing the numbers grow in all categories of risk, including this one.

When the project began, I felt it was vital to reach and serve lesbians with AIDS, regardless of our numbers; today I have met hundreds of lesbians with AIDS. LAPS HIV+ Lesbian Leadership Project has just begun to organize the first conference specifically for HIV+ women-who-partner-with-women and we expect that this local, one-day conference will have 100 to 150 HIV+ lesbians attending—and we're already worried that we are undercounting. Each of us doing this work has horror stories about those people in our own communities who still discount the expanding reality of lesbians and HIV, a crisis which we daily see broadening.

Our government also continues to confuse visibility, identity, and behavior—this same government which brought us the idea that a woman is a lesbian only if she has not slept with a man since 1977, and the same government which refuses to recognize or track our behaviors, rendering us paralyzed when we try to figure out exactly what is going on and why. We are in two-sided trouble— a) no serious help from the outside and b) a resulting debate and denial inside some of our own communities about these issues. The consequence of having so little to go on when we struggle to create sound, conservative, clear-eyed descriptions of our risks as women-who-partner-with-women and to quantify our numbers for HIV, leave many of us who are doing the work angry and bitter. We know that listening to the government is always tricky, though necessary, but that in this as in all else concerning our survival, we have to use every tool at our disposal. But what many of us are seeing, we fear, is just the lesbian tip of the HIV iceberg in our communities—a warning which we can pay attention to or dismiss at our own eventual peril. This is not about scare tactics, it's about survival.

Still, from its beginning two years ago, I have resisted LAP being pulled into the female-to-female sexual transmission debate because it was clear to me that people wanted to define our vulnerability and need for recognition, research, and AIDS services solely through this one question, rather than understanding that whatever we eventually learn scientifically about sexual transmission between unprotected female partners, lesbians as a people are uninformed about all the ways we may be vulnerable to HIV. Consequentially our communities lack vital, life-saving information which would prepare us to access adequately all our risks and vulnerabilities to HIV.

The tragic results of this continuing misguided and entrenched polemic concerning female-to-female sexual transmission, which is still positing that

lesbians cannot transmit the virus to each other sexually, has had broad and terrible consequences overall in our communities. We have been told that we are not at risk for HIV sexually and therefore are the "lowest" risk group over-all for contracting the virus, which has then led to many erroneous and tragic conclusions and confusions when each of us tries to understand her own per-sonal risk for HIV.

When a lesbian says that she doesn't know how she could have con-tracted AIDS because she only shared needles with other lesbians and, since lesbians are not at risk for AIDS, she thought she would be safe from the virus; or when another dyke says that she and her HIV+ female partner called the AIDS hotline for safer sex information and were told that there was little to no risk in "regular" lesbian sex and now she too is positive; or when a woman calls crying that she is a lesbian, really, has been all her life and has only slept with other women, many of whom were HIV+, though she was raped once and she can't get the CDC or her AIDS provider to not list her as heterosexual transmission because of the rape, even though she has buried two female lovers to AIDS, the catastrophe is laid bare. It means that as a lesbian body politic, we remain unreached and untargeted as a people trying to confront the intricate truth of our own histories, memories, conversations, accessments, knowledge, and geography.

In the midst of this tragic confusion, with little official or community recognition regarding all our risks (including our primary exposure for HIV still being drug use and unprotected sex with infected men), it is important to point out that the third and smallest category, of women who contribute their HIV infection to HIV+ female sexual partners, does continue to grow. Though these women have been vilified and belittled in many AIDS and lesbian com-munities and disbelieved by many healthcare providers, and though most of the research to date has been set up explicitly to try to discount their knowl-edge about how they became infected, more and more lesbians stubbornly continue to report female-to-female unprotected sex as their only or primary risk for HIV.

It is within that framework that I read articles that suggest that lesbians are not at risk. They put me in a rage. I find myself muttering arguments to them in my head as I walk down the street or lie in bed at night. I am tired of this fight, tired, sad, angry, and frustrated. How can people suggest that les-bians are so minimally at risk when we have sex with other women (the prob-ability of driving a car and having an accident theory-of-risk) that we really don't have anything to worry about? Worse, how can they suggest that those of us who are trying to talk about HIV in our communities, and, as one part of our work, are talking about safer sex, are condemning the women we reach and the larger communities themselves to rigid, fear-based unspontaneous sex,

unnecessary terror of lesbian desire itself, and a possible sexual paranoia which results in a dangerous crisis of erotiphobia and sex-negative messages both internally and externally? They state that we are already deluged with millions of messages which try to undermine our right to our own desires for women, and this bullshit about safer sex, for most of us, is both unnecessary and dangerous.

This fight about HIV transmission sexually between women calls up so many simmering issues in our communities and needs to be seen for what it is—a political battle, often between friends, about what we are seeing and hearing and how we interpret that information between us. Though I disagree with many of the arguments both scientifically and theoretically, I am confronted immediately by a set of ideological questions that cannot be shoveled under the "scientific" or "HIV medical expert" rug and which are painful to discuss and hard to bridge. How do we talk class and race in our various women-who-partner-with-women communities? Who are the "we," when we generalize the demographics of our lives and activities *vis à vis* any risk, and where does that leave us when we try to understand something as complicated as HIV jeopardy or even try to grapple with what "we" do in bed. What meter are we using to talk about "us," and how can we generalize and differentiate in this and other significant arguments within various lesbian communities?

Bottom line for me is, I can't let stand unspoken constructions of "our" lesbian community and judgment about the implications for or against our HIV risk; as many present it, we are a nearly monolithic, mostly middle-class, probably mostly white, serially monogamous group of women who sleep with each other and rarely or ever do the things which are identified with AIDS risk—not much shared needle drug use or unprotected sex with men, and certainly not much "rough sex," whatever that means. Do those assumptions really serve us well? Is that really who we are, or do we need much more rigor when any of us write or speak about HIV risk so that we call forth the true range and complexities of the many ways we present ourselves as a group—ages and identities and colors and behaviors-over-time and class stratifications and coming-out histories.

We all face a much larger problem when "we" write about each other. Who is being spoken to or about and who is being included in the construction of community and HIV risk? And who remains invisible or has been removed and dismissed with a sentence or a footnote as unimportant or not significant to this discussion? Do the places we can most easily document HIV amongst lesbians, such as prisons, outpatient clinics, shelters, and drug recovery settings, mean that many other lesbians who don't come out of those experiences can dismiss any significance for themselves and their own HIV risk because they see themselves differently from " those kind of women"? Some suggest

that they are much more middle class and/or white than these other women are, and therefore don't have to take on the issue of lesbian HIV.

These acted-on but usually unstated prejudices have led to a kind of lesbian-sexual apartheid when we talk about HIV: "it's over there, for those kinds of dykes, in those bars or those outside communities, but it is not about 'us.' We have nothing to learn from those others because we have named ourselves out of danger, we don't need to discuss our similarities, as well as our differences." And it has made most conversations about this issue nearly impossible to translate, because at the core we are fighting the race, class, and sexual differences among us, which are often based on our own opinions and prejudices but which we are reluctant to state openly.

I think this conflation of demographics, preconceived ideas, and risk significantly influences the overall understanding of HIV in various lesbian and women-who-partner-with-women communities. Research of any kind on this point is painfully scant, but what we do have indicates the frontline vulnerability of various parts of our communities—young lesbians; women who are coming out; poor, working class, and/or lesbians of color—and cries out for a passionate insistence by all of us for more research, more inclusion, more inquiry, and more subtle tracking mechanisms which can begin to unlock the rich, tangled meanings and significance of behaviors, activities, orientations, identities, and demographics. And when we look at these categories, we must stop to consider who it is we are asking about, who we are describing in our mind's eye. We have so little information or data about ourselves that when we come up against any of these Big Topics—parenting, breast cancer, chemical dependence and alcoholism, suicide, sex with men, sex with women—we have the skimpiest information to draw upon. This, sadly, is a literal reflection of our oppression and our need.

This leaves us staring out at an uncomfortable reality; we have no power to demand the research we need in order to understand what's happening in our communities. We have no long-range, significant research into the possible transmission activities which might be suggestive when looking at the arena of unprotected sex between women and HIV; no research on the different progressions and intensities of HIV viral load in a woman's bodily fluids over the course of HIV infection through to AIDS; no research to see if there is any corollary intersection when a woman is HIV+ and has a yeast infection or STD, which often causes an increase in the white blood cells present in vaginal secretions and could lead to a concentration of HIV in a women's vaginal secretions while fighting off that yeast infection or STD. Where is the research we need on cervical warts and cancers and their impact on virus distribution in vaginal fluids? What of HPV and HIV? Where is the research helping us determine the potential impact on an HIV-negative female partner if she has

herpes simplex and her lesbian lover has just contracted HIV?

Where can we find the work we need which reflects the reality of how few lesbians access any kind of health care preventatively, let alone get Pap smears or pelvic exams? What do we do when a lesbian's own medical provider often tells her she doesn't need these procedures for Pap or pelvic exams "since lesbians don't have sex with men"? What to do when chlamydia, which is so hard to identify and often remains hidden without specific testing, is being endlessly passed between female sexual partners without adequate medical interventions? When will it be stark enough that as lesbians, as women, we are not generally taught how to understand our own bodies or our own sexuality?

It is a perfect circle back to the magical-lesbian-free-of-contagion message reflected in their simplistic and dangerous representations of "the healthy vagina." True, both saliva and vaginal secretions are structured to fight infections. But there is an important piece of counterinformation any woman reading this can access for herself; simply consider your own pelvic history. For most of us, it is a history of cyclical yeast infections, tric, chlamydia, bacterial vaginitis, herpes, endometriosis, pid, interrupted menstrual cycles and unexpected spot bleeding, to name just a few. Sometimes I think our vaginal and pelvic histories are like our phenomenal ability to "forget" when our periods are coming, month after month, year after year. As women, we have vaginal memory loss and the Feminist and Lesbian Health movement struggles against this year after year. It is like pushing boulders up a hill.

There is also little relevant and useful research about all our "crossover" activities—which begin reflecting an accurate representation of the varieties of our sexual activities and of our shared drug use and which would begin to sketch out a more elaborate map of who and what we are doing sexually and socially and how that may contribute or mask our risks for HIV. In this debate, we are beached with deadend codes like "lesbian sex" or "rough sex" which tell us nothing, in lieu of a demand for serious, multifaceted sexuality and drug use studies which know how to ask a complicated trajectory of questions in order to capture the web of actions, desires, identities, and ideologies we practice in bed or put into our bodies.

Work to date also fails to represent adequately the bitter history of the "sex wars" and the correspondingly lost or hidden sexual narratives in many lesbian communities. These wars and their earliest foundation in our female socialization are the chronicles of our painful legacy as women kept ignorant about our bodies and our sexual options. When we speak of who we are and yet fail to mark out the tremendous effect of this silencing and lack of knowledge and the corresponding issues of needing a lesbian sexual language and how that scarcity affects our abilities to talk openly about what we really do in bed with another woman (or with a man), let alone speak about the impact of

the stigmas attached to acknowledging openly substance use or dependency; when these are hardly mentioned or only in passing as though very unimportant, we have not substantially addressed the complex lesbian needs for "safer sex for lesbians." What this sweeping dismissiveness does encourage, though, is the refusal in our different parts of our communities to recognize that we are in a world forever changed by AIDS and we merit more than simplistic "don't worry, we're really safe" messages as we confront the complicated nature of our lives as lesbians and bisexual women in the middle of the epidemic.

I think the bottom line of crisis and difference between different lesbian communities is reflected more realistically in the speed with which we can adequately address our individual health care needs, not whether any of this can or does happen to each of us similarly. And it is the same with HIV. The question isn't how we are different from each other and therefore not at risk, but only the actual distance between the most vulnerable amongst us and the most sheltered.

SO WHAT DO I THINK ABOUT OUR SEXUAL RISKS?

What do I think about transmission of the virus sexually between women? This is only my opinion and I won't try to represent it as "fact." It is based on the best thinking and research I can bring to it, but there is still much we need to know to come to any final answer. . . .

I think this virus is much harder to transmit between women who are having any kind of unprotected sex together than in similar situations involving shooting drugs where we are sharing works or are having unprotected sex with men. But I do think the virus can be transmitted through our vaginal secretions in high enough concentrations and over time, especially if there are existing co-factors, as well as through going down on each other when there is menstrual or any kind of blood. I don't think that "rough sex" has much to do with it, since vaginal "trauma" occurs with any penetrative sexual act: fingers, fists, or dildos. I think, from the just-analyzed data in LAPS sex survey, that women are practicing a wider range of sexual activities than we previously knew, from rimming and sex toy play to vaginal- and anal-fisting and group sex. The key piece in this, I think, is repeated exposure, and given the ways we partner (even casually with fuck buddies, whom we often see more than once), we have many community patterns which support our repeated exposure to HIV with a female partner who might be infected.

I also think that any yeast infection or STD compounds our risk dramatically. I am worried that we have no idea how widespread this crisis is in our communities and that co-factors like STDs, HPV, herpes and yeast infections, when they are combined with the notion that we aren't at risk for HIV (or

can't spread it sexually between women) increases again our chance at exposure. It also seems to me that lesbians don't often know their antibody status until very late in the progression of the disease and cannot therefore protect their partners, or even recognize the need to do so. I would also guess that transmission is more likely at the beginning of HIV infection than later in the disease, though it continues to be possible. I think that as more and more of us are infected, in whatever ways we are, the chances of sleeping with or being lovers with an HIV+ woman, whether she or her lover is aware of it, are increasing. And finally, I think the amount of crossover activities, both sex with men (often gay or bisexual) and our sharing of needles, is still very underreported and underrepresented in our communities, all our communities, and that too increases the numbers of us who are being infected by HIV.

In every study that I have seen about various lesbian and bisexual women's communities, we are the group who accesses any health care last, and with good reason. As lesbians, as women, often as poor or working-class women, as women of color, as lesbians struggling with addictions in an often homophobic recovery environment, as women who are "coming out," as mothers who fear the loss of our children if we self-disclose or are brought out, for all these reasons we use health care services last, and this, too, increases our risks for STDs, HIV, cancers, and many other illnesses.

Is saying this "erotiphobic" (a term I created in 1981)? Or, are we trying to say that as sexual adults we need to look frankly at what we are grappling with, in bed and in our heads, as women, as lesbians and which factor in when we are sexually active with anyone. If we are still at the point in our communities where we often cannot talk to a woman partner about much of anything sexually, of what would delight us or what isn't working when we are making love; if it is still hard to say "lower darling, and harder," where are we when we confront our risks for HIV? If many of us have been systematically excluded from the medical information we need to help us self-diagnose yeast infections and other sexually transmitted diseases and so can't tell when we have medical problems, this also increases our sexual vulnerability. If talking sex is still hard, then thinking hot and thinking safe is a wide stretch for most of us. It is for me. I am 47 years old and I am still struggling to bring voice and sexual awareness together with my desires and actions.

To know that HIV is in our communities and that it is growing and to know that working-class lesbians, most often African-American and Latino dykes are being hit hardest right now, is not to deny HIV's eventual power to affect and infect any of us. As a very diverse set of communities of women who love and have sex with each other, are we only going to believe numbers when it is too late to get in here and tackle it directly?

Finally, none of the lesbians I know who are doing this work are trying to

suggest that what is happening to us looks like the devastation long visible in the gay male communities. But I have been surprised and moved that when I say to gay men, "we need help precisely because it is still possible for us to reach our communities before the scale is tipped from prevention to brush fires, and if we get in here quickly enough we might be able to be one of the few remaining communities who could still turn this around," when I say that, they are right there. This battle for recognition of our risk to HIV and the numbers of lesbians now struggling with AIDS, is not "virus envy" or victim gliding, and it is not trying to scare our various women's communities. But it is saying that in a culture which hates and reviles us, refusing to recognize how and where and in which ways are we being affected by HIV and then pointing out where that will ultimately lead, is mandatory. We need to learn from the powerful histories of women and gay men which surround us and name this crisis now.

When I say that lesbianism is not a condom, I mean exactly to confront what many will not—that we are not immune to this virus, that our communities and behaviors and identities are extraordinarily broad and complex and HIV/AIDS is not insignificant in our communities. Our numbers of lesbians and women-who-partner-with-women continue to grow, while our access to health care and diagnosis remains minute. We can no longer afford to hide behind the false shelter of our identities while we watch our numbers grow.

REFERENCES

"Transmission of HIV Presumed to Have Occurred via Female Homosexual Contact," by J. D. Rich, et al., *Clinical Infectious Diseases*, vol. 17, no. 6 (1993).

HIV Seroprevalence and Risk Behavior among Lesbian and Bisexual Women: The 1993 San Francisco/Berkeley Women's Survey. San Francisco Dept. Of Public Health AIDS Office, October 1993.

"Out of the Question: Obstacles to Research on HIV+ Women Who Engage in Sexual Behaviors with Women," by Nancy Warren, MPH, At Issue with AIDS: About Women, *SIECUS Report*, vol. 22, no. 1 (1993).

Bibliography of Lesbian Health Literature by Liza Rankow, National Center for Lesbian Rights, New York (212-343-9589) or San Francisco (415-392-6257).

Author's note: I would like to thank my lover, Marj Plumb, as well as Beck Young, Laura Ramos, Melissa Murphy, Anita Rosa, Rochelle Burroughs, Alice Terson, Ana Oliveria, and all the HIV+ lesbians with whom I work. I would also like to thank the S/M lesbian community for its early commitment and safer sex training to the broader communities of women-who-partner-with-women. Thank you all.

Originally published in *Sojourner* (July 1994).

The Good and the Bad

Carmen Vazquez

I am a lesbian, a Puerto Rican Butch Lesbian, to be exact. I am also an HIV-negative lesbian, a status I make public because growing numbers of my sisters are not.

I am the eldest daughter of Claudiver and Carmen Vazquez who migrated to the United States in the early 1950s from the hills of Vega Alta to Los Nueva Yores, New York.

They came, like all poor immigrants and migrants, to this land of purple mountain majesties in search of prosperity and the freedom from hunger and violence and indignity prosperity promises. They never found it.

As I grew up on the lower East Side and the General Grant Projects in Black Harlem, I learned many things. I learned how to spare my mom's pride by editing the social worker's insults out of my translations. I learned how to take care of my father when he reverted to living out the terror of war on a South Pacific Island. I learned to take care of my sisters and brothers. I learned to stay one step ahead of the pride and shame game by not admitting to the neighbors that we were out of food because there was shame in hunger.

I learned about my butch self, about romance and passion and desire and love within a familial and cultural context. I learned how to flirt with and love women from my father and uncles and boy cousins. I learned how to please women from my mother and my aunts and my girl cousins. I learned, when I was thirteen or so, that who I loved the most, who I wanted to be with in that secret and sometimes tortured way that the young of any sexual orientation know so well, was women. I learned about passion and

communion and desire from a woman seven years my senior when I was fifteen. I learned what sex meant. I learned how taking Eva in my arms and kissing her and rolling around on the bed or the couch or the floor was to find and touch the deepest part of me. Later, with Toni, I learned how to suck and lick a woman to orgasm. Much later and with a butch I didn't have sex with, I learned how to strap on and use a dildo. I learned about the joy of imagination, about the unbelievable relief of surrendering to desire. I learned about the exhilaration that comes from being freely given the power to give my girlfriend a few moments, an hour, a night or a day of this exquisite pleasure, this sublime connection, this bizarre and wonderful thing we call sex.

I share this brief window into my childhood and early adolescent discovery of my sexuality because the silence on women's sexuality and most especially lesbian sexuality in the public discourse on AIDS and HIV has been deafening.

In the limited understanding we have of women's sexuality and AIDS what we have heard mostly is that women living with AIDS are bad heterosexuals or innocent heterosexuals. The bad heterosexual woman is usually a woman of color, the girlfriend of a junkie or a junkie herself or a hooker and we either don't name her at all in our policy debates or name her and let her be seen and heard after she has cleaned up, repented, and is now living her life for her kids. The "innocent" one is usually white and gets to address the national Republican or Democratic conventions and got AIDS from a transfusion or an unethical queer dentist. Lesbians and bisexual women are not a part of what America understands to be the face of women with AIDS—not scientifically, not politically, not in the culture of AIDS/HIV we have constructed to be gay, male, and bad no matter how much we try to de-gay AIDS and de-gay gayness itself; a culture America has constructed to be white, female, and innocent, and to be black and bad, regardless of gender or sexual orientation.

Nowhere in our cultural construction of AIDS are lesbian and bisexual women, women making love to women, a visible and cogent presence. In the last five years or so, some of us have had the courage and compassion to insist that we be named and seen, that the lives of grief and terror and denial our HIV-positive lesbian sisters experience be heard and validated, that we be given the resources we deserve to keep each other safe from infection, that we be given the resources we need to live with HIV, and that we be given the support we need to die in community and with dignity. The response has not been overwhelming.

To date, there has been no credible scientific inquiry into female-to-female transmission of the HIV virus. Assumptions and stereotypes about lesbian sexuality in the scientific community and in our own communities have

conspired to create the myth that lesbians aren't supposed to get AIDS. I vividly recall a lesbian health symposium in San Francisco in 1988 where the first HIV-positive lesbian I had ever met stood to disclose her HIV status and the reaction of "lesbian health advocates" who accused her of pandering to the "AIDS thing," of being "crazy," of diverting attention from "real" lesbian health risks and needs and, finally, of not being a "real" lesbian since "real" lesbians don't sleep with men. Real here reads "good" lesbian and good lesbians not only don't sleep with men, they also do not shoot drugs into their veins, nor do they sell their bodies for money or drugs. The fact that lesbians shooting drugs and those having sex with men for money or drugs are most likely to be poor women and/or women of color belies the race and class bias of lesbian "communities" shaped in the image of white and middle-class realities.

The courage of HIV-positive lesbians willing to disclose their status and the advocacy of their very few allies in AIDS policy circles have created some space for openly addressing the issue of lesbians and HIV. But the willingness to create this space has brought very little substantive relief in services, research, or education. A flurry of interest in lesbian sexuality have given us research projects and "surveys" that target the most privileged and least-at-risk members of our communities: women on college campuses, at music festivals, at gay pride events, etc.

The picture that emerges from these surveys is hopelessly class- and race-biased since it ignores the lives of women in prisons, of lesbians on the streets, of lesbian intravenous drug users, of closeted women who fear the loss of their children or their community or their jobs. It instead confirms the assumptions about "normal" lesbians and compounds the paucity of reliable research that might tell us the truth about female-to-female transmission of HIV.

What we wind up with as a result of government stupidity and indifference and our own race and class biases is an abyss of ignorance about lesbian risk for HIV that really should scare the hell out of us and I honestly don't know why it doesn't. It leaves us with absolutely no reliable way of knowing what a lesbian's risk for HIV really is, without knowing what to do to protect our lovers even when we know we are positive, with no language for the dialogue we must enter into with each other if we are to keep each other safe.

What do young lesbians, new to their experience of sex with another woman, or older lesbians, new to dating again, say to the women they desire? What do we ask? Whom have you slept with? Have you ever used intravenous drugs? Are you HIV-positive or -negative? Are dental dams safe? Are they always necessary? Do you like them? Do you hate them? Do you like penetration? With fingers, dildos, vibrators? With a fist? Does the woman with her heart racing and her panties or her briefs wet care to ask anything in that

moment when desire burns her and even the air itself feels like a barrier between herself and the woman she longs for? How does she learn to care about safety in that moment?

The construction of a "normal," "good," or "real" lesbian identity and sexuality is literally killing hundreds of us. We don't ask the questions we need answers to in order to protect ourselves. We don't ask them of each other. Very few of us demand an answer from the scientific and medical establishment. Why do we do it? I think that, like the rest of the population, we're scared to death of our own sexuality and mortality. We don't talk about what we do and don't do, about our fears and frustrations, about our desires and fantasies. In the silence, we make assumptions. We say we were born that way. For lesbians, I would presume that means we were born with an innate and unalterable longing for oral sex which we engage in mutually or in alternating moments after kissing and cuddling and nothing but God's intervention will ever change that and so, therefore, if we are to argue safer sex for lesbians, we use dental dams and saran wrap and we are safe. I don't think so. The romance of safety we like to shroud ourselves and our partners in is a public face that may, in fact, reflect the lives of some lesbians. For the rest of us, lesbian sexual histories and the variety of sexual behaviors we engage in are shrouded not in romance but in mystery.

To the out-lesbian, steeped in the requisite number of queer identity constructions learned in college courses, or the leather S/M dyke, meticulous in her insistence on latex on fingers, dildo, butt plug, and cunt, this may all seem a "been there, done that" message irrelevant to their modern lesbian reality. Perhaps it is for them. The silence on sexuality I speak of has different decibel levels depending on how and when a woman comes out as a lesbian and how available the HIV/AIDS dialogue is to her. But the silence exists. It exists about what we do and don't do. It exists and shrouds the risks we take because we don't believe that lesbian "AIDS" stuff, or we do, and we are repulsed by the barriers that keep us from the flesh we long to taste and touch and be buried in. Those of us willing and able to engage in an open and non-judgmental discourse about lesbian sexuality, eroticism, and desire are a minority of the lesbian population. We are not the lesbian world. Lesbian bars and music festivals and college courses are also not the lesbian world, not all of it.

The geography of what a lesbian world looks like is much more complex and overlaid with cultural, ethnic, racial, and class screens than most of us are willing to see or care about. It is also overlaid with a screen for what "normal" lesbian life means that creates whole countries of hidden lesbian life. The image of K.D. Lang in a barber's chair with shaving cream on her face and a mischievous Melissa Etheridge hovering over her might portend some level of "Lesbian chic" and popular acceptance, but it doesn't tell us anything about

our sexual lives. The handful of lesbian sex clubs in major urban areas that might actually allow a space for conversation about sexuality that isn't or is safe is not where the young woman who got pregnant with her drug-injecting male partner at sixteen is likely to go. She will lay trembling with passion in the arms of her first woman lover in an old tenement apartment somewhere in the underbelly of some American city, and the only safety they'll speak of is that which they can have away from the street. Where the work of preventing female-to-female transmission and the dialogue about our sexuality most needs to happen is not in the avant-garde world of fierce dykes, but in the hidden world of lesbian life. That it doesn't happen there is not the fault of the women who live there. It is ours.

Once upon a time, we were sick. But only in our heads. I refer to this as the original disease model, the one that replaced having the devil inhabit our bodies as the reason for our "condition" in Western lore. In 1973, the American Psychological Association voted to remove homosexuality from its list of clinical disorders. We were no longer sick. Illegal and immoral perhaps, but not sick.

By 1979, we were dying of AIDS, even if most of us didn't have a name for it or any awareness of its existence. The Centers for Disease Control gave it a name: Gay Related Immune Disorder: GRIDS. This disease was terminal and, like the first disease model, inextricably bound to our sexuality, our eroticism, our spirit, our power. Gay liberation had six years between disease models. Six years.

Women are no strangers to disease models. Virtually from the inception of the medical profession, we have been labeled as congenitally weak, hysterical, depressed, or simply unstable for a host of chronic disorders which are, in fact, structural and quite physical in nature. Clinical studies to determine the cause and treatment of common chronic medical disorders such as hypertension have only recently begun to include women. The assumption that men get sick for good reasons but women get sick because we are weak physically or mentally has long been the stuff of Western romance and commercialism, and has fueled the sexist assumptions of the medical profession and the Judeo-Christian "tradition" for centuries. The link between sexism and homophobia has been clear to many feminists and lesbian and gay activists for a long time but we consistently fail to make that link when we examine AIDS research, treatment, and education as they might relate to lesbians, bisexual women, or any woman who has sex with other women.

Why? I believe the overwhelmingly homophobic public response to "GRIDS," coupled with the still fresh memories of shock treatment for the psychological "pathology" of homosexuality, created in many of us a need for

the creation of a "normal" screen wherein our sexuality is left to innuendo but not open discourse. This need for a "normal" screen had little to do with individual morality or prudish holdovers from our various religious upbringings. It had more to do with a political decision we made a while back to de-gay AIDS, one which was part of a more complicated decision to de-gay gayness itself by presenting ourselves to the American public as "just like them," disease-free and mentally stable and fit. I believe that how we have dealt with the politics of AIDS is a mirror of how we have dealt with the politics of homophobia in America. To both these killers, our primary response has been an attempt at disease-free respectability, an invention of the "Good Gay Man" and the "Good Lesbian," that denies the centrality of sexuality to our identities, our spirit, and our liberation. It is an attempt at respectability that is itself homophobic and an evisceration of our self-respect.

We did this in an effort to accelerate our chances for greater integration into the "mainstream" as open "homosexuals" and to mitigate the stigma of homophobia, i.e. disease and immorality, in our efforts to secure funding for HIV/AIDS research, treatment, and education. The strategy resonates with many of us seeking common ground with our heterosexual allies, but it is, ultimately, a failed strategy based on a whitewashed and middle-class version of what "Happy homosexual" life might look like, a version that excoriates anything approaching the edges of sexual diversity (sado-masochism, promiscuity, sex work, butch/femme identity as a sexual construct embracing masculinity and femininity) and the reality of working-class and poor queer life (often messy, loud, economically unstable)—hardly the image of mainstream respectability.

I consider it a failed strategy, because despite considerable legal and legislative gains in the struggle to protect our rights as individuals, we have not integrated and we have yet to shed the "queer disease"–stigma assigned AIDS from its inception.

In light of this "Good" gay strategy intended to gain mainstream acceptance by deflecting the stigma of disease, it isn't difficult to see why lesbians would respond to AIDS in our midst with denial and "not us, we are good" rebuttals to the women in our communities identifying as positive and seeking comfort and support from us. Lesbians did not examine the race and class implications of de-lesbianizing AIDS any more than our brothers understood the same of their de-gay AIDS approach to government funding and Hollywood fonts of support. De-gaying AIDS has not worked and will not work, not only because homophobia remains entrenched in American culture as an acceptable form of bigotry that some elected officials actually use as an election plank, but because the vast majority of other people living with and dying of AIDS in America are people of color, intravenous drug users, prisoners, or all three.

They, like us, are expendable people in this country. Why spend money on AIDS prevention when the people dying of it are the ones who should be dying of it? The American response to AIDS is, in fact, a perfect example of public/private collaboration to a public health crisis reeking with racism, sexism, and homophobia.

For the most part, we have ceded to the public's (and the government's) response rather than challenging it because we have failed to understand that our country's response to AIDS and its response to lesbian and gay liberation are, whether we wish them to be or not, forever bound to each other. AIDS and homosexuality remain one disease in the eyes of many. They are linked forever by homophobia. Because they are, and because of the race and class realities of who is at greatest risk for AIDS in America, we cannot see our way to freedom or to a life without AIDS until we are willing to embrace and affirm what Audre Lorde has called the "erotic as power." We need to teach ourselves that there is beauty and grace in making love to another human being no matter what their gender, and we can't teach ourselves that until we learn to slay the shame that we have inherited. We will have neither freedom as queers nor safety from AIDS until we confront our country's homophobia and our own, until we are willing to denounce and resist our country's unethical and immoral devaluing of human life for the sake of preserving a morality and "family" structure that has little to do with how most people in this country live their lives.

As a movement and in our individual lives, we must stop denying the centrality of our sexuality to our identities and to the prevention of AIDS. We must celebrate the diversity of sexualities and cultures in our communities and give voice to them in a thousand languages. We must begin to recognize that the relationships we sustain, our "kinship" to each other and our sense of community are based on a shared experience of oppression, on a will to survive, on a desire for freedom and on love. This is not unlike what "family" looks like in most immigrant communities and in communities of color. This is, in fact, a multi-gendered and multi-racial epidemic that spans all ages and economic stratas regardless of whether we are addressing the homosexual world or the heterosexual world. We must behave as though it is. Our prevention work and our advocacy work, our practical and emotional support work, the research and treatment work we do or advocate for must publicly and in our own midst wear the faces of all our people.

On a practical level, this means that our broad-based prevention work has to include the women I'm talking about. To my knowledge, there is one lesbian-specific AIDS program in all of America: the Lesbian AIDS project at Gay Men's Health Crisis in New York. For the women who have found the project, it has been an oasis, a source of strength and empowerment, but one

small and underfunded project is not enough. We need Lesbian AIDS projects all over the country. We needed them yesterday. We need to support the women who do find the courage to come out as HIV-positive lesbians so that they can find and give voice to the language of their sexuality, a language they can take back to their neighborhoods, their Laundromats, their living rooms. We need to insist that there be safe spaces for sex talk for young lesbian and bisexual women, not just the boys. We need to demand female-to-female transmission studies of the scientific community, demand them again and again, until we have the answers we need. We need medical practitioners who can take a woman's sexual history without judgment or assumption, who can treat her for the medical conditions she presents rather than those the practitioner assumes she should have.

At the political level, we need to stop engaging the scarcity model approach to funding that leads white gay men, lesbians, bisexual and transgender people, and poor heterosexual people to demand less than what we need from government and private philanthropy in order for us to live with, survive, and end the spread of AIDS. We need to demand what we need for lesbians and bisexual women conscious of the fact that when we make the demand we are not in competition with our white gay brothers or our brothers of color or anybody else ensnared by AIDS. The notion that white gay men are soft pedaling their demands of government or the private sector for fear of being perceived as "Politically incorrect" is nonsensical whining. "Political correctness" is not what is killing us. Government and corporate priorities that don't include any of us and our health is what is killing us. We need to demand every cent of what it will take to meet the cultural, emotional, mental health, and community-building needs of white gay and bisexual men, of gay and bisexual men of color, of lesbians and bisexual women, of transgender people. We need to keep ever present on our agenda the lives and needs of the queer youth I call our children, because they are our children, of the queers in prison and the queers who survive on the streets. We need to name, acknowledge, and defend the queer immigrants, both men and women, for whom the terms "gay" or "lesbian" are luxuries their survival won't allow, but who belong to us because they are us in those stolen moments when they love as we love.

Finally, no discussion of the co-gendered and multi-racial nature of HIV/AIDS is complete without understanding the place of lesbian and bisexual women of color in this pandemic. It is a place, often unknown or buried in memories of war for most of our white sisters and brothers, of building community and sustaining community and hope through times of grief and despair. When Doug Warner, a white gay man who was family to my lover and me, died of AIDS, my heart broke into a million little pieces. When Richard Sevilla, a latino gay man and political comrade died of AIDS, my heart broke

into the same million little pieces. And when Margarita Benitez, a Puerto Rican lesbian, died of AIDS, my heart broke yet again into the same million little pieces. There is no difference in how we grieve. But there is a difference in how we survive. As a woman and as the daughter of a people who have had to survive for centuries under the weight of unbelievable grief and loss and indignity, I know something about survival, about hope and community and family. All I ever wanted from this movement, all my HIV-positive sisters want from our brothers is community. Ask me and my people to share our knowledge. Ask me and my sisters to join you in struggle for our survival and protection as a people instead of continuing to treat us as women getting in your way or in competition with you. My people and I actually may hold the key that will unlock the answer to how it is we will survive this pandemic, end it, and have community with each other. Ask me. Ask us.

fierce fists

cynthia madansky

In 1993, while working at the Lesbian AIDS Project at GMHC, I collaborated with Julie Tolentino Wood to write a safer sex handbook for lesbians. We wanted to write a text that was sex positive, sexually explicit and inclusive. The handbook was meant to fill the absence of information about HIV transmission between women and to resist the traditional didactic tone of most safer sex materials. It was our intention to be informative yet erotic. The handbook was produced for women who frequented lesbian bars and clubs and who, for the most part, participated in a wide range of sexual activities. The premise for this handbook was that no matter how you identified (as lesbian, bisexual or heterosexual), if you were a woman who slept with women there was some basic information which you needed to know about transmission of STDs and HIV during sexual activity. The most important thing, we decided, was to try to address any and all sexual activities between women that might involve transmission of HIV in some detail and to do so without censorship and without judgment.

Though this article is being written five years after the publication of the Lesbian Safe Sex Handbook, some of the circumstances surrounding the issue of lesbians and HIV, sadly, remain the same. On the whole, women, whether straight or gay, are being diagnosed later in the course of the illness and dying faster than men. As ACT UP has so forcefully claimed: "women don't live with AIDS, they just die from it." We specifically did not address issues of HIV transmission between women who sleep with men, as we felt that this information, however puritanical in context, was more readily available through numerous health organizations nationwide. Furthermore, within the field of health care for women, or lack thereof, lesbian-specific needs have tended to be completely neglected. It is well known that lesbians access health services less frequently than their heterosexual counterparts, mostly due to the heterosexual bias and homophobia found in the medical profession and their lack of medical insurance. The predicament of lesbian health care is exacerbated by the role lesbians have tended to take in this epidemic as caretakers of others first and of themselves last. Moreover, the general lack of services specifically tailored to the needs of lesbians is impacted by class and race determinants. With these general obstacles to lesbian health care information and practice, HIV presents yet another layer of complications as the manifestations of HIV in women's bodies is usually detected at a much later stage of development than in men. In this, lesbians are no different from their straight counterparts.

Ten years into the epidemic, lesbians were finally coming "out" about contracting HIV. The relentless, mostly white, middle-class belief among lesbians that "it can't happen to us" was finally dissipating. The growing visibility of lesbians with HIV/AIDS subjected this belief to debate. Simultaneously, the omnipotent myths that all lesbians have vanilla sex, no sex, or have one long-term monogamous partner, don't use drugs, don't sleep with men, were also, at long last, being dispelled. This new lesbian visibility has to do, in large part, with a movement toward increased frankness and public discussion

SAFER SEX HANDBOOK
for lesbians

about our sexual practices and desires. It is important to credit the lesbian SM community which has been in the forefront of talking, writing about, and practicing safer sex. Additional forms of resistance to lesbian invisibility in this epidemic were boldly vocalized by ACT UP Women, NYC, San Francisco, Chicago and by Lyon-Martin's Safer Sluts' performance in the lesbian clubs of San Francisco.

When the Lesbian Safer Sex Handbook appeared on this cultural landscape in 1993, it evoked a wide range of responses. Overwhelmingly and internationally, lesbians voiced their pleasure and relief that a pamphlet which addressed their needs and desires to be safe was finally available. Tens of thousands of copies were distributed and the handbook stirred debate wherever it went. Some bisexual women were angered that all of their needs were not specifically addressed. Anti-pornography feminists were offended, claiming that the language and imagery was too harsh and explicit. Countless other women were grateful that the text made no attempt to police lesbian desire and sexuality. These debates, however contentious, were extremely productive in terms of creating a context in which lesbians could begin to define their own relationship to safer sex. It was, however, the responses to this handbook that occurred outside of the lesbian communities that were the most heated.

One would expect it to be easy to locate the sites of censure and censorship, but they actually proliferated like a plague. The complexity appears when one begins to explore the underlining motivations of the urge to reprove and repress this handbook. Was it homophobia, misogyny, AIDSphobia, puritanism, racism, lesbophobia, or some vicious and pernicious combination of them all, that fueled this particular witch hunt? Without privileging one form of bigotry over another, I have tried to analyze the components of this hate campaign. The first thing that became apparent was that censorship originates at different points, intersects and converges to convey the inexhaustible boundary/less nature of this terrain. Censorship is truly a minefield. The censorship of the handbook by the Board of Education (NYC) in 1994, coincided with, and publicly legitimized the censure against the handbook led by the Christian Right and various Republicans in the Senate (notably Mel Hancock and Jesse Helms) who joined the mission to censor not only the Lesbian Safer Sex Handbook but lesbian sexual activity itself. I read this move toward censoring the handbook as symptomatic of a desire to silence the articulation of lesbian sexuality, specifically lesbian fisting. It is this panicked response to lesbian sexual visibility which I am interested in assessing, rather than the censorship of the handbook itself.

"Fisting" was the most frequently cited reason for censoring of the Lesbian Safer Sex Handbook (which turned out to be tantamount to repudiating lesbian sex in general). The act of fisting—penetration with one's hand in another's vagina or ass was interpreted not as an act of pleasure but as a "lewd pornographic act." A well-known Right Wing physician provided support material to the vocal opponents of the handbook by referencing a case where a young woman was raped and killed by a man who tortured her through the act of fisting. The relevant details—the rape and the man—were omitted from the presentation.

Why this obsessive fixation on fisting over all the other acts represented in the handbook? The handbook's Right Wing detractors could have had a field day with any number of sections in the

chronology

: february 12 1994
Conference of Peer Education (COPE) organized by and for youth HIV educators between the ages of 14 and 24 held at New York University. The conference was sponsored by 19 organizations—among them Chemical Bank, the AIDS Institute of NY State, the Unitarian Church/All souls AIDS Task Force, The Manhattan Borough President's Office, NYC Department of Youth, the Department of Pediatrics at NYU Medical Center, the Gay Men's Health Crisis (GMHC) and the Board of Education (BOE). The keynote speaker at the conference was Kristine Gebbie, the former national AIDS policy coordinator. The conference was only open to youth participants. The only adults permitted at the conference were a select number of speakers.

John Hartigan, an attorney from Hands Off Our Kids (HOOK), two members of the HIV Advisory Council from the Board of Education, and members of Parents for the Restoration of Values in Education (PROVE) failed to get permission to register for the conference. They proceeded by filing a complaint with the Commission on Human Rights claiming age discrimination. PROVE sent a 14-year-old Latino boy to the conference to get materials, and provide a descriptive report. This boy brought back the GMHC pamphlets.

GMHC distributed two pamphlets at the conference: The Lesbian Safer Sex Handbook and Listen Up, a brochure geared to young Black and Latino youth.

: february 16 1994
NY Post writers Mona Charen and Ray Kerrison, along with Jon Hartigan from HOOK, sent two letters of complaint to Cortines, the Chancellor of the BOE, demanding that he eliminate the High School HIV/AIDS Resource Center (located at the High School for the Humanities) and that he blacklist GMHC from entering the schools.

: february 18 1994
Cortines banned GMHC from educating at the high schools, calling for a year-long moratorium. He also moved the Resource Center to a BOE building in Brooklyn in order to insure closer surveillance. The Center's staff was fired without any prior notification. These decisions never came to a community school board vote.

: april 8 1994
During the recent debate in the House over an amendment to prohibit federal funds for gay youth programs, Rep. Mel Hancock (R. MO), circulated and displayed copies of two sexually explicit brochures which he said taxpayers funded: The Safer Sex Handbook for Lesbians and the Listen Up brochure.

: may 10 1994
Community School Board 30 voted to prevent GMHC from partaking in any educational efforts within its district. The 30 members voted 5–3 in favor of tabling the resolution indefinitely.

: june 6 1994
Bill Andrews, the chancellor of the HIV/AIDS Advisory Committee at the BOE, demanded that teachers be fired if they tell kids that condoms are safe.

: june 8 1994
Activists from PROVE and HOOK demonstrated against a revised Rainbow curriculum proposal, charging that it will recruit city school kids into a gay lifestyle. They claimed that the Rainbow curriculum is "pro-gay, uses gerbils to promote homosexuality, and uses books which extoll lesbianism."

brochure as it included discussions of safer sex practices in the following categories: mouth, lips, tongue; fingers, hand, fist; blood-letting sexual activities; more on needles; sex toys, including dildos, buttplugs and vibrators; menstrual blood; water sports; welts and blisters; and sex, drugs and alcohol. But the censors seemed most interested in and contemptuous of fisting. They attempted to capitalize on the public invisibility and ignorance of lesbian fisting. What could have been at stake? The act of fisting is no more or less provocative or offensive (or for that matter, pleasurable or delightful) than any of the other categories found in the handbook. Perhaps this vehement fear of fisting and obsessive reiteration of the anti-fisting sloganeering also represented their (read: male) ambivalence and terror of male-to-male penetration. Significantly, the fact that the handbook made no mention of men and referenced only woman-to-woman activity was never mentioned in their attacks. Perhaps their ambivalence about male fisting provided the means by which to insert themselves into the scenario in terms of a general, non-woman specific virile sex act. Indeed with the "fisting death" example provided, those detractors effectively did insert a male presence into the scenario.

It seems that for the censors (of whatever gender) the sore point is that lesbians, women who have sex with women, are not dependent on men for their sexual pleasure and that the hand could be a more than "satisfactory" replacement of the phallic object. The handbook's discussion of lesbian fisting suggests active sexual participation between women, supports women controlling their sexual experiences, encourages women to name their desires, ruptures the invisibility of lesbian sexuality, and applauds the deconstruction of the good girl/bad girl, good sex/bad sex dichotomy. Moreover, it supports the transgressive act of fisting for lesbians and uses explicit language that would hopefully encourage the integration of safer sex practices into the act. Lesbian fisting contains within it a whole constellation of (their) anxieties. For the Right, fisting all too starkly raises the specter of women's sexual agency. It symbolizes our autonomy from men, our potential to be aggressive and aggressors, and it highlights the strong and possibly exclusive, sexual bonds between women, all of which threatens the foundations of patriarchial hegemony. It is in this sense that fisting becomes a symptom of censorship, not its cause.

The Lesbian Safer Sex Handbook is unabashedly pro-pornography in that it doesn't merely show anatomically correct safer sex images, but rather quite enthusiastically celebrates the erotics of these images. It attempts to educate and arouse interest in safer sex, while boldly rupturing the silences surrounding lesbian sexuality. It is written to fight against a life-threatening sexually transmitted disease while challenging the contemporary landscape which is obsessed and fascinated by sex and yet spouts publicly that sex is dirty. A decade and a half into the epidemic, the censors' language perpetuates their steadfast phobia of people with HIV/AIDS. Our challenge is two-fold: We must not only protect ourselves from HIV but from the shameful lesbophobia and anti-sex fanaticism hurled at us with increasing vengeance from the Right.

Mona Charen: *New York Post*
At a "peer educators" conference organized by a coalition of New York City public-high-school students, and sponsored in part by the Gay Men's Health Crisis, the GMHC used the occasion to engage in homosexual propaganda. GMHC circulars were displayed to junior-high and high-school students that included pictures of a nude woman with her legs spread to an approaching fist. Lesbian "fisting," GMHC explained, can be safely enjoyed if latex gloves are worn. In fact, the painful and hazardous practice has resulted in many injuries and is believed to have been the cause of one death. Bleach and soap, condoms and dental dams this is the stuff that masquerades as fighting AIDS.

Rep. Mel Hancock
A conference convened by GMHC to brainwash young people in sexual perversion mixing porn with suicidal sex advice while excluding parents from participation.The Board of Education should cut all ties with the GMHC. Kick them out of the classroom just as they would if they were drug pushers. In the matter of stooping low, it would be hard to outdo GMHC using public facilities to encourage kids to engage in sodomy and sadomasochism.

Lynda Richardson: *NY Times*
In my viewpoint the Chancellor objected to materials displayed on a table operated by volunteers for the Gay Men's Health Crisis. The materials included graphic information on safe sexual practices, including anal and oral sex, and explicit descriptions of various sexual activities. They included vulgar words and phrases many considered shocking and unsuitable for children.

John Hartigan: Hands Off Our Kids (HOOK)
The indisputable medical fact is that fisting is so brutally sadistic that it often causes internal injuries that require major corrective surgery and can result in death.

John Beckman: spokesman for Chancellor Cortines of BOE
The literature at the conference bore a lot more resemblance to the walls of a bathroom in Penn Station or to *Hustler* than it did to legitimate AIDS education material. When the homosexuals are hitting on kids like this, it becomes my business.

no news. nothing new. no one pays attention if it's not new. no new angle. nothing new to show. more of the same. nothing new to report. no breakthroughs. no new perspectives. no one brought back from the dead. no illusions about a cure. science has failed us. twenty two years into the epidemic the only people who seem to still be around in the same form they were in 1985 are the AIDS bashers. the rest of us are transfigured, transformed, disfigured, or dead. stiff upper lip. chin up. smile. there's always tomorrow except when there isn't.

A Conversation about Sex
Developing a Woman-Centered Approach to HIV Prevention

Marion Banzhaf and Chyrell Bellamy

The authors thank the women who participated in this discussion for their open and candid contribution to this essay and for their continued work in the women and AIDS movement.

INTRODUCTION

"Talking about sex can be scary and hard."

"I am nervous about talking about issues that are so real. Sex is pleasurable or can be, but when you talk about it, you are often reminded of the painful experiences as well."

More than a decade into the AIDS epidemic, HIV-sexuality prevention programs remain mostly male-centered and mechanical, rather than encouraging an approach which examines women's sexual experiences and how those experiences and gender roles affect safer sex decision-making. Since women are the fastest growing group of people with AIDS, the fact that prevention initiatives have not yet fully incorporated the needs of women is stark. The messages of prevention include: abstinence or "revirgination" until marriage; know or select your partner carefully; be monogamous; use condoms; and limit the number of your sexual partners. Women are assumed to be exclusively heterosexual. Explicit discussions about women's sexual histories, choices, and relationships are

just beginning to become part of the theoretical approach to HIV prevention.

We live in a sex-negative society, where women are not supposed to talk about sex, especially not with strangers.[1] This notion of silence is pervasive, yet at the same time sexuality is used as a commodity. Sexual silence is a detriment within sexual encounters and must be overcome when instituting behaviors to reduce the incidence of HIV. Conversations that women have about sex everyday with their friends, co-workers, and partners must also be included in a discussion about AIDS. While we believe that this reality-based approach is being used by many people involved in HIV prevention, not enough educators and researchers are including essential elements of these conversations in their development of prevention interventions. We must begin to unite qualitative discussions to further develop and enhance behavioral theories addressing women and HIV prevention. Bringing HIV-positive women and safer sex educators to the table together is the beginning of a collaborative process which incorporates theory and practice.

When a conversational approach is used among a group of women, the complexity of women's sexual narratives, which often include both pleasure and pain, is revealed. Just as advocating for AIDS treatments cannot be effective without analyzing access to health care, HIV prevention cannot be effective without dealing with the complexity of sexual issues. HIV prevention for women must address: incest, sexual assault, and battery; whether and how women experience sexual pleasure; access to information about our anatomy; power dynamics within relationships; and women's sense of independence.

Our impetus for writing this essay grew out of a need not only to record what women are talking about, but to generate new ways this information could be used to understand the interconnection of gender differences, power, sexual satisfaction, and the practice of safer sex. This information is necessary for women today as we develop strategies for HIV prevention which account for the reality of women's histories and lives.

We gathered a group of women to discuss sex and HIV prevention. Our conversation began with a discussion about how we felt about talking about sex. Although most of us may have discussions with our friends about sex, knowing that this conversation was being taped for inclusion in a book made most of us nervous. One of the challenges we have to confront in HIV prevention is nervousness about talking about sex. By confronting it, and consciously deciding to break the silence surrounding sex, women take an integral step toward gaining more control over sex.

Our small group was comprised of five women: three African-Americans, one biracial Latina/African-American, and one European-American. Our ages were 19, 28, 36, 38, and 42. Three of us were HIV-positive and had children. All five of us had engaged in sex with men, four women had engaged in sex

with women, and two identified as lesbian. One of us was a recovering addict, and another one of us was still using but trying to kick her habit every day. Four of us had been raped or sexually abused.

SEXUAL HERSTORIES

"Let's keep it real if we are going to talk about it."

In keeping this discussion "real," we began by discussing our first sexual experiences. For many of us this meant recalling painful memories:

"I'm 36 and I have been in the streets since, well I've been active since I was 12, because this guy told me that if I did not do what he wanted me to do, he would kill my mother. Being young and dumb and scared, I kept that all to myself. One day I did what he wanted me to do. When I went home, I could not walk because he roughed me up. I did it partially because I knew that he would kill my mother. And I knew that my mother could not defend herself, because she was ill. On the other hand, my family could not understand why I did it. They said you should have told. He went to jail because of it and they messed him up in jail, and he killed himself. My life has been up and down since then. Now I have AIDS."

"I am 38 years old and I am HIV-positive. My first sexual encounter, that I can remember, was at the age of 4. I remember it. I remember my cousin, a female, making me suck her breasts and then my male cousin rubbing his penis on my vagina. She was 16 or 17, and he was about 12 or 13. I remember it like it was yesterday. My cousin told her friend that my male cousin did it to me. I was embarrassed."

"I was 17 the first time I actually had 'sex.' It was the most horrible experience I had ever had. It was my cousins again, but different ones. They put this guy up to have sex with me. When I was coming up, you were a prude if you were a virgin, so I was lying, saying that I was not a virgin. So they put this guy up to have sex with me. It was so painful. I wanted to prove to them that I was not a virgin. My girlfriends had said that having sex was so nice. I did not have sex with a guy for a whole year after that experience."

"I had sex when I was 17. Since I knew that whatever it was that I felt for women wasn't normal, I was determined to have sex with a lot of men. I was trying to 'fuck the lesbian out of me.' While I was in college, I probably had sex with about 50 or 60 men, I was raped a couple of times, and I was drunk or high most of the time."

"Well, the first sexual experience I had was when I was 13, because everyone was doing it. I am 19 now. All my friends told me how good it felt. My best friend sort of got me into it because she told me how good it felt. So I was going with this guy for a couple of months and I said it was time. And it was

painful and it hurt. So as far as protection, as far as condoms, he said, 'do you want me to use a condom?' and I said, 'I don't care what you use.' I just wanted this done and over with."

"I used to grind up against little boys and girls in the neighborhood but I never thought I was gay, because we all did it. But at the same time I was being abused by my father from ages 8–13. Someone would come into my room and play with me and do the same things that I did with the girls and things that I later learned that I did with boys. And I was having orgasms with my father and did not know what they were. Since then, I associated orgasms as a negative thing because I thought I got those weird feelings between my legs as a sort of punishment for thinking that it felt good sometimes."

Only recently has a discourse emerged which connects the effects of early childhood sexual abuse to HIV infection in adult survivors.[2] Most of the discussion concerns the adult survivor's ability to protect herself because of these negative childhood experiences. Many women who have survived sexual abuse may not have the same resources to negotiate sex, let alone safer sex. L. Galst describes these resources as a "sense of self-worth, an understanding of their own needs and desires, an ability to assert and defend themselves, and in many cases having an active interest in staying alive."[3] While we are aware of the connection that exists between sexual and physical abuse and HIV, no comprehensive research exists to provide statistics that reflect how many women have actually been abused or how many HIV-positive women have histories of abuse. This history and reality is a key factor that must be included in prevention interventions for women.

M. T. Fullilove and R. E. Fullilove relate the importance of understanding the connection of traumatic experiences in their intervention: "Stress and Sex, a Course for Women." This four-session course, designed for women also in Narcotics Anonymous groups, begins by discussing the interconnection of traumatic childhood experiences, with STDs, HIV, and alcohol and drug use/abuse.[4] Many drug and alcohol counselors and women who have attended treatment programs have cited stories which reveal that a large number of women in treatment have had a history of sexual and physical abuse. While some treatment centers try to address sexual abuse, most have not included this relevant aspect of a woman's recovery in their treatment framework.

Sexual and physical abuse was the reality for most of us in this conversation. Two women explicitly tell of the accounts of the abuse in their lives which related to their active addiction:

"The next time I had sex I immediately got pregnant with my child. I disregarded the fact that I was still attracted to women and married this guy. He was very abusive. That went on for a couple of years. Since I came from a broken home, I always wanted that love of my father, so it was like I was always

looking for love that I was missing from my father. My mother was not really there because she was working all the time. So in looking for love, I wound up being on drugs, prostituting and doing everything to get the drugs because I was sick. When I first started using drugs, marijuana and alcohol, I was 12 years old. But when I was 19, I started on acid. And at 22, I started on heroin, cocaine, and a lot of pills, just trying to escape. The prostituting came into play when I was in my 20s also. And I liked it. I remember even before I started prostituting I used to see movies with people on the corner, and I used to think it was so cool. I don't know why, but I liked it. So when I started doing it I would make sure that I had a couple of drinks, and I would play the part, dressing up and doing the whole nine. And I would make a lot of money. To this day, the repercussions behind that are that now I don't even like sex. I was so used to sucking and fucking for money everyday even when I did not want to. In the beginning I did have a choice. But when I got strung out on drugs really bad, I did not have a choice because I had to have the drugs.

"I rarely had intercourse when I was with men prostituting. I just performed oral sex. I remember being raped when I was a functional addict. I was raped and they sodomized me. I remember that I did not have sex for almost a year after that. I would allow no penetration, because immediately and even to this day, I have problems with it. It puts me in a bad space when I have sexual experiences today. I had to get stitches because they ripped me up."

We discovered that the challenge for many of us was either to continue or to begin to work out our painful memories in order to bring about healing within our lives, so that we could feel a sense of control and power of our lives. Marge Berer states, "eliminating the threat of violence and sexual violence from women's lives would be the best sign that safer sexual relationships might be possible for women."[5]

"It is so amazing that just the slightest pressure on my neck takes me back immediately to that point when I was being raped, even though I know who I am in bed with. That's because we don't talk about those things as women and you think that it just happens to you. That happened when I was 17, so that's 25 years ago. And it is as vivid as it was then. So we need to work on changing our responses to those memories."

Even for those of us who consented to sexual encounters, our first experiences were physically painful, stemming either from ignorance or indifference about what is pleasurable for women. Peer pressure, the desire to know how sex feels, and the promise of pleasure influenced our decision-making about when to initiate sex. Promoting abstinence without addressing those influences will not be a successful strategy either to reduce the incidence of HIV or to gain more power as women within relationships. The content of the discussion must also address what is being abstained from. Those who promote

abstinence-only education don't object just to discussions about sexual inter-course, specifically penile/vaginal or penile/anal sex, but to discussion and practice of any sexual activity.

Women who know better have unsafe sex anyway. What's going on?

Many people have described reasons why women may not have safer sex. Par-ticularly when discussing the multiplicity of problems faced by women of color, AIDS is often at the bottom of the list of the things with which some women concern themselves in the hierarchy of their survival list.[6] The com-mon notion is that those realities often stem from women not wanting to upset their male partners by asking them to use a condom because they may not continue to support them and their children. Most of the women in our conver-sation could attest to needing support from a partner, but support generally had to do more with emotional than financial support. As someone said, "I can do bad by myself," referring to the fact that her partner was not helpful in terms of finances or emotional support, therefore there was no need for him to continue to come around and bring her down further. Sobo suggests from her research that the decisions to engage in unsafe sex had little to do with eco-nomic dependence, but instead were related to the emotional and social depen-dence gained from either short- or long-term relationships.[7]

"We would practice safer sex, but a few times I did not use a condom be-cause he said that he did not want to use a condom. And it was like, he said, 'he's not getting the feeling, he can't get nothing out of it.' And I remembered me doing it anyway without a condom, because of fear of losing him, Mr. Money Bags or whatever. I remember doing it, then I felt guilty afterwards. Then I felt really guilty, because I thought, 'what if he is not infected and I wind up infecting him.' Then I had to put my foot down and say, 'if we don't use this condom, then you can't have any.' And I took my chances."

Sobo's study also discusses a positive correlation between unsafe sex and women's feelings of insecurity. She posits that women with support from friends and family would be less likely to go through the denial processes asso-ciated with the decisions to have safer sex during the "emotional charged pe-riod of love making."[8] Women must have support from other women, in particular, to carry out their plans for safer sex negotiation.[9] Many safer sex initiatives are now including support groups to address ongoing behaviors and situations that place people back into unsafe sexual scenarios. Many of us had a difficult time practicing safer sex for many of the same reasons that men have cited, i.e., lack of spontaneity and loss of sensation with condom use.

"The things that he did sexually were things that I had never experienced before. He would perform oral sex on me all day, I had to say, enough is enough! He was like anytime and anywhere. But as far as protection, it was

always raw. I was just really turned on by him. I am positive now, so I do try and be careful, now that I am dealing with my HIV. He says, 'before you knew, you would let me do anything.' Safe sex really does not interest me, even though I am positive. As far as the health thing, it's okay, but as far as pleasure, like condoms and stuff, it seems like it is ridiculous—mentally. Because now when he hits that spot you have to work extra hard."

"I had an affair with a gay man who had not been tested yet but we always practiced safer sex. It was very interesting because if he had been a different person I could have also been infected. There were some times when I wanted to fuck right that second, I didn't want to wait to put on that condom. But he was really resolved, he was really good, he would not put it in without a condom. But I would have. A few times."

"I had an encounter with a male friend who is bisexual, who has AIDS. And we did not use a condom. And then I said, 'wow, well he might give me some of his virus and I might make him sicker because he did not have that many t-cells.' It just happened and it would never happen again."

"I remember one time that I had sex with a woman. This was after I had been giving safer sex workshops all over the state. I did not even think about using safer sex and/or talking about our sexual histories. Afterwards, I said to her that we should have used something. And then we decided to talk about it."

Emotional intimacy, however, is only one part of the answer and does not take into account other reasons why women have sex, one of which includes wanting to have children. A full analysis of childbearing and its relation to sexual decision-making is beyond the scope of this discussion. However, providing the tools and knowledge about sexual functioning and its connection to reproduction is essential for safer sex education. If women know how to practice sex without getting pregnant, the focus can shift to the pleasure of sex, contrary to cultural expectations which tell us that women are expected to be less arousable than men.

TALKING WITH OUR PARTNERS

Talking about sex with each other and with our friends is one thing, but we must also be able to communicate our needs to our partners. Many women find this difficult to do based on cultural realities or because of the power imbalance in their relationships. These issues must be addressed when discussing negotiation strategies with women. Many women may not even know what negotiation means.[10] Furthermore, before women can negotiate safer sex, we must be able to negotiate sex itself. Speaking our sexual desires and dislikes out loud to our partners does not usually come naturally because it challenges women's passivity.[11]

"I think that one of the hardest things is to say, 'do that, do this . . . I want you to put your finger here or there.' I think that it is easier for me to take the hand and just do it. I still do it. I have to make my partner tell me what she wants me to do. Maybe we should turn it into a game or something."

"Because I was abused I have to have full control when it comes to the bed. I am almost offended when someone does something and they think that I am going to like it. I like to tell them what I like. But it may be hard with a new sexual partner. New experiences are always exciting, and sometimes I am not sure what I would do, unless they were totally boring."

"It really depends on how long you've been with that person whether you can tell them what to do."

"I tell, especially if it hurts. That's the true test if you are in control."

"If it hurts it is not fun to me, unless we were having a consensual pain experience. Slapping on the butt, etc. Then it does not hurt that much because it was a decision that we both discussed."

"Well sometimes talking about this stuff ruins it if it is not spontaneous. But I think that letting me know ahead of time—outside of a sexual setting is better. Tell me what you like before we get in the bed."

PLEASING OURSELVES

One of the topics we addressed dealt with ways which we please ourselves whether we are getting pleasure from a partner or not. Masturbation as a safer sex behavior is an important tool to discuss. We should be reminded, however, that former Surgeon General Dr. Joycelyn Elders was fired for saying that masturbation should be discussed in school-based AIDS education as a natural part of human sexuality. She was absolutely correct. Mutual masturbation offers an alternative to penetration, and regardless of political climate, must be reaffirmed as a healthy safe sex activity. Most of us, regardless of our HIV status, reported that masturbation was a source of sexual pleasure.

"I do masturbate on a regular basis. I think it is kind of bad now. I've been masturbating since 1990 and since then I can count on my hand the number of orgasms that I have had with another person. I am so used to me doing it myself that when someone else is doing it, they can do it for hours, and I still never have an orgasm. So if I think that there is a possibility that I am going to have sex, I will not masturbate for like a month, so that I will be ready. If you know about a person's body, you know when they have an orgasm. But I am still masturbating and it feels good. It's working fine for me. I really enjoy that now."

Rarely is the physiology of human sexual response reviewed in safer sex workshops where the focus is on negotiating condom use. Human sexual

response in males is apparent and well-known, based on observation. The man is aroused, an erection follows, the penis is stimulated, the man ejaculates, and his sexual response is over. The language of sexual activity supports emphasizing penis-vagina intercourse alone. Foreplay is, by definition, not the main event. However, many women report that they achieve more sexual pleasure from sexual interactions other than intercourse. Eroticizing safer sex workshops include expanding sexual activities beyond intercourse, and the term "outercourse" has become part of the discourse. This focus involves shifting attention away from the penis or the clitoris as the sole site of sexual stimulation and pleasure, a shift that benefits women's sexual response.

But how do we feel about touching our bodies? The feminist self-help health movement of the 1970s reached mostly white, middle-class women. Now that women from the feminist health movement are working with women with HIV, some have begun to share this demystification of women's bodies with women. In the New Jersey Women and AIDS Network's Sister Connect Peer Education and Training Project, pre-tests were administered to 24 women with HIV from the Newark area. These women ranged in age from 30 to 60. All reported that they had been sexually active, yet one-third of them did not know that urine comes out of the urethra and not the vagina.[12] During a training session, an outside trainer demonstrated how to do vaginal self-examination. Despite some initial embarrassment, all the women were curious and looked. None had ever been offered a mirror by a health care provider or closely examined her own genitalia.

The second wave of the feminist movement began to analyze the earlier research on sex and developed a critical approach to understanding how the social construct of gender affects our sexuality and sexual expression.[13] Now researchers interested in AIDS are looking at the intersection of relationships and relational thinking on risk behaviors. But even the physical mechanics of female sexual response have been expanded by feminists, although this "new view" is not often included in safer sex workshops.

In the 1960s, Mary Ann Sherfey, a psychiatrist, argued that the clitoris is more than Freud's notion of an "atrophied penis"; rather, it is an entire sexual organ, with all the corollary parts which comprise the penis. The woman's sexual organ is simply arranged differently, inside the body, to accommodate reproduction.[14] In *A New View of a Woman's Body*, the Federation of Feminist Women's Health Centers (FWHCs) used Sherfey's work, along with research on their own orgasms, to describe a feminist perspective of the clitoris and to expand the anatomy of the clitoris beyond the glans, "the button" most women identify as the entire clitoris.[15]

We discussed this expanded definition of the anatomy of the clitoris in our sex conversation, which led us to a discussion about orgasm and female

ejaculation. The FWHCs identify paraurethral glands surrounding what is called the "urethral sponge of the clitoris" as the source of ejaculatory fluid. A. K. Ladas, B. Whipple, and J. D. Perry have studied this fluid and found it to be similar in composition to male ejaculate.[16] Learning about the anatomy of the clitoris and the physiology of orgasm can help women understand and deepen their own sexual response, and helps to expand the range of activities available to practice safer sex.

"I ejaculate when I am really coming, but for years I suppressed it, because it makes a mess and I didn't know what it was. When women do ejaculate, because they can have multiple orgasms, women can come 10, 12 times in the period of five minutes. At least in my experience. It's not constant, but I have had to change the sheets before I could sleep on them. It generally only happens when the inside of my clitoris has been manipulated (the so-called g-spot), or if I am on my back, or if there is direct clitoral stimulation. I can do it when I masturbate but not as much."

"I don't think that I have ever ejaculated. I have had orgasms."

"It's interesting to me because when women start to come and you are all wet and then you just keep getting wet, who knows if that wetness isn't just ejaculate."

"When I have an orgasm, I stop right away. Are you saying that if I did not stop that I could have additional orgasms?"

"Well you know there is a fine line between don't touch me any more, but switch spots and go to something else and your clitoris will still be throbbing. That's why to get additional orgasms you need to switch what you are doing and stimulate other parts of the clitoris, because it's not just that one button."

"When I am masturbating I can have four orgasms, but some people get very discouraged if they are not willing to work with me. That's why I have to tell them what they should do."

"There are different levels of orgasms. And even if you don't have one that is okay, as long as you're enjoying yourself."

SAFER SEX AND HARM REDUCTION

"I was just having sex to please my partner. I was not getting anything out of it. He does not want to use plastic wrap. It's just about getting his thing off—wham bam thank you ma'am. It was not like that though when I was prostituting and he was a trick. Now he says that it has changed. After the virus his whole attitude has changed. He is so selfish. Most of the time he did not put on his condom. Even though he knew I was HIV+. I said to him, 'if you could put your penis in me without a condom, then why can't you kiss me on the lips?' I don't understand this."

Harm reduction models of safer sex must be considered. Women must assess their risk and ultimately make decisions based on the knowledge they have about safer sex. A large part of safer sex is not so much having the information and "tools" available, but also having the willingness to take the responsibility for one's sexual behaviors and to challenge expected passive behavior.

The strategy of harm reduction with drug users was developed out of the recognition that demanding abstinence was not always the appropriate approach.[17] After all, if a drug user is not ready or willing to stop using, demanding abstinence will not reduce their risk for HIV infection. Harm reduction strategies applied to drug use include establishing needle-exchange programs, teaching how to clean works and to inject more safely, suggesting inhaling or snorting instead of injecting, and providing the option for drug treatment.

Women may not always be in a position to protect themselves from sexually contracting HIV if their male partner is not willing to use a condom. Although the concept of applying a harm reduction strategy to safer sex has not been adopted by safer sex educators, we believe it is time to begin discussing and using it.

Harm reduction as it applies to sex would involve engaging in a less risky sexual behavior. The hierarchy of HIV sexual transmission in order of highest risk is unprotected anal intercourse, followed by vaginal intercourse, followed by oral sex. If a male partner will not use a condom, it would be less risky than using nothing if a woman performed oral sex on him or if she used a diaphragm or contraceptive film for vaginal intercourse. Of course, if he would be satisfied with her manually masturbating him to produce an orgasm, rather than performing oral sex, that would be even less risky, and would be truly "safe" sex.

Woman-to-woman transmission has been documented six times in the medical literature, and seems to occur less frequently than heterosexual transmission. However, many women studies examining drug-using women show that women who have sex with women (whether they identify as lesbian or bisexual or not) consistently have higher HIV and STD seroprevalence rates than their exclusively heterosexual counterparts.[18] Lesbians and bisexual women engage in behaviors besides woman-to-woman sex which can put them at risk, thus requiring the adoption of safer sex behaviors. Harm reduction and safer sex strategies are employed by lesbians and bisexual women. When HIV-positive lesbians converse about how they negotiate safer sex, the variation in risk assessment is identified and partners speak about levels of risk: "If my partner wants to lick my clitoris then I am okay with it. I would get a little nervous if she tried to stick her tongue in me, this is because we don't know the real risks."[19]

In heterosexual sexual intercourse, women are still dependent on men's willingness to wear condoms to protect themselves. The female condom is an option as long as the woman is using it because her male partner does not object to the concept of protecting oneself. But since the female condom is visible, it is not an option for the woman who does not feel she can raise the issue of protection against HIV for fear of violence or risking the relationship. Women with HIV and their advocates have been demanding the development of a microbicide women could use without their partner's knowledge, but the United States government did not allocate any research dollars in this arena until 1995.[20] Until such a microbicide is developed, women must implement sexual harm reduction strategies if their partner is not willing to participate in HIV-prevention activities.

"Are there choices besides sex without a condom to get both the man and woman off?"

"My partner and I do practice safer sex especially if she has a yeast infection, because there were times when I would get them too when I did not know she had one and I later learned that it was from her."

"There are a lot of ways to get off without just hands. You said your partner was a great lover, but I am curious about where he learned about all of this."

"Everything that he does just turns me on. He knows that I enjoy it. Now that I am positive, I don't like him to touch me much. We tried the finger cot, we used it on the thumb, but that does not get me off. Well, it does okay for the moment. I do want to use condoms for health reasons, but I don't want to use them, because they just don't feel good."

"Will men be satisfied with hand jobs? Would that satisfy them enough?"

"It all depends, some men like different things and are willing to get off any way they can."

"The man I was with had this principle, he behaved as if he was positive but believed he was negative since he didn't want to get tested. He did want to put his penis between my breasts, and do other things without penetration. He did not like using the condom that much because he would reduce his erection. That made him more into finding other ways besides penetration to get off. But he always used a condom for intercourse."

SAFER SEX WORKSHOPS

Safer sex workshops and home parties have been developed by many safer sex educators. While a one-time safer sex workshop is better than none at all, designing a series of programs is more valuable for the participants.[21] They can come together again to discuss whether they were able to implement the

mechanical skills and communicative techniques they learned. They will also hear other women's experiences and continue the conversation. Ideally, safer sex workshops should also discuss gender-role stereotypes, power dynamics, negotiated role plays for condom use, oral sex barriers, and outercourse activities.

With one exception, all of us had attended one or more safer sex workshops. The following is a dialogue about the effectiveness of such workshops. Would women be able to talk as openly in mixed-gendered workshops?

"My partner would come with me, but I am not sure that I want him to come because he has not gotten tested yet. Although maybe going to a workshop could sort of persuade him to go get tested."

"I can talk to strange women any time instead of talking about this stuff with men."

"It really depends on whether people are coupled off, versus if there was a bunch of men and women."

"Or if the men were not going to brag."

"I know a lot of bisexual men and they really need to come to these heterosexual workshops."

Openly talking about sex may be difficult for women to do in the presence of men. Amaro suggests that issues of gender inequalities and power may not be brought out in mixed-gendered discussions.[22] Male partners play a major role in women's risk. Safer sex workshops can be developed in a targeted fashion for various groups—same-gender groups, lesbians, couples, adolescents, divorcees, partners of drug users—any group that shares some commonality as a basis for sharing of experiences.

IMPLICATIONS FOR PRACTICE AND RESEARCH—CRITICAL CONSCIOUSNESS-RAISING THROUGH CONVERSATION

The conversation we had can occur in a support group, a home safer sex party, or a get-together among friends. The conversation we had with women must also take place by men and for men. This will enable forums in which mixed-gendered groups can engage in dialogue about these issues. Empowerment processes, based on Paulo Freire's work on critical consciousness, incorporate a "listen-dialogue-action" model and can be used with the groups separately as well as when they come together.[23]

During the listening phase, issues such as the ones we used for our conversation, i.e., sex, sexuality, power, gender inequality, and safer sex will be uncovered. The dialogue phase will allow for discussion about the topics raised in the listening phase, addressing some of the following questions. What are specific reasons women find it difficult to negotiate safer sex? Are there

acceptable alternatives to penetration? Will women be able to tell their part-
ners exactly what they want from them, sexually?

Finally, the aim of this process is to allow participants to be conscious
about these issues and concerns and talk about ways to work toward either
changing or reinforcing existing behaviors. Some may question the need to
empower men, when men are already presumed to have an established power
base. Facilitation in male groups could bring about dialogue that leads men to
understand gender inequality, power, and sexual satisfaction. What do these
concepts mean to them and what role have they played in the reinforcement of
these concepts? What steps can they take to change prior ways of thinking and
behaving which have been detrimental to women?

SAFER SEX REVISITED

We challenge the often-stated maxim, "there is no such thing as safe sex, there
is only safer sex." That statement perpetuates the definition of sex as only pe-
nis-vagina/anus intercourse, since condoms can fail. Our goal in facilitating
conversations about sex through safer sex workshops is to broaden the defini-
tion of sex, making it more satisfying for women. In fact, outercourse, mutual
masturbation, and other sexual activities that do not involve penile penetra-
tion can be completely safe. Women will be able to protect themselves from
HIV infection when they have power in their relationships and an independent
sense of self-worth. Applying consciousness-raising to safe sex workshops
evokes peoples' own ability to think and analyze their experiences critically, in
comparison with the experiences of other women as well. A conscious recogni-
tion of one's own oppressions is part of the process of empowerment.

The role of a facilitator is to provide structure in the conversation. Ice-
breakers, discussions about sexual-role stereotypes, and sharing games are a
way to point out what people already know but may not think about critically.
Fullilove and Fullilove facilitated a conversation about sex among African-
American women and girls and found that all knew that women's sexual roles
were divided into "good girl/madonna" or "bad girl/whore."[24] Through con-
versation, the variation in the meaning of these roles was identified. Where do
women place themselves on the continuum of prescribed roles and how can
women break free of those prescribed practices? Women can reject roles of
passivity, and claim their own sexual pleasure and identity.

Many practitioners—social workers, health care providers, case man-
agers—are concerned about whether women will be embarrassed to discuss
sex openly. In critical consciousness-raising, it is important for facilitators,
who may be practitioners, to participate in the sharing of experiences. They
cannot be outside the process. That participation challenges the distinct role of

provider/client and pushes at boundaries that are built into a therapeutic process. Nevertheless, practitioners have a critical role to play in one-on-one interactions as well as group structures to break the silence surrounding sex.

While more research needs to be conducted to gain answers to some of these questions, we don't need to wait to begin to start having honest and explicit conversations about sex within safer sex workshops, or within support groups for women with HIV. Our conversation incorporated a consciousness-raising approach within our narrative. Any group can make up their own questions. When women start talking explicitly to each other, and are then heard by safer sex workshop facilitators, researchers, community-prevention planners, we can begin to broaden an HIV-prevention strategy to incorporate the reality of women's lives. Building support networks, lessening emotional dependence on a primary partner, and valuing self are critical elements to incorporate behaviors to protect women from HIV infection.

NOTES

1. Chris, Cynthia. "Transmission Issues in Women." In *Women, AIDS, and Activism*, ACT UP/NY Women and AIDS Book Group (Boston: South End Press, 1990). See also M. T. Fullilove, R. E. Fullilove, K. Haynes, and S. Gross, "Black Women and AIDS Prevention: A View Toward Understanding the Gender Rules," *Journal of Sex Research*, vol. 27, no. 1 (1990): 47–64; E. J. Sobo, "Finance, Romance, Social Support, and Condom Use among Impoverished Inner-City Women," *Human Organization*, vol. 54, no. 2 (1995): 115–128; H. Amaro, "Love, Sex and Power: Considering Women's Realities in HIV Prevention," *American Psychologist*, vol. 50, no. 6 (1995): 437–447.

2. L. Galst, "Behind Closed Doors," *Village Voice* (September 1, 1992): 23. See also S. Rosenfeld and D. Lewis, "The Hidden Effect of Childhood Sexual Abuse on Adolescent and Young Adult HIV Prevention: Rethinking AIDS Education, Program Development, and Policy," *AIDS & Public Policy Journal*, vol. 8, no. 4(1993): 181–186; J. Cassese, "The Invisible Bridge: Child Sexual Abuse and the Risk of HIV Infection in Adulthood," *SIECUS Report*, vol. 21, no. 4(1993): 1–7; C. Kidman, "Non-Consensual Sexual Experience & HIV Education: An Educator's View," *SIECUS Report*, vol. 21, no. 4 (1993): 9–12.

3. Galst, "Behind Closed Doors."

4. M. T. Fullilove, and R. E. Fullilove, *Stress and Sex: A Course for Women*. Facilitator manual. Unpublished manuscript by the Community Research Group, the New York State Psychiatric Institute, Unit 29, 722 West 168th St., New York, New York 10032.

5. Marge Berer, *Women and HIV/AIDS: An International Resource Book* (London: Pandora Press, 1993).

6. V. M. Mays and S. D. Cochran, "Issues in the Perception of AIDS Risk and Risk

Reduction Activities by Black and Hispanic Women," *American Psychologists*, vol. 43, no. 9 (1988): 949–957. Also, Fullilove, et al., "Black women."

7. Sobo, "Finance, Romance, Social Support. . . . "

8. *Ibid.*

9. Amaro, "Love, Sex and Power."

10. Mays and Cochran, "Issues in the Perception of AIDS."

11. S. Hite, *The Hite Report* (New York: Dell Publishing, 1976).

12. New Jersey Women and AIDS Network, New Brunswick, New Jersey. The authors reviewed this unpublished data from pre- and post-tests administered during the program.

13. A. Snitow, C. Stansell and S. Thompson, *Powers of Desire: The Politics of Sexuality* (New York: Monthly Review Press, 1983).

14. Rebecca Chalker, "Sexual Pleasure Unscripted," *Ms.*, vol. 6, no. 3 (1995): 49–52.

15. Federation of Feminist Women's Health Centers, *A New View of a Woman's Body* (New York: Simon and Schuster, 1981). See also, Mary Jane Sherfey, MD, *The Nature and Evolution of Female Sexuality* (New York, Vintage Books, 1973).

16. A. K. Ladas, B. Whipple, and J. D. Perry, *The G Spot* (New York: Dell Publishing, 1981).

17. Risa Denenberg, "Applying Harm Reduction to Sexual and Reproductive Counseling: A Health Provider's Guide to Supporting the Goals of People with HIV/AIDS," *SIECUS Report* (1993): Oct/Nov.

18. R. M. Young, G. Weissman, and J. B. Cohen, "Assessing Risk in the Absence of Information: HIV Risk Among Women Injection Drug Users who have Sex with Women," *AIDS and Public Policy Journal*, vol. 7, no. 3 (1992): 175–183.

19. People with AIDS Coalition of New York, "Lesbians Living with AIDS," *Newsline* (June 1996): 7–15.

20. V. Thandi James, "Microbicides: An Issue of Female Empowerment," *NJWAN News*, vol. 5, no. 2 (1995): 3.

21. Nabila E. El-Bassel, and Robert F. Schilling, "15-Month Follow-Up of Women Methadone Patients Taught Skills to Reduce Heterosexual Transmission," *Public Health Reports*, vol. 107, no. 5 (1992): 500–503.

22. Amaro, "Love, Sex and Power."

23. Paulo Friere, *Education for Critical Consciousness* (New York: Continuum, 1973); L. Gutierrez, "Working with Women of Color: An Empowerment Perspective," *Social Work*, vol. 35, no. 2 (1990): 149–153; J. Rappaport, "Terms of Empowerment/Exemplars of Prevention: Toward a Theory of Community Psychology," *American Journal of Community Psychology*, vol. 15 (1987): 121–148; N. Wallerstein, "Powerlessness, Empowerment and Health: Implications for Health Promotion Programs," *American Journal of Health Promotion*, vol. 6, no. 3 (1992): 197–205.

24. Fullilove, et al., "Black Women."

Gendered Silence

Representation—
Exclusions and Inclusions

Maybe Next Year
Feminist Silence and the AIDS Epidemic

Paula Treichler and Catherine Warren

"There is not one, but many silences, and they are an integral part of the strategies that underlie and permeate discourse."
(Michel Foucault 1976, 27)

WOMEN AND THE "GAY MEN'S DISEASE"

Cases of AIDS and AIDS-like symptoms were reported in women as early as 1982, only the second year of the AIDS epidemic's official existence.[1] More than a decade later, in 1993, a woman named Beverly, recently diagnosed with AIDS, was interviewed for a prime-time news segment on the growing epidemic among women. Beverly had gone to a series of physicians before one finally tested her and diagnosed HIV: "They never looked for this disease in me," she told the reporter, "being as how they thought it was a gay men's disease."[2]

How had Beverly and her physicians missed the news that HIV can be transmitted to and from women? That AIDS was no longer "a gay men's disease," if indeed, it ever was? How had mainstream media themselves missed the news? By 1988, HIV had been widely proclaimed "an equal opportunity virus," transmitted through "what you do," not "who you are." By 1993, several thousand women had been diagnosed with AIDS and HIV infection in the United States—to say nothing of worldwide estimates in the

millions. Was Beverly unusually dense in failing to get the message? Were her physicians unusually ignorant?

The short answer is no. The long answer is more complicated and contradictory. It is the subject of this essay, an investigation of silence about AIDS and women. Broadly, it asks, why, today, in 1996, fifteen years into the epidemic, the fact that women get AIDS is still perceived as novel. It seeks to understand how silence, contradictory information, and ambivalence in many arenas, including the feminist community—where one might have expected to find activism and educational commitment—helped contribute to the situation of Beverly and other women with HIV.

"Silence" is a complicated cultural phenomenon, with multiple sources and causes. When a woman—any woman, indeed any person, in a rich, technologically sophisticated, postindustrial democracy—can become infected with a deadly virus years after the knowledge is available to prevent it, many sites of silence are implicated and many points of intervention have failed. What might have changed the broad cultural understanding of women and AIDS? What might have enabled Beverly and other women to identify and cope more effectively with the loaded new risks the epidemic posed? What different representations, language, educational approaches, spokespeople, or cultural models might have produced a different outcome? One way to begin to answer these questions is to document the evolution of representation and understanding over the course of the epidemic. In doing so, we can also look more closely at how AIDS and HIV are presented by and to various U.S. constituencies—as narrow personal risk, as urgent public health issue, as social phenomenon, as cultural crisis. What meanings are articulated, to whom, and to what are they linked?

This essay examines the failures, obstructions, and silences that have hindered our understanding of women's relation to HIV. It asks what we knew about HIV, when we knew it, and what lessons we can learn for the future. It also asks who is meant by "we." Who are the "we" with the knowledge to slow the spread of HIV to women? The "we" responsible for deploying that knowledge? The "we" who helped or impeded that deployment? In seeking answers, this essay is concerned not only with the conventional bad guys of AIDS scenarios—U.S. biomedical institutions, the media, Congress, the Christian Right, and the rest of the usual suspects. It also explores the failures and silences of the "good guys"—the feminist movement and the field of women's studies, constituting a "we" closer to home. This "we" includes us, the authors.

Silence about AIDS was, of course, never total. Like most Americans, Beverly knew the basic AIDS 101 message: AIDS is caused by a virus. That virus can be transmitted through sexual behavior, sharing contaminated drug

needles, or receiving contaminated blood or blood products. A fetus can become infected through its mother's infected blood. Finally, preventive behavior, such as the use of a condom, can reduce the likelihood of sexual transmission. But Beverly obviously still thought of AIDS as it had been initially and powerfully framed: a disease of the "4-H Club"—homosexuals, hemophiliacs, heroin users, and Haitians—with homosexuals leading the charge. Each member of those four groups, though for somewhat different reasons, was presumed to be male. And where sexual transmission was concerned, AIDS was almost universally understood as "a gay men's disease."[3]

Numerous analysts have sought to explain the power of this early framing and to debate its immediate and long-term consequences. We do not intend to revisit these questions here.[4] Nor do we wish to argue that the linking of AIDS to the gay community is historically inaccurate. As Edward King eloquently argues in his 1993 book *Safety in Numbers*, it was the gay population who first contracted AIDS and HIV in large numbers, who organized pioneering struggles against the disease, and who continues in many places to bear the brunt of the tragedy. (Despite these facts, many governments, including those in the United States and the United Kingdom, have still not launched public health education and intervention campaigns targeted specifically for gay men.) It is in the context of this framing that our examination of women and AIDS must necessarily occur. Additionally, key biomedical authorities on AIDS in the U.S. (C. Everett Koop, Mathilde Krim, and James Curran, among others) also cautioned early and often that *no group* should feel complacent about this epidemic. The Centers for Disease Control (CDC) certainly never told women to relax. It should not be surprising, though, that in the numerous struggles to call attention to the epidemic and obtain funding, institutions long accustomed to overlooking women—medicine, the media, state and federal legislatures and, to a degree, even gay men themselves—initially overlooked them in the case of AIDS as well. No one had time for a hypothetical future problem of women with AIDS in the face of federal indifference, CDC cutbacks, media passivity, and ambiguous data.[5]

As Beverly's case suggests, these early silences persisted and continued to effect what happened to women with AIDS. Only now, in the mid-1990s, can we really begin to evaluate the costs for women worldwide. These include continued barriers to diagnosis and care, exclusion from treatment and support programs, lack of information about sexuality and reproduction, lack of preventive technologies designed for women, and lack of resources and support services for women, children, and families. Moreover, the HIV/AIDS epidemic continues to fuel a relentless conservative agenda for women and amplifies already vocal calls for surveillance and punishment.[6] And finally, but not

insignificantly, our theoretical models of AIDS are still based primarily on research studies of men with HIV. When the World Health Organization estimated in 1990 that three million women worldwide were infected with HIV, its chief of surveillance noted: "Whether the natural history of HIV infection in women differs to any significant degree from that outlined for men is not known, and the detailed studies needed to answer this question are very difficult to plan and put into effect" (Chin 1990, 4). By 1992, with the HIV "gender gap" steadily closing and estimates that global HIV infection among women would soon equal that of men, it was still the case that little information existed specific to women.[7] Yet some gender differences are clearly relevant to diagnosis, treatment, and the design and delivery of services. For example, preliminary findings from an ongoing international study offer striking evidence that women's risk of HIV infection worldwide is linked in complex ways to their gendered social and economic status:

> In many settings, the cultural norms that demand sexual fidelity and docile and acquiescent sexual behavior among women permit and sometimes even encourage—early sexual experimentation, multiple partnerships, and aggressive and dominating sexual behavior among men. (Gupta, Rao, and Weiss 1993, 399)

One might even say that women contract HIV infection not only because of "what they do" but also because of "who they are." As Beth Schneider has pointed out, the AIDS epidemic simply exacerbates the mundane inadequacies of existing women's health care:

> Women need more of what they needed before AIDS—drug treatment programs for women, especially for those with children; sustained prenatal care; increased foster care services and childcare facilities; confidential counseling at family planning and prenatal clinics; continued access to abortion and state-funded abortions; sex education; national healthcare in some form; and basic survival provisions in food, clothing, and shelter. (1988, 104)

U.S. AIDS experts and opinion leaders interviewed in November 1994 for a study of AIDS stigma and discrimination emphasized that as women continue to become infected and ill, economic, social, and psychological costs will mount. The study's authors are pessimistic about the future: "Too often women are thought of as dispensable," they conclude, "and [their] dispensability as merely the natural order of things" (Public Media Center 1995, 16).

Such studies help document the effects of early silence about women and

AIDS. Those familiar with the longer history of women's health might have predicted that when women with AIDS did turn up, little public concern would be expressed about them except as threats to others: to their innocent babies if they were known to be pregnant, to their innocent clients if they were believed to be prostitutes, to "the general population" if they were neither of the above. Those familiar with the recent history of U.S. feminism, however, could not have predicted that on the subject of women and AIDS, feminists, too, would be largely silent in those critical first few years. While gay men fought against the disease, joined in their efforts by a core of health care professionals, community service providers, and a handful of activist lesbians and organized sex workers, most members of the mainstream feminist movement watched from the sidelines—or did not watch at all. Feminism did not take up the cause of AIDS even after heterosexual transmission became the fastest growing source of HIV infection in women. Here, feminism's special domain—straight men and their power over women—could, with some justification, have been evoked. Silence and ambivalence remained the operative status quo for mainstream feminism from 1981 until January of 1991, when *Ms.* magazine at last published a serious cover story on the scope and politics of the epidemic ("Women and AIDS," 16–33). By then more had been done on behalf of women by individuals and groups *outside* mainstream feminism, including, surprisingly, the slick women's magazines, as well as front-line health and service agencies, lesbians, predominantly male AIDS organizations like Gay Men's Health Crisis and ACT UP, and academics in various eclectic coalitions.[8] Moreover, even though the influence of the AIDS epidemic on policy, law, and health activism continues to be profound, AIDS/HIV is still not a firmly established item on the feminist or women's studies agenda.

Should it be? Yes. We believe that the AIDS epidemic encapsulates many goals and issues fundamental to women's interests and women's health: reproductive freedom, sexual equality, civil liberties, economic self-sufficiency, the right to effective protection against conception and disease, and the rest of a long-standing program. Even within the AIDS establishment and AIDS activism, there remains the need for voices to speak on behalf of women. A 1995 special issue of the PWA newsletter *Newsline* on HIV and pregnancy makes clear that childbearing women with HIV have few champions:

> For people with AIDS/HIV, the right to privacy and self-determination have been of paramount importance. Many battles have been fought over these issues and some have been won. Most people with AIDS and those affected are strong advocates for the right to make personal choices about everything from treatment to disclosure. Yet when people with AIDS are also female and pregnant, the discourse

around privacy and individual rights often takes a huge shift. (*Newsline*, 1995, p. 7)

A WORD ABOUT METHOD

This essay explores the troubled entry of women into the U.S. AIDS epidemic. Because we are interested in the evolution of AIDS awareness and concern within various women's and feminist communities, we use media coverage as an index of cultural knowledge. Because we are also interested in the direction, flow, framing, and interpretation of information and thinking about women and AIDS, we examine three specific domains of AIDS coverage in the print media: mainstream publications, glossy women's and feminist magazines, and alternative (including academic) feminist publications. This provides a rough method of tracking contributions and challenges to the dominant reading of AIDS—that AIDS is a gay men's disease and an epidemic that has little relevance for women. In asking who speaks for women, we explore, in particular, the dynamic of feminist silence surrounding AIDS.

In the following sections, we present capsule chronologies of women and AIDS coverage during the critical period 1981–1988 for the three media domains just identified. We then discuss these findings in the light of several key theoretical issues: the problematic representations of women and gender that underlie the construction of conventional AIDS chronologies; the processes by which media, whether "dominant," "alternative," or "oppositional," frame issues for their readers and audiences; and the complex responsibilities inherent in silence as well as in communication. Even now, we argue, feminist attention to the HIV/AIDS epidemic remains inadequate; nevertheless, at a point in history when new HIV infections are in principle essentially preventable, although in practice far harder to prevent, feminist insights and resources are absolutely critical. The epidemic continues to offer opportunities for feminist voices to be heard and to have significant impact on the course of the epidemic and related decisions about women's health.

CHRONOLOGICAL OVERVIEW OF MEDIA COVERAGE

In this section, we sketch how the HIV/AIDS epidemic—as disease, as disease affecting women, and as broad cultural crisis—was covered and constructed over time within three broad media categories or frames: the biomedical and mainstream press, the mainstream women's and feminist press, and the alternative women's press. The first category encompasses medical journals and leading media, where we find much of the key data through which accepted accounts of the epidemic and its epidemiology emerged; the second category encompasses media coverage in the glossy women's magazines, and in the

glossy feminist magazines like *Ms.* and *New Woman*; the third category includes journals like *Spare Rib, Off Our Backs,* and *Gay Community News,* and academic feminist journals such as *Signs* and *Hypatia.*[9]

MAINSTREAM AND MEDICAL COVERAGE

1981–1982

On June 5,1981, the *Morbidity and Mortality Weekly Report,* published by the Centers for Disease Control in Atlanta, described five cases of young, otherwise-healthy homosexual men with *Pneumocystis carnii* pneumonia in Los Angeles. Subsequent issues of the *MMWR* documented additional cases of unexpected illnesses in other cities. The mainstream media published three articles in 1981 on the new mystery disease plaguing gay men.

One year later, in July 1982, the CDC reported the first cases of the syndrome in men with hemophilia. At this point, the American Red Cross advised lesbians as well as gay men to refrain voluntarily from donating blood. In September 1982, an *MMWR* "AIDS Update" on the epidemic in the United States officially adopted the term acquired immune deficiency syndrome, or "AIDS." In this issue, it listed cases among women for the first time: of 593 total cases to date, 34, or 5.7 percent, were among women (*MMWR* [Sept. 24, 1982]: 607–614). In December the CDC reported cases of immune deficiency and opportunistic infections in infants and posited the existence of "vertical transmission" from mothers to their infants in utero or shortly after birth (*MMWR* 31 [Dec. 17, 1982]: 665–667). By the end of December 1982, 57 adult women, or 6 percent of total cases, had been diagnosed with AIDS (*MMWR* 31 [Jan. 7, 1983]: 697–698).

The mainstream media was not immune to this medical news. By the end of 1982, the general mainstream media had published 10 articles on the baffling new "epidemic of immune deficiency." Several articles, including the first front-page story on AIDS in a major newspaper (*Los Angeles Times* May 31, 1982), focused on the appearance of AIDS not in gay men but in hemophiliacs and infants, the "innocent victims" of the epidemic.

1983–1984

By Spring 1983, nearly two years into the epidemic, the CDC had found no evidence that "casual contact" contributed to the transmission of AIDS. In May 1983, however, a study in the *Journal of the American Medical Association* claimed to have identified cases of AIDS spread through "routine close contact" (Oleske, et al. 1983). An accompanying editorial by Anthony Fauci acknowledged the possibility of vertical transmission but emphasized the less likely, but more sensational alternative of routine household contact. Predictably, the wave of national media coverage that followed underlined the

dire implications of the household contact scenario. In response to intense pressure from the CDC and other AIDS authorities on the epidemic, the journal quickly downplayed the possibility of household contact in favor of vertical transmission—but this did little to contain the first round of "spread-of-AIDS" stories in the mainstream press. The ensuing "moral panic" (Watney 1996) was reinforced when reported AIDS cases reached 1,000—the kind of milestone the media rely on. By the end of 1983, two years into the epidemic, 77 articles had been published on AIDS in mainstream magazines.

For 1984 the *Reader's Guide* listed a total of 70 articles on AIDS. Of those, 52 were medical in nature, a focus partially brought about by the news that researchers had isolated the virus said to be the agent responsible for AIDS. Although a few titles left open the possibility that both sexes might be affected by AIDS, e.g., "AIDS Has Both Sexes Running Scared" (Cantarow 1984), no articles focused explicitly on women. Mainstream magazines mentioned and advocated safe sex for the first time in 1984. With the development of a test for antibodies to the virus, however, getting tested was pitted against safer sex and some articles urged anxious heterosexuals to get regularly tested as a solution to the problem of sex in the age of AIDS.

1985

In 1985, media coverage of AIDS in the United States increased dramatically. The *Reader's Guide* listed 176 AIDS articles, an exponential increase from 1984. In March, the first antibody test became available. In June, Hollywood great Rock Hudson acknowledged that he had been diagnosed with AIDS and was seeking experimental treatment at the Pasteur Institute in Paris. Between June and Hudson's death in October 1985, mainstream media coverage (print and electronic) climbed from an average of 18 stories to an average of 111 stories per month.[10] In July, *Life* ran a cover story on AIDS titled—in bold red letters— "Now No One Is Safe from AIDS" (Barnes and Hollister 1985). Cover photos showed a clean-cut white nuclear family, a black soldier in uniform, and a young white woman, all seemingly unlikely victims. All, in fact, had acquired HIV through familiar routes of transmission (respectively, blood products for hemophilia, transfusion, and sexual contact with a man with AIDS). The Burks, the wholesome nuclear family, were featured in many print and television stories, which typically cited the requisite elements that made them "innocent victims": they look like "a typical U.S. family," the father, Patrick, contracted HIV through contaminated blood products for treating his hemophilia. He then unknowingly passed the virus to his wife, Lauren, before he knew he was infected, and she, also unknowingly, passed it to their son, Dwight, during pregnancy or breastfeeding.

So it seems that despite erratic media coverage, "gay" had become the

presumed norm. Only exceptions, non-gay AIDS cases, were news. Both the *Life* and *Newsweek* covers were widely reprinted (together with the infamous tabloid headline "Long Island Granny Dies of AIDS!"). Media images were now available as graphic icons for the disease and, inevitably, media coverage itself became a story. *Newsweek*'s bold red Hudson cover, for instance, even appeared in the made-for-TV movie, "An Early Frost," broadcast on NBC in November 1985, to make the point that AIDS was an important public health crisis and information widely available. While public attention was still riveted on the Rock Hudson case, which was interpreted by some to mean "regular guys" were at risk, *JAMA* reported (in October 1985) the possibility of female-to-male transmission of HIV [HTLV-III] among U.S. servicemen in Germany; investigator R. R. Redfield suggested that "prostitutes could serve as a reservoir for HTLV–III infection for heterosexually active individuals." (*JAMA* [Oct. 18, 1985]: 2094–2096). Mainstream AIDS coverage for 1985 included only four stories explicitly about women and 10 about children.

Amid the consternation and confusion produced by these reports of seemingly "heterosexual" transmission, science writer John Langone's December 1985 article in the magazine *Discover* tried to set the record straight. In his view, AIDS posed no threat to the vast majority of heterosexuals because "AIDS is—and is likely to remain—the price paid for anal intercourse" (Langone 1985, 52). Though Langone's position departed from the thinking of a significant number of epidemiologists and biomedical authorities at the time, he argued with great clarity and few qualifications that a crucial physiological dichotomy between the rectum and the vagina protects women from HIV; unlike the "vulnerable rectum," the "rugged vagina," built by nature to take abuse, is therefore too tough for the virus to penetrate. Langone's assertion that AIDS was still, after all, a "gay men's disease" may not have been correct, but it was irresistibly clear and provided welcome relief from confusion and anxiety.

In the years to come, the media would often assert that women were as vulnerable to HIV as men and just as often categorically assert that they were not. (By the mid-1990s, when women began to account for more new infections and AIDS cases than men, they would assert that women were *more* vulnerable to HIV.) Meanwhile, the experts played their own version of is-she-or-isn't-she, with some espousing the Langone view, others disputing it, others voting don't know. Redfield's reports in *JAMA* suggesting female-to-male transmission, for example, provoked intense debate, in *JAMA* and elsewhere, over whether it was possible for women to be infected with HIV and in turn infect men through sexual contact. One proposed alternative was that apparent transmission via female prostitutes was actually "quasi-homosexual" (Client B contracting HIV from the reservoir of infected

semen from Client A)—a view that preserved the "gay men's disease" conception of AIDS.

1986–1987

In April 1986, the Association for Women's AIDS Research and Education (Project AWARE) in San Francisco launched a study to begin to assess HIV antibody seroprevalence in high-risk women in California; "high-risk" was defined as women reporting five or more sexual partners in the previous five years, or sexual contact with a high-risk male, and the study encompassed both prostitutes and non-prostitutes. The findings, published subsequently in the *MMWR* (36 [March 27, 1987]: 157–161), reported the same rate of seroprevalence in both populations—4 percent. The prostitutes who tested positive reported a history of IV drug use. How was this interpreted? Poorly. A multi-center study of female prostitutes, entitled "Project 72," was initiated by the CDC to clarify the issues. Of the 1,396 women enrolled, seroprevalence among those with no reported IV drug use was 4.8 percent; but this was perhaps high because many women in the study were from the Miami area, with its higher migration from the Caribbean, where heterosexual transmission was more common. Other news compounded the confusion. A possible case of female-to-female transmission was reported in a letter to the *Annals of Internal Medicine* (Marmor, et al. 1986). In March 1986, the Nevada Board of Health required prostitutes to be tested for HIV antibody as a condition of employment and, once employed, tested monthly thereafter (Campbell 1991); prostitutes themselves asked that clients be required to use condoms. In June, the CDC reported that IV drug use still accounted for the largest number of AIDS cases among women, at 20 percent; but the next highest category of transmission was "other," leaving a mysterious hole in the statistics. In November 1986, the *New York Times* spelled out AIDS' lessons to date: Women are "obliged to take on a new kind of responsibility for their sexuality and to reassess their roles as health professionals, relatives, lovers and friends of people with AIDS" (No lesson is offered to men, straight or otherwise.) By the end of December 1986, the CDC reported a total of 2,062 adult women with AIDS in the U.S., compared to 27,627 men, or 6.9 percent of the total.

The problem is that only a small number of researchers were focusing specifically on women and how they were represented (Corea 1992, discussed this research). The rest of the AIDS literature of this period tended to finesse the question of AIDS and HIV infection in women: in one review article on psychological issues in AIDS, for instance, women were mentioned only under such headings as "pediatric AIDS"; authors simply did not discuss the fact that most cases of "pediatric AIDS" presuppose a case of "maternal AIDS" acquired somewhere. The scenario was a familiar one: women with HIV/AIDS

were bracketed as individual exceptions or special populations, or as so patho-
logically diseased as to be uninteresting, or as mere medical surrogates for
their male partners or children. Randy Shilts, in his best-selling *And the Band
Played On* (1987), devoted only ten pages to "heterosexuals," and used most
of that space to concentrate on the story of a female prostitute. His only index
entry for "women" mentions that Larry Kramer wrote the homoerotic screen-
play for the film *Women in Love*.

An effort to dispel this silence was made by researchers Mary Guinan and
Ann Hardy, whose paper "Epidemiology of AIDS in Women in the United
States: 1981 through 1986" appeared in the *Journal of the American Medical
Association* (vol. 256(15) [May 17, 1987]: 2039–2042). Findings to date,
they contended, confirmed predictions that HIV/AIDS was being transmitted
heterosexually, to and from both women and men. Guinan and Hardy's article
was one of the first medical accounts to focus on women as a broad popula-
tion—rather than singling out prostitutes. While statistical increases among
women were less dramatic than those encountered previously among gay men,
they argued, vigilance and educational intervention were critical, especially in
several identifiable sub-groups, including female sexual partners of IV drug
users. They challenged the "rugged vagina" hypothesis: in fact, they argued,
we know very little about how much protection the vaginal mucus membrane
affords, but epidemiological and clinical experience with other STDs suggested
it may be quite permeable. Calling for prudence, they advocated risk-
reduction behavior for women, including "celibacy and having only one life-
time sexual partner." In an accompanying editorial in *JAMA*, Constance Wofsy
called attention to some of the misleading ways in which AIDS was repre-
sented visually (Wofsy 1987). People with AIDS were usually still pictured as
gay males, she noted, and when images of women appeared, they were white
and healthy. While such atypical images avoided stigmatizing or stereotyping
women who *did* have AIDS and sent the important message that despite
stereotypes about the epidemic, many kinds of people are potentially at risk,
they also reinforced the incorrect message to women of color and others that
they were *not* at risk, she noted.[11] Perhaps the one consistent message was that
infected or not, the burden was on women themselves to prove they mattered.
In a special AIDS issue in October 1988, *Scientific American* recapitulated the
story of the Burk family, who were featured in the big 1985 *Life* cover story
(Barnes and Hollister 1985) as a typical American nuclear family who just
happened to have AIDS (Patrick Burk's hemophilia was not evident in the
photos). Reproducing the *Life* photo, *Scientific American* updated the Burks'
story (p. 91): "When the photograph was made, Patrick and Dwight already
had AIDS; they have since died. The daughter, Nicole, is not infected." The
pattern of reporting on the condition of the husband and children, but not the

wife, or mother, or woman is not atypical. In these accounts, women remain primarily characters in other people's stories. Indeed, even in Guinan and Hardy's admirable article (1987), they (or perhaps their journal editor) felt obliged to argue that women with HIV and AIDS were of "special interest" to medicine for several reasons—none because women themselves were worthy medical subjects:

> [W]omen with AIDS or [HIV] are the major source of infection of infants with AIDS, and the second most common route of transmission of AIDS to women is through heterosexual intercourse. Trends in AIDS in women may help to determine future trends for pediatric cases and may be a good surrogate for monitoring heterosexual transmission of infection.

This was a theme that repeated itself at the Third International AIDS conference in June 1987, where researchers characterized women as "vessels of infection" and "vectors of perinatal transmission."

In September 1987, the CDC revised its AIDS guidelines and diagnostic criteria, and some researchers believed its expanded case definition would prove more sensitive in identifying signs and symptoms of HIV in women. On Dec. 31, 1987, the CDC reported 3,751 adult females with AIDS in the U.S., compared to 47,014 adult males, or 7.4 percent of the total cases among adults with AIDS. The official CDC message, nonetheless, was that although every sexually active person should be cautious, women and heterosexuals still made up only a tiny percentage of cases of HIV infection. Paradoxically, even as AIDS continued to be represented and understood primarily as a "gay men's disease," various versions of the following "urban legend" were turning up all over the U.S.: a straight man meets an attractive young woman at a singles bar and takes her back to his apartment where they make love (without condoms); she is gone the next morning, but written across the bathroom mirror in bright red lipstick he reads, "Welcome to the World of AIDS!" (Fine 1987). This contaminated woman was a cultural icon with a life of its/her own, a story waiting to run.

And run it did, in late 1986 and early 1987. In the last months of 1986, three different biomedical reports on AIDS—from the U.S. Surgeon General, the Institute of Medicine/National Academy of Sciences, and the World Health Organization (WHO)—collated available data and reached the same conclusion: the AIDS epidemic was urgent, global, increasingly transmitted through sex between men and women, and required immediate intervention. The reports received enough media coverage to launch major stories on AIDS as a threat to "all of us" in *Newsweek, The Atlantic, Village Voice*, and elsewhere.

On the *U.S. News and World Report* cover, a young white urban professional couple stared somberly out at the reader over the caption "What *You* Need to Know about AIDS" (Jan. 12, 1987); *Time*'s cover story, called "The Big Chill," showed a giant wave about to crash (Feb. 16, 1987). The tabloids got into the act. The *Weekly World News* on May 12, 1987 produced a morality tale of a female surgeon who literally infected her partner with AIDS: "Wife Murders Hubby with AIDS Cocktail" (The subheading: "He should have had a V–8!"). "Farewell, Sexual Revolution. Hello, New Victorianism," trumpeted a *Futurist* magazine title (CITE). One brand of condom reported a 55 percent increase in sales.

The *Reader's Guide* listed 231 articles on AIDS in 1987; women, with five articles, finally got their own sub-category in the listings (nine articles were on children). A cover story in the February 1987 *Atlantic Monthly*, "Heterosexuals and AIDS," showed a man and a woman huddled separately under their blankets, arms crossed protectively around their legs. Writer Katie Leishman warned against three "sub-populations" who constitute the danger for heterosexuals: Catholic priests, married gay men, and single, sexually active bisexuals (Leishman 1987). A similar theme was struck in *The Real Truth about Women and AIDS* by New York sex therapist Helen Singer Kaplan. The 1987 book spelled out the implications for women, arguing that their "moist vulnerable mucous membranes" put them at high risk for HIV. In Kaplan's view, women were the hoodwinked victims of individual men and a duplicitous federal government, who were selling them a bill of goods about "safe sex." "There are no safe behaviors, only safe partners," she wrote. In an August *Newsweek* interview on the book, Kaplan said, "I felt like Cassandra" (Seligman 1987).

1988

In January 1988, Cassandra was trumped. *Cosmopolitan* magazine published an article by a Dr. Robert E. Gould designed to reassure *Cosmo*'s women readers about AIDS: "There is almost no danger," wrote Gould, "of contracting AIDS through ordinary sexual intercourse," that is, unprotected penile-vaginal intercourse with an infected man. Gould, a psychiatrist with no special expertise in AIDS research or treatment, argued that a "healthy vagina" was protection enough against the virus. If it were not, he reasoned, the prevalence of AIDS in the U.S. heterosexual population would by now be extensive. To account for the existence of widespread HIV infection among heterosexual men and women in Central Africa, Gould offered two explanations: homosexuality among African men was common but taboo and therefore not acknowledged to investigators; and "many men in Africa take their women in a brutal way, so that some heterosexual activity regarded as normal

by them would be closer to rape by our standards" (Gould 1988, 146).

Though Gould's article was not unique in making categorical claims about women and AIDS based on limited research and experience (see Treichler 1988b), none had appeared in so widely read a publication as *Cosmo*. ACT UP immediately picketed and protested, calling attention to the article and calling for a boycott of *Cosmo*. The controversy was picked up by other media; Gould appeared on local and national talk shows, given automatic credence in some cases by his M.D. degree. On ABC's *Nightline*, however, Gould appeared with *Cosmo* editor Helen Gurley Brown, who claimed that while risk of HIV for normal heterosexual women was virtually nonexistent, *Cosmo*'s message was that women should "be safe—use condoms." "I'm sorry to contradict you," responded Ted Koppel, "but I read the article very carefully and that is precisely what you *don't* say."

These texts about women, such as they were, went largely unchallenged. Neither mainstream nor medical media took the time or responsibility to analyze and account for competing claims. They simply published them in serial order, touting each as "news." Indeed, the *Cosmo* splash had barely subsided when noted sex researchers William Masters and Virginia Johnson, with Robert Kolodny, declared in their book *Crisis: Heterosexual Behavior in the Age of AIDS* (Masters, Johnson, and Kolodny 1988) that "the AIDS virus is now running rampant in the heterosexual community." Hard on the heels of *Crisis* came Michael Fumento's book *The Myth of Heterosexual AIDS* (1990), which claimed there was no scientific evidence that HIV could be acquired through normal heterosexual intercourse.

As of August 1990, the number of women (adult and adolescent) in the United States officially diagnosed with AIDS included 7,000 women who were black, 3,500 who were white, 2,500 who were Hispanic, 75 who were Asian or Pacific Islander, and 30 who were Native American. The number of additional women in the U.S. with HIV infection and HIV-related symptoms was estimated to be much larger; Mays and Cochran estimated in 1988 that about 100,000 women were HIV-infected, with the total number of reported AIDS cases expected to reach 22,000 to 30,000 by 1991. These numbers conformed to earlier CDC predictions of a gradual increase of AIDS cases in the "heterosexual population."

THE WOMEN'S AND FEMINIST GLOSSIES

1981–1983

How did mainstream women's and feminist magazines frame the AIDS crisis during this same period? No articles appeared in these outlets during 1981 or 1982. In 1983, three articles were listed in the Reader's Guide: one in *Ms.* in May and two in the *Ladies Home Journal* in November. The *Ms.* story,

by Lindsay Van Gelder, was titled "The Politics of AIDS." Though it assumed that "a good many lesbians are monogamous" (and therefore not at risk for AIDS?), it examined the politics of funding and the problems of racism and homophobia (Van Gelder 1983). In the *Ladies Home Journal*, "AIDS: The Latest Facts," by Bibi Weinhouse, presented AIDS as an epidemic still confined to the familiar "high risk groups" but nevertheless as news, and as a potential personal health issue for women (Weinhouse 1983). The other AIDS story in that issue, "AIDS: What It Does to a Family," by K. Barret, was a sympathetic profile of the widow of a bisexual man who died of AIDS. "People need to understand that there are children involved," said the widow, "and wives and mothers. . . . I'm tired of hearing about AIDS as a gay disease. It doesn't matter how it's transmitted. What matters is how much AIDS victims suffer and how their families suffer" (Barret 1983). These two articles signaled the coverage that would predominate in the glossies: "What women need to know" was the first kind of story; the second was human interest or personal narrative. We first trace coverage in the glossies, than backtrack to outline the feminist coverage.

WOMEN'S GLOSSIES

1984–1985

As early as 1984, such magazines as *Glamour, Mademoiselle* and *Ladies Home Journal* indicated that women were perhaps at risk for AIDS. (*Ms.* was not to address personal risk or social politics for many years.) The six articles listed for 1985, for example, included a September story by Chris Norwood in *Mademoiselle* titled "AIDS Is Not for Men Only" (Norwood's book on women and AIDS appeared in 1987.) In November, *Good Housekeeping* based a story on the findings of the Project AWARE study (4 percent of the "high risk" women studied were found to be HIV positive), warned readers that antibody testing should not replace safer sex precautions, and gave the number of the 24-hour CDC hotline ("AIDS: What Women Must Know Now!" 1985).

1986–1987

In 1986, 12 articles appeared; as in the mainstream and medical media, condoms were a major issue, as were the cultural changes they implied. A January article in *Vogue* by Ellen Switzer (Switzer 1986) was titled "AIDS: What Women Can Do," and introduced a theme that would be picked up in biomedical and popular discourse: "The killer disease called acquired immune deficiency syndrome (AIDS) not only has begun to strike women, but its control and eventual conquest are probably in their hands, in the opinion of Michael Gottlieb, M.D." (222). The article continued: "In such battles," said Dr. Gottlieb, "Women have historically been our best allies. They want to protect their

families and themselves, so they pay attention to what science can tell them about any new threat, and act accordingly" (222). In Gottlieb's scenario, women can be counted on to get the facts: What we need desperately right now is an informed public . . . and that is where women can help us" (222).

A different spin was given to women's role by longtime feminist writer Barbara Grizzuti Harrison in February's *Mademoiselle*. "It's Okay To Be Angry about AIDS," wrote Harrison, and specifically okay to be angry that some gay men have had "as many as 50 sexual partners a week: Is that normal? I don't think promiscuous gay men have a right to demand that we think the way they live is fine and dandy; their business is now our business, and we are under no obligation to find it lovely. . . . Even, however, if we acknowledge our anger— and/or our aesthetic and moral revulsion—does it follow that we don't extend succor and compassion to AIDS victims? Of course not. They suffer; they must be helped" (Harrison 1986, 96). An example of a personal narrative appeared in the November 1986 *Ladies Home Journal*, "I'm Fighting for My Life," by a woman who contracted AIDS through a transfusion (Sloan 1986). The ambiguity of gender in the article—though the person with AIDS was a woman, transfusion was usually not a gendered route of transmission (transfusion during childbirth being an exception)—was echoed in a sidebar that updated AIDS statistics on people diagnosed with AIDS: 70 percent were homosexual and bisexual men, 17 percent were intravenous drug users, and 2 percent were adults who contracted the disease through blood transfusions. Accounting for 89 percent of the people diagnosed with AIDS, the article omitted the remaining 11 percent: the heterosexuals not infected through drug use or blood products, whether male or female.

In 1987, 14 articles appeared in the women's magazines. This was the year of the big heterosexual "spread of AIDS" scare, and women's risk and the problems of negotiating safe sex are taken up in women's media. If a man won't wear a condom, wrote Barbara Seville in *Today's Chicago Woman*, "Obviously he cares little for your emotional well-being, and more for satisfying his own physical needs. Give him a piece of liver and send him on his way" (Seville, 1987, 33). In *Mademoiselle*, three articles spoke to women's concerns: "Is there a man in your man's life?," asked the magazine in July 1987; "Never love a stranger," it warned in September (p. 214); and in October, a fresh theme at last—"The New Foreplay."

Four books were published in 1987 on women and AIDS: Diane Richardson's *Women and AIDS* was published in London; Chris Norwood's *Sensible Advice for Life: A Woman's Guide to AIDS Risks and Prevention* from Pantheon was the first book on women and AIDS published in the U.S. Helen Singer Kaplan's widely publicized book, *The Real Truth about Women and AIDS: How to Eliminate the Risks without Giving up Love and Sex*, called upon

women to be the conscience of the nation, using their monogamy to contain the infection and preserve relationships from the tides of men's sexual rampages:

> We women form the "bridge" that are virtually the only avenue by which the AIDS virus can escape from its current confinement to the small, highly concentrated pool of infected high-risk men and spread out to the general population, which is still largely uncontaminated. . . . Women do not mind monogamy and sexual exclusivity as much as gay men do; in fact, many prefer sex in a committed relationship. Women as a group have always been more interested in the quality of sex rather than the quantity provided by different partners. (Kaplan 1987)

Much less widely distributed was the pamphlet *Making It: A Woman's Guide to Sex in the Age of AIDS*, by Cindy Patton and Janis Kelly, a realistic and humorous pro-sex tract in which neither sex nor gay male sexuality was criticized or blamed for AIDS (Patton and Kelly 1987).

FEMINIST GLOSSIES

1981–1988

How did the mainstream feminist press cover the AIDS epidemic over this same period, 1981–1988? By 1988, the mainstream women's magazines—"the big glossies"—had run a total of 58 articles on AIDS (19 articles appeared in 1988). Despite the "Gee whiz, is it safe to date?" tone at times, these articles generally provided more substance than the mainstream feminist magazines (*Ms., New Woman, Self*, etc.). Until 1988, which was a turning point of sorts for the mainstream feminist media, three premises remained fairly constant in these magazines, particularly *Ms.*: (1) women prefer monogamy; (2) men are duplicitous; (3) getting tested—"the only way to know for sure"—is the answer to your prayers (Van Gelder 1987). Such a perspective only strengthened the dominant message that AIDS, "a gay men's disease," was a direct consequence of men's hedonistic, promiscuous, appetitive, destructive behavior. It failed to articulate the social and political aspects of the epidemic. Indeed, not only did feminist journals fail to produce an effective counternarrative, they often repeated, endorsed, and even magnified the standard account.

Ms. magazine, for example, the mother of mainstream feminist publications and still the most consistently feminist of all the glossies, was listed as running a total of 10 articles on AIDS between 1983 and 1988, most less than a page. And most of these articles, instead of undermining or challenging the

homophobic and racist rhetoric of mainstream reports, instead adapted it to *Ms.'* own preoccupation—the sterile "heterophobic," or anti-heterosexual sex, discourse of the new celibacy. Indeed, in the discourse of mainstream feminism, AIDS became a "good-news, bad-news" disease. The bad news was that thousands of people worldwide are dying, with no end in sight, and this was scary. But the good news, repeated in magazines from *Ms.* to *New Woman*, was that "women don't get AIDS." This interpretation fit nicely with the revisionist take on female sexuality: the sexual revolution, something forced on women by men, had been brought to an end by AIDS. Women had always preferred heterosexual monogamy, these magazines suggested, and AIDS was the ticket back to what women always wanted: a lifetime, monogamous partner—or maybe no sex at all.

In a 1986 article in *New Woman*, Erica Jong, creator of the zipless fuck, used AIDS to celebrate the new celibacy. "For some women," she wrote, "the AIDS crisis may be a way to come to terms with the fact that they never really liked multiple-partner sex in the first place." Parroting a conservative's dream of the ideal woman, she observed that "in our dreams and fantasies, promiscuity seemed to bring freedom from hypocrisy and repression. In reality, it often did not . . . Nor was it always a pleasure to have sex demystified and deromanticized . . . Many women were glad for an excuse to turn away from casual sex."[12] And what, in Jong's opinion, replaced casual sex? Chastity, family, gardening, and needlepoint. (She doesn't explain how chastity produces children—a basic family requisite.) A sidebar was entitled "Good News (for Women) about AIDS." Jong's point of view was echoed in other mainstream feminist publications. And AIDS brought home a lesson women have always known but may temporarily have forgotten. As *Ms.* stated it: "Brace yourself for a shocker. Men lie to get laid" (Van Gelder 1987, 71).

For some feminist journals, *Ms.* included, AIDS served to reinforce favored notions of global sisterhood. In 1986, in its fourth piece ever on AIDS, *Ms.* reported that "an anthropologist with the University of California" believed "the spread of Acquired Immune Deficiency Syndrome (AIDS) in Africa may be connected to the practice of female genital mutilation." The anthropologist, actually a doctoral candidate who had read some of the literature on AIDS, contended that in those areas of Africa where AIDS was prevalent, "intercourse between men and prepubescent girls is also common," noting, too, that because of infibulation, anal intercourse was a common alternative to penile-vaginal penetration (Hornaday 1986, 28). With little supporting scientific evidence, the article blindly reproduced familiar themes about Africa (e.g., social and sexual oppression of women, oppressive cultural traditions), joining them to the familiar "us/them" dichotomy of "4–H Club" rhetoric.[13] Other feminist authors (e.g., Fran Hoskens in her *International*

Women's Health Newsletter) continued to claim that AIDS was caused by female genital mutilation and other forms of male sexual exploitation.

It was not until April 1987, well after the publication of the books on women and AIDS noted above, that *Ms.* offered its first piece suggesting that women in the United States might be at risk for HIV. AIDS, the journal noted, had become the leading killer of women between the ages of 25 and 29 in New York City. The article does not mention race or poverty as factors, but instead assaulted "the media" for "priss[ing] on about things like 'the exchange of bodily fluids' without specifying what any sexually active person really needs to know: which ones?" (Van Gelder 1987, 71). But if you did want to know which ones, *Ms.* wasn't telling either.

In May, *Ms.* ran a short article, perhaps as a hasty corrective to April's, that mentioned racism and the isolation of women with AIDS (Bray 1987). In September, "Condoms: A Straight Girl's Best Friend" appeared, a common-sensical, straightforward discussion of current realities that included a buyer's guide and generally avoided blaming men (Hendricks 1987). In February 1988, *Ms.* ran a short article, "Women and AIDS: Who's at Risk?" (Sweet 1988), briefly summarizing the outcome of several reputable studies (Padian 1987; Cohen and Wofsy 1988). In July, Chris Norwood reported in *Ms.* that deaths of women from respiratory diseases had risen dramatically and that women with HIV or AIDS might be significantly under-counted because they showed different symptoms than men (Norwood 1988a).

Meanwhile, *Self* published a test, developed by Chris Norwood, enabling readers to assess their likelihood of exposure to HIV; in contrast to the usual boilerplate recitation of "risk factors," Norwood translated these factors into everyday experience and emphasized *degree* of risk (*possibility* of exposure) rather than a clear-cut division between "risk" and "no risk" (Norwood 1988b, 150). In July, *Self* reported that 31 percent of women responding to a survey said they had not changed their behavior in response to AIDS; the article emphasized the danger to women from bisexual men.

In 1991, the "new *Ms.*" arrived—ad-free and self-proclaimed to be "more feminist"— and published its first serious cover story on the scope, politics, and gender implications of the AIDS epidemic ("Women and AIDS" 1991).

In sum, for most of the 1980s, mainstream feminist publications gave the AIDS crisis scant attention. By the time *Ms.* got serious, other groups and institutions—including the glossy women's magazines, front-line health and service agencies, predominantly male AIDS organizations like Gay Men's Health Crisis and ACT UP, and feminist writers writing outside standard feminist outlets—had done more, written more, and acted more effectively on behalf of women.

Alternative and Academic Feminist Media

Alternative Feminist Media

The Alternative Press Index, which covers about 215 alternative magazines and newspapers, listed more than 2,000 total articles on AIDS between 1982 and 1988. Of that total, only 100 of them appeared in a feminist or lesbian publication or mentioned "women" or "heterosexuals" in the title; and nearly one-third of the total concerned with women appeared in a single publication, the Boston-based *Gay Community News*, mostly written by feminist and gay activist Cindy Patton.

Not unexpectedly, the first women concerned about AIDS and AIDS organizing emerged from organizations of prostitutes like COYOTE, from women's health clinics and programs, and from lesbian communities in cities with high rates of AIDS. Activist prostitutes, organized geographically and internationally for two or more decades, took the lead in identifying AIDS as a serious public health problem—for themselves as well as society—and calling for non-punitive efforts to assess seroprevalence and reduce risk among prostitutes. At a 1985 international conference in Amsterdam they drew up a series of demands for their protection including regular health care, required use of condoms, and legal sanctions against non-compliant clients.[14]

1981–1983

Women's clinics began producing brochures on women and AIDS as early as 1983, the same year that the Women's AIDS Network (WAN), a volunteer organization grounded in San Francisco, sponsored its first AIDS forum on women; the network encompassed COYOTE as well as gay and lesbian organizations. Lesbians provided an early feminist take on the epidemic from within the gay community: their gay male friends were sick or dying; they were seeing a rise in homophobia against both men and women; they feared that AIDS hysteria posed broad threats to civil rights; and at first, they also feared that this "gay disease" might spread to them.[15]

Throughout 1983, sporadic commentaries on AIDS and on women and AIDS appeared in the alternative feminist press. Sue O'Sullivan, writing in May in the British feminist journal *Spare Rib*, criticized a BBC1 program on Herpes and AIDS for its naturalized conflation of the biomedical with the moral; moreover, she began to articulate the importance of a feminist analysis: "This notion that somehow 'nature,' the 'natural,' had been offended against buried any idea that it was and is specifically socially constructed sexual practices which have to be looked at and criticized. And that's something feminists have been saying for a long time" (O'Sullivan 1983, 38). Back in the United States, the *Women's Press* of Eugene, Oregon, urged readers in its July/August

issue to confront homophobia and write their congresspersons about AIDS: "What we don't know hurts us and our sisters and brothers" ("Raid Kills Bugs Dead/AIDS Kills Gays Dead," 1983, 3). The Women's Caucus of the San Diego Democratic Club held a "Blood Sisters" drive, attracting almost 200 women (Califia 1984, 26). In September, Cindy Patton warned that the AIDS epidemic was producing both homophobia and erotophobia, not only from outside, but also internalized within the gay and lesbian community (Patton 1983)—a theme she later elaborated on in her book *Sex and Germs* (1985c). The following month, *GCN* reported 147 cases of women with AIDS, 51 percent acquired through IV drug use, 49 percent through sexual contact.

1984

In 1984, The Alternative Press Index listed 166 articles on AIDS, 10 of them, just under 6 percent, in women's or gay/lesbian publications. Seven of these stories involved women or women's issues. In March 1984, for example, Patton suggested in *GCN* that lessons for the AIDS crisis could be drawn from women's reactions in the crisis over Toxic Shock Syndrome (Patton 1984). *On Our Backs*, a lesbian publication whose title, a play on that of the more politically orthodox *Off Our Backs*, flaunted its pro-sex politics, asked "How is AIDS affecting us, particularly as gay women?," and wondered why no one had posed this question in print before. In an article "AIDS—Should We Care?," *Spare Rib* identified sources of tension between gay men and lesbians in San Francisco as they worked together to fight AIDS (Miller 1984). Some lesbians believed "men brought it on themselves" with their "fast lane" lifestyle; at the same time they shared political beliefs, bonds of friendship, and concern over homophobia in the society at large. Another concern involved the practice by lesbians of obtaining sperm (in vitro or in vivo) from gay male friends in order to have children: with HIV transmissible through semen and the latency period between exposure and symptoms often years, artificial insemination may provide a "bridge" to the lesbian community; yet alternatives are not obviously apparent. Other tensions within the left emerged as well. In June, Patton reported in *GCN* that 340 women in the U.S. had AIDS; nevertheless, she wrote, "the feminist movement at large has yet to take on AIDS as a women's health issue" (Patton 1984). Efforts initiated at the 1983 Denver National Lesbian and Gay Health Conference, she noted, had foundered; more important, "most of the discussion by women to date has revolved around how women can support their gay brothers. We must move that dialogue. . . . " (*GCN*, June 30, 1984).

In July 1985, Marea Murray questioned women's lack of interest in AIDS in a letter to the editor of *Sojourner*, a Boston-based newspaper:

Women's lack of interest strikes me as odd and reflective of the common presumption that AIDS is a gay men's disease. Women who use needles, who receive transfusions, and, probably most of all, who are partners of bisexual men are all at risk for exposure to and contagion by this dreaded illness. . . . I continue to be astounded by the lack of information and stereotypes I encounter among otherwise aware women and lesbians around AIDS. There have been intimations that women should work on "women's issues," and questions like, "Why should we help the boys? Would they do the same for us?" (4)

In an October 1985 article, also in *Sojourner*, Cindy Patton charged that "Feminists Have Avoided the Issue of AIDS"; the efforts of the Women's AIDS Network, she argued,

were hampered by the lack of institutional support and the unwillingness of the feminist activist community to perceive AIDS as an important health and political issue. . . . Feminists have not mounted an organized effort to cope with the AIDS epidemic or its political aftermath. There are simple and complex reasons why feminists around the country have avoided the issue of AIDS, including burnout from other work, persistent homophobia, sex-negative attitudes, and fear of confronting such an unprecedented health problem. . . . As a feminist and a gay activist, the denial I see in the women's community feels very much like the denial among gay men five years ago. (1985b, 19)

Many early women AIDS activists were brought up short when they encountered the same mantra from their feminist and lesbian colleagues that gay men had long been hearing from the right, from politicians, from mainstream media, and from spokespersons for "the straight community": it's your problem, not ours. Patton called for a change in consciousness:

Those feminists who had been involved in AIDS organizing experience frustration and anger at our sisters' callous attitudes and refusal to believe the magnitude of the political and health problems caused by the AIDS epidemic. it can happen here and it is happening here . . . Five years into the AIDS epidemic, feminists should make good on the promise of "global feminism." (Patton 1985b, 20)

But other feminists and lesbians were having none of it. Jackie Winnow (1989), working with people with AIDS and their caregivers in the Bay Area, was one of the first to see the AIDS epidemic as the thief of resources for women's health problems and to make a direct comparison between AIDS and breast cancer; seeing all the human and monetary resources being poured into AIDS, and the exhaustion in the community of women caring for AIDS sufferers, Winnow feared for women who were sick, for nothing was there for them. Patton was criticized for her presentation of the lesbian/gay community as a harmonious united front—and, in her call to activism, not articulating the understandable ambivalence of many lesbians, toward, for instance, male sexuality (Cayleff 1989).

Yolanda Retter, a feminist activist and lesbian separatist, put it this way:

> I still think that lesbians are going to inherit the earth, because males, straight and gay, can't control themselves. They're very self-destructive . . . The boys are still asking for Mommy to come help them, and when lesbians want to play Mommy, I really despair . . . One thing that made me very angry was when someone told me that 48,000 women per year die of breast cancer—that's more per year than have died of AIDS. And who's mobilizing for them? Nobody. I wanted to cry. I thought, "That's it, don't even talk to me about AIDS." (quoted in Limmer 1988, 26–27)

When biomedical researchers suggested that lesbian sex was too gentle, infrequent, or boring to transmit HIV, lesbians and AIDS activists at an international AIDS conference staged a public kiss-in and distributed safer sex brochures aimed at lesbians (Crimp with Rolston 1990). Yet the feminist activist paper, *Off Our Backs* responded with a 1991 story by Beth Elliot: "Does Lesbian Sex Transmit AIDS? GET REAL!" Any move to focus on women's own behavior, especially sexual behavior, raised a highly contentious question—what was "women's sexuality"? Did the notion encompass the whole range of sexual practices that women, in their infinite diversity, might engage in? Or did it define only the sexual practices that are wholesome, ethical, and politically appropriate? Many versions of this question (e.g., can a lesbian have sexual intercourse with a man and still be "a lesbian"?) cropped up repeatedly.

For the most part, the AIDS epidemic did not open a feminist-lesbian conversation about sexuality, and the voices calling for a reexamination or restructuring of sexuality were few. Notable exceptions were United Kingdom feminists Susan Ardill and Sue O'Sullivan, writing in *Spare Rib*:

AIDS touches off deeply buried fears or ignorance of sex . . . The negative aspect of the AIDS crisis—don't do this, avoid that, change or you may die strikes at the heart of sexual acceptance and celebration. For women, the acceptance of the body—for oneself, of the other—is such a breakthrough. Separating out sexual pleasure, procreation, and marriage was a huge step towards women seizing control of their lives. This was what makes our fear now so heart rending and what we, as feminists, must seize hold of and attempt to turn round. (1987)

Ardill and O'Sullivan called for collaboration among gay men, lesbians, AIDS activists, and feminists in rethinking and restructuring sexuality. In *Z* magazine, Cynthia Peters and Karen Struening argued, similarly, for a view of sexuality as socially constructed and hence open to discussion and rethinking:

A "new morality" should not stress monogamy and celibacy, but the value and importance of sexual desire in our lives. The importance of sexuality as a political issue should not be underestimated by the Left. While mainstream culture (and even the Left) interprets sex narrowly as a physical pleasure analogous to other leisure time activity, and as easily commodifiable, feminists and gay and lesbian activists have pointed to the importance of sexual desire and its centrality to the formation of identity. A social construction of women that makes us invisible does not leave us well-equipped to take on the active re-creation of sex so desperately needed in the age of the AIDS epidemic. Safer sex requires that, in the context of sexuality, which is so often (and incorrectly) mythologized as a depoliticized zone devoid of rules and norms, women be active subjects of desire, constructing sex in order to be safe . . . (Peters and Struening 1988, 135)

To fill in our chronological story: in 1985, the Alternative Press Index listed 278 AIDS articles, 13 of them (4.5 percent) about women, heterosexuals, or in a lesbian or feminist publication. On September 24, 1985, *The Village Voice*, a national "alternative" publication, ran "Women with AIDS: Untold Stories," a long article by Peg Byron on AIDS and women, the first of its kind in anything approaching a mainstream magazine. In 1986, 356 articles on AIDS appeared in alternative media, 14 (4 percent) on women or in feminist-lesbian publications. For the first time, titles were explicit: "Women and AIDS Update," "AIDS: The Risks for Women," "Lesbians and AIDS." In 1987, of 422 articles on AIDS, 16 (3.6 percent) were on women or in

women's/feminist publications. *Making It: A Woman's Guide to Sex in the Age of AIDS*, by Cindy Patton and Janis Kelly, was promoted by the Women's Caucus of ACT UP/New York as a "hopeful, humane alternative" to prevention campaigns emphasizing abstinence or monogamy; Helen Singer Kaplan's Book, *The Real Truth about Women and AIDS*, was boycotted for its racism and its blaming of those in "high risk groups" for the advent and spread of AIDS.

In early 1988, the ACT UP/NY Women's Caucus brought the issue of women and AIDS to national attention and, though not immediately transforming a confused discourse into a coherent one, provided a new model for feminist AIDS activism and cultural work. The provocation was psychiatrist Robert E. Gould's assertions in *Cosmopolitan* magazine (noted earlier) that women were in no danger of AIDS from "ordinary sexual intercourse." A protest action outside *Cosmo*'s offices challenged the view of AIDS as a "gay men's disease" and led to media appearances, a video, a handbook on women and AIDS, and more demonstrations including a protest in Shea Stadium, where the women (and men) of ACT UP passed out condoms and unfurled banners with messages like "Men: Don't balk at condoms" and "No glove, no love" (Treichler 1992, Crimp with Rolston 1990, Juhasz 1995, Maggenti and Carlomusto 1989, and ACT UP/NY Women and AIDS Book Group 1992). Feminist silence and ambivalence began to give way to diverse responses and organized action.

ACADEMIC FEMINIST MEDIA
1981–1988

The story of women and AIDS was much the same in academic feminist publications as in mainstream feminist publications—absent. In the women's studies literature, there was virtually no story at all. *Studies on Women Abstracts*, an international index covering about 250 specialized journals, listed no articles on AIDS between 1982 and 1986. Yet, for comparison, there was no dearth of articles on other topics in women's health: in 1986, for example, the *Abstracts* listed 13 articles on abortion, 10 on anorexia and bulimia, and 20 on menstruation and menopause. It was not until 1987 that five articles on AIDS finally appeared in the women's studies academic press; five more were listed in 1988 (e.g. Scott 1987; Lindhorst 1988). There were feminist voices in the earlier academic literature, but few were accessible through standard feminist listings like *Studies on Women Abstracts*. Based on a 1985 conference on AIDS organized by San Francisco psychologist Leon McKusick, for instance, a collection of published papers (McKusick 1986) included the groundbreaking feminist work on women and AIDS by sociologists Nancy Shaw and Lyn Paleo. Chapters on women in several published AIDS

collections of predominantly biomedical and epidemiological papers made strong, if not radical, arguments on behalf of women (e.g., Guinan and Hardy 1987, Schneider 1988, Campbell 1990a, Stephens 1989, Cohen and Wofsy 1988). Additional research on women was represented by abstracts and papers at international AIDS conferences and at professional disciplinary meetings. Some of the most interesting feminist work on AIDS was interdisciplinary and generally reflected the influence of critical and cultural theory, postmodernism, postcolonialism, and what was to become queer theory. Such work found a home where it could, in odd journals, special journal issues, and conferences in fields like cultural studies, art history and criticism, media studies, sociology and history of science, and cultural anthropology.[16] But it found little welcome in women's studies.

For many, AIDS became an occasion for analyzing the dominant feminism of the 1970s and 1980s, even a test case for its assumptions—which in some cases were found wanting. "It is inherently assumed that women are weak, powerless and dependent on men while we maintain sexual relationships with them," wrote Peters and Struening. "It stopped us from looking at women's power and sexual pleasure within heterosexual relationships" (Peters and Struening 1988, 135). AIDS, in fact, intensified questions many feminists had been asking since the late 1970s: when we say we are feminists, who are the "we," and at what price?

We have cited examples that document debate, conflict, and analysis in the alternative feminist and lesbian media; they also show—for better or for worse—the greater fragmentation of ideas in media that lack national distribution and institutional hierarchies. Debate and cultural critique are often fresh, unexpected, and diverse; yet they may also be local, parochial, and highly individualized. Thus on the one hand, some oppositional voices challenged, analyzed, and reinterpreted the dominant us-versus-them reading of AIDS as a rigidly gendered epidemic and instead took it up as "our" epidemic, not "theirs." But other voices, just as "oppositional," not only accepted, but capitalized upon the dominant reading. For some, it exacerbated and indeed justified the sometimes troubled relations between lesbians and gay men; for others it represented and further naturalized an even deeper divide perceived between male and female. AIDS, in this account, was just another chapter in the long bitter battle of the sexes: men hogging the resources, calling the shots, erasing women, and demanding nurturing, caretaking, and sacrifice. Clearly, responses to AIDS within the alternative and academic feminist media emphasized the existence of feminisms, plural, and lesbianisms, plural. They showed, too, the growing strain of maintaining the fiction of an undivided lesbian-feminist, multi-ethnic, multi-racial, woman-identified "we."

DISCUSSION

This chronological sketch of three broad types of media coverage suggests that data about women with AIDS, though somewhat ambiguous, were available from the very early years of the epidemic; the mainstream media took little leadership in exploring AIDS' potential threat to women and women's interests. Feminist publications, too, took little leadership in the epidemic: they largely failed to challenge mainstream neglect of women, to clarify the data on gender, to articulate for their constituencies "women's interests" in relation to the epidemic, or to counter the conservative forces that were aggressively constructing the social meaning of AIDS.

Several points warrant discussion. First, the process of actually constructing a chronology (or chronologies) of AIDS media coverage poses some problems. While chronologies appear to chronicle history, they also create it—through selection, emphasis, language choice, and omission. To try, in 1996, to disentangle the threads of "women" from the various patterns and fabrics into which they have been woven over the years is an extremely difficult, perhaps impossible, task. Our account here does not transcend the problems of constructing any chronology. Though individual researchers, like sociologist Carole Campbell, tried to keep separate statistics for women, they found themselves creating "shadow chronologies" that remained largely unpublished, private, and not easy to maintain as statistics, geographical sites, and surveillance categories shifted and proliferated.[17] In addition to these problems and ambiguities, HIV statistics in general are still the subject of intense political, disciplinary, and institutional debate and professional investment. Some commentators, therefore, hold fast to accounts of the epidemic that discount heterosexually acquired cases among women, attributing them (as Gould and Fumento did) to drug use, lying, pathological clinical conditions, or what are perceived as non-ordinary or stigmatized sexual practices (rape, anal intercourse, sado-masochism, etc.). At this point, too, the long accumulation of inconsistent terminology and reporting protocols problematizes any claims and findings about "women." Researchers, clinicians, and surveillance agencies may use the term "women" more or less interchangeably with "prostitutes," "heterosexuals," "women at risk," "sex partners," and/or "sexually active women." They may define any single unmarried sexually active woman as a prostitute, establish no clear definition for "sex with multiple partners," "promiscuity," or "prostitution," lump as one risk factor "sexual contact with multiple partners, including prostitutes," and in some health jurisdictions classify cases in this category as "heterosexual transmission," in others as "no identifiable risk" or "other." Such confusions make it impossible to sort out the potentially salient issues of risk and prevention that each term connotes,

and render much research on "women" and AIDS meaningless.

Terminology, a second important issue, has erased women in another way. The standard chronologies of AIDS, produced in the 1980s and tracing the evolution of the epidemic, typically encompass scientific, epidemiological, clinical, and legislative and policy events. In the United States, AIDS first appeared among homosexual men (with various speculations as to where they acquired it), then spread to other individuals and groups by the familiar "modes of transmission." While no chronologies focus specifically on the epidemic's movement among women, virtually all describe the inexorable spread of HIV to families, sexual partners, and infants. Yet even in accounts of the "heterosexual scare" of 1986–1987, explicit mention of women (i.e., the actual words "woman," "women," "female," or "she") is rare, and almost always confusing. The gender-neutral term *PWA*, person with AIDS, for example, does nothing to undo the perception that the PWA is male.[18]

Could an AIDSWATCH for women have been established early on to track, analyze, explain, and disseminate the statistics of the epidemic? Could the CDC have been pressured to set up more sensitive tracking mechanisms? At the least to establish a category for multiple sources of exposure for women? Could the CDC or a comparable agency have been required to regularly produce alternative scenarios? Or depart from the "gender-neutral" and presumed politically correct language to use the word "women" when it was pertinent? To accomplish any of these outcomes would have required organized lobbying, not just by individual researchers and clinicians, but by feminist and women's health institutions and organizations. And that, in turn, would have required a radically different formulation of the AIDS epidemic.

Let us turn to a third general issue, that of perspective, or framing. The concept of "media frames," developed by Stuart Hall, Todd Gitlin, Gaye Tuchman, Anne Karpf, and others, seeks to explain how hegemonic discourse selects, orders, or excludes certain versions of reality in its effort to organize the world according to its own purposes. Karpf, drawing on the assumptions of this body of work in her 1988 study of media approaches to medicine and health, argues that the media production process inevitably transforms material and data into a recognizable, accessible form; this form (frame, approach, peg) defines the scope of the piece, determines the approach to the subject, and invites the viewer to ask certain questions and not others. Frames are "principles of selection, emphasis, and presentation composed of little tacit theories about what exists, what happens, and what matters"—theories that also help us understand "what and how alternative frames or approaches are regularly excluded" (Karpf 1988, 3). What, then, is "dominant"? "Oppositional"? What is the "hegemonic" truth the "alternative" press is positioned to critique? Scholarly work on "the media" is typically concerned with the "mass

media," which it often reifies as a monolithic institution with few nuances and internal distinctions. Simultaneously, the "alternative press" is viewed, often approvingly, as contestational to the dominant hegemonic order. The dichotomy assumes, implicitly, that the "alternative media" can be trusted to identify and adequately cover "alternative issues" of interest to "the community." A 1996 symposium on alternative press coverage of women's and feminist issues, for example, clearly articulated this expectation: "Stories that appear for the first time in so-called "feminist" or "women's" outlets just don't get "buzzed about" as much as comparable stories elsewhere" (Flanders 1996, 14). Editor John Stoltenberg charged that mainstream and progressive editors have a "responsibility to pay attention to the feminist press and to echo it. . . . It's not a female ghetto that you can afford to ignore" (quoted in Flanders 1996).

With respect to the gay (male) media, the chronological record of AIDS media coverage bears out the view that editors should "pay attention to," even echo, the voices on the ground captured by the alternative press. To take only one example, Larry Mass, a gay physician and fledgling journalist in Manhattan, was the first to publish a story or report on AIDS. Quoting directly from CDC officials who basically denied the problem, "Disease Rumors Largely Unfounded" appeared on page 7 of the alternative gay newspaper, *The New York Native*, on May 18, 1981. When the *MMWR* report appeared on June 5, 1981, confirming the "unfounded" rumors, Mass, with the backing of *Native* editor Charles Ortleb, determined in the future to track down the real facts firsthand. Mass's second report for the *Native*, "Cancer in the Gay Community" (July 27, 1981), was on page 1 and heralded the *Native*'s central role in covering the epidemic and providing an early—if usually unacknowledged—source for mainstream media (see Kinsella 1989 for more information). The same cannot be said of the feminist alternative press (nor, it should be added, of the progressive alternative media in general). As we noted above, of 2,000 articles on AIDS listed in the Alternative Press Index between 1981 and 1988, fewer than 100 were either by, for, or about women. And, as we have suggested, stories in feminist (and alternative) outlets were more likely to "echo" mainstream sources than the other way around.

Karpf identifies four "persistent frames (or approaches) used in the media coverage of health and illness" (Karpf 1988, 3): the medical approach, the consumer approach, the self-help/alternative approach, and the environmental/systemic approach—approaches readily applicable to media coverage of the AIDS epidemic. What we call here medical/mainstream coverage consistently embodied the medical approach. As we have seen, the glossy women's magazines took up medical/mainstream information about AIDS and repackaged it for their female readership—as health news that women, as sexually

active health consumers, needed to know. These magazines embodied the consumer frame, and with it broad assumptions about society—for example, that federal agencies can generally be trusted, that most women are, have been, or will be sexually active, probably with men, and that most women are willing to take responsibility for their health. Gay publications, and especially AIDS activist groups, incorporated medical/mainstream and consumer perspectives, but filtered them through a fairly explicit alternative frame that could be termed "What do People with AIDS need now?"—a frame that in turn led to an environmental/systemic frame that called for a broad-based strategy that included political action. The glossy feminist press, however, seemed unable to carry out any comparable tasks for its readers: presumably deeming the "4–H club" categories irrelevant to its readership, it chose not to challenge the categories themselves nor to revise or update its own understanding of a "feminist frame."

What might this revision have encompassed? As Clay Stephens (1989) has long argued, AIDS showed us, early on, the state of women's health in microcosm: women are low priority; if they are valued, it is in their roles as wives, caretakers, and mothers; they are readily stereotyped; and few resources are provided for them. AIDS should have gone to the heart of feminist inquiry, for it raised fundamental questions about how sex, gender, sexual identity, and sexual worthiness are described and understood.[19] But, in fact, not a single woman had to acquire HIV or die of AIDS to establish that the epidemic embodied stereotypes and blaming practices that feminism had sought to combat for decades. As soon as AIDS was linked to sexual transmission, female prostitutes were blamed for the epidemic; even when prostitutes failed to oblige by coming down with AIDS *en masse*, the media ran stories in which alarmed experts voiced the fear that they *would* acquire it at any moment, by which time it would be too late: AIDS would have spread to respectable men and to their innocent families everywhere. Reinforced by murky photographs of working girls on the job, these stories revealed the legacies of cultural memory even as they updated them. So what if the HIV/AIDS epidemic in the U.S. never "exploded" as predicted among female sex workers? Feminists should have heeded the warning signs of stigma and persecution: the familiar virgin-whore discourse appropriated from earlier epidemics, the focus on prostitutes rather than their clients as carriers of disease, the use of stock photographs as evidence for favored "spread-of-AIDS" hypotheses, and so on. AIDS discourse, in other words, readily came to reenact many of the semantic and political battles that had characterized relations between women and biomedical science since at least the mid-nineteenth century.

Mostly, however, feminists at last reaped a Pyrrhic victory from decades of virgin/whore discourse: while homosexual and bisexual men stood in for

women and were assigned women's historical roles and images, women—
including women who were longtime feminists—for the most part stood by
and let the men be the whores this time. Breathing deep sighs of relief, per-
haps, they accepted for women the much more sympathetic virgin roles: help-
mate, caretaker, mother, deceived wife or lover, puzzled daughter, compassion-
ate physician. To this list, we can now add unsullied feminist, complacent
about images of women as moral saviors of the nation. AIDS coalesced with
"the new femininity/monogamy/abstinence" to reinstate oppressive gender
stereotypes and warn women that if they were careerist and sexual, like Glenn
Close in the 1987 movie, *Fatal Attraction*, they would die the terrible death
they deserved, while the pure survived, happy and healthy.[20] What one might
normally and approvingly term "oppositional discourses" within feminist
media operated in their own hegemonic fashion within the feminist communi-
ties involved. These frames worked to organize, select, or exclude information
to order to sustain a particular reality, a reality that shared some features with
the dominant ideological discourse and divided on others.

What does it mean when feminists act to corroborate, by default, a domi-
nant account? In closing, we wish to address the phenomenon of silence and,
with regard to the AIDS epidemic, the role of silence and omission within the
feminist media. By the early 1980s, the feminist movement may have been
fragmented, but it was far from powerless. The movement had the resources,
the channels of discourse, and the ability to speak out and gain attention on
many issues. Where AIDS was concerned, they chose not to; yet AIDS repre-
sented a crisis of morality, sexuality, and structural inequality, issues that fem-
inism had addressed for more than 200 years. Moreover, medical discourse
had played its part in that history, inventing and sustaining gender distinctions
that for the most part did not further women's stature as independent human
subjects. Feminist interventions into that discourse have altered medicine's lin-
guistic and cultural constructions of women and reshaped medical practice in
a number of ways—epistemological changes brought about by a social move-
ment (noted Donna Haraway, "I don't think epistemological changes can hap-
pen without social movements," cited in Darnovsky 1991, 76). The feminist
critique of science and medicine demonstrates how feminist process, feminist
activism, feminist research, and feminist theory interconnect. Indeed, the
strength and current sophistication of feminist work comes from this history of
feminist process and activism, where science, technology, and constructions of
race, class, and gender meet. So why, in the AIDS epidemic, did feminists have
so little to say? Why, when they had the tools to intervene, did they choose not
to? The lengthy and voluble history of medical discourse that represented
women's bodies as pathological and contaminated is matched by a history of
silence—silence in which women are virtually non-existent, their interests and

health concerns simply ignored. To understand what it means for feminism to collude in the silence surrounding women and AIDS requires us to examine not the power *to intervene*, but the power *not to*.

Silence, when it is linked to power, has mostly been understood as the domain of the oppressed, not the putative oppressor. Such classics as Paulo Freire's *Pedagogy of the Oppressed* (1970) helped establish an understanding of this. The erased voice of the oppressed has been well theorized, especially within feminism. That work first posited a silence that was "unnatural," that came from oppression: being a woman, being black, being poor. Feminist criticism developed and refined this model substantially over the years, recovering the "lost," undervalued, misrepresented, suppressed woman's voice, in history, in literature. This recuperative work of feminism in the 1970s and early 1980s theorized numerous types of gendered silences: "[S]ilence because women are not speaking, silence because their voices are not heard, silence because their voices are not understood, silence because their voices are not preserved" (Balsamo and Treichler 1990, 6).

What tends to be elided in these accounts, which focus on language and discourse as the consolidating point of power, is the power of silence. We are familiar with the concept of the silenced victim, that is, of someone *being silenced*. We are familiar, too, with *silencing*—the power of the powerful to silence others. But a third element exists: the silence of the powerful themselves. The ability to keep an area silent and virtually unexamined is an important, if not ultimate, key to institutional power (Warren 1996). In this trilogy of silence, the first two kinds of silence could not occur without the third. Hence to the gendered silences with which feminists must be concerned, we can add another category: silence because women choose not to speak. This notion has an implicit power in it, a notion of choice (Hedges and Fishkin 1994; Lewis 1993) that transforms the "silencing of" into "the silence of" and grants some degree of power to the silent. Such a notion of silence bridges the divide between the erased voice of the oppressed and the voice of the powerful—voluntarily suppressed. Feminists who chose not to speak out in the early stages of the AIDS crisis are on that bridge.

Tracing the feminist silence about AIDS presumes links that need to be made more explicit. This is relevant to questions of race, class, sexuality, and gender, for dominant constructions of those subject positions depend implicitly on the selective silences of the powerful. It is the three formations of silencing—the silence of the weak, the silencing of the weak by the powerful, and the silence of the powerful themselves—that provide a foundation for structures of power. None of these silences exists separately; their interdependence is implied when Lewis terms the silence of the powerful themselves a "double-cross-reversal, that is, the privilege of the dominant to talk at great

length about that which is not and to stay silent about what which is"
(1993,191).

Any institution, in other words, has areas it vigilantly ignores, black holes
that constitute nodal points of power. The black hole, for *Ms.* and much of the
feminist media by the 1980s, involved the founding notion of "women" as a
self-evident category. Through vigilant policing, feminist publications ulti-
mately acted to suppress emerging narratives that threatened to dissolve such
treasured identities as "woman," "lesbian," "feminist," "victim of sexual
oppression," and so on. Feminist omissions and silences surrounding AIDS
were produced out of a complex nexus of tangled loyalties and stereotypes
involving sexuality, sexual orientation, race, and class issues. But in the face of
the AIDS epidemic, this complex feminist nexus became simplified into Victo-
rian dualisms: women represented virtue and men represented vice. AIDS was
simply the latest item on a long deadly list of men's acts—including sexual
harassment, incest, pornography and rape. Lying somewhere between repres-
sion and power, feminist non-intervention worked ultimately against women
as well as men infected with HIV, collaborating with medical and social dis-
courses about contamination and contributing to the lack of action by health
and government agencies. And when the various feminist silences began to
break, it was too little and too late. By the time they got the message that con-
doms were okay, for example, and that it was politically respectable to say so,
the feminist media had been scooped—by *Vogue*, the *Ladies Home Journal*,
and even *Consumer Reports*.

Finally, it is important to work to better understand media institutions
and the work they do. One continuing effect of the media in the AIDS epidem-
ic, including feminist media, was to obscure structural inequalities. Effective
feminist activism, regardless of its specific object and subject, has long worked
to bring such inequalities to light. But we have argued here that mainstream
feminism's ability to enforce silence about AIDS and keep the epidemic virtu-
ally unexamined can be seen as a key index of its power. In ignoring AIDS and
hence problematic aspects of the category "women," mainstream feminism
preserved silence about its own foundations and protected its power to define
its corporate mission. When we, as feminists, regard "the dominant media" as
patently manipulative and our own "alternative media" as transparently trust-
worthy, we limit the value of progressive commentary and compound the con-
sequences of silence.

CONCLUSION

In this essay, we have reviewed U.S. media coverage of women and the AIDS
epidemic, emphasizing the critical years 1981 to 1988. In doing so, we have

sought to understand better the silence and invisibility that have made the story of women and AIDS so slow to emerge and so difficult to hear. At a time when the AIDS crisis was in grave danger of being hijacked by the right, many battles were fought by and on behalf of the many constituencies affected by the epidemic; and indeed, a number of projects and agencies during these years attempted to alert women to their potential risk of contracting HIV, to devise programs and services appropriate to women's needs, and to put out a call to arms on behalf of solidarity and progressive politics. But the media generally failed to cover or amplify these initiatives and hence participated in the wider failure to link AIDS and HIV to other significant social problems. We conclude that the silence of mainstream feminism contributed to this wider failure by uncritically adopting the widespread but problematic proposition that "AIDS is—and is likely to remain—the price paid for anal intercourse." By adopting the view of AIDS as a "gay men's disease," feminist leaders missed a major opportunity to articulate the AIDS epidemic to long-standing feminist concerns, to influence the development of AIDS-related resources, to identify and address a range of women's health concerns, and to capitalize on existing women's networks and infrastructures to disseminate AIDS/HIV information and guidance.

Women's rights are being challenged today in a discouragingly cyclical manner on a multitude of fronts, so certainly, activist feminists have other things to do than untangle AIDS narratives. Yet, feminist silence has had powerful effects, in part by facilitating and legitimating a range of anti-feminist and anti-woman interests. We cannot strictly quantify what was lost in those years of relative silence about AIDS between 1982 and 1988, or what difference an active coherent challenge would have made. The fragmentary and contradictory information about women and AIDS continues to cloud efforts to address problems specific to women. AIDS, in summary, is one of the premier symbolic battlegrounds of our time. It needs articulation by all feminists—not just those on the front lines, not just those whose friends are dying, and not just those concerned about "women" as the monolithic category championed by dominant feminism.

NOTES

1. The Centers for Disease Control published its first "Update" on the epidemic in the U.S. in the *Mortality and Morbidity Weekly Reports* (*MMWR*) in September 1982. Officially adopting the term "AIDS" and listing cases among women for the first time, the Update reported a total of 693 cases to date; of these 34, or 6.7 percent, were among women (*MMWR*, vol. 24, no. 31 [Sept. 24, 1982]:607–614). By December 1982, 67 adult women had been diagnosed with AIDS, or 6 percent of the total cases.

In this essay, subsequent citations from the *MMWR* will be documented internally.

2. ABC *World News Tonight* with Peter Jennings, Sept. 7, 1993.

3. This early framing and potent shorthand of AIDS as a "gay disease," widespread in the 1980s and persisting to some degree even now, has seemed impervious to repeated challenges—including epidemiological counter-evidence, public attacks from left and right, the "heterosexual panic" ironically triggered by the news that Rock Hudson had AIDS, extensive media coverage of "innocent [i.e., non-homosexual] victims," news that AIDS in Haiti and elsewhere appeared to be transmitted through sex between men and women, and a public health doctrine that declared HIV to be transmitted through specific behaviors regardless of gender, age, race, or ethnicity. A critical overview of public information campaigns can be found in Flora, et al. (1995).

4. See, for example, Shilts 1987, Panem 1988, Fumento 1988, Arno and Feiden 1992, Kinsella 1989, Lupton 1994, and Farmer, et al. eds. 1996.

5. The ambiguity of data is not a trivial factor in trying to account for inattention to the issue of women and HIV. Had large numbers of women emerged with symptoms suddenly and in some setting in which they were likely to be identified, the history of AIDS might have unfolded very differently. A sharp contrast in terms of media coverage is provided by Toxic Shock Syndrome (TSS) in 1979; developing acute symptoms suddenly and dramatically, women began showing up in emergency rooms around the country, a health care setting where emergent conditions and illnesses are reported promptly to the Centers for Disease Control in Atlanta. With 136 cases showing up each month, and some patients dying of an as-yet unidentified disease, TSS made headlines fast and was as rapidly taken up by women's health groups and feminist journals. Even so, women's health interests were not automatically given top priority. When it was determined that toxic shock was most typically triggered by the use of super-absorbent tampons, women's lobbies had to work intensively to reduce blame-the-victim media coverage (women are too cheap—ignorant—lazy—whatever to change their tampons often enough; if God had wanted women to wear tampons. . . ; and so on) and to convince the FDA to require manufacturers to package tampons with warning inserts and with information about absorbency capacity. The unexpected difficulties of bringing about these sensible changes led one feminist journal to suggest that TSS stood for Tough Shit, Sweetie.

6. For women, this has already brought about court-ordered caesarean sections, penalties for health care providers who provide contraceptive information, incarceration for drug-using pregnant women, and calls for an end to legal abortion. For a fuller analysis, see Hunter 1992, ACT UP/NY Women and AIDS Book Group 1992; and Campbell 1995. For women in many third world countries, surveillance and repressive legislation are even more widespread with fewer protections available. See Berber with Ray 1993; Mann, ed. 1992.

7. See Jonathan Mann, ed. 1992. The CDC's 1992 revised definition of AIDS and HIV infection attempts to provide criteria that will better identify and track potential

manifestations of HIV infection specific to women; these diseases, which appear to occur at a higher rate in HIV-infected women, include cancer of the cervix, vulvo-vaginal candidiasis, cervical dysplasia, and pelvic inflammatory disease (Douglas and Pinsky 1996, 60; see also Kloser and Craig 1994, 18–31). Meanwhile, experts continue to debate the accuracy of statistical estimates and the value of models for arriving at those estimates. We refer interested readers to Appendix 2.2. 871–884 in Mann, ed. (1992).

8. Many good collections of papers on the AIDS/HIV epidemic reflect such coalitions, cutting across biomedicine, caregiving, community service, policy and politics, activism, and academics in relevant fields. See, for example, McKusick (1987), Crimp (1988), Aggleton and Homans, eds. (1988), Fee and Fox, eds. (1988), and Fee and Fox, eds. (1992).

9. This research is based primarily on the following sources. The *Reader's Guide to Periodical Literature*, which indexes about 176 periodicals in the U.S. and Canada, was the main source for identifying mainstream AIDS coverage. Mainstream (glossy) women's and feminist magazines are listed in the *Reader's Guide to Periodical Literature*. Though we are categorizing magazines like *Self* and *New Woman* as "feminist" on the grounds that they emphasize women's professional lives over fashion and personal issues, only *Ms.* offers an explicit feminist politics. The main source for coverage in the alternative feminist/gay/lesbian press was the Alternative Press Index, which covers about 216 alternative magazines and newspapers. Two subcategories were broken out: feminist journals and gay/lesbian journals. For the academic feminist press, the indexes searched were the *Studies on Women Abstracts*, an international index that covers about 260 specialized journals. Searched by computer using the key words AIDS, WOMEN, POLITICS, FEMINIST, LESBIAN, HIV, PROSTITUTE, and IMMUNO- were the *Social Science Citation Index* from 1973 to present; *Dissertation Abstracts* from its inception through October 1990; and *Sociological Abstracts* from 1963 through 1990. Secondary sources that were particularly helpful include Kinsella 1989, Colby and Cook 1992, Lupton 1994, Watney 1996, Dearing and Rogers 1988, and McAllister 1990.

10. These figures are based on the quantitative investigation of AIDS coverage by James Dearing and Everett Rogers at the University of Southern California in leading U.S. media from 1981 through 1987. By "leading national media" they meant the *New York Times*, the *Los Angeles Times*, and the *Washington Post*, and the three major television networks (CBS, NBC, and ABC). By "every story" they meant those that could be identified via standard computer databases. The research papers based on this study (e.g., Dearing and Rogers 1988) are informative, and show that media coverage of AIDS was not consistently triggered by such "real world indicators" as number of cases or scientific discoveries. Still, the Dearing and Rogers chronology misses some crucial points through its decisions about what to count. Gay outlets including *The New York Native*, *The Advocate*, *Christopher Street*, and *Gay Community News* covered the epidemic earlier and more consistently than the national media; these stories, together

with Randy Shilts' reporting in the *San Francisco Chronicle*, provided historical and cultural background, informed sources, and a professional goad for subsequent national stories.

11. See Treichler (1988b) and Treichler (1992) for more discussion of representation of people with AIDS. For example, women through most of the 1980s were largely represented as loving companions or caring moms who humanize the gay men in their lives, a role they share with stuffed animals and pets; women with AIDS/HIV are invisible by default.

12. Erica Jong (1986). See Treichler (1988b) for more extensive discussion of Jong's article and its use of Langone (1985) as a source.

13. Research by Jenny Kitzinger and David Miller (1991) shows that both journalists and their audiences drew on stock white cultural images of black Africa in structuring their understanding of AIDS in Africa, but that the media are neither "all powerful" nor their output "one dimensional." Audience understandings were shifted and negotiated, given new information, and alternative media accounts played a role. Yet the process of "scapegoating" is clearly evident in a "mock" news report prepared by a young, white lesbian, who notes that "AIDS is said to have spread though the homosexuals in America and a lot of the practices they participate in whereas in fact it could have originated from Green Monkeys in Africa, spreading from the heterosexual population over to America."

14. The conference is reported in *World Wide Whores News* (1985), a mimeographed newsletter, not available at the corner newsstand. Though some of the presentations from the conference trickle up to more accessible outlets here and there, the example points out that established indexes will miss instances of "alternative media" that are published irregularly, presented locally, or circulated privately. See Delacoste and Alexander (1987) for more on prostitutes' organizations.

15. Cindy Patton indicated, in a personal conversation with Catherine Warren, in April 1991, that before the HIV virus was identified, "it seemed possible that we'd be next." Not until the frame of the disease shifted from immunology to virology and legitimated the STD model did tendencies to blame gay men emerge (paralleling the pattern that Allan Brandt documents in his historical analysis of venereal disease).

17. In a December 1990 conversation with Catherine Warren, Carole Campbell said her article tracing the epidemiology of women and AIDS was motivated by her mounting frustration with contradictory, partial information. A similar frustration was expressed by physician Janet Mitchell at the Los Angeles 2nd Annual Conference on Women and HIV (Nov. 14, 1993). Based at Harlem Hospital in New York City, Mitchell saw a growing number of women patients with AIDS-like symptoms throughout the 1980s, and became convinced that they were infected primarily through heterosexual transmission. The voices of individual clinicians, however, were no match for the machinery of epidemiological surveillance, which already attributed such cases to "IV drug use," or "no identifed risk."

18. For example, James Kinsella's timeline of medical, political, and media events (1989, 269–270) runs from the beginning of the epidemic through early fall 1989; in its 116 entries, persons with AIDS or at risk for AIDS are referred to 90 times. Out of the total 90 references to those who have acquired or might acquire HIV infection, 88 are gender-neutral or are gendered male. While gender-neutral language is often admirable in challenging sexist stereotypes, it is no help when information about gender should be communicated and emphasized.

19. Beth Schneider has argued similarly that (1) AIDS among women necessarily raises a host of issues that do not emerge clearly when the focus is on men, including gay men: reproductive, sexual, economic, historical, family, kinship issues. It is a microcosm of women's social relationships and arrangements; (2) Women are not a class worldwide; and (3) wherever there is AIDS, the fault lines and deficiencies of systems are revealed. Responses to AIDS reveal a great deal about gender systems of specific cultural locations and their potential for change (1988, 73).

20. Laurie Stone (1987, 79) among others, observed that the 1987 film told women that they should stay at home, that single, working women were damaged, barely human. "This is a fairy tale for the age of AIDS if there ever was one."

WORKS CITED

ACT UP/NY Women and AIDS Book Group (1992). *Women, AIDS, and Activism.* Boston: South End Press, 1990.

"AIDS: What Women Must Know Now!" (1985). *Good Housekeeping* (Nov.): 245–246.

Aggleton, Peter and Hilary Homans, eds. (1988). *Social Aspects of AIDS.* New York: Falmer Press.

Ardill, Susan and Sue O'Sullivan (1987). "AIDS and Women: Building a Feminist Framework," *Spare Rib* 178 (May): 40–43.

Arno, Peter S. and Karyn L. Feiden (1992). *Against the Odds: The Story of AIDS Drug Development, Politics and Profits.* New York: HarperCollins.

Balsamo, Anne, and Paula A. Treichler (1990). "Feminist Cultural Studies: Questions for the 1990s." *Women & Language,* vol. 13, no.1: 3–6.

Barnes, E. and A. Hollister (1985). "The New Victims," *Life* (July): 12–19.

Barret, K. (1983). "AIDS: What It Does to a Family," *Ladies Home Journal* (November): 98+.

Berer, Marge with Sunanda Ray (1993). *Women and HIV/AIDS: An International Resource Book.* London: HarperCollins.

Brandt, Allan (1987). *No Magic Bullet: A Social History of Venereal Disease in the United States Since 1880.* New York: Oxford University Press.

Bray, Rosemary L. (1987). "Facing the Fear: Help for Women with AIDS," *Ms.* (May): 31.

Byron, Peg (1985). "Women with AIDS: Untold Stories," *Village Voice* (Sept. 24):

16–19.

Califia, Pat (1984). "Face to Face: Women React to AIDS," *The Advocate* (April 3): 26.

Campbell, Carole A. (1990a). "Prostitution and AIDS." In *Behavioral Aspects of AIDS*, ed. David Ostrow. New York: Plenum.

——— (1990b). "Women and AIDS," *Social Science and Medicine*, vol. 30, no. 4: 407–415.

——— (1991). "Prostitution, AIDS, and Preventive Health Behavior," *Social Science and Medicine*, vol. 32, no. 12: 1367–1378.

——— (1995). "Male Gender Roles and Sexuality: Implications for Women's AIDS Risk and Prevention," *Social Science and Medicine*, vol. 41, no. 2 (July): 197–210.

Cantarow, E. (1984). "AIDS Has Both Sexes Running Scared," *Mademoiselle* (February): 158–159+.

Cayleff, Susan E. (1989). "The Politics of a Disease: Contemporary Analysis of the AIDS Epidemic," *Radical History Review*, vol. 45: 172–180.

Chin, James (1990). "Challenge of the Nineties," *World Health* (Nov./Dec.): 4–6.

Cohen, Judith and Constance Wofsy (1988). "Heterosexual Transmission of HIV." In *AIDS Pathogenesis and Treament*, ed. Jay A. Levy. New York: Marcel Dekker, 135–157.

Colby, David C. and Timothy E. Cook (1992). "The Mass-Mediated Epidemic: The Politics of AIDS on the Nightly Network News." In *AIDS: The Making of a Chronic Disease*. Berkeley: University of California Press, 84–122.

Corea, Gena (1992) *The Invisible Epidemic: The Story of Women and AIDS*. New York: Harper Collins.

Crimp, Douglas (1988). *AIDS: Cultural Analysis, Cultural Activism*. Cambridge: MIT Press.

Crimp, Douglas with Adam Rolston (1990). *AIDS Demo Graphics*. Seattle: Bay Press.

Darnovksy, Marcy (1991). "Overhauling the Meaning Machines: An Interview with Donna Haraway," *Socialist Review*, vol. 21, no. 2: 65–84.

Dearing, James W. and Everett M. Rogers (1988). "The Agenda-Setting Process for the Issue of AIDS." Conference paper, International Communication Association, May 28–June 2, 1988.

Delacoste, Frédérique, and Priscilla Alexander, eds. (1987). *Sex Work: Writings by Women in the Sex Industry*. Pittsburgh: Cleis Press.

Douglas, Paul Harding and Laura Pinsky (1996). *The Essential AIDS Fact Book*. New York: Pocket Books.

Echols, Alice (1984). "The Taming of the Id: Feminist Sexual Politics, 1968–83." In *Pleasure and Danger*, ed. Carol Vance. Boston: Routledge & Kegan Paul, 50–72.

Elliot, Beth (1991). "Does Lesbian Sex Transmit AIDS? GET REAL!," *Off Our Backs*, vol. 21, no. 10 (November): 6.

Farmer, Paul, Margaret Connors, and Jamie Simmons, eds. (1996). *Women, Poverty, and AIDS: Sex, Drugs, and Structural Violence*. Monroe, ME: Common Courage Press.

Fee, Elizabeth and Daniel M. Fox, eds. (1988). *AIDS: The Burdens of History*. Berkeley and Los Angeles: University of California Press.

———— (1992). *AIDS: The Making of a Chronic Disease*. Berkeley and Los Angeles: University of California Press.

Fine, Gary Allen (1987). "Welcome to the World of AIDS: Fantasies of Female Revenge," *Western Folklore* (July 1987): 192–197.

Fischoff, B., S. Lichtenstein, P. Slovic, S. I. Derby, and R. L. Keeny (1981). *Acceptable Risk*. New York: Cambridge University Press.

Flanders, Laura (1996). "How Alternative Is It? Feminist Media Activists Take Aim at the Progressive Press," *Extra!* (May/June): 14–17.

Flora, June A., et al. (1995). "Communication Campaigns for HIV Prevention: Using Mass Media in the Next Decade." In *Assessing the Social and Behavioral Science Base for HIV/AIDS Prevention and Intervention, Workshop Background Papers*. Washington: Institute of Medicine, 129–154.

Foucault, Michel (1976). *The History of Sexuality*. New York: Vintage Books.

Freire, Paulo (1970). *The Pedagogy of the Oppressed*. Trans. Myra Bergman Raymos. New York: Continuum.

Fumento, Michael (1990). *The Myth of Heterosexual AIDS*. New York: Basic Books.

Gitlin, Todd (1980). *The Whole World Is Watching: Mass Media in the Making and Unmaking of the New Left*. Berkeley: University of California Press.

Gould, Robert E. (1988). "Reassuring News about AIDS: A Doctor Tells Why You May Not Be at Risk," *Cosmopolitan* (January): 146–147.

Guinan, Mary E. and Ann Hardy (1987). "Epidemiology of AIDS in Women in the United States: 1981 through 1986." *Journal of the American Medical Association*, vol. 257, no. 15: 2039–2042.

Gupta, N., Geeta Rao, and Ellen Weiss (1993). "Women's Lives and Sex: Implications for AIDS Prevention." *Culture, Medicine, and Psychiatry*, vol. 17, no. 4: 399–412.

Hammonds, Evelynn (1987). "Race, Sex, AIDS: The Construction of 'Other'," *Radical America*, vol. 20, no. 6: 28–37.

Harrison, Barbara Grizzuti (1986). "It's Okay to be Angry about AIDS," *Mademoiselle* (February): 96.

Hedges, Elaine, and Shelley Fisher Fishkin (1994). *Listening to Silences: New Essays in Feminist Criticism*. New York: Oxford University Press.

Hendricks, Paula (1987). "Condoms: A Straight Girl's Best Friend," *Ms.* (September): 98, 100, 102.

Hornaday, Ann (1986). "New Theory: AIDS and Women," *Ms.* (November): 28.

Hunter, Nan D. (1992). "Complications of Gender: Women and HIV Disease." In *AIDS*

Agenda: Emerging Issues in Civil Rights, ed. Nan D. Hunter and William B. Rubenstein. New York: The New Press, 5–39.

Jong, Erica (1986). "Women and AIDS," *New Woman* (April): 42–48.

Juhasz, Alexandra (1995). *AIDS TV.* Durham, NC: Duke University Press.

Kane, Stephanie and Theresa Mason (1992). "AIDS Research, Anti-Drug Policies, and Ethnography." In *The Time of AIDS*, ed. Gilbert Herdt and Shirley Lindenbaum. Beverly Hills: Sage.

Kaplan, Helen Singer (1987). *The Real Truth About Women and AIDS: How to Eliminate the Risks Without Giving Up Love and Sex.* New York: Simon & Schuster, Inc.

Karpf, Anne (1988). *Doctoring the Media: The Reporting of Health and Medicine.* London: Routledge.

King, Edward (1993). *Safety in Numbers.* London: Cassell.

Kinsella, James (1989). *Covering the Plague: AIDS and the American Media.* New Brunswick, NJ: Rutgers University Press.

Kitzinger, Jenny and David Miller (1991). "In Black and White: A Preliminary Report on the Role of the Media in Audience Understandings of 'African AIDS'," a paper presented at the 5th Conference on Social Aspects of AIDS, South Bank Polytechnic, March.

Kloser, Patricia and Jane Maclean Craig (1994). *The Woman's HIV Sourcebook: A Guide to Better Health and Well-being.* Dallas: Taylor Publishing Co.

Langone, John (1985). "AIDS: The Latest Scientific Facts," *Discover* (December) 27–52.

Leishman, Katie (1987). "Heterosexuals and AIDS: The Second Stage of the Epidemic." *The Atlantic* (February): 39–49+.

Lewin, Tamar (1995). "Fears, Suits and Regulations Stall Contraceptive Advances," *New York Times* (Dec. 27): A1–A9.

Lewis, Magda Gere (1993). *Without a Word: Teaching beyond Women's Silence.* New York: Routledge.

Limmer, Melissa (1988). "A World Apart," *The Advocate* (Oct. 10): 26–27.

Lindhorst, Taryn (1988). "Women and AIDS: Scapegoats or a Social Problem?," *Affilia* (Winter): 51–59.

Lupton, Deborah (1994). *Moral Threats and Dangerous Desires: AIDS in the News Media.* London: Taylor & Francis.

Maggenti, Maria and Jean Carlomusto (1989). *Doctors, Liars, and Women: AIDS Activists Say No to* Cosmo. Video, Gay Men's Health Crisis. Color, 28 min.

Mann, Jonathan J. M. and Daniel Tarantola, eds. (1996). *AIDS in the World II: Global Dimensions, Social Roots, Responses.* New York: Oxford University Press.

Marmor M., et al. (1986). "Possible Female-to-Female Transmission of Human Immunodeficiency Virus" (letter), *Annals of Internal Medicine*, vol. 105: 969.

Masters, William, Virginia Johnson, and Robert Kolodny (1988). *Crisis: Heterosexual*

Behavior in the Age of AIDS. New York: Grove Press.

Mays, Vickie M. and Susan D. Cochran (1988). "Issues in the Perception of AIDS Risk and Risk Reduction Activities by Black and Hispanic/Latina Women." *American Psychologist* 43: 949–95.

McAllister, Matthew (1990). *Medicalization in the News Media: A Comparison of AIDS Coverage in Three Newspapers.* Doctoral Dissertation, University of Illinois at Urbana-Champaign.

Mckusick, Leon (1986). *What to Do about AIDS: Physicians and Mental Health Professionals Discuss the Issues.* Berkeley: University of California Press.

Miller, Barbara (1984). "AIDS—Should We Care?." *Spare Rib* (April): 28.

Murray, Marea (1985). "Too Little AIDS Coverage" (letter), *Sojourner* (July): 4.

Newsline (1995). Special Issue on AIDS/HIV and Pregnancy, 6–32.

Norwood, Chris (1988a). "Alarming Rise in Deaths," *Ms.* (July): 65+.

—— (1988b). "How Real is *Your* Risk?." *Self* (June): 148–151.

—— (1987a). Sensible *Advice for Life: A Woman's Guide to AIDS Risks and Prevention.* Pantheon Books: New York.

—— (1985). "AIDS Is Not for Men Only," *Mademoiselle* (September): 198–99, 293–296.

Oleske, et al. in *JAMA* (1983) "Immune Deficiency in Children," 249: 2345–2349.

O'Sullivan, Sue (1983). Reviews: "Panorama," *Spare Rib* (May): 38.

Padian, Nancy (1987). Kinsey Institute Conference Paper.

Panem (1988). The AIDS Bureaucracy: Why Society Failed to meet the AIDS Crisis and How We Might Improve. Cambridge, MA: Harvard University Press.

Patton, Cindy (1983). "Taking Control: Women, Sex, and AIDS," *Gay Community News* (Sept. 17): 5.

—— (1984). "Illness As a Weapon," *Gay Community News* (June 30): 5.

—— (1985a). "Heterosexual AIDS Panic: A Queer Paradigm," *Gay Community News* (Feb. 9): 1.

—— (1985b). "Feminists Have Avoided the Issue of AIDS," *Sojourner* (October): 19-20.

—— (1985c). *Sex and Germs: The Politics of AIDS.* Boston, South End Press.

Patton, Cindy and Janis Kelly. (1987). *Making It: A Woman's Guide to Sex in the Age of AIDS.* Ithaca, NY: Firebrand Books.

Peters, Cynthia and Karen Struening (1988). "Talking with Women about AIDS," *Z* (July/August): 133–137.

Public Media Center (1995). *AIDS Stigma and Discrimination: The Attitudes of National Experts and Influentials.* Public Media Center in Association with the Ford Foundation and Joyce Mertz-Gilmore Foundation.

"Raid Kills Bugs Dead/AIDS Kills Gays Dead" (19830. *Women's Press*, 3.

Randolph, Laura B. (1988). "The Hidden Fear: Black Women, Bisexuals and the AIDS Risk," *Ebony* (January): 120, 122, 123, 126.

Redfield, Robert R., et al. (1985). "Heterosexually Acquired HTLV-III/LAV Disease (AIDS-Related Complex and AIDS)," *Journal of the American Medical Association* (October 18): 2094–2096.

Richardson, Diane (1988). *Women and AIDS*. New York: Methuen.

Rudd, Andrea and Darien Taylor, eds. (1992). *Positive Women: Voices of Women Living with AIDS*. Toronto: Second Story Press.

Schiller, Nina Glick (1993). "The Invisible Women: Caregiving and the Construction of AIDS Health Services." In *Women, Poverty, and AIDS*, ed. Paul Farmer, Shirley Lindenbaum, and Mary Jo Delvecchio Goode, 487–512.

Schneider, Beth E. (1988). "Gender and AIDS," In *AIDS 1988: AAAS Symposia Papers*, ed. Ruth Kulstad. Washington, D.C.: AAAS, 97–106.

Scott, Sara (1987). "Sex and Danger: Feminism and AIDS," *Trouble and Strife* (Nov.): 13–18.

Seligman, Jean (1987). "A Warning to Women on AIDS: Counting on Condoms Is Flirting with Death" (interview with Helen Singer Kaplan), *Newsweek* (Aug. 31): 72.

Seville, Barbara (1987). "Aids [sic] and Women," *Today's Chicago Woman* (September): 33.

Shaw, Nancy S. and Lyn Paleo (1986). "Women and AIDS." In *What to Do about AIDS: Physicians and Health Professionals Discuss the Issues*, ed. Leon McKusick. Berkeley: University of California Press, 142–154.

Shilts, Randy (1987). *And the Band Played on: Politics, People, and the AIDS Epidemic*. New York: St. Martin's Press.

Sloan, Amy (1986). "I'm Fighting for My Life," *Ladies Home Journal* (November): 22–23.

Sobo, E. J. (1996). "Inner-City Women and AIDS: The Psycho-social Benefits of Unsafe Sex." In *Women, Poverty, and AIDS*, ed. Farmer, et al. Monroe, ME: Common Courage Press, 455–485.

Stephens, Clay (1989). "U.S. Women and HIV Infection." In *The AIDS Epidemic: Private Rights and the Public Interest*, ed. Padraig O'Malley. Boston: Beacon Press, 381–401.

Stone, Laurie (1987). "The New Femme Fatale," *Ms.* (December): 78–79.

Sweet, Ellen (1988). "Women and AIDS: Who's at Risk?," *Ms.* (February): 26.

Switzer, Ellen (1986). "AIDS: What Women Can Do," *Vogue* (January): 222–223+.

——— (1988). "AIDS: Fear and Loathing," *Vogue* (March): 326+.

Treichler, Paula A. (1988a). "AIDS, Homophobia, and Biomedical Discourse: An Epidemic of Signification." In *AIDS: Cultural Analysis, Cultural Activism*, ed. Douglas Crimp. Cambridge: MIT Press, 31–70.

——— (1988b). "AIDS, Gender, and Biomedical Discourse: Current Contests for Meaning." In *AIDS: The Burdens of History*, ed. Elizabeth Fee and Daniel M. Fox. Berkeley: University of California Press, 190–266.

——— (1992). "Beyond Cosmo: AIDS, Identity and Inscription of Gender." *Camera*

Obscura, no. 28: 21–76.

Tuchman, Gaye (1978). *Making News.* New York: The Free Press, 1978.

Van Gelder, Lindsay (1983). "The Politics of AIDS," *Ms.* (May): 103.

——— (1987). "AIDS," *Ms.* (April): 64, 71.

Vance, Carole S. (1984). *Pleasure and Danger: Exploring Female Sexuality.* Boston: Routledge & Kegan Paul.

Warren, Catherine A. (1996). *First, Do Not Speak: Errant Doctors, Sexual Abuse, and Institutional Silence.* Doctoral Dissertation, University of Illinois at Urbana-Champaign.

Watney, Simon (1996). *Practices of Freedom: Selected Writings on HIV/AIDS.* Durham, NC: Duke University Press.

Weinhouse, Bibi (1983). "AIDS: The Latest Facts," *Ladies Home Journal,* (November): 100, 202.

Winnow, Jackie (1989). "Lesbians Working on AIDS: Assessing the Impact of Health Care on Women," *Out/Look* (Summer): 10–18.

Wofsy, Constance (1987). "Human Immunodeficiency Virus Infection in Women," (editorial), *Journal of the American Medical Association,* vol. 257, no. 15: 2074.

"Women and AIDS" (1991). Special section. *Ms.* (January/February): 16–33.

Worth, Dooley and Ruth Rodriguez (1987). "Latina Women and AIDS," *Radical America,* vol. 20, no. 6: 63–67.

Scarlett Begat Kim
A Counter-Biography

Carra Leah Hood

PROLOGUE

Too much is left out. Not enough is explained. Too many assumptions are made. In the end, I don't know where to start or how to stop. And there's no conclusion, because the story can't be finished.

You might as well know that I despise Kimberly Bergalis, which isn't a fitting emotion for a biographer. I'd rather tell another story, defacing her, erasing her, but that's not possible. This story's already been written, although it's incomplete, and wasn't written by me. We all know it backwards and forwards.

The story I'd rather tell has no plot.

When all is said and done, you might decide that it's not very feminist of me to admit that I hate her, and her story, and myself for not being able to get out of it, shut her up, and tell the story I'd rather tell if I could locate the plot, but I can't. You might be right, but there are limits, and I love someone else, but you might also be wrong, because I can't love her without hating the subject. I'd betray myself. And that's unacceptable. Besides, someday I might finally figure out the plot and be able to tell the story I'd rather tell but can't, right now. Or someone else will. I can't see that far ahead, though, without falling all over myself, and making up whatever end I want and need for the sake of the story I'd rather tell. But I've already gone too far and it's not time for that yet. In short, I hate her because I know that she lied, but I don't know whether she knows she lied, exactly, and I do know that some people in powerful places did not care whether she was lying, and

others who may have cared did not bother to find out whether she was Let me explain.

WHO'S THAT GIRL?

FROM ROBERT RUNNELLS' *AIDS IN THE DENTAL OFFICE: THE STORY OF KIMBERLY BERGALIS AND DR. DAVID ACER:* "Kimberly was born to Anna Cathcart and George Bergalis on January 19, 1968, in the Coaldale General Hospital, just a short drive from her home in the small coal mining town of Tamaqua, Pennsylvania. She was the oldest of three children, with two sisters, Allison and Sondra, three years and ten years her junior. Of Lithuanian-Scottish heritage, she was reared in a middle-class, Catholic family by a loving and, at times, overprotective mother and father. Kimberly grew up with an appreciation for morality and family values."

7/27/90 AP HEADLINE: "WOMAN CATCHES AIDS FROM DENTIST": Body: In the first case of its kind, federal researchers reported Thursday that a woman apparently got AIDS from her dentist during a tooth pulling, even though he was wearing gloves and a mask.

KIM TO HER MOTHER: ". . . I've never done anything to get AIDS. I've never slept with boys. I've never used drugs. I was a virgin when I left home and I'm still a virgin. I have nothing to hide. That's what's so upsetting. I must have gotten the virus some other way, and I can't remember how. It must have been something I was stuck with or . . . I just can't figure it out. But it wasn't from sleeping with boys or from drugs." (Runnells, 38)

CDC CASE #242284: Patient History: Oldest of three daughters. Mother is a public health nurse at the neighboring county health department—does the HIV pre and post test counseling for the county. Father works in a white-collar job for the city. Religion is Roman Catholic. Socio-economic status appears to be middle-class. At the health department, mother has said that her daughter is a virgin, therefore there must be other ways to transmit HIV. . . . The patient was born in Tamaqua, Pennsylvania, and the family moved to Fort Pierce, Florida in 1978, an area currently known for high prevalence of crack use. . . . She graduated from high school in 1981. During the summer she worked as a waitress at the Pelican Yacht Club in Fort Pierce. A busboy there was thought to have had AIDS. She denied any sexual contact with this busboy. . . . She was not allowed to date in high school, and only admits to kissing one or two boys during this time. On at least one occasion she snuck out of the house to go on a date, telling her parents she was going to a girlfriend's

house. Admits to drinking a small amount of alcohol during this time, denied smoking marijuana or any other drugs. One friend during high school gave a slightly different account of her activities during this time. She said that she did smoke marijuana, drank a fair amount, and would be out with boys although no particular boy was named. . . . The patient started college in the fall of 1985, majoring in finance. She lived in a dormitory her first year, then moved to an apartment. She always had female roommates. Soon after she arrived at college, she met boyfriend #1, an Hispanic male from Miami. Their relationship lasted for approximately one and a half years, but they remained just friends. Patient wanted to have sex with him, but he resisted. At least once, they were nude in bed, and he had a condom on. The patient reports that they stopped because they thought they heard her roommate. They apparently broke up over his disinterest in having sex with her.

10/20/87: University of Florida infirmary records: seen for genital itching and discharge, no UTI, denied current sexual activity, not on contraceptives, denied ever being pregnant, claimed to have never had sexual intercourse, external genital area slightly reddened at introitus, levator muscle on posterior lateral vaginal wall was very sore when palpated.

11/6/87: dental visit, Dr. David Acer, D.D.S.—check wisdom teeth

12/17/87: dental visit, Dr. David Acer, D.D.S.—malposed #1 and #16 wisdom teeth extracted

1/9/88: UF Mental Health records: Boyfriend of two years broke up with her. She was upset because he just wanted to kiss her, didn't want to be sexually involved. She asked boyfriend if he was gay or had a disease and he couldn't handle it. Family had psychotherapy in January 1987 because mother was hypercritical and rejects all of her daughters. Given Xanex for anxiety.

PHYLLIS B. TOON, MD, GYNECOLOGICAL REPORT: "Patient physical exam compatible with prior intercourse. Two fingers easily admitted into vaginal canal, hymen irregular at three and nine o'clock as can happen with intercourse. . . . Perineum/Introitus Colposcopic Exam compatible with HPV infection." (Runnells, 118)

FROM KIM'S LETTER TO MA JAYA BHAGAVATI: ". . . At first I was angry—not particularly at anyone—but that was my first reaction. Just angry—angry because I always thought I had been a good person; I never did anything to put myself at risk for this. I went to Church on Sundays; I always thought I wanted to get

married someday and have children, but now that may never happen . . . I've even had thoughts like 'well maybe I judged somebody when I shouldn't have and now I'm being punished.' I just don't understand why God takes some people home to Him sooner than others. I suppose we're not meant to understand, only accept. . . . I think about how Jesus knew he was going to die by being nailed to a cross. He could have easily said 'Father—this is ridiculous—do you know how much pain I'll be in? Forget it.' Yet he didn't, he carried his cross and suffered for mankind. I feel that maybe this illness is the cross I have to carry. . . . Maybe there's something God wants me to do with however much time I have. . . . I know and believe that one day I'll be united again with friends and family . . . but it doesn't seem to be of any consolation at this moment. And, you know, maybe I'm blessed because I won't be in a world of hatred and anger and pollution—I'll be at peace in paradise." (Runnells, 31)

NOTES FROM THE FIRST INTERVIEW WITH FLORIDA HEALTH AND REHABILITATIVE SERVICES INVESTIGATOR, NIKKI ECONOMOU: "Patient was alert, intelligent and cooperative. We discussed all issues of sexuality and drugs—she detailed her physical relationship with people she dated while in school. Moderate petting is as close as I can come to describing her activities. No mutual masturbation; no sexual contact and never any drugs. She drinks a wine cooler every couple of weeks. . . . Thorough physical by her physician shows her hymen to be intact and no signs of rectal or oral sexual interactions." (Runnells, 84)

ROBERT MONTGOMERY TO KIM: If God ever punished anyone, Kim, it wouldn't be you. I've known a lot of young people in my life, and you are at the top. For whatever reason, you've had more tragedy piled on you than anyone—anyone—deserves. But Kim, hear me now, it's not because you're being punished. You're too good for that. That's just not the way God works." (Runnells, 123)

FATHER: "I feel she was chosen because she possessed qualities many do not have. She had faith, upbringing, religion, and love of the closeness of family life. She was bright, with common sense—sensitive and compassionate—and she loved people, animals and the environment . . . she was a very special person who made believers of others. She was chosen for this mission." (Runnells, 9, 37)

MA JAYA: "All that she wanted was for me to help her conquer her ego. She listened and it just melted away. She was such a beautiful child. She had . . . such love of life, and she knew how to use each moment . . . She was my most anxious, my most receptive student. She made death a friend. She was a warrior. . . . We talked of death and she befriended (it). Such courage is

so hard to find anywhere on this earth. . . . When she came here, we thought we could teach her (but instead) she taught us." (Runnells, 50)

Kim "I miss being who I was." (Runnells, 146)

Kathleen O'Boyle, anchor on November 11, 1990 "A Current Affair": "You will meet a young woman you will never forget." (Runnells, 148)

Kim, in a letter to Nikki Economou: "Who do I blame? Do I blame myself? I sure don't. I never used IV drugs, never slept with anyone, and never had a blood transfusion. I blame Dr. Acer and every single one of you bastards. Anyone that knew . . . and stood by not doing a damn thing about it. You are all just as guilty as he was. You've ruined my life and my family's." (Runnells, 172)

Patient History, CDC case #242284 continued: During her second year at UF, she lived in an apartment with three other girls, two of whom she felt were wild and brought over some boys who she suspected used some drugs. . . . In the spring, she had several dates with boyfriend #2. The patient reports that she had been to a fraternity party with boyfriend #2. She says that she had two to three large glasses of beer that evening. Boyfriend #2 returned with her to her apartment. Subsequently all of his clothing was removed and some of hers. He performed cunnilingus on her and attempted to have her perform fellatio. . . . Boyfriend #2 performed heavy labial and vaginal petting. She does not think his penis penetrated her vagina but is not sure. . . . The next morning she noted blood on her underwear. She does not think she was menstruating. Boyfriend #2 had a reputation for sleeping with multiple women. . . . He is from a Central American country, and has been there since 1988. . . . During her time at college, she frequented Latin nightclubs, and her friends said that all of the boys she was attracted to were Latins, mostly from Miami. It was the impression of her friends that she had had sex, most certainly with boyfriend #1, and probably with others.

Jay R. Trabin, M.D., gynecological exam: HPV—inconclusive (Runnells, 128)

Gerre, Kim's best friend: "Kim is a virgin. I'm her closest friend. If she had had sex, she would have told me. She didn't. She is a virgin. I know!" (Runnells, 14)

from interviews with Robert Montgomery: She was a beautiful young woman.

father: "Dr. Acer might as well have shot her in the head." (Runnells, 186)

FROM "LETTER TO MY FORMER PATIENTS," BY DR. DAVID ACER: "It is with great sorrow and some surprise that I read that I am accused of transmitting the HIV virus to one of my patients. I do not understand how such a thing could have happened, and I do not believe it did happen. There was no puncture or cut incurred by me during the procedure, and I followed the CDC guidelines with this patient in the belief that I would safely prevent the transmission of the disease as advised by the CDC. If the CDC had advised me to stop practicing because the guidelines were not safe, I would have immediately done so. However, it was my belief that the CDC would never issue guidelines that would put patients and health care workers at risk in transmitting this disease."

MOTHER: "Where did my daughter's AIDS originate? . . . with uncaring politicians." (Runnells, 187)

PATIENT HISTORY, CDC CASE #242284 CONTINUED: During an interview, the patient admitted that her mother often has needles in the house. She produced a needle of approximately 18 gauge in its opened package from her mother's medicine chest which the patient speculated was used for puncturing boils. . . . The only friends we could speak to were friends she gave us permission to and they had all been forewarned by the case that we would be calling. We believe that case is concerned that, if she tells us her risk, her mother would find out because she works in a neighboring health department where there is frequent communication. There is reason to believe that the patient believes there would be serious negative impact if her mother believed she participated in any risky behavior. Though initially cooperative, the mother is now upset with the investigation and has informed the local health department through an intermediary that we are to leave the family alone as they are being harassed.

FROM *PEOPLE* MAGAZINE'S COVER STORY, "KIM'S BRAVE JOURNEY," BY BONNIE JOHNSON: "For the most part, though, the 19 1/2 hour train trip—Kim's first—seemed almost more than she could endure. She was lifted from her berth only at mealtimes—her fork moving in slow motion as she picked at turkey, beets, and cheesecake. Then, hollow-eyed and gaunt, she huddled again under a blanket. She seemed to lack the energy even to enjoy the scenery she had so looked forward to seeing. . . . Kim had hoped to walk into the hearing room the next morning but instead had to be taken in a wheelchair."

KIM'S TESTIMONY BEFORE THE CONGRESSIONAL SUBCOMMITTEE IN SUPPORT OF THE KIMBERLY BERGALIS PATIENT AND PROVIDER PROTECTION ACT OF 1991, SPONSORED BY SENATORS DANNEMEYER AND HELMS: "AIDS is a terrible disease that you must take seriously. I did nothing wrong, yet I'm being made to suffer like this. My life

has been taken away. Please enact legislations so no other patient and health-care provider will have to go through the hell that I have. Thank you." (Runnells, 185)

THE LAST CONVERSATION BETWEEN FATHER, MOTHER, AND DAUGHTER BEFORE SHE DIED:
> father: "How you doing?"
> Kim smiled.
> father: "You sure look like hell. See you in the morning."
> Kim: "I hope not."
> mother: "Baby, you're with God. We're OK. Don't hang on for us. Don't
> face the dawn."

FATHER AND MOTHER, AFTER SHE DIED:
> mother: "George, something wonderful has happened. The virus finally
> took her."
> father: "No! She finally got away from it. She's escaped that bastard
> virus." (Runnells, 192)

FATHER: "We continue Kim's fight to protect the rights of the uninfected. This generation has failed to protect our young and it's up to us to tell this generation why we have failed. In Kim's short 23 years, she left the world a safer place than before. Kim's legacy did not die with her." (Runnells, 193)

MOTHER: "She educated people to respect AIDS and to take diseases seriously. Her life was like a passage from Tolstoy, where a woman is writing to another lady who has lost her son, that says: 'Why, for what purpose, good and noble beings, able to find happiness in life and who have not only never harmed anyone but are indeed necessary to the happiness of others, are called away to God, while wicked, useless, maligned persons are those who are a burden to themselves and others are left to live?'" (*Ibid.*)

FROM LEE BLESSING'S PLAY, *PATIENT A*:
> Lee: Though they should wash their guilty hands
> In this warm life-blood, which doth part
> From thine, and wound me to the heart,
> Yet could they not be clean: their stain
> Is dyed in such a purple grain,
> There is not such another in
> The world, to offer for their sin.
> Matthew: That's a little extreme, isn't it?
> Lee: What? Oh—hyperbole is a central device of the poem. The fawn is

seen as a perfect ideal of innocence. To harm it was a profound sin. I'm not saying that's Kim's story exactly.

Matthew: Then what are you saying?

Lee: That I miss . . . innocence.

AN AFRICAN-AMERICAN MAN IN THE AUDIENCE AT THE YALE LAW SCHOOL IN 1991 AFTER MONTGOMERY SPOKE IN DEFENSE OF MANDATORY TESTING: Kimberly Bergalis is evil. I hate her and I hate you and I hate everyone else too because all of you can turn into Kimberly Bergalises.

So, there you have it. The many versions of Kim. And what's to hate? I didn't know her, you're right, but hate doesn't have anything to do with knowing. So what if she lied? So what if she waited for her dentist to die before suing his corpse for everything it was worth? This is America, after all. And when push comes to shove, we all know we have our price. Push mostly doesn't come to shove, though, so we forget how ugly it looks, until it stares back at us from the likes of her reflection. So what if she was wrong? We all make mistakes. But Helms? Dannemeyer? We don't all make that mistake. Besides, I don't have any reason to hate her. I just hate back because there isn't anything else to do when most of America weeps, after laying the innocent victim to rest. It's not her, she's irrelevant. It's what she represents. It's her story. It's that she even has a story. It's that we all know her story before reading the first word. That's what I hate. Because not everyone gets a story. There wasn't even a published obituary for Dr. David Acer. She shouted him down and took over the narration. And now he doesn't have a story that isn't hers from start to finish. And it goes like this. The horror, the tragedy. Kimberly Bergalis will never get married. She won't ever have kids or grandkids. David Acer took that away from her.

NO WAY OUT

Permutations on endings. Marriage or death? If not marriage then death, if not death then marriage. Marriage because not death. Death because not marriage. Does death explain why not marriage? Does marriage explain why not death? But isn't marriage sometimes like death? Well, no matter . . . a woman gets pregnant, a child is born . . . then marriage then death then marriage then death then . . . so it goes. Repro-narrativity gone mad.

At the very least, it should have bored us, by now. At most, which is obviously too much to expect, we should have thought ourselves out of genealogical plots. However, according to Peter Brooks, in *Reading for the Plot*, we are

"determined" by and "dependent" on conventions of plot and closure. Stories aren't lives. Or the truth. They're about something called meaning—that kind of meaning, incidentally, which seems to only be construed through tropes of reproduction.

In *Fear of a Queer Planet*, Michael Warner attaches repro-narrativity to anxiety about self and world, specifically the tension between self in the world and self distinct from the world, a narrative resolution for Leviathan, alive, alone, and afraid. The beast may be, temporarily, narrated out of the story, but it's never gone for good, which is the point, because if the beast is eliminated once and for all, we wouldn't be condemned to tell the same story over and over again. Repro-narrativity is reproductive before it is narrative, and narrative only to the extent that it either demonizes the girl in the closet or knocks her up. The non-repro, non-narrative, doesn't fit, can't be told, and since it can't be told, can't possibly exist. Non-repro means non-narrative means meaninglessness. But how can meaninglessness mean anything? It can't, theoretically, but it does. Problem number one. Problem number two. Non-repro refuses to obey, and reproduces right before our very eyes.

Brooks tells us that we depend on narrative conventions because we read in "anticipation of retrospection"; that is, "what remains to be read" structures "provisional meanings of the already read" as well as the not yet read, the story in-waiting to be read. We need to know, or at least claim to as-if know, what can only be known after the fact of having read the story, before reading the first word, otherwise, the story is incomprehensible. And unable to be retold. "Anticipation of retrospection," transforms metaphors of narrative transmissibility into metonymic structures, he adds. What appears to have cause and effect, and sequentiality, in the context of a narrative is something that we can only know and that can only be comprehended and meaningful because we read back from the end. Transmission of the story, then, is figured in the story before the fact because we read backwards.

Brooks says that telling "claims genetic force." What he means is that stories are told and read from one generation to another, that they provide us with genealogical understanding, placement, and access to an inheritance. What he also means is that an imagined act of transmission precedes narrative—before the fact of writing, reading, telling, or listening to the story—even though it can only occur and be known to have occurred posthumously.

Telling claims genetic force. The language is not accidental. It indicates, on the one hand, a suspicion about nature in the face of nurture, culture confronted with science. And, on the other, raises questions about what's in the genes and what's in the air, how or whether what's in the genes and what's in the air gets in us and, importantly, how or whether what's in the genes gets in the air, what's in the air gets in the genes. We claim to believe that science and

culture form two distinct categories of knowledge yet we talk about transmission of both stories and genetic traits, as if they are identical, continuous, or at the very least, connected processes. Don't argue about the limits of vocabulary. It's metaphor turned metonymic, sameness with a difference that contains its own conjunction.

The marriage plot. It's a failure of imagination. That we depend on and are determined by narrative structures that prefigure the end, collapsing what has been with what will be, so that we can read on? Maybe it's sophisticated theory. Maybe it's just scared. We read the male and female couple not as a configuration of a dialogic context—that is, storytelling requires more than one person—but as quite literally reproducible and reproducing. We are unable to separate biology and genetics from storytelling, as if they authenticate, author, and contain each other, because it relieves us of uncertainty about what we don't know, because we will know it, if it can be known, because marriage guarantees that whatever it is will be transmitted and, in the act of its reproduction, become meaningful.

The story of Kimberly Bergalis prefigures the absence of the marriage plot—death to explain why not marriage—which is attributed to the introduction of non-repro, non-narratible Dr. David Acer. A vampiric figure, so the story goes, with bad blood that somehow got into her blood, transmitting his virus, which reproduced, in such a way that she was rendered non-repro, too. But not non-repro like him. An obvious question, at this point is: What if Kimberly Bergalis had been a dyke? What if she had been a non-repro, non-narratible figure, too? What would blood mean, then? What would the virus mean? Would the story have been told? (Well, Kim wasn't Gia. Stephen Fried's biography constructs the former supermodel as anything but an innocent victim. She's transgressive and excessive. "The purest homosexual," one of her friends is quoted as saying, like a man that's all woman and a woman that's all man or something else altogether. And she had a heroin habit she couldn't break.) After coming out HIV+, Bergalis's construction was very carefully narrativized to preclude the risk behavior analogies, "like a gay man," and "like a person of color." Kimberly Bergalis "never did anything wrong." She didn't use drugs. And she was a virgin, a straight virgin, that is.

Her story's as close as it gets to the resurrection of pure white southern womanhood. In the old South, African-American men were lynched if they looked in the wrong direction. The fear, miscegenation. The crime? Well, the look was enough to constitute rape. In Kimberly Bergalis's story, Dr. David Acer's the criminal who stole her reproductivity. Somehow. I don't even want to imagine what might have happened if he had lived long enough to sit through the trial. However, it wasn't only that Dr. David Acer was the demon queer, but that because he was the demon queer, he was also as-if black,

because he and everyone like him represent a threat to straight white girls like Kimberly Bergalis.

So, what's the South got to do with it? Maybe nothing. Could be just my imagination. Since I'm from the South, I can't help it, Dixie's always on my mind. In addition to everything else we might think about Florida, however, it is, after all, a southern state. Whether geographically North or South, though, we are always and forever in America. This means to me that race should always be considered an issue, even when it appears not to be. Although Kimberly Bergalis's construction is not an explicitly racialized construction, I believe it is attached to the discourse about race in significant ways, in its absence, even primarily because of its absence.

Ft. Pierce, and all of the towns along the so-called Treasure Coast of Florida, are residentially segregrated by Route One. Whites live to the East, people of color to the West. The statistical profile of AIDS in these communities, according to Stephen Barr's "In Defense of the AIDS Dentist," can be mapped onto this racial geography. In addition, Barr says, "Florida's Treasure Coast constitute(s) what may be the heterosexual-transmission capital of the United States." Fifty percent of all people living with AIDS in St. Lucie County, where Ft. Pierce is located, are straight. Nationally, heterosexuals constitute only seven percent of PWAs. For the past ten years, in the local Florida press, AIDS seems to be two different epidemics. A white gay male epidemic, and a straight, black, mostly Haitian-immigrant, mostly female, epidemic. So, where does Kimberly Bergalis fit in? She doesn't. That's the point. That's why she needs an explanation, and a story.

"Nothing could be more meaningless than a virus," Judith Williamson says to begin her article, "Every Virus Tells a Story." Race, I would argue, is just as meaningless. And when race is mapped onto a virus, meaninglessness is multiplied. According to Williamson, meaninglessness is intolerable since it is as impossible to include in any system of meaning as it is to exclude. As a result, meaninglessness accrues meaning by being "fitted into a language that was already there," into narratives that we have already read. In Kimberly Bergalis's story, the virus, which ruptured the plot and interferred with "anticipation of retrospection," became racially coded. The repro-narrative that might have been was detached from its "genetic force," and was reconfigured instead—reading back from the end—as an antecedent to *Gone With the Wind*. Kim is Scarlett's descendant, in other words, as well as her ancestor. Although, Scarlett rejects the ideals of pure white southern womanhood. "Not being myself has always been my greatest trouble," she admits, referring to all those years passing as the embodiment of an ideal. And after the Civil War begins, Scarlett becomes masculinized, then unsexed, and finally describes herself as "darkness," "black darkness." Although her heir, Kim is constructed

as a reproduction of these ideals of white womanhood. Quite self-consciously, I suspect, to narrate out the conjunctions of race, gender, and sexuality that the discourse about AIDS produces, that Scarlett represents in the end, but that Kim is defined against.

WORKS CITED

Acer, David. "Letter to my Patients," advertisement in *The Stuart News* (Martin County, FL), September 6 and September 7, 1990.

Barr, Stephen. "In Defense of the AIDS Dentist," *Lear's*, April, 1994.

Blessing, Lee. *Patient A*. New York: Heinemann, 1993.

Brooks, Peter. *Reading for the Plot: Design and Intention in Narrative*. New York: A. A. Knopf, 1984.

Fried, Stephen. *Thing of Beauty: The Tragedy of Supermodel Gia*. New York: Simon and Schuster, 1993.

Mitchell, Margaret. *Gone With the Wind*. New York: McMillan, 1936 (New York: Scribner, 1996).

Runnells, Robert A. *AIDS in the Dental Office: The Story of Kimberly Bergalis and Dr. David Acer*. Fruit Heights, UT: I.C. Publications, 1993.

Warner, Michael. *Fear of a Queer Planet: Queer Politics and Social Theory*. Minneapolis: University of Minnesota Press, 1993.

Williamson, Judith. "Every Virus Tells a Story." In *Taking Liberties*, ed. Erica Carter and Simon Watney. London: Serpent's Tail, 1989.

Gendered Visibilities in Black Women's AIDS Narratives

Katie Hogan

The remarkable force with which traditional myths of gender are reproduced in progressive AIDS narratives, including feminist narratives by and about black women, is rarely analyzed.[1] Given that conservative responses to those who are most vulnerable are so audible and harsh, it is understandable why critics have not developed a cultural critique of alternative, left-leaning perspectives. Yet entrenched gender ideology in relation to HIV/AIDS emerges in many liberal texts, from Tony Kushner's award-winning *Angels in America* to Charlotte Watson Sherman's groundbreaking feminist novel, *touch*.[2] And while gendered, racial, and sexual narratives clearly pre-date AIDS, the epidemic infuses the social institution of gender with new life, creating what cultural critic Paula Treichler terms, "an epidemic of signification" (Lorber). In short, all textual and visual representations of AIDS inevitably interact with and negotiate pre-existing myths of difference and deviance.

　　Art historian and AIDS cultural critic Douglas Crimp makes progressive writing the object of critical scrutiny. In his 1988 essay, "How to Have Promiscuity in an Epidemic," Crimp unabashedly voices his dislike of what smacks of sexual repression and internalized homophobia in AIDS journalism written by well-meaning gay men.[3] Crimp analyzes the ways in which some work produced by gay men ironically reproduces the homophobia of state-sponsored AIDS education, public service announcements, public health policy, and mainstream film and television. For example, Crimp challenges one of his own, the highly respected and successful

journalist, Randy Shilts, who has since died. He offers a careful analysis of Shilts's characterization of gay sexuality and politics in the author's best-selling, *And the Band Played On* (1987). Shilts's formulaic "thriller" plot and his problematic presentation of "Patient Zero" as a hedonistic, amoral "for-eigner"—Patient Zero was the French-Canadian flight attendant whom the Centers for Disease Control scientists discovered to be the sex partner of numerous gay men in the United States—signals Shilts's own subtle complicity with homophobia, xenophobia, and fear of gay sex.

Crimp also analyzes Shilts's problematic discussion of female prostitu-tion, which is figured as a transmission route to heterosexual men and their innocent families. Such frameworks, as many have observed, imagine women as conduits of infection to men and children; their own multifaceted individu-alities, not to mention their sexual health, are rendered invisible (Corea). Crimp's essay is lengthy, detailed, and highly controversial, but his overall point is that gay discourse on AIDS is not exempt from discriminatory cultural obsessions and narratives. His analysis suggests that the multiple stigmas and fantasies associated with AIDS, in particular, the stigma (and attraction) of "perverse" sexuality, subtly encourages progressive writers to temper their narratives on AIDS by employing stereotypes that separate out good women and good gay men from bad women and bad gay men.

The power of Crimp's critique of Shilts, while directed at a single author, lies in its applicability to all discourse on AIDS. Crimp's reading of Shilts's text provides an angle of vision that unmasks the underlying assumptions structur-ing and shaping AIDS narratives, wherever and whenever they emerge, includ-ing in award-winning gay plays and films, and ground-breaking feminist novels. The critical goal is to discover contradictions in textual and visual rep-resentation that are tied into the production of gender, racial, and sexual ide-ologies; to tease out subtle assumptions in progressive textual and visual language on HIV that suggest the historical baggage with which all AIDS nar-ratives engage.

GENDERED AND RACED VISIBILITIES

Author Paul Monette, winner of the National Book Award, wrote a novel that enacts fantasies of gender and race at the same time that it challenges the stig-ma of AIDS. In Monette's *Halfway Home*, all the female characters are carved up into emblems. For instance, Mona, the best friend of the gay male protago-nist with AIDS, is affectionately and repeatedly referred to as "Very Mom-is-it-lunch-yet" and as "remarkably Donna Reed in her dealings. . . . cutting the crusts off sandwiches" (5). Mona/Mom is given few interests outside of her emotional and physical caretaking of Tom, her gay friend with AIDS, and

thus, as often happens in narratives of the epidemic, Mona's characterization is flat and undeveloped. She exists solely in terms of Tom's perspective, symbolizing "woman" as the asexual female carer, a conservative belief that places women in traditional roles (Gorna, 57). Mona's opposite is the male protagonist's sister-in-law, Susan, an emotionally sealed, sexually repressed, homophobic heterosexual who frustrates Tom's last chance for reconciliation with his estranged brother, Brian. She, like Mona, is developed solely in terms of how she either supports or frustrates the male protagonist. Susan is the "bad" heterosexual mother while Mona is the "good" lesbian mom.

Racist fantasies emerge in *Halfway Home* in terms of a Native American male character named Merle who is repeatedly described as "an ox" (112), "a hulk of an Indian chief . . . who spoke with curious elegance for one who looked so adamantly untamed" (55). At one point, Tom "wondered if perhaps [Merle] *couldn't read*" (56, my emphasis). In short, the raced and gendered bodies of this text reinforce the conception of women and North American Indians as animalistic and intellectually inferior, as nothing more than human scenery. Monette's fictional world is created to produce sympathy for gay men, a worthwhile literary goal, yet in producing the narrative, his text reproduces an undeniably male and white supremacist vision, with female characters positioned in the sidelines, supporting or frustrating the male characters' various aspirations, and with the one male character of color depicted as "untamed" and as possibly illiterate (Brownworth).

Monette's novel should be understood in relation to other examples of discourse on AIDS, such as public education, which also reproduces similar gendered and raced conceptions. In public service announcements, women's actual realities as people infected with or affected by HIV are concealed. Instead women are overwhelmingly pressed into the familiar symbols of moral guides, physical caretakers, and maternal surrogates (Johnson, 26; Gorna). According to Deborah Johnson, who has analyzed over three hundred public service announcements on HIV shown throughout the world, most public education emphasizes the risks for men, even in countries where women's rate of infection equals men's (26). In the majority of public service announcements, more men than women serve as narrators, and more male actors and celebrities are featured, even when the information is directed at women (Johnson, 26). Furthermore, the information directed at women completely ignores the contexts of women's lives. Women are simply instructed to use condoms, a directive that ignores the reality that men, not women, wear condoms. When women do appear in these announcements, they are placed, as in Monette's novel, "in self-effacing, caregiving roles as wives, mothers, and friends of people with AIDS" (26). As Johnson concludes, this kind of inclusion (and isolation) situates women in gender-conforming roles, contributes to women's

invisibility as infected and affected people, and increases all women's subordination. By emphasizing women in terms of what they are to other people—mothers, wives, best friends—women's own multifaceted individualities as well as their multifaceted experiences in the epidemic are marginalized (Johnson, 26). As Robin Gorna argues, women are "misused" in representations of AIDS in an effort to make the topic generalizable and "normal" (51). Women are "misused" in representations as a way to consolidate the institution of gender.

For example, ushering in a visibility of women with HIV in textual and visual representations of AIDS, while important, will not necessarily solve the underlying problem of gender, as Johnson's research demonstrates. As more HIV-infected and affected women publish memoirs, fiction, poetry, and speeches, they challenge invisibility and sometimes even expose controlling ideology. Yet, as AIDS theorist Cindy Patton argues, it is not so much that women have been invisible in the discourse on AIDS, but that the category "woman" is sectioned off into various ideological meanings (2). As Johnson's research indicates, women are included in public health education, but in ways that increase, rather than challenge, their health risk and their subordination. The diversity of the world's women is collapsed into the category "woman," which is then manipulated to mediate the multiple stigmas associated with AIDS. In other words, a traditional idea of "woman" is used to reinforce traditional gender. Women's actual diverse experiences and needs are replaced with imagery of traditional femininity and with the idea of "woman" as a role. The Christian Right might use the HIV-infected woman as an example of how homosexuality and feminism are destroying the traditional family. International, national, state, and local health organizations might use women in AIDS discourse as emblems of compassion, moral superiority, or gatekeepers of sexual restraint. News media might exploit the category "woman" to symbolize the ancient theme of woman as a cesspool of sexual pollution.

Take the contrasting ways that Helen Cover and Kimberly Bergalis, both women with HIV, were figured by the U.S. media. Cover was a sex worker who, after performing fellatio on an undercover agent, was legally charged with attempted murder. The presiding judge denied her lawyer's bail request, even though there is no evidence of a man getting AIDS as a consequence of fellatio with a woman (Corea, 173–175). The judge hearing the case declared Helen Cover's medical problem as a risk to the community. Her arrest made the front page of the *Syracuse Herald-Journal* on January 29, 1989: "Prostitution Suspect Has AIDS: Officials Try to Keep Her Jailed" (Corea, 173–175). Middle-class, white Kimberly Bergalis, on the other hand, was presented by the media as an innocent victim, a virgin who contracted HIV through her infected gay dentist. It was recently discovered that Bergalis was not a

"virgin," a fact that was intentionally downplayed by Bergalis's lawyers and family, and by the media (Gorna, 54).[4]

When poor women and women of color are not being presented as containers of sexual pollution and moral pathology, they are reduced to signifiers of abjection and unspeakable impoverishment. In discourse on AIDS from a global perspective, for example, women are often framed as one-dimensional victims who are located in far-away, pitiful developing countries (Ogur). In the United States, HIV-positive women who live in cities are similarly constructed in totalizing terms—either as essential victims or as infected predators who dwell in "the ghettos" (Corea; Ogur). All of these ways of "carving up the category 'woman'" are rooted in social control and systematic gender oppression (Schneider and Jenness; Patton). As AIDS critic Jenny Kitzinger asserts, "[B]oth the condemnation of Bad Woman and the equal but opposite adulation of Good Woman serve to control female sexuality and police the boundaries of acceptability." Popular fiction, public service announcements, television and print news, Hollywood films, and made-for-television movies are more concerned with promulgating ideas of what counts as an acceptable woman than in exploring women's actual experiences in the pandemic.

Compared to the media construction of Helen Cover, as discussed above, Whoopi Goldberg's character in the 1995 film, *Boys on the Side*, may seem like an improvement. The character played by Goldberg, Jane Deluca, is an HIV-negative lesbian who takes care of a white woman with AIDS and a young white friend who is pregnant. The problem arises in that there is nothing in the story of *Boys on the Side* that explains why the character would allow herself to be consumed by the needs of these two white female characters. Black men and men of color are similarly portrayed as "mammies" in much mainstream AIDS literature and popular culture (hooks). The character of Belize in Tony Kushner's *Angels in America* plays the role of former drag queen, lover, and nurse to the main protagonist with AIDS, the thirty-one-year old Prior Walter. In addition to Belize's unwavering devotion to Prior, are the lessons Belize tries to teach Louis, Prior Walter's self-absorbed, errant ex-lover: "Softness, compliance, forgiveness, grace" (*Millennium*, Kushner, 100).

In *Reel to Real : Race, Sex, and Class at the Movies*, bell hooks develops this theme further when she argues that in the first U.S. mainstream AIDS film, *Philadelphia*, Tom Hanks's character's Latino lover, played by Antonio Banderas, "is portrayed as living only to be the little mammy, taking care of the great white man" (87). As hooks further points out, "Nothing in the script of Philadelphia even hints at what would lead Denzel Washington's character to divest himself of his homophobia and take time away from his wife and newborn baby girl to work overtime defending a gay white lawyer with AIDS. The implication is that 'good' white males are inherently worthy, deserving of

care, and, of course, always superior to black women in their values and actions, even when they are sick and dying" (87). Popular representations of African-Americans and AIDS, as the examples of Belize and *Philadelphia* suggest, are framed through the lens of white domination. Around the time that *Boys on the Side* was released, according to a 1995 U.S. Centers For Disease Control study, one out of five deaths among black women between the ages of 25 to 44 was caused by AIDS, a reality the film willfully ignores by focusing on a white, single, heterosexual woman who contracts HIV from a one-night stand with a male bartender (Schoofs, 45).[5]

However, since the release of *Boys*, two examples of progressive, black feminist literary discourse, Sapphire's *Push* and Charlotte Watson Sherman's *touch*, have emerged. Both novels focus on AIDS in black women and girls and both novels negotiate the standard ideas of AIDS that I have been delineating. They are trailblazers in terms of breaking silence, and they draw from black feminist literary traditions to redefine the story of AIDS. They also candidly challenge black communities' silences on HIV. In short, Sapphire and Sherman use the terms of feminist literary traditions to force a dramatic convergence between the evolving discourse on women and AIDS and black women's writing. However, these two rebellious texts subtly reveal conceptions of women commonly found in dominant AIDS discourse. They demonstrate how textual and visual representations of AIDS are a key site where gender ideology in language is produced.

In other words, I celebrate the fact that both novels actively outline AIDS from a black feminist standpoint, but as with much progressive AIDS discourse, I demonstrate how they cannot escape the deeply entrenched gender ideology of language and culture. As critic Henry Louis Gates observes, "the tensions that beset any project of emancipation . . . illustrat[es] the difficulties of ever escaping entirely the confines of patriarchal discourse" (15). Both novels announce the desire for emancipation from the raced and gendered silences on HIV, yet the subtle contradictions in their narratives demonstrate the futility of complete escape. These contradictions are significant markers of the interplay of gender ideology and AIDS. Instead of interpreting them as flaws, I argue that they offer an assessment of how representation on the epidemic manipulates the linkage of women and AIDS in the name of traditional gender. In short, these two novels confirm my view that representations of AIDS are a central site of multiple oppressions for women.

Before turning to a more detailed analysis of how *touch* and *Push* nourish traditional gender in the context of black feminist narratives on HIV, I want to explore how they challenge complex silences on HIV in black communities by drawing from black feminist literary traditions. In doing so, I hope to emphasize the revolutionary aspects of *Push* and *touch*.

BETRAYERS OR DEFENDERS

To date, few literary texts authored by African-Americans address HIV in black women. Homophobia, racism, and sexism in publishing, education, medicine, and the family are clearly some of the fundamental reasons for this absence, but a complex reticence on HIV in black communities has also contributed to the denial of women and AIDS (Boykin; Hammonds; Schoofs). According to Mario Cooper, co-director of the 1996 Harvard AIDS Institute Conference on AIDS in African-Americans, "except possibly for slavery, nothing in our history will have killed so many black people in such a short time as AIDS" (Schoofs, 45). Despite Cooper's linkage of slavery in the same sentence as AIDS and African-Americans, most African-Americans, let alone most Americans, do not interpret the epidemic as equivalent to slavery or as a predicament worthy of a full-scale civil rights mobilization. Yet, as previously mentioned, recent CDC statistics reveal that HIV/AIDS is a central experience in African-American communities. Twice as many young black men die of AIDS than of homicide, and one out of three black men between the ages of 25 to 44 has died of AIDS, while one out of five black women in this age group has died (Schoofs, 45). Furthermore, the Harvard AIDS Institute predicts that by the year 2000 "more than half of AIDS cases in the United States will be among blacks" (Rimer). [6]

At the same time, euphoric news accounts of cutting-edge combination drug therapies have led many to believe that the epidemic is over. The fact that many individuals cannot tolerate the new intricate drug regimes, and that most who need these treatments lack the financial wherewithal and health insurance to access them, is repeatedly ignored (Schoofs, 45; Shernoff, 16). For many poor people, the so-called "end of AIDS" is one more example of how the story of the epidemic is constructed so that women and people of color are virtually erased (Shernoff; Sullivan). For example, while the overall number of deaths from AIDS among men has dropped in the last year, a three percent increase in women's deaths from AIDS has occurred in the same period (Denison, 4). These were some of the issues discussed in late October 1996, at the Harvard AIDS Institute Conference, which attracted the participation of many prominent leaders, including Henry Louis Gates, Jr., director of African-American Studies at Harvard and co-organizer of the conference. The purpose of the professional gathering was to confront the devastating toll that AIDS is taking on African-Americans. Much discussion centered on the startling fact that although "Blacks comprise just 12 per cent of America's population" they make up "40 per cent of all AIDS cases, more than half the female cases, and more than 60 per cent of children with AIDS" (Schoofs, 45).

Homophobia and the stigmatization of drug addicts within black communities were cited as key causes of apathy and denial (Schoofs, 45). For

example, though the conference coordinators invited members of the Black Congressional Caucus, the executive director of the NAACP, and the president of the National Urban League, not one member or representative from these organizations attended the Harvard AIDS Institute Conference (Schoofs, 45). The fact that many prominent black church leaders also failed to attend suggests a profound level of fear and denial. There are indications that serious discussions on the impact of HIV in black communities is forthcoming, especially among some black church and health leaders who have lost family, friends, and community members to the disease, but the silence on HIV within diverse black communities is very real.

Contemporary silence on HIV in black communities has extremely complex causes and meanings. Historically, black leaders and social reformers have used reticence on issues concerning sexuality and "immorality" as a strategic defense against racism. As AIDS advocate Keith Cylar explains, "To counter white bigotry. . . . African-Americans often try to present a flawless image. Anyone who deviates from that ideal—such as those who are at highest risk for HIV—face extra ostracism for 'betraying the race.' Then there is the widespread fear that if the truth about who is getting AIDS is known, whites will use it as another club to pummel blacks" (quoted in Schoofs, 45). The more that black communities feel besieged by an illness that is associated with white gay men and illegal drug use, the more these same communities adopt a protective reticence.

The silence on HIV in black communities also stems from a deep reluctance to discuss homosexuality openly. Keith Boykin explains that while many African-Americans are homophobic, many blacks acknowledge and accept male homosexuals in the community, although they might not state this support openly to other blacks or to white people. Some black gay men have experienced a degree of acceptance within black American cultures even though the rhetoric of homophobia, particularly that of church leaders, suggests the opposite. For example, Boykin describes how numerous black gay men in Washington, D.C., are practicing members of a predominantly heterosexual church where they are "accepted" and subjected to homophobic sermons. On average, however, black communities are no more or less homophobic than white communities. Denial within black communities on AIDS and issues of sexuality differs, in a few crucial areas, from the denial and responses of mainstream (and non-mainstream) white America.

Feminist historian of science, Evelynn Hammonds, has been analyzing responses to HIV in black communities since 1987. Hammonds's theories confirm Cylar's and Boykin's views that contemporary silence on AIDS is related to the taboo subjects of sexuality, homosexuality, and drug use. Thus, by not talking about or addressing AIDS, some black communities feel that they are

"defending" their communities and "race" from historically entrenched stereotypes of black sexualities. The adoption of a sexually conservative rhetoric may or may not be what black communities actually practice, but as a political strategy, this representation acts as a bulwark against white bigotry. For black women in particular—a point of view that neither Boykin nor Cylar develop—AIDS evokes old racist stereotypes of black women as innately promiscuous and diseased (Hammonds). In discussing these stereotypes of African-American women, Hammonds repeatedly uses the concept, "racialized sexuality," which is the "powerful effect that race has on the construction and representation of gender and sexuality" (130). Racialized sexualities are central to conceptions of HIV, as the media reports of Helen Cover, discussed in my introduction, indicate. Hammonds argues that raced sexuality and gender are connected to the fact that "little attention has been paid to the plight of African-American women with AIDS because they are women" (8).

Black women's resistance of racist representations of their sexualities has a long history in the United States. Since at least the late nineteenth century, African-American women club leaders, church women, writers, and activists have wrestled with several stereotypes, especially that of the black woman as hypersexual whore. This fantasy was created by white men and women as a rationalization of the repeated mass rapes of young black women by white men during and after slavery. It is a conception of black female sexualities that has caused, and continues to cause, enormous pain and distortion. Scholar-activist Angela Davis writes that African-American women dealt—and deal—with this hypersexual image by adopting a sexually conservative rhetoric as a political strategy (19). For instance, the black women's club movement of the late nineteenth and early twentieth century encouraged black women to "defend" their race against the relentless accusation that all black women were immoral. Some black women were encouraged by middle-class leaders to devote their lives to "racial uplift" and to the creation of respectable heterosexual families, regardless of their actual desires and realities. Other black women willingly assumed a desexualized self-presentation as a psychological coping mechanism. In either case, black women's right to self-definition was greatly hindered.

It was not uncommon, explains Angela Davis, for some middle-class black women of the club movement to judge as unfit other working-class women—in particular, sex workers—whose sexualities and self-presentations did not conform to the supermoral, black woman image. Many black club women saw the "improvement" of black women as their life's mission, and they resented and were intolerant of women who were different. As historian Deborah Gray White explains, "For all of the club movement's good works, including employment agencies and self-improvement programs for women, it

never abandoned its need to play it safe and be polite." Thus the work of countering repeated charges of sexual immorality and impropriety became intertwined with black women's desexualization. The repression of sexuality, then, became a deliberate defense against racism. Davis proposes that the "defending our name" strategy worked brilliantly on a political level, but it severely affected black women's ability to explore and express self-defined sexualities and individualities. Since black women's sexualities and bodies were constructed in relationship to white racist imagery, these women tried to erase sexual agency in an effort to resist white domination.

Both Hammonds and Davis believe that the legacy of "defending one's name" continues to influence how contemporary black women speak and write about their sexualities, bodies, and lives. For example, Hammonds suggests that contemporary black feminist academics continue to contend with the "betraying or defending the race" formulation, and one telltale sign of this is an undeveloped affirmative discourse on black women's sexualities, especially young girls' and lesbian sexualities. As Lisa A. Crooms of Howard University Law School argues, "our institutional history of club-and-church-based movements have force[d] black women into restrictive molds of middle-class femininity" (quoted in Zook, 88). Since AIDS has revived all the familiar scapegoat discourses and bigoted ideas of genders, sexualities, bodies, race, and class, the unresolved anxieties about how to approach constructions of black women's sexualities and sexual agency in a racist country have reemerged as well.

BLACK FEMINIST LITERARY TRADITIONS AND AIDS

Black women writers' literary traditions have paved the way for Sapphire and Sherman's fictional accounts of HIV/AIDS in girls and women. For despite the code of silence on sexualities in black communities, many black women writers have boldly addressed issues associated with sexuality and gendered ideas in their texts. In fact, black women writers have been creating literary traditions that address numerous controversial and difficult themes. Incest, infanticide, internalized racism, misogyny, female genital mutilation, domestic violence, lesbian relationships, slavery, rape, gang rape, cancer, abortion, tuberculosis, poverty, interracial relationships, biracial identities, and male homosexuality are some of the themes dramatized in black women's literature stemming back, in some cases, to the late nineteenth century. Black women writers have long rejected aspects of the "defenders or betrayers" binary, as evident in the work of Zora Neale Hurston, Toni Morrison, Alice Walker, Ann Petry, Maya Angelou, Toni Cade Bambara, and Barbara Smith, to name just a few. These writers evade the moralist legacy of the black women's club and

church-based movements while always honoring them for their social activism. Likewise, many of these writers reject the desexualization of black women—even as a defense against racism.

Hurston's privileging of the theme of women's struggle for self-defined individuality over African-American community in the character of Janie Crawford is such an example (Gates, 15). And Morrison's character, Sula, distorted by racism, thwarted creativity, and her need for female companionship, resorts to "unwomanly" violence. Alice Walker's Celie restores her battered self through the healing love of another black woman, and Audre Lorde's landmark essay, "Uses of the Erotic," candidly celebrates black lesbian sexualities and bodies, and has influenced generations of diverse women writers and activists, as have Lorde's essays and poetry on interracial love, African lesbian traditions, medical racism, and the politics of breast cancer. Shame, secrecy, and self-imposed invisibility around issues of race, gender, health, and sexuality are countered with healing images, explosive emotion, sexual self-esteem, and personal power. Yet, despite these courageous thematic traditions within black women's writings, few contemporary women writers explore black women's individualities, sexualities, and histories in relation to HIV/AIDS.

Push and *touch* emerge as watershed moments, as strategic responses to both the silences within African-American cultures on HIV and to the predominant racist and gendered ideologies of AIDS used to construct black women. In 1993, Charlotte Watson Sherman was one of the first to initiate a black feminist literary intervention into the discourse on HIV with the publication of her anthology, *Sisterfire: Black Womanist Fiction and Poetry.* Under a section heading, "Prelude to an Endnote: The Body's Health," Sherman includes an interesting array of contemporary black women writers' poetry and short fiction on HIV, including a rather weak excerpt from what would become her novel, *touch.* In 1995, Sherman continued to fill the vacuum with the publication of *touch,* one of the first narratives on HIV from the standpoint of a black woman character. In June 1996, Sapphire's *Push* appeared, signaling an evolving black feminist literary discourse on AIDS. Both novels, as their titles suggest, focus on bodies—women's and girls' bodies—in terms of HIV infection. Both see the body as a site of power and ingenuity as well as of oppression and pain. Both authors see the HIV/AIDS pandemic as offering either the consolidation or rejection of prescribed gender roles. In addition, each author makes her main black female character HIV-positive yet engaged in self-determination and creative self-exploration.

Echoing Alice Walker's epistolary format in *The Color Purple,* both texts use their main female characters' journal entries as a narrative device, although Sapphire's use of this literary technique is far more extensive and successful than is Sherman's. In *Push,* which has been compared to Walker's

The Color Purple in several reviews, Sapphire creates the voice of a sixteen-year-old girl named Precious Jones, an illiterate incest survivor who is taught to read and write from a black lesbian literacy teacher, Ms. Rain. Midway through the novel, Precious begins to write poetry at the same time that she learns that she has contracted HIV from her father. Precious's reaction to this news, as recorded in her journal, is a skillful exposure of sentimentalized constructions of women and girls in white mainstream AIDS discourse: "I don't want to cry. I tell myself I WILL NOT cry when I am writing, 'cause number one I stop writing and number two I just don't always want to be crying like white bitch on TV movies" (127).

Providing their female characters with inner strength and artistic desires, Sapphire and Sherman honor self-definition and creative exploration as a central theme in black women's literary texts, yet, most significantly, they introduce this central theme for young women characters living with HIV. In *touch*, Sherman's character with HIV infection is Rayna Sargent, an introspective, unconventional, thirty-four-year old, middle-class artist who makes her living as a hot-line crisis counselor. Before Rayna learns she is HIV-positive, she has spent years rejecting her family's and community's expectations of marriage and law school so that she could spend her time developing her work. Her abstract expressionist paintings characteristically convey meaning and feeling through figures of women's bodies and faces and through the use of color. Rayna paints from her dreams, memories, and uses her personal journal for ideas and themes. Even after she tests positive, she uses the new uncertainty of her body to create: "She had been having a strong urge to paint something new, an image she saw in her mind's eye that was different from anything she had ever done before" (143). Given the dominant image of women in AIDS discourse as emblems and as instances where prescribed gender roles are reinforced, Rayna's struggle for self-definition, independence, and creativity, despite testing positive, are inspiring and moving. Her personality is initially forged, not in terms of her relationships, but in terms of her autonomous act of creating art.

In chronicling the multiple effects of the epidemic on her character's life, Sherman addresses several political issues on gender and AIDS that are rarely discussed: sterilization abuse; coercive abortions; refusal of abortion services; black women's AIDS activism; safe sex; heterosexual and homosexual crossings and social alliances; and AIDS phobia in black communities, to name just a few. Sherman explores this last theme in the character of Novel Lewis, an AIDS-phobic, black, middle-class psychotherapist who is Rayna's best friend, and in the response of Rayna's adoptive parents, Circe and Carr. For example, Rayna begs Novel to collaborate with her on a ceramic tile collage for an art show at Bailey-Boushay House, a residential facility for people with AIDS.

Novel says that having her work displayed in an AIDS hospital was too distressing and bad publicity—"What if people think I've got AIDS?" (6). And when Rayna finally tells her parents that she has tested positive, her father wonders "how his Rayna could get something he heard that mostly pretty boys, junkies, and prostitutes got"(135–137).

Unlike *touch*, Sapphire's text has been heavily promoted and, as a result, the subject of controversy. Reminiscent of the critical reaction to Walker's *The Color Purple*, *Push* has been rejected by some readers and critics as " a tool of white people" intent on showing " a dysfunctional view of the black family" (Bell-Scott, 80). In graphic detail, Sapphire delineates the sexual and emotional violence that Precious Jones endures at the hands of her disturbed, sadist parents, whose behavior towards their daughter is never explained away as "cycles of abuse" (Kennedy). *Push* has little patience for the worlds of social work, public health care, and public education, populated as they are in this fiction with indifferent, unethical characters who are black and white, male and female. Instead, *Push* directs its angry gaze at the family and community of Precious Jones. Not interested in promulgating a positive black family or community image, nor concerned with how white readers will use the narrative it tells against black people, *Push* exposes father-mother-daughter incest, black homophobia, and the seriousness of HIV in the context of gender and race as systemic institutions (Lorber). For example, Precious eventually has to grapple with a disease that she thinks is naturally associated with "white faggits" and "crack addicts," and part of her struggle will include facing her own learned homophobia and internalized racism and sexism.

The disappointment in these two novels arises in terms of their overall retreat from an in-depth exploration of girls, women, HIV, and gender. Ironically, the characters in both texts never move beyond shadowy individualities, a dynamic that resembles the emblematic use of women in dominant representations of AIDS that results in the consolidation of prescribed gender. Although more true of *touch* than of *Push*, both novels sometimes recapitulate the predominant conception of women and girls as one-dimensional beings who are inevitably defined by someone else or through the structure of traditional gender (Lorber). For example, *Push*'s "abbreviated" characterizations of Precious, the other young black women in Precious's literacy class, and her mentor, Ms. Rain, are denied the full-scale characterizations that would dismantle the prevailing gendered representations of women in AIDS (Gomez). Precious's journal entries record her determination and initiative, but the other crucial characters who supposedly foster her self-definition and she theirs are out of focus (Gomez). In order to understand how Precious transforms from an illiterate, overweight, incest survivor into a budding poet and caring mother of two children—one with Down's Syndrome—spawned by her brutal father, it would

help to understand how her teacher, Ms. Rain, an out black lesbian, reaches her when all of the adults in Precious's life, particularly her warped parents, have failed her miserably. It is as though the embedded systems of race and gender are miraculously overcome through individual will power and commitment, yet one would like to see this restructuring spelled out in more detail.

For instance, the ferocity of Precious's hunger for self-expression and her difficult struggle to engage in the demanding process of intellectual-creative labor demand much more detail and considerations than they are given. Also, one speculates as to how Precious is able to connect with the other young women in her basic literacy class (Gomez). Because we never see the process by which these relationships develop, they, and Precious's emerging literacy, seem fuzzy. While Sapphire's novel comes closer to externalizing the politics of the theme of self-definition for Precious than Sherman's Rayna Sargent— largely because *Push* stays closely focused on Precious's journal entries and includes the writings of Precious's classmates at the novel's end—the reader is basically deprived of the inner lives of these other key characters in terms of maintaining and/or resisting the institutions of gender and race (Lorber).

Sapphire's purpose seems to be to detail the impact of a prescribed gender and a racist, homophobic culture on her girl character, and, at the same time, the author seems to want to create a character who cannot be reduced to the talk-show labels: "incest survivor," "HIV-positive teenager," "unwed, young, black teenage mother on welfare." In other words, Precious is more than a collection of "social ills." Yet in many ways, Sapphire fails her, and the other characters, by not dramatizing how it is that Precious is more than a collection of social ills. One reviewer of the book argues that Sapphire seems to reinforce racialized gender rather than expose it by making Precious seem "like an incompetent fool" and an "imbecile" (Grey, 19). Giving her characters the space and time they need to create their own self-defined individualities might have helped Sapphire in her effort to expose the institution of gender and race as oppressive, dominating, human inventions (Lorber). This lack of development shifts the narrative toward the genre of a slick, superficial, tabloid story—a genre that, on average, works with dominant race and gender rather than against it. Since Sapphire correctly suggests that AIDS and incest are not "private" issues, what is needed in *Push* is a longer, more developed novel, so that the characters' development matches the "bigness" of the novel's social themes.

GENDERED MANDATE

In *touch*, what is needed is the author's rethinking of the implications of her sentimental notion of women and care in the context of AIDS. While Sher-

man's *touch* succeeds in challenging denial on black women and AIDS by creating a middle-class female artist who contracts HIV (and who confronts her own and her family and community's stereotypes and silences), it recapitulates the deterministic association of women with caretaking. The novel opens with Rayna preparing for a solo art show. Her friends complain that she spends much more time developing herself as an artist than in developing her relationships. While she has two, reliable, close female friendships, she has no lover, although she is not opposed to casual sex or to a long-term relationship. Her friend, C'Anne barks, "Art isn't life," to which Rayna responds, "But art is my life."

Rayna's movement into a more communal life, and, as a result, a more prescribed gender role, occurs as she enters the world of HIV/AIDS. First, her friend and fellow artist, Ricky Adonio, is diagnosed with AIDS. Now that he is ill, she feels guilty and writes him a letter. Then Rayna learns of the Briggs case. A hospital psychiatrist where she works tried to convince an HIV-positive black woman named Latosha Briggs to have an abortion, but Latosha refused. In response, one of the hospital's ob-gyn doctors sterilized her without her consent. Then Rayna encounters the Prejudice Posse, a woman's political action group that advocates on behalf of Latosha Briggs and all HIV-positive women. The Prejudice Posse decide to perform several demonstrations at the hospital where Rayna works and they want her support. Finally, Rayna tests HIV-positive; she seeks out a counselor, joins an HIV-positive women's support group, and does volunteer work for HIV-infected children. By the end of the novel, a ten-year-old girl with AIDS asks Rayna to be her "mother," and Rayna agrees. At the end of the novel, Rayna is convinced that she should give up painting and devote herself to teaching art to infected children.

Feminist critic Patricia Hill Collins might explain Rayna's increased caretaking as indigenous to black women's cultures. Unlike the character of Jane Deluca in *Boys on the Side*, who cares for two white women, Collins might explain Rayna's caretaking of black children as an expression of a black woman's emerging cultural consciousness. Similarly, Collins might argue that communal caregiving offers Rayna additional ways to express her creativity and self-definition; it doesn't stifle her or contribute to her own subordination. Collins explains that "motherhood [including surrogate, communal, and activist motherhood] can serve as a site where Black women express and learn the power of self-definition, the importance of valuing and respecting ourselves, the necessity of self-reliance and independence, and a belief in Black women's empowerment." Rayna does not lose independence, she enlarges her independence as she adopts a more communal notion of self and creativity. Anika's request that Rayna be her surrogate mother suggests Sherman's awareness of how many black women, to quote again from Collins, "feel

accountable to all the Black community's children" (205). Furthermore, Collins might argue that the changes in Rayna's character suggest a strategic "rejection of separateness and individual interest as the basis of either community organization or individual self-actualization. Instead, the connectedness with others and common interest expressed by community 'othermothers' models a very different value system, one whereby Afrocentric feminist ethics of caring and personal accountability move communities forward" (Collins, 207). Thus, from Collins's perspective, "the importance that people of African descent place on mothering" explains the changes in a character such as Rayna.

But what exactly does Hill Collins mean by the phrase, "people of African descent"? For example, in K. Anthony Appiah's essay, "The Arts of Africa," he calls into question the idea of a "shared African essence" (47). Do all the women in the countries of "Africa" share unified notions on any aspect of life, let alone mothering and female caretaking? Do all black women of "African descent" in the United States share unified standpoints? Appiah's deconstruction of "Africa" as a unified, homogenous entity challenges Hill Collins's evocation of "African descent" and "Afrocentric" in her argument on black women and caretaking. Appiah argues that the very notion of "Africa" as a continent is inaccurate since historically most people who lived in the countries now called Africa did not think of themselves as living on a continent called "Africa," rather "Africa" the continent was invented for them by imperialists and colonists and, in the United States, through the shared experience of slavery.

In contrast, I interpret the changes that occur in Rayna's character as evidence of how the HIV/AIDS epidemic intersects with entrenched ideas of gender. Not only has the pandemic increased the amount of unpaid labor women are expected to perform—caring for sick family and community members, even when women are HIV-infected or ill—it creates a representational rationalization in which woman as caregiver is constructed as the inevitable, and natural "answer" to the crisis of AIDS.

For instance, Julia T. Wood argues that "Just as empathy, nurturing, and caring can enlarge women's understandings of themselves and others and can prepare them to form relationships of extraordinary depth, so too can these qualities threaten women's ability to develop and maintain a clear sense of themselves as individuals" (Wood, 5). As discussed earlier, in the opening chapters of the novel, we are reminded that Rayna has consciously rejected all the conventional options—marriage, secure profession, children—so that she can focus on self-exploration. Yet with each new chapter, Rayna's artistic self-exploration seems to shrink rather than enlarge. She increasingly sheds her core identity as an artist and takes on the mantle of communal caregiver, even

though the narrator states that art is " the most intimate part of [Rayna's] life." For example, after Rayna finally gathers up the courage to tell her new boyfriend that she is HIV-positive, one of his immediate responses is that she "do something." His advice is that she volunteer to teach art to HIV-positive children and children living with AIDS. With some trepidation, Rayna eventually finds herself at the Dancing Unicorn House, where Theodore has arranged for her to teach art to the children. Rayna uses the experience for her personal development as well as to perform community service, but she is clearly being put in the role of caretaker, an activity that takes her away from creating art. And with the introduction of the character, Anika, a child with AIDS, Rayna's sense of herself as an artist is almost completely lost.

Anika is an adorable, ten-year-old girl who contracted HIV as a result of child sexual abuse. Living with a mother who traded sex for drugs, Anika was exposed to HIV when several infected men sexually abused her. Now Anika lives in an AIDS residence for children, Dancing Unicorn House, directed by Mrs. Jenkins, a woman whose husband died of AIDS. As a newly diagnosed HIV-positive person herself, and as an adopted child who was taken away from an "incompetent" mother, Rayna is ambivalent about working with the children, especially the "motherless," sexually abused Anika, who is in late stages of AIDS. After some avoidance, Rayna begins regular visits, teaches art to the kids, and befriends Anika, who, just before she dies, asks Rayna to be her "mother." Rayna has always feared motherhood, yet she agrees (195). Her involvement with the children at Unicorn House, and particularly with Anika, increases in time and intensity, and subsequently, she begins to question her life-long preoccupation with making art. Near the end of the novel, she admits to her two best friends, Novel and C'Anne, that taking care of these children is more important than being an artist. Luckily, unlike in other exchanges with her friends, and as with Theodore, Rayna's friends disagree with her plan. C'Anne responds with open disapproval: "You can use your art for healing if you want, healing yourself and others. Cutting yourself off from one of the things that has sustained you most in life seems ridiculous, and, frankly, over-dramatic" (184). C'Anne and Novel remind her that making art is the core of who she is, and while caretaking and working with these children is vital and important work, so is her art.

However, while her friends say that they want Rayna to return to her painting, they also spend a great deal of time throughout the story questioning Rayna's serious engagement with her work. C'Anne implies, for instance, that Rayna's preoccupation with art is not "life"—"You gotta leave that art alone sometime and get out in the world." While Rayna is in the midst of creating new paintings for her first solo art exhibit, which she works on after eight hours a day on the hotline, C'Anne urges her to call Theodore, the man with

whom C'Anne thinks Rayna should become romantically involved. Both C'Anne and Novel feel that Rayna is too intense, and they neither understand nor support her ongoing periods of paralysis followed by outbursts of productivity. Later in the narrative, Theodore also accuses Rayna of using her creativity as a "crutch." Although Sherman seems aware of the centrality of Rayna's art to her autonomy and personal well-being, she seems curiously unaware of how the voices of these characters trivialize her main character's radical commitment to creative expression. It is as if the text, similar to the characters, C'Anne, Novel, and Theodore, does not take Rayna's aspirations seriously.

Ironically, while Sherman incorporates several key experiences of black women and AIDS in her text, from sterilization abuse to safer sex, she seems completely unaware of how the figure of the child with AIDS is often used to undermine Rayna's—and women's—individuality.[7] As many critics have demonstrated, women (and most infected children) are literally and symbolically hidden behind the cultural spectacle of the idealized dying child. In contrast to the many AIDS narratives in circulation, the child with AIDS in this text does not overwhelm or dominate the text. Equally important, Sherman does not include the child's death bed scene.[8] Yet Sherman does not consciously challenge the underlying structure of gendered caretaking or the ways in which the ill child is used to maintain it.

In short, while Collins might urge critics to interpret the treatment of care in the novel in terms of complex practices of mothering in black communities, the cultural issues of care and the gendering of care in the HIV/AIDS crisis have some detrimental effects on women. The gendered mandate that women should care is one of the fundamental ways in which women are oppressed in the epidemic. As Deborah Johnson argues, "[I]n health education, putting a woman in any role is problematic. Being a wife or a mother has never protected any woman from HIV/AIDS" (26). In light of Johnson's argument, giving Rayna's character aspirations and dreams, especially as an HIV-positive black artist, is one of the best defenses against the prevailing conceptions of women and the trivialization of women's struggle for self-definition. Sadly, *touch* enacts, rather than challenges, the themes on women and care found in medical, political, and cultural discourses on AIDS and unwittingly evokes the historically entrenched imagery of woman as innate caretaker of children.

As a result, a female character with HIV infection is subordinated, once again, to a supposedly "larger" perspective and Sherman loses touch with the significance of Rayna's power as a woman who exists for herself and not for the caretaking of others. An underlying message of touch is that when HIV/AIDS enters a woman's life, regardless of her own health status, conventional feminine behaviors are expected. The anxiety, fears, and stigmas revived

by a sexual-health epidemic such as HIV convince many women to adopt conservative, conventional ideas of female agency, and Sherman's Rayna is no exception. Instead of HIV/AIDS offering a character such as Rayna a new basis for self-development and connection, I argue that the coded theme and message of *touch* is that women should abandon their dreams of autonomy and return to their caretaker role.

FEMINIST CULTURAL THEORY AND AIDS

Contemporary feminist theories reject the tenet that textual and visual representations "reflect" reality. Jackie Byars writes, "[R]epresentation is not reflection but rather an active process of selecting and presenting, of structuring and shaping, of making things mean" (quoted in Walters, 47). Thus, which representations are good for women and which are bad is not the point. As theorist Suzanna Walters puts it, feminist cultural theory and practice has shifted its emphasis from "reflection" theory, or "images of women," to the theory of "woman as image." As a result, the question is not whether or not a given text could ever construct a "true" or "real" image of women in any discourse, let alone AIDS. A contemporary feminist standpoint would argue that moving "beyond" gendered visibilities is theoretically impossible since the dismantling of gender would require more than replacing discriminatory imagery with "positive" images (Walters). More importantly, who would decide which representations constitute positive or negative images of women in any context, let alone in the context of HIV?

For example, *touch* includes a memorable scene of a feminist health educator presenting a sex-affirmative workshop/lecture to Rayna's HIV-positive women's support group. The workshop focuses on women's right to sexual pleasure, despite their HIV status. Compared to mainstream public health education, in which HIV-positive women are figured as selfless carers, and newsprint, in which they are hypersexual pools of infection (yet still responsible for safe sex—"use a condom"), Sherman's safe-sex erotic workshop scene addresses HIV-positive women as wholesome sexual people. Furthermore, Rayna's support group is composed of an unusually diverse group of women— a heterosexual, Japanese-American woman; a young African-American lesbian; an upper-class, heterosexual white woman; a married, thirty-year-old Latina woman—who are all being told that they have a right to practice their diverse sexualities. It is as if Sherman were dramatizing Evelynn Hammonds's vision that the epidemic might "be used to foment the sexual revolution that [women] never had" and "make visible black women's self-defined sexualities" (Hammonds, 141). Yet, as with other textual instances in the novel, this one is not convincing because the individualities of the characters are not

allowed to develop. How do these racially, ethnically, culturally, and sexually diverse characters learn to talk across difference about their sexual desires let alone their HIV infections? How do they deal with imbalances of power in their sexual relationships with men and women, and in their relationships with one another? How many of them are concerned with the effects of the prevailing conception of acceptable femininity? Also, since women's sexuality is often the site of male domination and violence, how do these characters get their "partners," a term that assumes equality, to use condoms and/or dental dams? For instance, an erotic, safe sex rhetoric is not going to make much difference in the life of Sapphire's character, Precious Jones, since her abuser father can hardly be seen as her sexual "partner." *Push's* graphic inclusion of Precious's orgasm during a rape-incest scene challenges the simplified message of sexual affirmation for young women. In other words, Sherman's scene assumes that the only gender-based oppression these characters encounter is in the realm of sexual desire, yet HIV emphasizes how women and girls suffer equally when either their pain or their pleasure is denied.

Sherman's inclusion of the safe sex workshop and the scene of Rayna and Theodore's safe sex lovemaking session that immediately follows, indicates Sherman's belief that, as Hammonds proposes, the epidemic does hold the potential to redefine sexuality for women. The problem is not in the validity of the vision; the problem lies in the one-dimensional presentation of the characters who are affected by the vision. They, like HIV-positive women in general, need to be presented as more than an idea. Since Sherman has not offered any in-depth analysis of these characters, this safe sex scene for women, which is perhaps the first such scene in fictional representations of AIDS that addresses women, comes off as sentimentalized, feminist multiculturalism. While the theme of women's socialization to estrange themselves from their bodies and sexualities is central to the story of women and AIDS, because Sherman presents the issue of sexual pleasure and women's activism without a context, she reinforces the popular idea that women need information and directives—specific contexts and individualities are rendered trivial.

Perhaps my desire that *touch* (and *Push*) dismantle every gendered narrative pivotal to the symbolization of women in AIDS discourse (and Western culture) is itself rooted in my own sentimental idealization of the power of feminist writing. Yet one powerful aspect of both novels, in addition to initiating a black feminist literary intervention into the realm of HIV, is that they tell us something about representation and gender in the age of AIDS. Both texts produce contradictions that draw attention to the tenacity of gendered ideology at the heart of representation on AIDS. What these novels suggest is that U.S. women have struggled with historical and cultural fantasies of their raced and gendered bodies and sexualities for centuries, and while differences

among women have made this struggle more difficult for many women, all women have had to struggle for the right to develop and practice multifaceted individualities. An analysis of the linkages of women and AIDS in representations suggest that, given the entrenched institution of gender, this basic human right has yet to be fully accomplished anywhere.

In general, women rarely emerge in any representation of AIDS as individual people, regardless of their racial, economic, and social privilege; instead they are reduced to stereotypical symbols of either national decay or moral resolve (Ogur, 138). The subtle gendered writing practices in *touch* and *Push* do not, however, undermine their important literary and political contributions. Integrating the experiences of women and girls into AIDS discourse, and initiating the theme of AIDS into black feminist literary traditions, could save young women's lives.

NOTES

1. I am using Judith Lorber's concept of gender as a social institution, that is, a social institution similar to language, religion, the economy (Lorber). From Lorber's standpoint, gender is a constant "process of social construction, a system of social stratification, and an institution that structures every aspect of our lives because of its embeddedness in the family, the workplace, and the state, as well as in sexuality, language, and culture" (5). In like manner, I argue that a cultural critique of how women are constructed in representations of AIDS reveals gender as a formidable social institution with accompanying practices and structures that affect "every aspect of our lives" (Lorber, 5).

My perspective differs from most cultural studies approaches to HIV/AIDS in that I focus on gender as a social institution that determines how AIDS is talked about and imagined. In other words, cultural representations of AIDS offer a lens through which to study how gender as a social institution is entrenched in all aspects of social life. In contrast, most cultural studies on HIV/AIDS focuses on representations of the pandemic in terms of the heterosexual/homosexual binary. In this view, AIDS revives pre-existing medical and fundamentalist ideologies, and the continued policing of gay male sexuality. On the contrary, I see the policing of gay male sexuality and the dehumanization of people with AIDS as an aspect of entrenched gender, with heterosexuality as one way in which the institution of gender is accomplished and maintained. For example, while cultural studies, akin to other forms of progressive textual and visual AIDS culture, typically frames the pandemic as a pivotal political, social, ethical, and representational issue of the late twentieth century, the central role of gender in the politics of representation of AIDS is too often underestimated. In Stuart Hall's response to recent attacks on cultural studies, he argues that the field emerges from an ethical and humanist tradition, and points to the ways that cultural studies specialists see AIDS as

"a site of life and death" thus providing evidence of this continued humanistic tradition (Nelson and Gaonkar, quoted in the *Chronicle of Higher Education*, B13). However, Hall, similar to many AIDS critics and theorists, points to pleasure and desire as the key organizing terms of AIDS analysis, which typically focuses on gay male sexualities or the demonization of female prostitutes. My argument is that cultural studies and other forms of progressive writings on HIV/AIDS enact gendered and raced visibilities, even as they contest the threat to pleasure and desire. In fact, as with conservative and reactionary responses to HIV/AIDS, much progressive writing—including cultural studies—unwittingly reveals how AIDS is a site where the reproduction of traditional gender ideology is aggressively maintained and asserted, although this process is rarely explored.

2. In Sue-Ellen Case's essay, "Toward a Butch-Feminist Retro-Future," Case writes, "I like *Angels in America*—it has a big cast and a big theme—a critique of nationalism and, well, I'm pretty sure the angel is a lesbian" (211). In most ways, I like *Angels in America*, too. However, the construction of gender to which I refer cannot be erased by making the play's angel a lesbian. In fact, even if the angel were to "come out" as a lesbian, the underlying structure of gender as an enormously powerful social institution would still be intact. For there exists a division of labor along traditional lines of gender that this Pulitzer prize-winning play enacts. Just as public service announcements and medical texts on AIDS reveal the social institution of gender, so does Kushner's drama; in all these texts, women are figured as symbols of passivity and nurturing, as ministering angels and caretakers, while men act, express their individualities and needs, and literally take center stage.

3. Larry Kramer and Gabriel Rotello are also routinely criticized in the popular gay press and in queer texts for their "sex-negative" themes—themes which are interpreted as evidence of internalized homophobia. In terms of challenging the vision of traditional gender that I feel permeates representations of AIDS, this somewhat polarized debate over sex-negative/sex-positive discourse in relation to gay men and AIDS does not come close to considering the kind of entrenched gender that I think is central to how AIDS is constructed. This is more than another instance of how AIDS continues to be coded "male." For while people throughout the world are affected by the bombardment of negative ideas of sex and sexuality associated with AIDS, the connections between such "sex-negative" messages and ideas of gender are often overlooked. For example, despite the anti-sex homophobia integral to AIDS discourse, AIDS activist and health practitioner Risa Deneberg points to a "breakthrough of sexual silence in the public health sector in regard to gay male sexuality" yet a continued silence on women's sexualities. Deneberg continues: "the increasing rate of HIV infection in women has not compelled the same attention. Until women's (straight, lesbian, and bi) sexuality becomes part of the public discussion on HIV prevention, early detection, and treatment, all women are being neglected"(1). Similarly, Tamsin Wilton and Diane Richardson focus on gender as an embedded structure in their recent examinations of

sex-positive/sex-negative safer-sex rhetoric. Thus while feminists are aware of how conservative and fundamentalist groups exploit the sexual-health epidemic to control sexuality outside of reproductive, heterosexual marriage, as Linda Singer outlines in *Erotic Welfare*, identifying that alone will not capture the multiple ways women are affected by the gendered epidemic.

4. I want to thank Carra Leah Hood, a contributor to this volume, who first told me that information had emerged disproving Bergalis to be a "virgin."

5. As I discuss in my dissertation, the film problematically focuses on a woman with AIDS whose greatest regret is that she will never be a stay-at-home mom, a clear signal of the ways in which representations of AIDS operate as a reinforcement of traditional gender. AIDS is framed as both a threat to the traditional family and an opportunity to consolidate the traditional social institution of gender. Furthermore, the hidden realities of black women and AIDS are suggested by placing Jane in the caretaking role.

6. AIDS physician and writer Barbara Ogur warns that statistics only tell us where the virus has been, not necessarily who is being infected now or who will be infected in the future: "we must be very cautious about what conclusions we draw from epidemiology. The most consistent data are from the CDC, categorized by ethnicity, age, and by simplified risk behaviors. These data still show the majority of cases of AIDS in men who have had sex with men or in people who have used injecting drugs; it shows that the majority of U.S. women with AIDS are African-American and Hispanic. However, since it takes eight to ten years for AIDS to develop after infection with HIV, these data are simply a reflection of where the virus was eight to ten years ago, a fossilized footprint" (150). For example, Corea reports that many white middle-class women, the very women who look at representations of AIDS and don't see themselves, are repeatedly refused HIV tests when they ask for them. Corea documents a case in which a woman repeatedly asked to be tested but her doctor refused. The woman, not surprisingly, went on to develop AIDS.

7. I discuss the racial and class effects of the spectacle of the child with AIDS on representations of women's sexualities and health in my reading of the made-for-television film, *A Place For Annie*. Also see my dissertation.

8. I develop this thesis further in "'More Angel Than Ordinary': Little Eva, Topsy, and AIDS."

WORKS CITED

Appiah, K. Anthony. "The Arts of Africa." *New York Review of Books*. 24 April 1997: 46+.

Bell-Scoff, Patricia. "The Artist as Witness: A Conversation with Sapphire." Rev. of *Push* by Sapphire. *Ms.* 7.5 (March/April 1997): 78–81.

Boykin, Keith. *One More River to Cross: Black and Gay in America*. New York: Doubleday, 1996.

Brownworth, Victoria A. "Someone Has to Say No: Women in Gay Male Writing." *Lambda Book Report*. Oct./Nov. 1990: 6+.

Case, Sue-Ellen "Toward a Butch-Feminist Retro-Future." *Cross Purposes: Lesbians, Feminists, and the Limits of Alliance*. Ed. Dana Heller. Bloomington: Indiana University Press, 1997. 205–220.

Collins, Patricia Hill. "Black Women and Motherhood." *Rereading America: Cultural Contexts for Critical Thinking and Writing*. Ed. Gary Colombo, Robert Cullen, and Bonnie Lisle. Boston: Bedford, 1995. 195–211.

Corea, Gena. *The Invisible Epidemic: Story of Women and AIDS*. New York: Harper-Collins, 1992.

Crimp, Douglas. "How to Have Promiscuity During an Epidemic." *AIDS: Cultural Analysis, Cultural Activism*. Ed. Crimp. Cambridge: MIT, 1988. 237–271.

Davis, Angela. "DefendingOurName." *Sojourner: The Women's Forum*. 19.11 (July 1994): 1+.

Denenberg, Risa, FNP. "Positive Lesbians Deserve the Best!" *LAP Notes: Lesbian AIDS Project at GMHC*. 5 (1997): 1+.

Denison, Rebecca. "Women and AIDS: An Update." *World*. May 1997: 4–7.

Gates, Henry Louis. *Reading Black, Reading Feminist: A Critical Anthology*. New York: Meridian, 1990. 1–25.

Gomez, Jewelle. Rev. of *Push* by Sapphire. *Ms.* 7.5 (July/August 1996): 82.

Gorna, Robin. *Vamps, Virgins and Victims: How Can Women Fight AIDS?* London: Cassell, 1996.

Grey, Amanda. "The Right Kind of Push." Rev. of *Push* by Sapphire. *New Youth Connections*. (Sept./Oct.): 19.

Hammonds, Evelynn. "Race, Sex, AIDS: The Construction of 'Other.'" *Radical America*. Sept. 1987: 28–36.

Hogan, Kathleen J. (Katie). "Immaculate Infection: Women, AIDS, and Sentimentality." Dissertation, Rutgers University, 1997.

hooks, bell. *Reel to Real: Race, Sex, and Class at the Movies*. New York: Routledge, 1996.

Johnson, Deborah. "Women Who Trust Too Much: What AIDS Commercials Don't Tell You." *On the Issues: The Progressive Woman's Quarterly*. 5.3 (Summer 1996): 26–28.

Kennedy, Lisa. "Shoved." Rev. of *Push*, by Sapphire. *Village Voice*. 25 June 1996: 76.

Kitzinger, Jenny. "Visible and Invisible Women in AIDS Discourse." *AIDS: Setting a Feminist Agenda*. Ed. Lesley Doyal, Jennie Naidoo, and Tamsin Wilton. London: Taylor & Francis, 1994. 95–112.

Kushner, Tony. *Angels in America—Part One: Millennium Approaches*. New York: Theatre Communications Group, 1993.

Lorber, Judith. *Paradoxes of Gender*. New Haven: Yale University Press, 1994.

Monette, Paul. *Halfway Home*. New York: Crown, 1991.

Nelson, Cary, and Dilip Parameshwar Gaonkar. "*Ex Libris:* The Duties and Ethical Pressures Facility in Language Brings With It." *Chronicle of Higher Education*. 4 April 1997: B13.

Ogur, Barbara. "Smothering in Stereotypes: HIV-Positive Women." *Talking Gender: Public Images, Personal Journeys, and Political Critiques*. Ed. Nancy Hewitt, Jean O'Barr, and Nancy Rosebaugh. Chapel Hill: University of North Carolina Press, 1996. 137–152.

Patton, Cindy. *Last Served?: Gendering the HIV Pandemic*. London: Taylor & Francis, 1994.

Richardson, Diane. "AIDS: Issues for Feminism in the UK." *AIDS: Setting a Feminist Agenda*. Ed. Lesley Doyal, Jennie Naidoo, and Tamsin Wilton. London: Taylor & Francis, 1994.

Rimer, Sara. "Group of Leading Blacks Urges Campaign on AIDS Awareness." *New York Times*. 25 October 1996: 18.

Sapphire. *Push*. New York: Knopf, 1996.

Schneider, Beth E., and Valerie Jenness. "Social Control, Civil Liberties, and Women's Sexuality." *Women Resisting AIDS: Feminist Strategies of Empowerment*. Ed. Beth E. Schneider and Nancy E. Stoller. Philadelphia: Temple University Press, 1995. 74–95.

Schoofs, Mark. "Blackt Up!: African Americans Confront Their Worst Health Crisis: AIDS." *Village Voice*. 5 Nov. 1996: 45.

Shernoff, Michael, MSW. "Challenges and Dilemmas Regarding Protease Inhibitors." *Body Positive*. March 1997: 15–18.

Sherman, Charlotte Watson, ed. *Sisterfire: Black Womanist Fiction and Poetry*. New York: HarperCollins, 1994.

——— *Touch*. New York: HarperCollins, 1995.

Shilts, Randy. *And the Band Played On: Politics, People, and the AIDS Epidemic*. New York: St. Martin's, 1987.

Singer, Linda. *Erotic Welfare: Sexual Theory and Politics in the Age of Epidemic*. New York: Routledge, 1993.

Sullivan, Andrew. "When Plagues End: Notes on the Twilight of an Epidemic." *New York Times Magazine*. 10 Nov. 1996. 52+.

Walters, Suzanna Danuta. *Material Girls: Making Sense of Feminist Cultural Theory*. Berkeley: University of California Press, 1995.

White, Deborah Gray. *Arn't I a Woman? Female Slaves in the Plantation South*. New York: W. W. Norton., 1985. 27–61.

Wilton, Tamsin. "Silences, Absences and Fragmentation." *AIDS: Setting a Feminist Agenda*. Ed Lesley Doyal, Jennie Naidoo, and Tamsin Wilton. London: Taylor & Francis, 1994. 1–8.

Wood, Julia T. *Who Cares?: Women, Care, and Culture.* Carbondale: Southern Illinois University Press, 1994.

Zook, Kristal Brent. "A Manifesto of Sorts for a Black Feminist Movement." *New York Times Magazine.* 12 Nov. 1995: 86+.

The Person With AIDS
The Body, the Feminine, and the NAMES Project Memorial Quilt

Flavia Rando

The AIDS epidemic—a bio-medical, political, and social crisis—has brought with it a crisis of representation. In this essay,[1] I will consider key aspects of a crisis marked by an unprecedented focus on homo-/hetero-sexual identities and practices, as well as the highly publicized inability of bio-medical science to contain the AIDS epidemic. Thus, the AIDS crisis has been marked by a challenge to the normative power of (bio-medical) science and a heterosexuality once considered, at least in public discourse, to be hegemonic.

In the absence of a vaccine, or a cure effective at any stage of Acquired Immune Deficiency Syndrome (AIDS), an alternate means of containment has been sought in the construction and management of the figure of the person with AIDS (PWA). The PWA has been the object of conflicting constructions of medical science, government policy, popular media, and finally, AIDS activists, who challenge the inaction and misinformation that has too often constituted the response to, and representation of, the AIDS crisis. In the representations and self-representations that construct the figure of the PWA, we see the impulse to express the enormity of emotion that attends this crisis: to understand and console; place blame and condemn; and, often to isolate PWAs by creating two mutually exclusive categories—PWAs, and the "general population."

Because the AIDS population (in the United States) has been perceived as marked by profound differences of sexuality, race, and class from this imagined "general population," all aspects of the crisis have been highly politicized. The course of AIDS research, for example, has been determined to a large extent by the limited allocation of resources deemed appropriate for those populations—gay men, IV drug users, and the poor, often black and Hispanic, populations of the inner city—that have been most vulnerable to the spread of AIDS—populations that must be scorned and/or disregarded in order to maintain the myth of an invulnerable "general population"—figured as heterosexual, middle class, white, with a lifestyle defined by monogamy and nuclear family. This imagined AIDS-free "general population" is recognizable as the sadly outdated ideal of what Simon Watney describes as "the ever anxious neo-conservative imagination in which the family . . . hero and heroine and 2.8 children snuggle down chastely after prayers, in pajamas under *granny's patch work quilt*" (1989, my emphasis; 16).[2]

The PWA, a figure overdetermined by the conflation of a pre-existing outcast status and a new status—carrier of pestilence—has become a paradigmatic figure testing the representation of bio-medical science and its practitioners. And, indeed, medical professionals have been shown to be as susceptible as any other segment of society to the politicalization of AIDS. While individual health care workers have been heroic in their dedication, negative ideologies of difference such as misogyny, homophobia, and racism have often shaped the responses of science, and these responses have been recycled back to the public as "scientific findings." The history of AIDS research, so-called pure science, has been plagued by the revelation of disputes between scientists claiming credit for "discovering the cause" of AIDS, and by the exposure of profit motives in developing drugs that will (after all) merely alleviate, not cure, AIDS.

In addition, an explicit and successful agenda of AIDS activists, instituted by ACT UP and informed by the lesbian and gay activist struggle against the construction of homosexuality as disease, has been to expose the irrationality of the bio-medical profession at every level, displacing bio-scientists as the site of specialized and determining knowledge. What Sandra Harding refers to as the "religious" concept of science, marked by the "insistence on its own absolute authority . . . on its inherent moral good . . . [and] its intolerance of criticisms from 'outside'. . . " (87), has been profoundly challenged. The scientist can no longer be viewed as having extraordinary knowledge enabling, in Rosi Braidotti's words, "the rational management of all living matter" (149); instead, he has been recognized to be merely part of the "general population."

My intention to use paradigms developed within feminist theory to foreground gender and sexuality as organizing concepts is immediately

complicated by the fact that the female body, the trope through which discourses of both the diseased body and desire have been developed in modern Western medicine and art, is relatively absent. Instead, in representations of the PWA and the AIDS crisis, the gay male body is often the vehicle for both the desiring gaze and the representation of disease. The question would seem to be: how does the economy of Western representation function without the metaphor of the female body—and how will this absence reconfigure her faithful companion, the feminine. In addition, one must ask how this absence, described by Paula Treichler as the "ambiguous positioning of women in AIDS discourse" (220) affects actual women who are PWAs. And finally, how does the NAMES Project Memorial Quilt, the most familiar, and for many the icon of the AIDS crisis, figure in this "ambiguous positioning."[3]

The absence of the easy availability of the feminine body as mediating metaphor (of desire and disease) presents the possibility that representations of the AIDS crisis may begin to make apparent previously unmarked aspects of the masculine. Useful here is Nancy Hartsock's description of masculinity as "an abstract ideal to be achieved over the opposition of daily life. . . . It is not accidental. . . , " she continues, "that women are systematically used . . . to characterize the lives of those ruled by their bodies" (241); and I would add, positioned in counterpoint to the knowing subject who, although coded as male, is effectively represented as free from the limitations of body. We can begin to see (visual) representations of the (male) PWA, who both endures and tests the limits of the body, as approaching the divide (in Western thought) between a vulnerable embodiment and the fantasy of an abstract subject/ivity.

Tragically, along with the absence of the female body as metaphor, actual women who are PWAs have been largely absent from representations of the AIDS crisis, although the Centers for Disease Control and Prevention report that through 1994, "AIDS was the third leading cause of death for all [American] women, 25 to 44 years of age . . . and the leading cause of death for African American women"; that as of March 1997, "women constitute the fastest growing group of people with HIV/AIDS in the United States"; and by the year 2000, more women than men, worldwide, will be HIV-positive.[4] And we can not just speak about women, but about specific populations of women: many women who are HIV-positive are members of populations that have only limited access to (public and private) resources.

While paradigms developed by feminist theorists have been critical for activists in understanding and strategizing the AIDS crisis, it becomes necessary to interrogate the "weak and belated" role feminism has played in coming to terms with the crisis (Segal 135). Can this be a reflection of the perception that AIDS is the disease and therefore the concern of the other—"from the successful white gay businessman or doctor to the poverty stricken black mother"

(Bersani 204)? (I would note the many possibilities for problematic discussions of difference implicit in this phrase.) It is also necessary to challenge this assumption of neglect and to ask—which feminists? Has a limited construction of feminism(s) been played out in the AIDS crisis, one that confronts us with the possibility that "feminism" could be deployed as merely another "technology" of privilege?

The most difficult task for the scholar/artist/activist entering the highly contested arena of AIDS discourse is that of situating oneself while aware of the possible implications of one's work for the construction of the crisis, and, therefore, the quality of life and death. As Rosi Braidotti asks, "What is the most suitable speaking stance, or place of enunciation . . . [when] faced with the discourse of bio-power . . . ?" (147). The debate concerning the "artists' response" to the AIDS crisis has been marked by activist protest, leading to a blurring of the distinction between artist and activist and a reconceptualization of art forms.[5] The politically charged reconfiguration of gender, sexuality, body, and disease of the AIDS crisis has been mirrored in the proliferation, even redefinition, of art forms, as Jan Zita Grover comments, "AIDS provides many of us with a paradigm for the ineffectiveness of even the most rigorous modernisms. . . . introduce[ing] . . . practices and techniques thought obsolete or moot . . . " (2).

As we again witness the inadequacies of master narratives and of formal means thought to be universally applicable, as we again face the failure of science's will to know, and of the categories securing that knowledge, those who construct visual representations of the AIDS crisis, seek recourse to forms marked as folk, as feminine—the "obsolete." The recognition that art forms are both marked by and re/inscribe notions of gender and sexuality becomes inescapable. One example might be found in the rejection of a documentary practice that pictures the bio-medical repertory of causes and symptoms — from poverty to infection—as inadequate for the portrayal of the PWA. In such photographs, the category of disease overwhelms the specificity of individual lives, even as the documentary photograph (which, after all, owes debts of origin and form to science) becomes science's promissory note to know and contain the PWA.

The NAMES Project Memorial Quilt began as a gesture of mourning by San Francisco's gay activist community, suggested to Cleve Jones, on November 27, 1985 by "placards bearing the names of people who had died of AIDS" that were carried during a "candlelight march commemorating the murders of Mayor George Moscone and Harvey Milk, San Francisco's first openly gay supervisor" (Ruskin 9). The NAMES Quilt is the most familiar, and has generally been the most sympathetically received visual representation of PWAs and the AIDS crisis; however, until recently, it has received little critical discussion

as an art form whose effectiveness is the result of a specific history and symbolic associations.

Perhaps the Quilt has been considered by some to be too well-meaning and naive to merit comment; or, in the contested and constantly endangered arena of AIDS representation, the silence surrounding the Quilt may be strategic—preferable to a less-than-positive response in the continuing struggle to maintain the arena at all. For example, although Watney used the "patch work quilt" as an icon of the repressions and comforts of the "neo-conservative imagination" (1989, 188), he then refers to the NAMES Quilt merely as a "specific cultural form," without characterizing the quality of its specificity. Still lacking a critical context, the Quilt has appeared to be (received as) *the natural* choice with which to memorialize those PWAs who have died.[6]

The NAMES Quilt has received a mixed critical reception. This echoes the reception given to eighteenth- and nineteenth-century quilts, when, in the early 1970s, they were "re/discovered" as exciting examples of non figurative, geometric abstraction, then the normative criteria of formalist art criticism. The 1972 Smithsonian Institution catalogue, *Pieced Quilts*, reads, "We can see in many [quilts] such phenomena as 'op' effects, serial images, use of 'color fields,' a deep understanding of negative space, mannerisms of formal abstraction and the like" (Holstein 13). Exhibitions were arranged and catalogues written that managed to incorporate this perspective while still perpetuating a lingering devaluation of women/quiltmakers as artists. The text of *Pieced Quilts* continues, "Too much, can, of course, be made of these resemblances [between pieced quilts and contemporary painting]. . . . They were not made as paintings, nor did the people who made them think of themselves as 'artists'" (Holstein 13). Traditional quilts were seen as an art form without an artist—she was anonymous—her creative and, often, even her literal signature not read. "Those anonymous women whose skilled hands and eyes [note the order] created the American pieced quilt" (Holstein dedication/unpaged). Quilts read as the everyday, marked by the feminine, were fantasized as ideal in their simplicity, in the beauty and fullness of their abstraction, and at the same time dismissed as trivial, even banal, in their ideology and intent—the quiltmakers' accomplishments almost accidental.

Cindy Ruskin's *The Quilt: Stories From the NAMES Project*, describes the Quilt's purpose: "The NAMES Project is a national effort to create a hand-sewn tribute to the tens of thousands of Americans struck down by AIDS" (9) and she quotes Jones, "the whole purpose of quilting is to have a sense of community" (11). While quilting has historically been a means of expression for individuals in subjected communities, quilts were designed, and most often, sewn, by one individual. Nineteenth-century women, denied the vote, often illiterate, expressed their world view, documented the realities of gender

relations, of African-American and other communities, and recorded support of political movements, such as abolition, in their quilts. This aspect of quilt-making often utilized a shared, abstract symbolism, that if subsumed into formalist concerns, distorts the quiltmaker's project. While the quilting bee was a vital means of social interaction, and even community survival, the mythology of the quilting bee—the myth that intricate designs were conceptu-alized and executed spontaneously by groups of women in the midst of social exchange, creates, once again, an art form without an artist. [7]

The art of quilting has been notable for its role in the psychic survival of individual quiltmakers, as well as the material survival of their families and community, and the NAMES Quilt is layered with the history of its "specific cultural form." The apparently transparent choice of this art form and its suc-cess as a memorial can be understood in terms of its ability to resolve, or at least re/contain, many aspects of the crisis of representation caused by AIDS. Quilting is a traditional woman's art form now inscribed with nostalgia for an (imagined) better past in which family and community were known and com-prehensible institutions. It is an American art form—"the great American art" (Mainardi)—and, as such, provides for the re/construction of those who have died of AIDS and those who are left behind into a "general population," the mythical community denied to them during their lifetime.

Jones's relatively common mis/understanding of the history of quilting, however, has mediated our view of the Quilt and must lead us to consider the paradigm/s of gender and (hetero)sexual relations encoded within such mythi-cal ideals of family and community. Douglas Crimp, discussing the necessity of both "Mourning and Militancy," considers the Quilt's importance for the activist community: "perhaps only the NAMES Project Quilt displays some-thing of the psychic work of mourning, insofar as each individual panel sym-bolizes—through its incorporation of mementos associated with the lost object—the activity of hypercathecting and detaching the hopes and memories associated with the loved one" (7). It is critical to note here the difference in address between Crimp, whose focus is the experience of individual mourners, many who have been denied access to the rituals of mourning commonly avail-able to the "general population," and the NAMES Project, whose focus is the willful construction of community. And indeed, the NAMES Quilt has allowed even those in the "general population" to finally approach (their) negative ide-ologies of difference, to realize that "real people" have died, and to mourn.

However, an examination of the Quilt's production reveals discrepancies from Jones's statement that "[Each] of these panels . . . embodies the love and grief of the family, friends and lovers who created it" (Jones quoted in Ruskin 9). The Metro New York Office and Workshop of the Memorial Quilt, under the direction of volunteer (and PWA) Robert Wilson was housed in Wilson's

small three-room apartment overflowing with finished panels, panels in progress, material for panels, sewing machines, photographs of the quilt, and bags of clothing salvaged from the apartments of those who have died of AIDS that will be recycled to those who are living with AIDS.[8] Many of the panels created in New York City have been designed and sewn here, often with only the most minimal information—name, dates, interests, favorite colors—extracted from grudging "family, friends and lovers" who call to "custom order" a panel, and to rid themselves of conflicting emotions and conflicted consciences. When asked if these panels would be made by mourners if volunteers could not fill the "custom orders," Wilson responded, "I don't think so—no." In New York, the volunteer sewers of the Metro Project were one (American) community that insisted that the NAMES Quilt would exist even if there is no other "family" or "nation" to create it.

The construction of the NAMES Quilt as mythical American community is further subverted by those makers of individual panels who persist in remembering the very aspects of the lives of PWAs that contradict a "general population's" notion of ideal community. Individual panels of the Quilt may document and celebrate gay male sexuality: the first two panels made by Wilson were for his lover Miguel; one, red and black, incorporated Miguel's flannel shirts; the second, black leather with Miguel's name spelled out in metal studs, celebrated the "leather scene" they had shared.[9] These images, like the subversive political messages and complex narratives of traditional quilts have not been generally recognized in the ideology of transcendent community surrounding the Quilt.

As many turn to an art form coded as feminine to assuage the grief that cannot be relieved by a medical science coded as masculine, the Quilt succeeds because it carries affective meanings—articulated through already understood concepts of gender—particular to the appropriation of a traditional folk, that is, pre-modern, art form in the midst of a postmodern crisis. Quilts, signifying a place of rest, are a link between bed and grave. The Quilt returns us to the myth of the indomitable mother who addressed her children's death in mourning quilts, that, like the NAMES Quilt, incorporated bits of clothing and other remembrances of the dead, while she continued to serve as an affirmation of life through renewed (and enforced) childbirth. Today, this pattern is echoed in the Quilt panels made by women for their children, in which they include their own names, leaving only the date of their impending death to be filled in by volunteer sewers.

In a crisis of the body that has been singularly immune to either the symbolic presence of "Woman" and the feminine body, or actual women who are PWAs, the Quilt inscribes a particular aspect of the feminine, as well as a role for women—"Woman" as nurture, caretaker, mother—thus addressing the

"ambiguous positioning of women" in the crisis. This re/inscription of the
maternal is at the heart of the Quilt's effectiveness as a national symbol of
mourning. The maternal has, of course, also been occupied by the gay male
community as it has become (of necessity) a community of caretakers. As
Braidotti says: "The feminine emerges as the privileged symptom and sign or
in some cases, even solution to the crisis. . . . [but, the question remains]
What does it have to do with real-life women?" (152).

For women in the AIDS crisis, representation and action often converge
in the pattern of women's AIDS activism and illness—both reverberate with
the figure of "Woman" as the caretaker whose caretaking does not easily
include, in fact, often precludes, taking her own care into account. The ACT
UP Women's Book Group notes the tension between women's traditional care-
taking role and the effective AIDS activist, and cautions that the activism of
both lesbians and heterosexual women is subject to assimilation unless they
articulate women's specific needs agendas. Cindy Patton points to the "mid-
dle-class, white, heterosexual women [who] perceive their volunteer work as
altruism, not self-help thus diminishing women's ability to perceive HIV risks
within the home" (22). This familial paradigm also constructs (gendered)
meaning in *Common Threads: Stories From the Quilt*, the 1989 Academy
Award-winning documentary of the Quilt. Women who speak of their losses—
whether the mother of a hemophiliac son, the lesbian co-parent whose own
political position is subsumed to an image of "the all-American mom," or the
woman who finally reveals, after telling the story of her husband's death, and
of her lengthy and loving caretaking, that she too is HIV-positive—are all rep-
resented as the archetypal enduring mother whose strength will insure the
viewer's—our—survival.

The pattern of positive HIV status in women not only reveals, yet again,
hetero/homosexual patterns that do not fit sanctioned norms, but presents the
opportunity to deconstruct the institution of heterosexuality, and its identities
and practices. The pattern of HIV infection in women (world-wide) suggests a
radical critique of what has often been a punishing heterosexuality in which,
"Male domination is becoming a public health issue."[10] Instead, when female
PWAs are considered at all in representations of the AIDS crisis, the figure of
the "sexual woman" as source of contagion and transmitter of disease, has
been the only available alternative to the familiar figure of caretaker. In either
case, the danger she represents to her (innocent) children or (heterosexual)
partners is the issue; her PWA status is not often considered.[11]

The continuing inability to attend to female PWAs may involve, as
Treichler suggests, "a desperate and terrorized effort to control signification"
in the presence of another "contaminated other" (220–21), the male PWA.
The figure of the male PWA—whether gay man or male IV drug user for

whom penetration has led to an ecstatic state—has been appropriated to occu-
py the feminine in the AIDS crisis, his overdetermined feminization confirmed
by bio-medical science in which, Haraway suggests, the immune system has
become a metaphor for "the determination of self," and "individuality is a
strategic defense problem" (212). Once the possibility of vulnerable male
embodiment is recognized and the male PWA is understood as not in control of
(even biological) boundaries, the symptoms of AIDS, the discharge of a virus
in control, can be read as sign of disorder within a masculinist social structure.
The phallus is replaced by a vulnerable sex, and masculinity, no longer
abstract or unmarked, can not function as a symbol of social control. In light
of this failure, the stabilizing presence of the m/other becomes critical.

Through its re-inscription of the feminine as maternal, the NAMES Quilt
puts into play an alternate gender/ed relation for containing the crisis: once a
traditional and comforting notion of the maternal is evoked, a similarly com-
forting notion of the masculine can be retained. The NAMES Quilt allows for
the possibility that this dangerously feminized and eroticized male PWA can
be transformed: under cover of the quilt, the sexual can become comfort and a
familiar heterosexual paradigm—mother and son—re/appears. The body of
the mother and the male PWA, both marked by the feminine, both traced by
absence, converge in the Quilt—it is a matter of scale and perspective.

As Quilt panels—made in the size and shape of a coffin—are laid on the
ground, the mother's body and the body of the earth converge, the Quilt
(re)inscribes the maternal, and the site of death is traced by the promise of
life. In implicit contrast to the AIDS-ravaged body, the Quilt offers another
model of the corporeal/body, one whose lack of boundaries signifies not death,
but the life promised by the inexhaustible nurture (of mother/earth). Julia
Kristeva says, "Man [that is, generic man] subverts death . . . by postulating
instead maternal love" (111). The Quilt carries with it not only the promise of
woman's care, but her (understood as) natural responsibility for life and
death—a comforting alternative to the ineffective response of bio-medical sci-
ence. When the bio-technical knower does not know, and "his" technology
cannot cure, we find the residue left by the gaps in "his" knowledge assigned
to the realm of the natural and its care to the responsibility of women.

In the crisis of representation that accompanies AIDS, women who are
PWAs are caught between "the archaic maternal power . . . and the test-
tube[s] of bio-medical science . . . [and] run the risk of losing" (Braidotti
152). Deflecting the scene of death away from the discourse of bio-science,
away from the body inscribed by bio-technology, back onto the natural realm
(and body) of the mother, the NAMES Quilt reassures the living. It shifts our
focus: a politicized bio-technology in crisis can now share its responsibility for
the dead and dying.

Frequently compared to the Vietnam Memorial, each panel of the Quilt names those who have been lost. One memorial however is permanent, stone embedded in the earth; the other is transient, perishable, conditional.[12] When the Quilt was inaugurated in October 1987, it contained 1,920 panels; in October 1992 it contained more than 21,000 panels and covered an area of fifteen acres. It shrouded the Capitol Mall stretching to the Ellipse, dwarfing the officially sanctioned monuments to community and nation, recreating in every respect, an "uncanny double," of the public sphere.[13] With this shift away from the individual and privatized body/bed/coffin, the Quilt becomes a metaphor for the body/politic as re/constructed by the AIDS crisis—archaic and postmodern meet. A shift must occur in the focus of the "general population" that will enable it to see its double.

NOTES

1. This essay is dedicated to Robert Wilson, founder of the New York Metro Quilters. I wish to thank Mathew Baigell for his support; Maxine Wolfe for discussions about the Quilt; Katie Hogan, Ferris Olin, and Marcia Salo for comments on earlier drafts of this essay; and Fran Winant for her always generous and invaluable reading of my work.

This essay was first written in 1992 while I was a fellow of The Rutgers Center for the Critical Analysis of Contemporary Culture, studying the relations between "Science, Technology and Culture" and presented at the 1993 College Art Association session, "The Occupation of Art History: New Interventions in an Expanding Field."

2. In "AIDS: Keywords," Jan Zita Grover characterizes the term, "general population," as the polite formulation of "heterosexual [which] is not a polite word. To employ it . . . suggests that heterosexuality is . . . something to be accounted for. . . . how much more diplomatic to employ a term that doesn't raise the specter of sexual practices or identities. . . " (23).

3. The NAMES Quilt retains this status even in the midst of an outpouring of other visual representations by PWAs and their communities exhibited under such titles as "The Indomitable Spirit," "Witnesses: Against Our Vanishing," and "Arts Communities, AIDS Communities: Realizing the Archive Project."

4. These figures are from the Center for Women Policy Studies: National Resource Center on Women and AIDS Policy, September 1997 fact sheet, "Data on Women and HIV/AIDS." Jennifer Smith of the Center reported in a personal communication the necessity of including data from 1994 as yet another indication of the continuing neglect of women in the AIDS crisis.

5. Key discussions are Douglas Crimp's "AIDS: Cultural Analysis/Cultural Activism," and the catalogue, *AIDS: The Artists' Response*, ed. by Jan Zita Grover.

6. This mood has shifted somewhat, see especially, Jonathan Weinberg's "The

Quilt: Activism and Remembrance," in which he addresses this silence and the ambivalence felt about the Quilt by many AIDS activists.

7. As the feminist art movement grew, feminist artists and art scholars began to investigate and document the specificity and complexity of the aesthetic and political expressions of quiltmakers. Early studies, in addition to Patricia Mainardi's classic, "Quilts: The Great American Art," include Patricia Cooper and Norma Bradley Buferd's *The Quilters: Women and Domestic Art* and C. Kurt Dewhurst, Betty MacDowell, and Marsha MacDowell's *Artists in Aprons: Folk Art by American Women*. Most recently, see *The Power of Feminist Art* edited by Norma Broude and Mary D. Garrard for the importance of quilting and quiltmakers to the feminist art movement.

8. I am indebted to Robert Wilson for our 1992 discussions about the Quilt and the New York Metro Workshop. The New York Metro Workshop was not directly affiliated with the NAMES Project and closed shortly after Robert Wilson's death in December of 1994.

9. For example, *The Quilt: Stories From the NAMES Project*, is listed as a juvenile title in my university library system. This placement is in stark contrast to, for example, the catalogue for *Witnesses: Against Our Vanishing*, which includes curator Susan Wyatt's apology and caution, "the opinions and language contained in this publication . . . *may not be appropriate for children*" (my emphasis 3). I would stress that this positioning of the Quilt remains despite any sexual imagery "children" might encounter viewing the Quilt.

10. Personal communication, Dr. Johathan Mann, Director of the Francois-Xavier Bagnoud Center for Health and Human Rights and the International AIDS Center, Harvard AIDS Institute.

11. The definition of AIDS, for example, was changed only under activist pressure, to include cervical cancer, one of the many gynecological diseases that are the most prevalent symptoms of women who are PWAs. As recently as the last quarter of 1992, more than twice as many articles, in both the popular and the scholarly press, were published about pediatric AIDS, than were published about women and AIDS.

12. It is interesting to note that mourners, by adding personal remembrances of their dead, have recreated the Vietnam Memorial in the image of the NAMES Quilt.

13. The Freudian concept of the "uncanny double"—"'unheimlich,' literally 'unhomely,'"—refers to a known shelter, whether domestic, the home, or feminine, the womb, suddenly perceived as strange, frightening, a portent of danger and death, rather than comfort and life.

SOURCES CITED AND CONSULTED

ACT-UP/NY Women and AIDS Book Group, *Women, AIDS and Activism*. Boston: South End Press, 1990.

AIDS: The Artists' Response, curator, Jan Zita Grover, Ohio State University, 1989.

Atkins, Robert. "Photographing AIDS," *AIDS: The Artists' Response*, curator, Jan Zita Grover, Ohio State University, 1989, 26–28.

Bersani, Leo. "Is the Rectum a Grave?" *AIDS: Cultural Analysis/Cultural Activism*, ed. Douglas Crimp. Cambridge, Mass.: The MIT Press, 1989, 197–223.

Braidotti, Rosi. "Organs Without Bodies," *Differences: A Journal of Feminist Cultural Studies: Life and Death in Sexuality: Reproductive Technologies and AIDS*. Vol. 1, No. 1, Winter 1989, 147–161.

Broude, Norma and Mary D. Garrard, eds. *The Power of Feminist Art: The American Movement of the 1970s, History and Impact*. New York: Harry N. Abrams, Inc., Publishers, 1994.

Center for Women Policy Studies: National Resource Center on Women and AIDS Policy. *Data on Women and HIV/AIDS: The National Facts*. Washington, DC, September 1997.

Common Threads: Stories From the Quilt. Dir. Robert Epstein and Jeffrey Friedman, Screenplay by Robert Epstein, Jeffrey Friedman, and Cindy Ruskin, 1989, Video, Direct Cinema Limited, 1990.

Cooper, Patricia and Norma Bradley Buferd. *The Quilters: Women and Domestic Art*. Garden City, New York: Anchor Press/Doubleday, 1978.

Corea, Gena. *The Invisible Epidemic: The Story of Women and AIDS*. New York: HarperCollins Publishers, 1992.

Crimp, Douglas. "AIDS: Cultural Analysis/Cultural Activism," *AIDS: Cultural Analysis/Cultural Activism*, ed. Douglas Crimp. Cambridge, Mass.: The MIT Press, 1989, 3–16.

———— "How to Have Promiscuity During an Epidemic," *AIDS: Cultural Analysis/Cultural Activism*, ed. Douglas Crimp. Cambridge, Mass.: The MIT Press, 1989, 237–271.

———— "Mourning and Militancy," *October*, No. 51, Winter 1989, 1–18.

Crimp, Douglas and Adam Rolston, *AIDS/Demo/Graphics*. Seattle: Bay Press, 1990.

Curtis, Tom. "The Origin of AIDS," *Rolling Stone*, March 19, 1992, 52 and cont.

de Lauretis, Teresa. "The Technology of Gender," *Technologies of Gender*. Indiana University Press, 1987, 1–30.

Dewhurst, C. Kurt, Betty MacDowell, and Marsha MacDowell. *Artists in Aprons: Folk Art by American Women*. New York: E. P. Dutton and the Museum of American Folk Art, 1979.

Differences: A Journal of Feminist Cultural Studies: Life and Death in Sexuality: Reproductive Technologies and AIDS. Vol. 1, No. 1, Winter 1989.

Freud, Sigmund. "The 'Uncanny' (1919)," *The Standard Edition of the Complete Psychological Works of Sigmund Freud*, ed. James Strachey. London: The Hogarth Press, 1955, 217–252.

Gilman, Sander. *Disease and Representation: Images of Illness from Madness to AIDS*. Ithaca, NY: Cornell University Press, 1988.

Grover, Jan Zita. "AIDS: Keywords," *AIDS: Cultural Analysis/Cultural Activism*, ed. Douglas Crimp. Cambridge, Mass.: The MIT Press, 1989, 17-31.

——— "Introduction to AIDS: The Artists' Response," *AIDS: The Artists' Response.* Columbus Ohio State University, 1989, 2–7.

Haraway, Donna. "The Biopolitics of Postmodern Bodies: Determinations of Self in Immune System Discourse," *Differences: A Journal of Feminist Cultural Studies: Life and Death in Sexuality: Reproductive Technologies and AIDS.* Vol. 1, no. 1, Winter 1989, 3–46.

——— *Simians, Cyborgs, and Women: The Reinvention of Nature.* New York: Routledge, 1991.

Harding, Sandra. *Whose Science? Whose Knowledge? Thinking from Women's Lives.* Ithaca, NY: Cornell University Press, 1991.

Hartsock, Nancy. *Money, Sex, and Power: Toward A Feminist Historical Materialism.* Boston: Northeastern University Press, 1983.

Holstein, Jonathan. *American Pieced Quilts.* Washington: The Smithsonian Institution, 1972.

——— *The Pieced Quilt: An American Design Tradition.* Greenwich, Conn.: The New York Graphic Socitey, Ltd., 1973.

Johnson, George. "Once Again, a Man With a Mission," *New York Times Magazine*, November 25, 1990, 56–61.

Kristeva, Julia. "Stabat Mater," *The Female Body in Western Culture*, ed. Susan Rubin Suleiman. Cambridge, Mass.: Harvard University Press, 1985, 99–118.

Maindardi, Patricia. "Quilts:The Great American Art," *Feminism and Art History: Questioning the Litany*, eds. Norma Broude and Mary D. Garrard. New York: Harper & Row, 1982, 331–346.

Patton, Cindy. *Inventing AIDS.* New York: Routledge, 1990.

Ruskin, Cindy. *The Quilt: Stories From the NAMES Project.* Photographs by Matt Herron. New York: Simon & Schuster, 1988.

Segal, Lynne. "Lessons from the Past: Feminism, Sexual Politics and the Challenge of AIDS," *Taking Liberties: AIDS and Cultural Politics*, eds. Erica Carter and Simon Watney. London: Serpents Tail, 1989, 133–147.

Treichler, Paula A. "AIDS, Homophobia and Biomedical Discourse: An Epidemic of Signification," *AIDS: Cultural Analysis/Cultural Activism*, ed. Douglas Crimp. Cambridge, Mass.: The MIT Press, 1989, 31–71.

——— "AIDS, Gender and Biomedical Discourse: Current Contests for Meaning," *AIDS: The Burdens of History*, ed. Elizabeth Fee and Daniel Fox. Berkeley: California University Press, 1988, 190–266.

Watney, Simon. *Policing Desire: Pornography, AIDS, and the Media.* Minneapolis: Minnesota University Press, 1989.

——— "Representing AIDS," *Ecstatic Antibodies: Resisting the AIDS Mythology*, ed. Tessa Roffin and Sunil Gupta. London, Rivers Oram Press, 1990, 165–192.

Weinberg, Johnathan, "The Quilt: Activism and Remembrance," *Art in America*, November, 1992, 38–39.

Wyatt, Susan. Introduction, *Witnesses: Against Our Vanishing*: Artists Space, 1990.

Wolfe, Maxine. "AIDS and Politics: Transformation of Our Movement," ACT-UP/NY Women and AIDS Book Group, *Women, AIDS and Activism.* Boston: South End Press, 1990, 233–239.

Make a Video for Me
Alternative AIDS Video by Women

Alexandra Juhasz

INTRODUCTION

The production and viewing of alternative AIDS video is a form of
direct, immediate, product-oriented activism which brings together
committed individuals who insist upon being industrious. No won-
der so many alternative AIDS videos have been produced. Since the
mid-1980s there have been hundreds if not thousands of media
productions about the crisis, made by videomakers who work out-
side of commercial, broadcast television. The work of the alterna-
tive AIDS media addresses the great variety of needs, beliefs,
communities, and politics of the now immense "AIDS community":
everything from safer sex videos for teenagers to scientific data
about drug protocols, from autobiographies of PWAs to music
videos about homophobia. A great many of these activist videos are
produced by women; their projects have challenged and politicized
the meanings of both AIDS and video.

In the following article I look briefly at four such videos—
alternative AIDS media made by and for women—to see what they
tell us about the media, identity, community, and feminist politics
in the age of AIDS. I have selected videotapes which are distinct,
engaging, and creative, but which also represent more general for-
mal and theoretical trends found within women's AIDS activist
video from the early 1990s[1]: *Current Flow*, by Jean Carlomusto for
the Gay Men's Health Crisis (GMHC); *Like a Prayer*, by DIVA TV
(Damned Interfering Video Activist Television); *Women and Chil-
dren Last*, the trailer made to raise funds for the feature-length

video *Heart of the Matter*, by Amber Hollibaugh and Gini Reticker; and *The Embrace/El Abrazo*, by Diana Coryat. These tapes were all completed in 1990 by New York videomakers. Although their makers are all feminists who are active in the AIDS and media communities in New York City, each of these projects targets a more select community within this larger community (i.e. lesbians, activists, HIV-positive women, Latinas). It is this very process and possibility of winnowing smaller and smaller communities from and to which to speak that raises many of the questions most central to this analysis of women's alternative AIDS media. How do such tapes, specifically by New Yorkers, about New Yorkers, speak to an audience of New Yorkers? How do such women's tapes speak to other AIDS activist communities? Does work by Brooklynites speak to women from the Bronx?

The AIDS community is itself speckled with hundreds of smaller communities and is bordered by its own margins. Women in the AIDS community form a subset, or margin, with different (and similar) needs to the community as a whole. Like the artists, gay white men, AIDS activists, and countless other smaller communities whose needs and issues are targeted in the video projects of the alternative AIDS media, women have learned that there are specific HIV-related issues relevant to them which may differ from those of other communities. For instance, to teach a woman to practice safer sex has little—other than the mechanics of condom or dental dam use—to do with teaching a gay man to do so. Thus, female videomakers have produced educational work that is explicitly for and/or about particular communities of women. There are a wide range of smaller communities that have been focused upon within the AIDS community of women: activists, lesbians, lesbian activists, Asian-Americans, blacks, black lesbians, black lesbian activists . . . Clearly, such a process of infinite regression could ultimately reduce every community to the individual: make a video for me! Sounds absurd, but in fact, it's the point.

A most significant way in which alternative videomaking—usually work produced for little expense and with little formal training using camcorders and other inexpensive or "low-end" video technologies—counters and alters mainstream media is that it localizes the production and reception of this usually universalizing mode of discourse. This is not to suggest that a black lesbian activist cannot watch or learn from a video for an Asian-American straight social worker, but that she *can*. The political impact of alternative media comes as much from oppositional distribution and exhibition strategies (organizing screenings *outside* the community), as it does from oppositional production (making images from *within* a community). As video production becomes more and more accessible, and less and less expensive, there is no reason not to use this medium to educate our own, particular and private communities, *while also* inviting other communities to see the ways in which we

talk about and to ourselves. Of course, film or video can be made by cultural outsiders about people or communities other than themselves, but this is a different manner of production—not alternative media, and in fact, one of the foremost defining features of mainstream television.

CURRENT FLOW: LEARNING FROM THE EXPERTS

Current Flow, a safer-sex porn short for lesbians, is one in a series of such shorts produced by GMHC's media department. Because most of the funding for this project is dependable and constant, coming internally from this relatively well-off AIDS service organization, the production standards of the work are high. Directed by Carlomusto in conjunction with a lesbian task group, *Current Flow* opens upon a white woman masturbating with a vibrator to the sounds of a televised interview with Madonna and Sandra Bernhard. As the woman moves towards climax, a black hand stops the electricity flowing to the vibrator. Although initially angered by this interruption, another flow, equally exciting, begins as the mysterious intruder joins her upon the couch, and Sinead O'Connor's "Just Like You Said It Would Be," enters the soundtrack. Long, close, and barely edited shots of safe oral sex with a dental dam and penetration with a well-washed sex toy and then a latex-gloved hand, are the tape's highlights. The short ends with the two women kissing, the glow of the television lighting their faces. The implications of such unapologetic, unabashed images are enormous. Carlomusto explains:

> Lesbian-identified sex-positive imagery is scarce . . . Although many videotapes depicting lesbian sex created for straight men are available on the shelves of even the most mundane video rental stores, only a few tapes trickle in from the West Coast made for, by, and about women. And even fewer of these deal with safer sex for lesbians. This is both oppressive and dangerous because in order to educate lesbians about safer sex we have to establish what it is.[2]

There is no one better qualified to say what is sexy (and safe) for lesbians than lesbian producers. And what better way is there for the larger community to gain insight into a desire and discourse different from their own than by watching the images lesbians create for and of themselves?

Certainly, questions of exhibition and audience are critical for understanding this work. GMHC has a specific distribution strategy to target the audiences addressed by the tape (as well as the other safer sex shorts, all produced for sexual subcultures): the safer sex shorts have been shown in bars, projected before porn features, and used during safer sex workshops. There is

little chance that *Current Flow* will flow onto the TVs of people uninterested in lesbian sex. Although making resistant straight people see lifestyles different from their own is a political tactic (Queer Nation, initially a spin-off of New York's ACT UP, staged queer kiss-ins at straight singles' bars, for instance), it is not the politics of most alternative AIDS media. Many disenfranchised producers need the certainty of an accepting audience to feel comfortable speaking the things which often, in "mainstream" culture, bring antagonistic responses, discrimination, and sometimes violence. Instead, alternative video production is about communication: a willing dialogue. Unlike mainstream media, a tape like *Current Flow* is not made to reach a mass audience, is not made to make money, but rather has a limited audience and agenda. When and if such a tape finds its way outside the particular community for which it is targeted, this must almost always be because someone *brought it there*. Works with a specific agenda need tailored distribution: screenings at conferences, workshops, community organizations or classrooms; screenings accompanied by literature, speakers, or other forms of contextualization. Straight people can and should see *Current Flow*, but in a context where they can discuss lesbian sexuality in a productive, not punitive fashion.

LIKE A PRAYER: OPENING UP TO ACTIVIST VIDEO

Like A Prayer (1990) is DIVA's third tape. The tape documents ACT UP (the AIDS Coaltion to Unleash Power) and WHAM's (Women's Health Action Mobilization) controversial "Stop the Church" demonstration against the policies of New York City's Cardinal O'Connor. The tape is broken into six major sections dealing with issues like the history of the Catholic Church's position on condom use and safer sex education, a deconstruction of mainstream press coverage of the demonstration, and the activities of Operation Ridiculous, an organization of clowns joined "to go where clowns have never been"—namely to the demonstrations of the militant pro-life organization, Operation Rescue. Each section was produced separately by individual members of the collective. The varied sections are held together by Madonna's song "Like a Prayer," interviews with Catholic members of ACT UP who were denied a voice in mainstream coverage of the incident, and hilarious advertisements performed by the late DIVA member and AIDS media activist, Ray Navarro. Dressed as Jesus, Navarro advertises a pro-sex Catholicism: "Make sure your second coming is a safe one. Use condoms."

Clearly, such humor at the expense of the Catholic Church does not make this a tape for everyone—it isn't for everyone. Similarly, not all viewers are convinced that direct action—something the tape unapologetically takes as a given—is the best response to the AIDS crisis. For instance, a group of women

with whom I worked on a video project by and for care providers of PWAs who were all certainly committed to AIDS "activism" themselves,[3] discussed feeling distanced from many ACT UP tapes: because the demonstrators reflect the largely young, white, gay, and male constituency of ACT UP, or because the privilege implicit in the time commitment of direct action is unimaginable for working women with children, or because civil disobedience is not a form of activism with which everyone feels entirely comfortable. There are two important points evidenced here. One is that anyone who doesn't feel invited to watch this tape, explicitly by and for AIDS activists, probably never will be. And two, those who do feel it is for them ("I'm an AIDS activist") and then disagree with the politics or opinions found in the tape's conception of AIDS action, nevertheless use this as a learning process, itself of great use ("I'm an AIDS activist, but my AIDS activism does not include direct action").

This productive moment of individual and community definition can occur watching *Like A Prayer* because, unlike typical mainstream media celebrating its presumed objectivity, DIVA is committed to identifying its messages as the opinions of individual people, just as they are committed to showing the process of how these opinions were formed. "Alternative media are not neutral. They are, instead, highly partisan media enterprises that make no attempt to disguise their partisanship," writes David Armstrong in his history of radical media in America.[4] And Sean Cubitt writes of activist video: "these are voices raised in anger, seeking not to describe reality but to change it. They do not pretend to objectivity."[5]

The effect of watching political, opinionated documentary is itself rarely theorized in analyses of media spectatorship. Two competing theories of mass-media spectatorship leave the viewer of alternative media out of the picture. Frankfurt School-inflected theories of broadcast television spectatorship are based upon an understanding of lemming-like viewers who can't or are too indifferent to tell the difference between opinion and objectivity.[6] Although important in explaining the power of ideology in the maintaining of cultural hegemony, these ideas become less useful in a discussion of cultural production that passionately claims its biases because it is made and received by people motivated by a critique of current systems of power and oppression. On the other hand, descriptions of broadcast television's alienated, negotiating, or resisting viewer inflected by theories of the Birmingham School[7] are inadequate for describing the activity of viewing a video that people *need* to see, a video that addresses a specified and small viewership, even if they disagree with or challenge information in that video. Whereas resistance and negotiation are the key strategies of the broadcast television viewer who needs to make useful for herself TV that is most typically racist, sexist, homophobic, or in other ways simple-minded, the alternative AIDS video viewer to a large

extent can accept, support, and *identify* with the work she sees. Of course, she probably also rejects or questions material. But her criticism doesn't function in quite the same way as the resistance or negotiation of a spectator of mainstream media who is participating in what Jacqueline Bobo calls "counter-reception," the critical viewing of mainstream culture by "minority" viewers who are perfectly well aware that there is only a slight connection between their lived experiences and the world envisioned on the tube.[8] This strategy of reception is described by bell hooks as "critical resistance, one that enabled black folks to cultivate in everyday life a practice of critique and analysis that would disrupt and even deconstruct those cultural productions that were designed to promote and reinforce domination."[9] Counter-reception or critical resistance is a tough pose taken up for protection against the cultural production of an oppressive society. However, TV work produced outside dominant systems—work designed to challenge domination—can allow for, in the right context, of course, a loosening of that protective stance, an opening up and an acceptance (which does not mean the loss of criticality). Conscious processes of identification are progressive strategies in response to activist television because they enable a critical consideration of new and radical visions of the world, the self, the political.

IDENTIFICATION AND IDENTITY POLITICS IN ALTERNATIVE MEDIA

Tapes like *Current Flow* and *Like a Prayer* exemplify how alternative AIDS media moves towards a production and audience of the specific, just as the mainstream media continues to fabricate work for a general, disease-free public to which none of us really belong. A lesbian or activist viewer of *Current Flow* or *Like a Prayer* finally sees an explicit and proud version of herself in a public forum. In *Current Flow*, she sees cunnilingus performed by a woman; in *Like a Prayer*, she hears a new list of the Seven Deadly Sins: "Assault of Lesbians and Gays, Bias, Ignorant Denial, Endangering Women's Lives, No Safe Sex Education, No Condoms, No Clean Needles." Unlike how she may have recognized herself previously, by having "aberrant readings," where she "reads against the grain" of the homophobic or apolitical work usually presented to her, she may instead recognize part of herself as "lesbian" or "activist" in her similarities to, her identification with, the images constructed before her—images which insist that they come from communities with these explicit names. She can say: I've seen that before in my own bed; those sins I agree with.

Yet, of course, no identity, even an "identity politics," is that simple, so she will also always see, in an image that is not of herself, how she *differs* from others who call themselves lesbians or activists. Maybe she is an Asian-

American lesbian, or a Southern AIDS activist. These identities, like others, are complex, mobile, strategic at times, and only partially conscious. Viewing activist video provides a site where the interrogation and even potential change of one's "identity" can occur on both conscious and unconscious levels since it is precisely in moments of *identification*, when a non-lesbian or non-activist viewer of *Current Flow* or *Like a Prayer*, sees herself and her needs in another's, the "other's," that communication—and politics—begin. "I'm a heterosexual, but that looks pleasurable to me." "I'm straight, but that's what oral sex feels like for me." "I'm Catholic, but I do not believe that the oppression of gays is condoned by God." In such moments of identification, a more complicated notion of identity is supported: as I see my own lesbianess or activistness (or blackness or whiteness or maleness), even as I am not a "lesbian," "activist," "black," "white," or "male." Whether one's "identity" is as an insider or outsider to the position claimed by a tape, viewing alternative media that willingly identifies its construction from a position of difference or opinion can function to expand or at least challenge originary positions of identity. Activist video provides this forum because it is produced by and then exhibited to people who are actively defining their political agendas, the identities which make such demands, and the possible identifications with others who will stand in support of the ideas, policies, or goals under contestation.

Feminist film theorists have argued that the psychoanalytic mechanisms of identification inspired by viewing realist representation are one of the cinema's greatest powers and dangers. "'Identification' itself has been seen as a cultural process complicit with the reproduction of dominant culture by reinforcing patriarchal forms of identity," writes Jackie Stacey.[10] Stacey quotes Anne Friedberg, who emphasizes that, "Identification enforces a collapse of the subject onto the normative demand for sameness, which, under patriarchy, is always male."[11] If the confirmation of a unified, gendered subjectivity is one, most commonly theorized effect of identification within the cinema, there are many others. Paula Treichler notes many of these forms of unconscious *and* conscious identification in her reflections upon the abilities of mainstream media viewers to "identify" with PWAs:

> Questions of identification appear to involve memory, the nervous system, present goals and activities, life experience, familiarity with and pleasure in the conventions of a given narrative genre, demographic and circumstantial characteristics of the human figure (including their physical appearance, political perspective, values, real-life similarities and differences—class, gender, etc.), emotional and political connections to the text, and psychic commitments.[12]

As Treichler details, the point is not to abandon a psychoanalytic conception of identification but to supplement it with consideration of the more conscious levels of interaction which also occur when film and video texts, especially those which are politically motivated, are viewed by spectators who are seeking a politicized engagement with such texts as well as the real world they represent. When a viewer identifies with activist AIDS video, while it is probably true that a patriarchal form of gendered identity may be being reinforced on an unconscious level, she is also being invited to imagine herself with the anything-but-normative identity of a member of an oppositional community working and struggling in a lived reality at least somewhat similar to her own. When engaging with activist realist video, processes of self-recognition— the naming and claiming of complex identities and identifications found outside of dominant culture—are important in constituting politicized (if still also perhaps patriarchal) forms of identity.

WOMEN AND CHILDREN LAST: NEW CENTERS FROM OLD MARGINS

In her writing on indigenous media—video made by the "first nation" peoples around the world—Faye Ginsburg describes a postcolonial situation where ethnic or indigenous identity is affected and inflected by knowledge of, and participation in, the culture of the colonizer: "reflections of 'us' and 'them' to each other are increasingly juxtaposed."[13] The recent accessibility of video production and viewing allows a place in culture where this more fluid construction of images and identities can occur. Alternative media production allows the complicated work of identification to occur both within oppressed communities and between different communities. The possibility of self-definition occurs as the once "center" is allowed to identify with the "margin": to see itself there. In fact, alternative video allows the center and the margin to begin to see their reflection in the lives and experiences of the other.

This phenomenon is exemplified in *Women and Children Last* (1990), directed by Amber Hollibaugh and Gini Reticker. The ten-minute tape served as a trailer to raise funds for their final project, *The Heart of the Matter* (1993), a sixty-minute broadcast documentary. In their project, Hollibaugh and Reticker have re-defined the "general public" for whom their work is made to look more like the public they know: working- and middle-class black Americans. The film takes for granted that viewers from the "center" can identify with a "marginal" voice.

The tape focuses upon Janice Jirau, an HIV-positive black woman. Filmed in the close and intimate detail that only friendly relations between filmmakers and subject can produce, we hear Janice speak about the impact that AIDS has had on her life. She discusses her husband's death from AIDS,

and her own infection with HIV. He didn't want to use a condom, and she participated in unsafe sex because she wanted to "prove she loved him . . . reassure him . . . because he was hurting." We are also privy to a moving gathering of her family. They eat, sing, and speak together about Janice's illness and their love and support for her. In conventional and beautifully shot documentary footage, we see what network television rarely shows us: a strong black woman and a strong black family—not Bill Cosby's TV family, or Oprah's melodramatic mothers, but real people with real class, ethnic, and political identities. A black woman and her family become the recognizable "center" of the tape. But this center, Janice's interview, is framed with information which helps the viewer make sense of black, female experience, at least in a political sense: this frame is "white" representation.

The film opens with the title "1940s," which is followed by the title card from what appears to be a forties film, *Easy to Get*. In the appropriated images from this film, we see a white officer talking to a black man, also in military attire, although clearly with lower rank. The white officer quizzes the black man about where and how he met his girlfriend: "Was she a pick-up?" No, he met her on the street. "And you had her that night?" No, after a few dates. "And you didn't use a rubber . . . " "She looked clean." "Where you touched her she was filthy and diseased." Then another title appears —"1990s"— followed by a cut to Janice who explains: "I don't like the good girl/bad girl syndrome. I'm not good or bad, I'm just Janice."

This framing asks all viewers, white or black, male or female, to understand the subject of the film—the contemporary phenomenon of a black woman's experience with AIDS—in relationship to a long history of racial and sexual oppression, in and out of representation. To understand how critical it is for Janice to not understand herself as either a good girl or a bad girl, the viewer must try to understand a complicated history of racial and gender oppression, and a complicated black identity created from this history. The viewer must understand a long legacy of presumed guilt and responsibility for the spread of disease, especially for black women. The viewer must consider how white people have constructed blacks, and how black people construct themselves in light of the legacy of such images.

Most activist AIDS video, like *Heart of the Matter*, takes the form of documentary and the conventions of realism to transfer their respected subjects from a position of marginal to central status. This elevated or at least shifted subjectivity is necessary for performing the tasks of education, documentation, and self-identification central to the politics of AIDS video. Yet because activist producers rely on conventions that mimetically record reality does not require a lack of sophistication on their part about the fact that this representation of reality is *constructed* for clear and conscious ends. Feminist film

theory has conceptualized how patriarchy replicates and perpetuates itself through the formal mechanisms of the cinema as much, if not more so, than through the overtly sexist stories, roles, or stereotypes found in Hollywood films. In the 1970s, using newly-translated-to-English critical theory as their guide, influential theorists created a decidedly feminist set of interpretations which began to explain the structural basis of the maintenance of patriarchy through dominant systems of representation. Realist style was understood to be one of these devices: "realism as a style is unable to change consciousness because it does not depart from the forms that embody the old consciousness. Thus, prevailing realist codes . . . must be abandoned and the cinematic apparatus used in a new way so as to challenge audiences' expectations and assumptions about life."[14]

As was true for my brief discussions about prevailing theories of media reception and the effects of identification, the majority of feminist discussion about realist form has been developed through analyses of mainstream media. What has continually lacked theoretical attention are the effects of using conventional structures like realist style to represent oppositional content, which may be nothing more or less radical than using the camera to testify to the reality of one individual's underrepresented experience. AIDS activist videomakers—women who are drawn to media production because they have something urgent and opinionated to say—often use the camera as a tool for defining themselves as individuals or members of minority or political communities. People hitherto represented only in the punitive or oppressive manner of mainstream media can begin to confront how they want to see themselves and their concerns. Amy Taubin insists that an important lesson of the realist documentaries of the women's movement in the early 1970s is that "the way to insure marginalized people a place in history is to record their stories on film."[15] Realist codes and talking-head conventions are most typically used to do the political work of entering new opinions, new selves, or newly understood selves into public discourse. A political act founded in an awareness of what ideas and images hegemonic culture typically includes and precludes, the realistic representation of new "centers" of expertise is necessarily a self-conscious process.

THE EMBRACE: DISTRIBUTION AND RECEPTION ORGANIZE ALTERNATIVE PRODUCTION

Mainstream media flows quickly through our lives; unless we go to special efforts with our VCRs, it's broadcast and then gone. Because alternative media is not necessarily made to be broadcast, each project can develop its own plan for distribution and reception which often then organizes its mode of

production and formal strategies. Take, for example, *The Embrace/El Abrazo: A Video Performance* (1990), the documentation of a theater piece of the same name. The tape was produced by Pregones Touring Puerto Rican Theatre Collection, a group who uses an interactive theater technique known as Forum Theater. Directed by Diana Coryat, the video version performs the same, innovative educational function as the live performance.

Pregones produces bilingual Spanish/English theater to educate Latino communities about AIDS. The actors perform a scenario raising issues about AIDS which are common to the communities for whom they perform in East Harlem. In the performance documented in the tape, a married couple with a child decides to kick the wife's brother out of their apartment. The couple believes the brother is using drugs and, therefore, must be infected with HIV. At a critical juncture in the performance, a Joker character stops the action and asks the audience to identify the most oppressed character in the scenario. The audience is then instructed to consider how they would behave differently to resolve the confrontation. The scene is then enacted again on the tape, with an audience volunteer playing the part of the oppressed character. The new performance can be interrupted at any time by other audience members if it is decided that the situation could still be handled differently.

The video sticks to this interactive format, "encouraging critical thinking and audience participation," by using the Joker character as a narrator who instructs the spectators to turn the video off, and discuss or even enact their solutions, whenever he gives the word. When the video spectator turns the video back on, documentary footage of the solutions of two actual audiences is presented. Question and answer sessions from live performances, interviews with participants, and sections which provide accurate safer sex information are also included in the tape.

The tape, which is funded as AIDS education and not through media or arts organizations, challenges many expectations about the purposes and possibilities of media. Unlike television, which asks for the limited interaction of a maximum and universalized viewership, *The Embrace* is made to be used in small groups from specific communities and to incite audience action, education, participation, as well as their entertainment. Imagine a network televised educational program that asks the viewers to turn off their set! How would the home-viewer catch the commercials? Unencumbered by TV's mode of financing, *The Embrace* entirely refashions the uses of the television screen for local, specific, interactive education.

We have known since early in the course of the AIDS crisis that education is most effective when it comes from, and is made specifically for, the diverse communities who most need to be addressed. An entire chapter of the Panos Institute's 1988 analysis of the effects of AIDS on international ethnic

minorities, *Blaming Others: Prejudice, Race and Worldwide AIDS*, is devoted
to the necessity of minority communities educating themselves:

> AIDS prevention can only be effective if it changes people's sexual
> behavior. In the Third World, and among ethnic minorities in the
> North, this is unlikely to happen if AIDS education is perceived to
> emanate from the predominantly white, relatively privileged, out-
> side establishment.[16]

The chapter then goes on to document innovative global programs where
Zambians are educating Zambians, where prostitutes lead safer sex workshops
for other prostitutes, where churches educate their parishes, where Hispanic-
Americans produce AIDS-educational materials in Spanish. "We don't believe
in translations," says Dr. Jane Delgado, president of the National Coalition of
Hispanic Health and Human Service Organizations.[17]

 In the production of educational AIDS video there has been a similar
trend. Jose Guiterres-Gomez and Jose Vergelin, producers of one of the earliest
telanovela-style educational AIDS videos, *Ojos Que No Ven* (1987), explain:

> Effective AIDS education directed at minorities requires a show and
> tell medium that can also role model positive behavior change while
> reflecting the language, culture, values, and lifestyles of the target
> audience . . . Government agencies will often translate materials in
> order to save money and the result is, almost inevitably, a useless
> one. People simply cannot relate what they are being taught (to
> their lives), and the educational message falls on deaf ears.[18]

Guiterres-Gomez and Vergelin call for a move towards producer/audience
identification in the production of educational AIDS media. Appropriate and
useful education demands a specificity of voice and address: an explicit
acknowledgment of what unifies, and identifies, maker and audience. From
early in its representational history, this connection between audience and pro-
ducer has occured in the "artist's response" to AIDS as well, according to Jan
Zita Grover:

> AIDS activist groups and service organizations now spend as much
> time defining and addressing questions about audience—i.e., appro-
> priate language, idiom, graphic style, literacy level and circulation
> for different "markets" of AIDS information—as any art director or
> account rep at DD or Chiat-Day. Many young artists have had their

first introduction to their own marginality as speakers and audiences (e.g., as gay men, as lesbians, as sex workers, as artists) while working on these projects. They have also learned the salutary lesson that it is difficult to speak effectively for or to people unlike themselves.[19]

The educational work of the alternative AIDS media in this way is forced to contradict the legacy of ethnographic film, where the "other" is represented by an outsider. With the democraticization of camcorder technology, the culturally disenfranchised who are most typically the victims of the curious gaze and cameras of outsiders can for the first time afford to represent themselves using video. The camcorder offers a practical response to the theoretical dead ends of ethnography and multiculturalism. Ethnography is most typically an unreciprocated will to know some disempowered "other," while multiculturalism, according to independent media producer Ada Gay Griffin, often belies "the diversity of the self-determined points of view of the disempowered."[20] With a camcorder, marginal communities are able to represent themselves cheaply and easily. This allows for the most pressing issues of our era to be documented by people from within affected communities for spectators who share all kinds of self-identified difference with the makers. Such projects emphasize the "self-determination of the disempowered," documenting the experiences and needs of the disenfranchised because they want them to be imaged. While such forms of "indigenous media" will never be viewed by a mass audience—and while it would be beneficial if they could—this is not why the work is made, and it is not why the work is powerful. Rather than making the kinds of concessions typically made by broadcast TV so as to speak to the many, alternative AIDS video is founded upon the power of intimate, deliberate, supportive communication between allies.

CONCLUSION

An intense relationship between subject, maker, and audience has contributed to the art work of other political causes. In the 1940s, feminists were making documentaries about which, Barbara Halpern Martineau has argued, "the relationship of commitment between filmmaker and subject, and between these two and the audience, provides a little-discussed dimension to the issues of how women are 'represented' in (feminist) documentaries."[21] It does not surprise me that the comfortable and explicit relationship between filmmaker, subject, and audience is also invoked by AIDS-activist videomaker Gregg Bordowitz as he tries to give words to the new cultural production by gays and lesbians, especially their AIDS activist video:

A queer structure of feeling can be described as an articulation of presence forged through resistance to heterosexist society. Cultural work can be considered within a queer structure of feeling if self-identified queers produce the work, if these producers identify the work as queer, if queers claim the work has significance to queers, if the work is censored or criticized for being queer. A particular work is queer if it is viewed as queer, either by queers or bigots.[22]

I feel something akin to a "queer structure of feeling" when I see and write about AIDS activist video, by, for, and about women. An "insider" to the AIDS movement, as well as the AIDS activist video movement, I see myself and my needs—so rarely represented in popular culture—in video recordings of other women's faces, their words of anger and bodily gestures of defiance, in the intense and fast-paced editing which tells their stories, and in the grainy footage which identifies a camera that needs to record what is in front of it, no matter what. What I see when I view these videos, as a woman who has been moved to act because of the tragedies of AIDS, are communities of women both similar and different from myself who have also been moved to act. I see lesbians making love in *Current Flow*, women protesting in the street in *Like a Prayer*, Janice and her family in *Women and Children Last*, the women in the audience participating in the workshop in *The Embrace*. I see myself in them: in their strength, and purpose, and politics; in the common struggles we have shared as women. I do not see myself in them: in our differences of language, needs, ethnicity. Yet, I see that I have a community around me, even if these women will never know me, nor I them. Through these video representations and video communities, I find power to go on as I learn what has been done, what still needs to be done, and as I learn that I am not alone.

NOTES

1. The formal and theoretical trends demonstrated in activist AIDS video change, adapt, and interact with other styles and ideas as rapidly as does AIDS activism. Thus, the activist video work made in 1990 most likely has a distinct look and approach, and sets out premises about AIDS and AIDS activism that is different from work made only a few years earlier or later.

2. Jean Carlomusto and Gregg Bordowitz, "Do It!", *Video Guide*, vol. 10, nos. 3–4 (November 1989): 22.

3. The group of women were involved in a project called the Women's AIDS Video Enterprise (WAVE) which attempted to integrate video education and AIDS support so as to provide a model for the production of community-specific and community-produced AIDS education. WAVE made the video "We Care: A Video for Care

Providers of People Affected By AIDS" (1990). I have written extensively about this project in *AIDS TV: Identity, Community and Alternative Video* (Durham, North Carolina: Duke University Press, 1995).

4. David Armstrong, *A Trumpet to Arms: Alternative Media in America* (Los Angeles: J. P. Tarcher, 1981), 22.

5. Sean Cubitt, *Timeshift: On Video Culture* (New York: Routledge, 1991), 140.

6. See for example, Andrew Arato and Eike Gebhardt, eds., *The Essential Frankfurt School Reader* (New York: Urizen Books, 1978); and Max Horkheimer and Theodor Adorno, *Dialectic of Enlightenment*, trans. John Cumming (New York: Seabury Press, 1972).

7. See, for example, Stuart Hall, et al., eds., *Culture, Media, Language* (London: Hutchinson, 1980); James Curran, et al., eds., *Mass Communication and Society* (Beverly Hills, California: Sage, 1979); or John Fiske, "British Cultural Studies," in Robert Allen, ed., *Channels of Discourse* (Chapel Hill: University of North Carolina Press, 1987): 254–289.

8. Jacqueline Bobo, "The Color Purple: Black Women as Cultural Readers," in E. Deidre Pribram, ed., *Female Spectators* (London: Verso, 1988), 90–109.

9. bell hooks, *Yearning: Race, Gender and Cultural Politics* (Boston: South End Press, 1990), 6.

10. Jackie Stacey, "Feminine Fascinations," in Christine Gledhill, ed., *Stardom: Industry of Desire* (New York: Routledge, 1991), 147.

11. Anne Friedberg, "Identification and the Star," in Christine Gledhill, ed., *Star Signs* (London: BFI, 1982), 50.

12. Paula Treichler, "AIDS Narratives on Television," in Timothy Murphy and Suzanne Poirier, eds., Writing AIDS. (NY: Columbia University Press, 1993:) 186–187.

13. Faye Ginsburg, "Indigenous Media: Faustian Contract or Global Village?," *Visual Anthropology*, vol. 6, no. 1 (1991): 108.

14. E. Ann Kaplan, "Theories of the Feminist Documentary," in Alan Rosenthal, ed., *New Challenges for Documentary* (Berkeley: University of California Press, 1988), 80.

15. Manohla Dargis and Amy Taubin, "Double Take," *Village Voice* (January 21, 1992): 56.

16. Renée Sabatier, ed., *Blaming Others: Prejudice, Race and Worldwide AIDS* (Philadelphia: New Society Publishers, 1988), 123.

17. Jane Delgado, "Interview, October 1987" in *Blaming Others*, ed. Sabatier, 139.

18. Jose Guiterres-Gomez and Jose Vergelin, "Mining The Oro Del Bario," *Video Guide*, vol. 10, nos. 3–4. (November 1989): 13.

19. "Introduction to AIDS: The Artists' Response," *Exhibit Guide: AIDS The Artists Response*, ed. Jan Zita Grover, (Columbus: Ohio State University, 1989).

20. Ada Gay Griffin, "What's Mine is Not Mine/What's Mine is Ours/ What's

Mine is Yours/What's Yours is Yours (Power Sharing and America)," *FELIX* , vol. 1, no. 2 (Spring, 1992): 15.

21. Barbara Halpern Martineau, "Talking About Our Lives and Experiences: Some Thoughts About Feminism, Documentary and 'Talking Heads,'" in Thomas Waugh, ed., *Show Us Life* (Metuchen, New Jersey: Scarecrow Press, 1984), 254.

22. Gregg Bordowitz, "The AIDS Crisis is Ridiculous," in Martha Gever, John Greyson, and Pratibha Parmar, eds., *Queer Looks* (New York: Routledge, 1993).

MARION D. BANZHAF starting working in the women's health movement in 1975. While a member of ACT UP/NY, she was a co-author of *Women, AIDS, and Activism* and became the Executive Director of the New Jersey Women and AIDS Network from 1990–1996. She is pursuing graduate studies in New York.

CHYRELL BELLAMY Educator, advocate, and activist in the AIDS field since 1987, specifically on behalf of issues of women, and people of color. She is currently a doctoral student in Social Work and Social Psychology at the University of Michigan. Her research experience includes prevention and treatment issues of women living with HIV, as well as understanding the experiences of recovery for women with mental illness. She is also a former assistant Director of NJWAN.

JOHN NGUYET ERNI is the author of *Unstable Frontiers: Technomedicine and the Cultural Politics of "Curing" AIDS* (University of Minnesota Press, 1994), and numerous articles on AIDS and cultural studies. He teaches media and cultural studies in the Department of Communication, University of New Hampshire. He is currently working on a book about HIV/AIDS in Southeast Asia, globalization, and sexual politics.

AMBER HOLLIBAUGH has thirty years experience as a national organizer, educator, policy analyst, filmmaker and writer. She has worked as a theoretician and activist on issues including prisoners' rights; homophobia; women's rights; incest; domestic violence; rape; race and class oppression; and sexuality. For the last ten years she has worked as a health educator for the NYC Department of Health, as the Video and Education Director for the NYC Human Rights Commission–AIDS Discrimination Unit. She was the founding Director of the Lesbian AIDS Project at GMHC in New York City and is now the National Field Director of Women's Education Services at Gay Men's Health Crisis.

She is an award winning film and video producer with fifteen years experience in film and video production. She was the Co-Producer/Director of *The Heart of the Matter*, an independent hour

long documentary film examining women's sexuality through the prism of AIDS. This film won the Freedom of Expression award at the 1994 Sundance Film Festival. The film made its 1994 national premiere on PBS in its national POV series. She is an essayist and published writer.

KATIE HOGAN received her doctorate in English at Rutgers University, New Brunswick, New Jersey. Her dissertation, "Immaculate Infection: Women, AIDS, and Sentimentality" examines representations of women in AIDS literature and popular culture. She is an assistant professor of English at LaGuardia Community College, City University of New York, Long Island City, NY.

Professor Hogan has published several essays on women, HIV, and feminism, including "Sentimentality, Race, and *Boys on the Side*" in *Women's Ways of Acknowledging AIDS: Communication Perspectives*, ed. Nancy L. Roth (New York: Haworth Press, 1997); "Where Experience and Representation Collide: Lesbians, Feminists, and AIDS" in *Cross Purposes: Lesbians, Feminists, and the Limits of Alliance*, ed. Dana Heller (Indiana: Indiana University Press, 1997); and "'Victim Feminism' and the Complexities of AIDS" in *Bad Girls/Good Girls: Women, Sex, and Power in the Nineties*, ed. Nan Bauer Maglin and Donna Perry (New Brunswick: Rutgers University Press, 1996).

In addition, Professor Hogan was a recipient of the 1996 Pergamon-National Women's Studies Association Award for Graduate Scholarship in Women's Studies and has taught both introduction to women's studies and undergraduate courses on women and AIDS.

CARRA LEAH HOOD, a graduate student in Comparative Literature at Yale University, is currently completing her dissertation, "Reading the News."

ALEXANDRA JUHASZ is an Assistant Professor of Media Studies at Pitzer College. Her work as both feminist film/video-maker and scholar focuses on committed uses of the media towards social change. She has recently written *AIDS TV: Identity, Community and Alternative Video* (Duke, 1995), and produced the feature film *The Watermelon Woman* and the documentary *Women of Vision: Twenty Histories In Feminist Film and Video*.

CYNTHIA MADANSKY is a visual artist, and designer. She recently completed an hour long 16 mm film in collaboration with Alisa Lebow, entitled *Treyf*. Mandansky is a graduate of the Whitney Independent Study Program and completed her MFA at Rutgers University. Her work has been exhibited in East and West Jerusalem, Caracas, Sydney, Paris, Montreal, Toronto, San Francisco and NYC.

CINDY PATTON teaches in the Graduate Institute of the Liberal Arts at Emory University. She has been active in AIDS politics and cultural criticism since the early 1980s. Her numerous writings on the epidemic include *Sex and Germs: The Politics of AIDS* (1985), *Making It: A Woman's Guide to Sex in the Age of AIDS* (with Janis Kelly, 1987), *Inventing AIDS* (1990), *Last Served? Gendering the HIV Pandemic* (1994), and *Fatal Advice* (1996). She also writes about American popular culture and is currently completing a book about race and acting in post-World War II films.

FLAVIA RANDO is the co-editor of *Gay and Lesbian Presence in Art and Art History*, a special issue of the *Art Journal*. She has been teaching in the Women's Studies Program at Rutgers University while she completes her doctorate in the Art History Department of Rutgers.

NANCY L. ROTH is an Outcomes Manager at Roche Labs, Inc. Prior to joining Roche she was an Assistant Professor of Communication at Rutgers University. Her research explores issues of identity and policy in Health Communication and her recent work focuses on those concepts as they emerge in attempts to include underrepresented groups in drug clinical trials. Publication credits include: *Women and AIDS: Negotiating Safer Practices, Care and Representation* (Haworth, 1997, with Linda K. Fuller), articles in major journals including *Aids Care, Howard Journal of Communications, Organization Science*, and *The Journal of Psychology and Human Sexuality*, and chapters in several recent books, including *The Psychology of Sexual Orientation, Behavior and Identity* (Greenwood, 1995), *HIV and Sexuality* (Haworth, 1995), *Health Workers and AIDS: Research, Intervention and Current Issues in Burnout and Response* (Harwood, 1995), and *Communication about Communicable Diseases* (HRD Press, 1995). She has won two Teaching Fellowships from the Lilly Endowment, Inc., a Research Fellowship with the National Centre for HIV Social Research, University of New South Wales, Sydney, Australia, and several teaching awards and research grants. Work on this book was completed during her tenure at Rutgers University.

PAULA TREICHLER is an associate professor at University of Illinois College of Medicine at Urbana-Champaign. She has concurrent appointments in Women's Studies, the Institute of Communications Research, and the Unit for Criticism and Interpretive Theory.

CARMEN VAZQUEZ is Director of Public Policy for the New York Lesbian and Gay Community Services Center. A self-identified "Puerto Rican Butch Socialist," she is a veteran of more than twenty years of activism to realize economic

justice for poor and working-class people and liberation for all oppressed and marginalized people. She is the founding Director of the Women's Building in San Francisco and served as Coordinator of Lesbian and Gay Health Services for the San Francisco Department of Public Health from 1988–1994.

CATHERINE WARREN is an assistant professor in the Department of English, North Carolina State University.

KAREN ZIVI is a graduate student in the Department of Political Science at Rutgers University where she has taught a course on HIV and Public Policy. Her dissertation research explores the intersections of liberal political theory and feminist practice in AIDS policy debates.